The Golden Thread

Also by Kassia St. Clair

The Secret Lives of Color

The Golden Thread

How Fabric Changed History

Kassia St. Clair

Liveright Publishing Corporation A Division of W. W. Norton & Company Independent Publishers Since 1923 Copyright © 2018 by Kassia St. Clair First American Edition 2019

First published in Great Britain in 2018 by John Murray (Publishers) An Hachette UK company

All rights reserved Printed in the United States of America First published as a Liveright paperback 2021

For information about permission to reproduce selections from this book, write to Permissions, Liveright Publishing Corporation, a division of W. W. Norton & Company, Inc., 500 Fifth Avenue, New York, NY 10110

For information about special discounts for bulk purchases, please contact W. W. Norton Special Sales at specialsales@wwnorton.com or 800-233-4830

Manufacturing by LSC Communications, Harrisonburg Production manager: Anna Oler

Library of Congress Cataloging-in-Publication Data

Names: St. Clair, Kassia, author.

Title: The golden thread : how fabric changed history / Kassia St. Clair. Description: First American edition. | New York : Liveright Publishing Corporation, 2019. | Includes bibliographical references and index.

Identifiers: LCCN 2019021979 | ISBN 9781631494802 (hardcover) Subjects: LCSH: Textile fabrics. Classification: LCC TS1765 .S7 2019 | DDC 677—dc23 LC record available at https://lccn.loc.gov/2019021979

ISBN 978-1-63149-901-2 pbk.

Liveright Publishing Corporation, 500 Fifth Avenue, New York, N.Y. 10110 www.wwnorton.com

W. W. Norton & Company Ltd., 15 Carlisle Street, London W1D 3BS

234567890

To my father, for tenacity and storytelling

Contents

	Preface	xi
	Introduction	1
	1. Fibers in the Cave: The Origins of Weaving	19
	2. Dead Men's Shrouds: Wrapping and Unwrapping Egyptian Mummies	35
	3. Gifts and Horses: Silk in Ancient China	55
A.	4. Cities That Silk Built: The Silk Roads	75

	5. Surf Dragons: The Vikings' Woolen Sails	95
- KA	6. A King's Ransom: Wool in Medieval England	115
en e	7. Diamonds and the Ruff: Lace and Luxury	135
(p)	8. Solomon's Coats: Cotton, America, and Trade	157
	9. Layering in Extremis: Clothing to Conquer Everest and the South Pole	181
Prf.	10. Workers in the Factory: Rayon's Dark Past	201
	11. Under Pressure: Suits Suitable for Space	223

12. Harder, Better, Faster, Stronger: Record-Breaking Sports Fabrics

247

269

13. The Golden Cape:	
Harnessing Spider Silk	

Golden Threads:	
A Coda	287
Acknowledgments	293
Clossary	395
N	200
Notes	299
Bibliography	317
Index	337

Preface

If you take your eyes off this page and look down, you will see that your body is encased in cloth. (I am assuming here, dear Reader, that you are not naked.) Perhaps you are sitting on the cushioned seat of a train or bus, or in the bosom of a plump sofa. You may be enrobed in a towel, confined within the colorful enclosure of a tent, or enfolded in bedsheets. All are made of cloth, whether woven, felted, or knitted.

Fabrics—man-made and natural—have changed, defined, advanced, and shaped the world we live in. From prehistory to the early Middle Eastern and Egyptian civilizations; via the silken dragon robes of Imperial China to the Indian calicoes and chintzes that powered the Industrial Revolution: arriving finally at the lab-blended fibers that have allowed humans to travel farther and faster than ever before. For much of recorded history, the four principal sources of natural fibers—cotton, silk, linen, and wool have borne much of the strain of human ingenuity. They have been pressed into service to give warmth and protection, demarcate status, confer personal decoration and identity, and provide an outlet for creative talent and ingenuity.

We live surrounded by cloth. We are swaddled in it at birth and shrouds are drawn over our faces in death. We sleep enclosed by layer upon layer of it—like the pea that woke the princess in the fairy tale—and, when we wake, we clothe ourselves in yet more of it to face the world and let it know who we shall be that day. When we speak, we use words, phrases, and metaphors in which the production of thread and cloth have insinuated themselves. The words "line," "lining," "lingerie," and "linoleum," for example, are all rooted in the word "linen." For most people, who know little of the practical business of turning the stems of flax into thread or conjuring damasks from a skeletal warp on a loom, these linguistic motifs could seem little more than empty shells washed up on a beach: a pallid reminder of something greater, richer, only half understood today, but worth our curiosity.

When I studied eighteenth-century dress at university, I was constantly confronted with the stubborn belief that clothing was frivolous and unworthy of notice, despite its evident importance to the society under discussion. When I went on to write about contemporary design and fashion I encountered similar snobbery. Examination of fabrics is often ghettoized. Even when it is the principal focus of mainstream attention, it is usually the appearance and desirability of the end product being discussed, rather than the constituent raw materials and the people who fashion them.

This book invites you to take a closer look at the fabrics that you surround and clothe yourself with each day. It is not—and was never intended to be—an exhaustive history of textiles. Instead, *The Golden Thread* contains thirteen very different stories that help illustrate the vastness of their significance. In one chapter you will be invited behind the scenes to watch the making of the spacesuits that allowed us to walk on the moon. Another looks at the craft that inspired Vermeer to paint *The Lacemaker*. Elsewhere you'll meet the people who wrapped—and those who unwrapped—Egypt's mummies; inventors and scientists who have spent their lives trying to make cloth from spiders' silk; and those whose clothes failed them in the most extreme environments on earth with fatal consequences. It is a book written for the curious: I hope you enjoy it.

I give you the end of a golden string; Only wind it into a ball: It will lead you in at Heaven's gate.

William Blake, "Jerusalem," 1815

Introduction

Threads and the Body

The threads the Fates spin are so unchangeable, that even if they decreed to someone a kingdom which at the moment belonged to another, and even if that other slew the man of destiny, to save himself from ever being deprived by him of his throne, nevertheless the dead man would come to life again in order to fulfil the decree of the Fates.

Flavius Philostratus, Life of Apollonius Tyana, third century AD

The ancient Greeks believed human destiny was controlled by the Fates, three mythological sisters who visited every child soon after birth. Clotho, the most powerful, would take her spindle and spin the thread of their life; Lachesis carefully measured its length; and then Atropos would sever it, determining the exact moment of death. No human or god had the power to change their decisions once made. The Romans named their trio the Parcae; and the Norse had the Norns. This ancient story still echoes through the way we think about ourselves and our society. When we talk of lives hanging by a thread, being interwoven, or being part of the social fabric; or if we want to help someone in danger of unraveling, or being torn away from their friends or family, we are part of a tradition that stretches back many thousands of years. Fabric and its component parts have long been a figurative stand-in for the very stuff of human life. In many ways this is only natural. The production of cloth and clothing has always been of great importance to the global economy and its cultures. Cloth gave humanity the ability to choose their own destiny. It's believed that prehistoric cloth-making in temperate regions consumed more working hours than the making of pottery and food production combined. In ancient Egypt, linen was revered. Not only did it form part of most people's everyday experience—it was, after all, the most common textile used for clothing and many people would be involved in farming and making it—it also held profound religious significance. So much so, in fact, that the very act of mummification and the wrapping of the body with specially prepared cloths, as well as those that had been passed down through generations, transfigured ordinary human remains into something divine.¹

Our cavalier attitude to cloth today would be anathema to our ancestors. Textiles have allowed humans the ability to live in and travel through a plethora of regions that might otherwise have proved too cold to be hospitable. Rich silks and warm woolen cloths bartered through trade networks such as the Silk Roads facilitated cross-cultural exchanges of ideas, craft techniques, and people. The dexterous, finger-plied work of producing thread and cloth was the daily experience of countless individuals. It has been estimated, for example, that over a million women and children were employed in spinning in England alone by the mid-eighteenth century. On the eve of the Industrial Revolution, the income they earned might represent a third of a poorer household's income. This great economic shift, which in today's collective imagination is so closely bound up with steel and coal, was in fact largely powered by textiles, and of one kind in particular. "Whoever says Industrial Revolution," wrote Eric Hobsbawm in Industry and Empire, "says cotton." This cropand the textiles made from it-was arguably the first global commodity.²

While we no longer pay as much attention to the sourcing and quality of the individual pieces of cloth that we interact with on a daily basis, they remain deeply personal. We use clothing, for example, to signal to those we meet who we are and how we want to be perceived. Distinct uniforms exist for those working in London

2

hedge funds, Silicon Valley start-ups, and media companies, for example, even though most of these people will actually spend the majority of their days in offices and behind desks. Subordinates often adopt the sartorial preferences of their bosses, and trends spread like wildfire within the confines of small institutions. (There was an inexplicable vogue for sleeveless sweaters in one office where I once worked; and the same professors who earnestly explained how futile it was to find meaning in the clothing choices of eighteenth-century ladies and gentlemen were usually clad in nearly identical tweed jackets and cord trousers, perhaps leavened with brightly colored socks if they fancied themselves rebels.)

Social strata have long been codified—legally as well as unofficially—using cloth. Among the many strange prohibitions in the Old Testament, believers were enjoined not to "sow thy field with mingled seed: neither shall a garment mingled of linen and woolen come upon thee." This wasn't a moral objection: priests' garments were made of both and this special combination was an honor recorved for them alone.

Sumptuary laws that restrict the wearing of certain types of fabric to specific classes have existed for millennia. They can be found in cultures as diverse as those found in ancient China, classical Rome, and medieval Europe. A proclamation passed in England in 1579, for example, forbade "Ruffes made or wrought out of England, commonly called Cutworke" to be worn by anyone "Under the degree of a Barons Sonne, a knight, and Gentleman in ordinarie office, attending upon her Maiesties person." Queen Elizabeth I, the reigning monarch, was consummately skilled in the arts of using luxurious display to express power, as her portraits so elegantly attest. Although it seems likely that she loved beautiful fabrics for their own sake too. In a famous—although possibly apocryphal story, she was given a pair of knitted black silk stockings by her silkwoman Mrs. Montague in 1561 and refused to wear any other kind thereafter.³

Tools of the Trade

- I'm a weaver, a master weaver, I've got a loom where the best cloth's made.
- Plain cloth, twill, brocade or satin, I'm the master of my trade.
- Shed the warp and swing the shuttle, beat the reed, the weft is laid.
- I can wind a flying bobbin, I can warp a theme of thread.

I can weave a sheet of linen, fit to grace a royal bed. Lift the heel and fly the shuttle, swing the reed, the

weft is laid.

English folk weaving song

All textiles begin with a twist. The word "spinning" now evokes an idea similar to twirling, like the action of a spinning top, but it originally denoted an action that was at once a twirl and a drawing out, akin to pulling candy floss out around a stick at a fair. Much the same action is used when spinning thin, delicate fibers by hand to make thread, which is altogether tougher and more useful. Fibers of wool or flax or cotton—which are shorter, finer, and more slippery, and so trickier to work with—are drawn out from a large, loose mass of their fellows and simultaneously twisted into yarn. This takes practice: jerky movements will result in lumpy, clotted thread, while drawing out too quickly or too slowly will mean the finished product is either too thin or too thick. The twist can either be clockwise, in which case it is a Z-twist, or counterclockwise: S-twist. But getting it just right is vital: under-twisted yarn will be too weak, but if it is over-twisted it will

5

buckle up on itself and be prone to wayward knots and tangles as you work with it. Able spinners are the products of hours of repetition and, usually, instruction from a good teacher, who introduces the learner to the intricacies of the craft.⁴

There are many ways to spin, and the methods a spinner uses depend on their culture, personality, the kind of product they wish to create, and the materials they are using. Some twist fibers between hand and the big toe or thigh, others use a spindle—a rod, usually around a foot long—even a hooked stick will do. (Spindles give spinners an advantage, since they also provide a place on which to wind the thread as it is made, preventing it from getting knotted.) The same community might use several different methods. Threads, once made, might be used as they are or plied with other threads to create stronger, thicker ones better suited to hardier tasks.

Thread, once made, can be put to all manner of uses: braided or corded to make laccs or ropes; knitted or, of course, woven. Weaving is essentially the process of interlacing sets of threads together to form a continuous web. Classically, two sets of threads are woven together at right angles. The warp is held on a loom to prevent an unholy muddle, while the weft threads are patiently threaded through. There are countless ways of intersecting the threads when weaving. The simplest form is plain or tabby weave, where each weft thread goes over one warp thread and under the next. More complex methods, where the weft goes over or under several warp threads, for example, can produce cloth with diverse characteristics or patterns. Twill, for example, used to make denim, is created by passing the weft threads over one and under two or more; the finished fabric appears scored by diagonal lines and is hard-wearing.

Given how finicky the processes involved are, and how soft, unruly, and fragile the raw materials, it's only natural that a whole dynasty of technologies has been developed to help in the production of cloth. Some—such as the spindle, mentioned above, and the distaff, which was used to hold quantities of raw, unspun fibers were allied to spinning. Others, such as the loom, were used for weaving. In essence, a loom is an implement used to hold the warp taut. One of the very earliest kinds, the back strap, used the weight of a person's body to create tension. Another kind, common in ancient Greece, was known as the warp-weighted loom. It involved an upper horizontal bar from which the warp threads were suspended with weights at the bottom. No matter what the design, the weft is passed through from one side to the other, building up the fabric thread by thread. Later, more complicated loom designs allowed weavers to lift up some of the warp threads so the weft could be rapidly pushed through the gap—known as the shed—all in one go. The earliest use of this technology, known as the heddle loom, was in Egypt around 2000 $BC.^5$

Much of the work that was needed to produce early thread and textiles is, of course, all but invisible today. The makers didn't often leave written records behind, and their techniques and skill have rotted away with the objects they created. What does survive leaves us with an asymmetrical impression: someone using hand and thigh to spin will be invisible to the archaeological record, for example, while someone using a large stone spindle whorl will not. The same is true of looms: the more complex and permanent they are, the more traces they leave behind.⁶

Clothing is the most obvious use for textiles, but threads and fabrics reside in many places we do not expect them. My boots are laced with jaunty braided strands of red cotton, and as I type this my wrists occasionally bump against a suede-like material called Alcantara that covers my laptop keyboard and that is more usually found in high-end cars. If you own a Google Home, you may have noticed that portions of it are swathed in a comforting blend of polyester and nylon. Indeed, the designers of consumer electronics increasingly incorporate fabrics into their creations as a way of softening technology. Tech devices are now so much a part of our daily lives it no longer makes sense to make them look hard-edged and futuristic. Instead, makers want them to blend into our surroundings, just another cuddly component of our domestic landscape: hence the use of fabric. But the idea of "softening" tech products using fabric is itself inherently odd. The industry of fabric is older than pottery or metallurgy and perhaps even than agriculture and stock-breeding. Cloth is the original technology.7

Trade and Technology

The weavers take the intertwined threads and through their expert, value-added activity create a strong fabric—which is exactly what the global distributed network of computers creating the Bitcoin Blockchain does.

David Orban, "Weaving Is a Better Metaphor for Bitcoin, Instead of Mining," 2014

In 2015, Google I/O, one of the firm's secretive research and development divisions, announced that they were planning to make a pair of trousers that would also be computers. They would be made of a special textile—available in a wide palette of colors and myriad textures—that would function as a touchscreen, registering special gestures and able to control devices such as smartphones. Two years later it turned out that while the trousers had proved unworkable— Google I/O partnered with Levi Strauss to produce a denim jacket instead—the fabric itself functioned exactly as it was supposed to. The jacket, which can be tapped or stroked to play or pause music, skip through tracks and so on, and which will also alert you if you get a text, went on sale for 350 dollars. Although early reviews have found the technology rather limited—you're only controlling the smartphone that's in your pocket, after all—others see such smart fabric as the wearable tech of the future.⁸

The name chosen for this futuristic endeavor was Project Jacquard, a name with a nineteenth-century pedigree. In 1801 Joseph Marie Jacquard invented a loom that made it possible to mass-produce textiles with complex woven patterns, something that previously had taken a great deal of skill, time, and expertise to produce. His "Jacquard Loom" was controlled, or programmed, by pieces of cardboard marked with a series of holes that determined the pattern. Much later, these ingenious, hole-punched cards paved the way for another invention: computing. An American engineer repurposed the punched-card system to help record census data. His firm eventually became part of International Business Machines, latterly known as IBM.⁹

The Jacquard Loom is one of the more obvious links between technology and textiles, but examples can be found much further back. The earliest fabrics that we know were made by human hand were created using fibers gleaned from flax plants over 34,000 years ago. Transfiguring flax, wool, cotton, silk, hemp, or ramie into thread was a technological feat, requiring skill and tools—spindles and distaffs—many millions of which have been excavated from the world's oldest archaeological sites. These threads could then be used to create rope, nets, and—when woven together on looms, felted, or knitted—textiles. Such technologies allowed our early ancestors to gather food more quickly, transport it over greater distances and more easily, and venture farther afield to less temperate regions to seek out new habitats.

At every stage of production these materials were traded by their makers, forming a vital part of networks that crept over the globe like arteries, carrying language and ideas as well as goods. This trade meant that sophisticated methods of credit and bookkeeping were developed. Making cloth meant making money. Wealth created by the production and sale of textiles funded the Italian Renaissance. The Medici family, who were involved in the production of woolens, became the bankers of Europe during the fifteenth century. Their patronage helped Michelangelo make his David, Filippo Brunelleschi rebuild the Basilica di San Lorenzo and Leonardo da Vinci paint the Mona Lisa. Farther east, cotton textiles powered the Mughal Empire; calicoes were exported to America, Africa, Europe, and Japan. China, meanwhile, jealously guarded the secrets of sericulture-silkworm rearing-for many centuries, monopolizing the lucrative silk trade. Even today, the results of specialization persist. Italy is the place to go for fine silks and baroque prints. Mantero, a hundred-year-old firm based near Lake Como, has an archive of over 12,000 books of swatches and samples from which to draw inspiration. The United Kingdom's mills remain the gold standard for woolens and worsteds.

Chanel sources its tweeds from Linton Tweeds, a relationship that dates back to the 1920s when Coco Chanel met William Linton. For the latest in textile innovation, buyers will usually begin and end their search in Japan, which has a decades-long tradition of successful innovations with man-made fibers, such as Uniqlo's beloved Heattech range.¹⁰

The desire to produce more cloth more efficiently provided the impetus for a jolting, uneven cascade of technological advancements. The earliest looms, requiring the weight of a human body, gave way to more complex horizontal or vertical models made of wood and weighted with large beads of clay or stone. Much later, as markets expanded and demand increased, the need for innovation became ever more urgent. In 1760 the Journal for the Society for the Encouragement of Arts, Manufactures, and Commerce offered rewards for "a machine for spinning six threads of Wool, Cotton, Flax, or Silk, at one time, and that will require but one person to work and attend it." They soon got their wish over the course of a century the Spinning Jenny, the Water Frame and the Power Loom, and a host of other inventions exponentially increased the rates of production. Think of the Industrial Revolution and coal and steel will spring to mind, but it would be more accurate were we to picture instead the busy whir of threaded looms and cavernous factories choked with cotton dust. Indeed, even so fundamental an economic principle as division of labor had as a model the making of textiles. Nearly a century before Adam Smith conjured his hypothetical pin factory, the economist William Petty wrote that "Cloth must be cheaper made, when one Cards, another Spins, another Weaves, another Draws, another Dresses, another Presses and Packs; than when all the Operations above-mentioned, were clumsily performed by the same hand."11

All this change had profound consequences for spinners and weavers. Take, for example, the plight of woolen cloth workers in Leeds in 1786, who suddenly found their livelihoods threatened by the invention of new "scribbling machines' able to card the fibers more quickly and cheaply than they could. "How are those men," they asked in a petition to a local newspaper, "thus thrown out of employ to provide for their families; and what are they to put their children apprentice to, that the rising generation may have something to keep them at work, in order that they may not be like vagabonds strolling about in idleness?" It was fears such as these that gave rise to the Luddite movement, a wave of violence against machinery by unemployed cloth workers. The term Luddite has since become derogatory, used to signify a techno-dinosaur vainly standing in the way of progress. Today, when the livelihoods of workers in diverse industries are similarly threatened by the development of new technologies, the lamentations of the Luddites feel all too relatable once more.¹²

Spinning Tales

"That must be wonderful cloth," thought the Emperor. "If I were to be dressed in a suit made of this cloth, I should be able to find out which men in my empire were unfit for their places, and I could distinguish the clever from the stupid. I must have this cloth woven for me without delay." And he gave a large sum of money to the swindlers, in advance.

Hans Christian Andersen, "The Emperor's New Clothes," 1837

The threads spun by the Fates were relentless: however much their subjects tried to avoid the futures spun for them, they found that they could not. Oedipus's parents tried desperately to prevent the boy from murdering his father and marrying his mother, as had been foretold, but these events played out nevertheless. Likewise, wishes granted in stories often rebound horribly on the wisher. So it is with the Greek legend of King Midas. In the story, the king is so enamored of wealth that he prays to the gods to make his mere touch enough to turn any object immediately to gold. His wish is duly granted. Not long thereafter, the king dies of starvation, unable to eat so much as a single grape without it turning to a gold nugget the moment it touches his lips.

While this tale is familiar, less well known is the historical King Midas, the likely model for the myth. He ruled Phrygia, an ancient state in what is now Turkey, in the last decades of the eighth century BC. He makes an appearance in Greek historical records, but archaeological traces remain too. The Phrygian capital of Gordion was razed in the early seventh century BC, and its destruction was so swift that the city and much of what was within it burned where it stood. Excavations of the citadel turned up a great many things abandoned in the rush. One of the most extraordinary finds were over 2,000 loom weights discovered in neat rows within one hundred and nine yards of each other, lying where they had dropped as the flames consumed the cloth they hung from. Given this number, over a hundred women must have been busily weaving oloth for the Phrygian rule: when the city was destroyed "No wonder," Elinabath Barber wryly notes, "the Greeks viewed Midas as synonymous with gold!"¹³

Many other myths have thread at their heart. Think of Sleeping Beauty and her deadly spindle, or the malicious woodland sprite Rumpelstiltskin, who spins straw into gold. In another tale from the Grimm brothers' collection, a beautiful but lazy girl is saved from a life spent spinning when her husband—a king, naturally—meets her "aunts," each of whom possesses a deformity caused by a life spent working with thread: a swollen foot, an enlarged thumb, and a pendulous lip, respectively. Told by the clothmakers themselves, this story would have had even more resonance.

It is no accident that the entire fabric of mythology and fairy tales is shot through with references to textiles and weaving. The work of making cloth was particularly conducive to storytelling: groups of people, usually women, penned together and engaged in repetitive work for hours on end. How natural to create and exchange tales to pass the time. This also explains why spinning and weaving characters appear so frequently and are so often blessed with preternatural skills and guile. Take Penelope, the wife of Odysseus in Homer's *Odyssey*, who uses weaving to delay the impertinent Achaean suitors,

11

who descend like locusts when they believe her husband to be dead. "She set up a great web on the loom in her house and began to weave at it—a very fine thread, and very wide," wrote Homer sometime around the end of the eighth century BC. "[In] the day time she would weave away at the great web, but at nights she would undo the work, with torches set by the loom." This stratagem apparently bought her three years' grace—indicative, perhaps, of just how little men understood this traditionally female craft.¹⁴

Women's Work

And what did I amount to, once the official version gained ground? An edifying legend. A stick used to beat other women with. Why couldn't they be as considerate, as trustworthy, as all-suffering as I had been? That was the line they took, the singers, the yarn-spinners. Don't follow my example, I want to scream in your ears—yes, yours! Margaret Atwood, *The Penelopiad*, 2005

> Deities associated with spinning and weaving are almost exclusively female. Neith in pre-Dynastic Egypt; Athena for the Greeks; Frigg for the Norse—the warlike Valkyries also wove—Holda in Germanic mythology; Mama Ocllo in that of the Incas; and Tait (also spelt Tayet) in Mesopotamia during the Sumerian period. Amaterasu, the Japanese sun goddess, weaves, as does the weaver girl of Chinese mythology, but only when she is separated from her husband, the cowherd, by the Milky Way. (Their separation was in fact engineered so that she wouldn't neglect her needlework.)

Stories of fierce fertility goddesses, nimble-fingered old crones, and vengeful maidens were sustained over the centuries by women, unraveled and rewoven daily, like Penelope's tapestry, by countless retellings. Tales were spun, murmuring, to offspring in the dark, or recounted to companions as they sat and created cloth of their own. The making of thread and textiles, after all, has for centuries been seen as women's work. This is perhaps because it was the form of work most compatible with child-rearing: it could be done at home with only half an eye by those with experience, and could also usually be interrupted and resumed at will.

Nevertheless, transfiguring fibers into thread was time-consuming and highly skilled work, performed by hand by many millions of women up until the spread of mechanization following the Industrial Revolution. Through this and other textile-related labor, such as the rearing of silkworms, women provided the materials essential for their families, paid taxes-which were, at times, demanded in the form of thread or finished oloth and supplemented household incomes. In turn, the tools involved became irrevocably linked with womanhood. Many women were buried with their spindles and distaffs. In the Greek world, the birth of a baby girl was marked by placing a tuft of wool by the door of a family's house. Less concretely, the association made it into language too. In China, a popular proverb decreed that while "Men plough; women weave." The traditional English saying, "the distaff side," refers to the maternal family, while the word "spinster" was, from the mid-sixteenth century, used to refer to single women.

The age-old kinship between women and cloth can be seen as both a blessing and a blight. In the *Shijing* or *Book of Odes*, a selection of Chinese poems thought to date from between the twelfth and seventh centuries BC, the care of silkworms and the use of their silk to create thread and fabric is approvingly spoken of as appropriate women's work. Many other societies—although not all—felt the same way. Men were often involved in growing and reaping fiber crops such as hemp and flax and the husbandry of sheep and goats. Children of both sexes would likely have helped too, perhaps by sorting wool or winding thread as it was spun. And in some cultures it was just as, or even more, common for men to weave. The Arthashastra, an Indian administrative treatise, the earliest portions of which date back to around the third century BC, is strict on this point: "Weaving shall be carried out by men." Women were permitted to spin, but even this was restricted rather grudgingly to "widows, cripples, [unmarried] girls, women living independently, women working off their fines, mothers of prostitutes, old women, servants of the King and temple dancers whose services to a temple have ceased."

In ancient Greece, by contrast, all women—from goddesses to queens and slaves—were involved in spinning or weaving. This, in the view of contemporary writers, was the natural order.¹⁵

Where the making of fabric was so strongly associated with women it was seen as unlucky for men: Jacob Grimm recorded an old German superstition that if a man was out riding and came "upon a woman spinning, then that is a very bad sign; he should turn around and take another way." Perhaps because of this, or because men were not usually as involved in the production of textiles, the end results have often been undervalued. Freud was certainly no help in this regard. "It seems that women have made few contributions to the discoveries and inventions in the history of civilisation," he wrote in a lecture on the topic of femininity. "[T]here is, however, one technique which they have invented—that of plaiting and weaving." He argued that these skills had been honed in response to a subconscious feeling of shame and "genital deficiency": that women wove to hide their lack of penis from the male gaze. Such is the power of the *idée fixe*.¹⁶

Accomplished spinners or needleworkers were an important—if often overlooked—part of the economy. Assyrian merchants in the second millennium, for example, frequently wrote to their female relatives about their cloth work, asking them to make a particular kind, for example, or letting them know what was selling well. Lamassï, the wife of one such merchant, responded chiding her husband for making too many demands:

About the fact that I did not send you the textiles about which you wrote, your heart should not be angry. As the girl has become

15

grown-up, I had to make a pair of heavy textiles for [placing/wearing] on the wagon. Moreover I made [some] for the members of the household and the children. Consequently I did not manage to send you textiles. Whatever textiles I can manage I will send you with later caravans.¹⁷

Working with textiles was largely indoor work-that, it was hoped, would keep women occupied and out of trouble-but it could also be a source of justified pride. The Bayeux Tapestry, to take one famous example, was likely designed and produced by English craftswomen to record the Norman victory over their own countrymen in the eleventh century. Despite this, it is a work of great skill and beauty, recording around fifty scenes, graphic-novel style, using only eight colors of worsted and a length of tabby-weave linen about seventysix yards long. Centuries later, anonymous lacemakers created baroque designs of dizzying complexity, each one requiring exacting, mathematical planning to ensure the correct numbers of bobbins were in play. Much more recent is the work of Sonia Delaunay, an abstract artist who created textiles in the first decades of the twentieth century. One of her first pieces, made in 1911, was "a blanket composed of bits of fabric like those I had seen in the houses of Russian peasants." The end result evoked the work of the Cubists. Her oeuvre included costumes for films, an interiors boutique, a Vogue cover, and hundreds of dazzling textiles so colorful that they almost hum with energy. Fifty years later, working with her mother, Faith Ringgold began creating lush, storied quilts. (These padded and stitched textiles, valued for their warmth and the canvas they provide for intricate decoration, date back to at least 3400 BC Egypt.) Ringgold's work is now on display at museums including the Guggenheim and the Museum of Modern Art in New York.

The consumption of fabrics was also gendered. In England in the eighteenth century it was usual for women to buy fabrics and garments, such as linen shirts, for their family. Sarah Arderne, a married member of the lesser gentry in northern England in the late eighteenth century, spent a good deal of time and money on her husband's linens, as her account book reveals. She bought him muslin for cravats and handkerchiefs and supervised the laundering of his linens. One entry, in April 1745, reads: "Pd Mary Smith for making ten fine Holland shirts for my Dear Lord." (Supplying his wants was her largest expense, representing 36 percent of her annual expenditure; just 9 percent went on the care of her five children.)¹⁸

Needlework, spinning, and other textile skills provided women with a means of expression. "The needle is your writing brush," as Ding Pei, a famous female embroiderer, wrote in a treatise published in 1821. Spinning, lacemaking, sericulture, embroidery, and other textile-related crafts could give women economic power and status. In England in 1750, for example, spinning was the most common paid form of employment for women and a relatively lucrative one at that. Single women were estimated at the time to be able to spin around six pounds of wool per week; a married woman would probably only be able to manage two and a half pounds. Given the current rates offered, a spinster would therefore have been able to earn as much in a week as a skilled weaver—who were more usually men and were often in guilds, meaning their work was thought of as more valuable. It is only more recently that the word spinster has picked up negative connotations.¹⁹

Even if they could not expect equal remuneration, women could stave off absolute poverty if they possessed skill with a spindle, loom, or needle. This, for example, was the assumption behind the need for women to spin in the *Arthashastra*: "Spinning shall be carried out by women [particularly those who are dependent on it for a living]." Similarly, a law passed in Amsterdam in 1529 commanded "all poor girls . . . who are unable to do any lacework" to report to a couple of locations in the city where they would be taught to ply a needle to earn their keep. Just over a century later in the southern French city of Toulouse, the municipal dignitaries found so many poorer local women were engaged in lace production that there was a dearth of domestic servants. Here too a law was passed, this time forbidding lacemaking.²⁰

Today, even though machinery and the expectation that production be done in factories during working hours have expunged the initial reasons that textiles became "women's work," the association remains. In Bangladesh, some four million people are employed in the textile industry; 80 percent of them are women. Only a tiny fraction—just 150,000 in 2015—are represented by unions, with workers fearing reprisals from the mostly male factory bosses and political establishment. (Garment exports accounted for 80 per cent of the country's exports in 2014.)²¹

Weaving Words

He draweth out the thread of his verbosity finer than the staple of his argument.

William Shakespeare, Love's Labour's Lost, c.1595

I he words "text" and "textile" share a common ancestor: the Latin "texere," to weave. Similarly, "fabrica"—something skilfully produced—birthed both "fabric" and "fabricate." That language and cloth are so interwoven should not surprise us: they are, in some ways, intimately related. As one of the earliest technologies, fabrics played an important role in the material history of the written word. Paper was once made from discarded rags and many texts have been wrapped and covered with textiles both to protect them and to increase their value and worth. Bookbinders have long wielded needle and thread, and parallels can be drawn between calligraphy and lacemaking. The relationship wasn't all one-sided, as samplers embroidered with homilies and fabrics decorated with symbols and words rich in metaphorical meanings illustrate.

That the production of textiles was, up until the modern era, pervasive, strengthened the relationship. Children would have grown up seeing and helping their family members spin and weave. For poorer households, many of the textiles they used—clothing, sacking, furnishings, and sheets—were the product of labor inside the home using raw materials harvested within a few miles. Tears, frayed hems, and unraveling seams would have been darned, stitched up, and resewn: cloth was valuable and not to be discarded lightly. Makers would have told tales, gossiped, and squabbled while they wove and sewed, so it was natural that terms common in the creation of textiles came so readily to hand in storytelling and rhetorical argument. These were lively, tactile images that almost every audience would readily understand.

Today, the interface between "text" and "textile" has proved to be fertile ground for literary critics. They also unpick, fashion, piece together, or unravel, only their raw materials are more likely to be arguments, poems, characters, and plots. Similarly, wrapping and unwrapping have become vibrant themes in history and anthropology.

Scholars, of course, aren't the only ones to use words rooted in textile crafts. You may have inherited a well-worn heirloom or two. Or been on tenterhooks, spun a yarn, or privately thought someone's decoration looked a bit chintzy. The language of textiles is like the ticking of a clock in a room: inescapable once noticed.

Many of these metaphors, however, are themselves becoming overstretched and threadbare, because most of us have very little experience or understanding of their original meanings. How much richer it must be to talk about weaving a coherent argument, if you yourself have threaded a loom and flown a shuttle from one side of the warp to the other. Take the phrase "tow-headed": tow refers to pale gold flax fibers before they are spun, while being "on tenterhooks" comes from the frame, or "tenter," on which woolen cloth is stretched out after being washed. If the vanishing of such expressions seems unlikely, you need only consider the fate of those that became baggy from repeated use or incomprehension decades ago. Few people today would refer to a knotty problem as a "tangled skein" as Arthur Conan Doyle's Sherlock Holmes does more than once. Or use "hatchel"-an instrument for combing out the fibers of flax or hemp-as a synonym for "harass" or "worry." Even being accused of talking "fustian" has lost its sting. Fustian, a type of coarse cloth, often made from cotton, was hijacked to indicate "inflated, turgid, or inappropriately lofty language."

From language to fairy tales, technology and social relations, our lives are woven through with the threads of fabric production. The Fates would likely have it no other way.

Fibers in the Cave

1

The Origins of Weaving

The First Weavers

With the tie of the sacrificial meal, the amulet, with the thread of life, the colorful, whose knot is the truth: with that I bind your heart and spirit. What is your heart, should be mine. What is my heart, should be thine.

Vedic mantra

When Eliso Kvavadze bent to the eyepiece of her microscope, what she expected to see was Neolithic pollen. As a botanist at the Georgian National Academy of Ociences this was her stock in trade. Microscopic traces of ancient plant life scraped from the floor of a remote cave would, she hoped, reveal information about the changing climate of the ancient world. Different trees and plants flourish during ice ages and more temperate times, so pollen samples from different species are an eloquent witness to the weather of their time. On this particular day in 2009, however, the minute pollen grains on the slide were rudely thrust from the limelight by something extraordinary lying beside them: the oldest fibers known to have been used and produced by humans.

The cave that Kvavadze—and a team of Georgian, Israeli, and American researchers—was investigating is known as Dzudzuana. It bores into the Caucasus Mountains in the western part of the Republic of Georgia. To the casual eye this cave might not seem so remarkable. Its puckered mouth, the shape of a letter "D" lying on its back, is just over half a mile above current sea level, and from this opening the cave squirms back and down into solid rock.¹

Radiocarbon dating suggests that modern humans first pressed timid, wandering feet into its floor as early as 34,500 years ago. Although they were there for around twenty millennia, the people of Dzudzuana trod lightly and left relatively little behind. We do know that these first weavers were efficient, unfussy hunters. From bones scattered through the cave floor, the Paleolithic inhabitants seem to have favored mountain goat and, later, bison, but they also brought down aurochs, pine marten, wild boar, and even wolves. We know too that they made a variety of tools—scrapers and cruelly sharp blades made from stone and obsidian—and wore decorative pendants.²

So far, so typical. But Kvavadze's discovery showed that they were creating fibers from plants too, a fiddly undertaking at the best of times and using a technology previously believed to be much more recent. This undercuts long-held assumptions about our early ancestors, stretches the history of fabric back much farther than many had ever imagined, and gives us a fuller, richer picture of the lives lived by some of our early ancestors.

New Threads

Brother, when you have brought me the woven flax, Who will dye it for me, who will dye it for me? That flax, who will dye it for me?

Sumerian love song, 1750 BC

The threads that Kvavadze found are invisible to the naked eye, and the objects they were part of disintegrated long ago. Nevertheless, these fibers do allow the curious to get some intriguing glimpses of their secrets. One thing they reveal is that the people who made them were industrious. Well over a thousand microscopic fibers were found in the clay that had slowly accumulated on the floor of the Dzudzuana cave over time, representing many hours of work, from collecting the flax to weaving threads together to create whatever it was that they were creating. In the oldest layer, there were nearly 500 fibers; a more recent one, dating from 19,000 to 23,000 years before present (YBP), contained 787. The means of creating these fibers must have been carefully handed down from one generation to the next. The secrets of their manufacture may have been taught using the light at the mouth of the very cave in which they were found.³

The threads were made from bast—flexible fibers made from the innards of plants—which requires sophisticated processing. Some of the fibers had been spun, and some were simply twisted. In a paper announcing their discovery, Kvavadze and her team noted with some astonishment that several samples "appear to be two-ply S-twisted in a relatively complex pattern." A plied yarn is one that is made from two or more threads, twisted together in the opposite direction to that in which they were spun. What this means practically, when it is done well with just the right amount of twist, is that the finished yarn is balanced and casier to work with. it will neither unravel nor twist up on itself. In short, If these samples are indeed two-ply S-twisted, then they indicate an astonishing level of mastery.⁴

More confounding still was that many of the fibers appeared to have been dyed, probably using colorants from plants. And, just as with the twisted samples, the range of colors found suggests that the Dzudzuana weavers were very good at it. Although the majority of the threads were gray, black, and turquoise, there were also yellow, red, blue violet, green, khaki, and even pink ones, suggesting a sophisticated knowledge and use of local dye-plants and other colorants. The two older layers, which represent the period from around 32,000 YBP to 19,000 YBP, contained the most dyed fibers. Of the 488 found in the oldest layer, fifty-eight were dyed; of the 787 fibers found in the next oldest, thirty-eight were dyed, although the variety of colors was greater—it was here that the pink thread was found.⁵

Researchers examining the cave also discovered the remains of moth larvae commonly found on decaying textiles, fungus that grows on clothes, and evidence of hair from a goat species. The bast fibers may therefore have been used to make thread to sew together animal hides for clothing. Other probable uses include making string or cords for hafting tools or basket weaving. Ofer Bar-Yosef, an Israeli archaeologist who worked closely with Kvavadze, wondered if all those thousands of years ago the cave's inhabitants had woven the fibers together in a manner not dissimilar to macramé. Elizabeth Wayland Barber, an expert in prehistoric textiles, argues that the simple fabrication of string was a powerful technology, revolutionizing what they could do. "You can tie things up in packages so you can carry more. You can put out nets and snares to catch more game so you can eat better."⁶

Whither Fur?

Clothes make the man.

English proverb, fifteenth century

Clothing is thought by anthropologists to perform two important functions in human society. The first is display. But humans are perfectly capable of visually distinguishing themselves without clothes, using everything from tattoos, to jewelry, to body piercings and adaptations. Many peoples, including the fifth-century Huns who so terrified the Romans, bandaged children's skulls to flatten them, making the heads of adults sweep backwards and up, for example. Once humans were wearing clothes they would have used them to display their status, but that doesn't seem like a wholly convincing reason for them to have been adopted in the first place.⁷

A more practical explanation for clothing is to protect against cold. Humans are ill-adapted for living outside the warm climates in which they first evolved. Compared to many other mammals—even other primates—our defenses against cooler temperatures are inefficient.

25

We lack brown fat, for example, which can readily be metabolized to provide heat, a stratagem deployed by many of our genetically closest relations. But perhaps our most obvious weakness in this area is our relative hairlessness.

Rabbits reach their cold limit at around -49° F; without their fur it would only be around 32°. An unclothed human begins to feel chilly at a balmy 80°. Our core body temperature is around 98°; if it falls below 95° hypothermia sets in, and death would be expected once it drops to 84°. Even mild hypothermia is problematic. A pamphlet produced by the British army warns soldiers that it can make sufferers behave irrationally, and that the risks are exacerbated by exhaustion or malnourishment.⁸

If being hairless is so disadvantageous to our species, when and why did we become the naked ape? Humans are the odd mammals out in this regard. (Others, such as elephants and whales, have had special evolutionary reasons for losing their hair.) To explain this oddity, some have theorized that we perhaps went through a semiaquatio phase. The slight webbing between our fingers, the theory goes, is one vestigial link to this previous way of life and our hairlessness another. A second theory is that our lack of hair kept us cooler when we swapped our shaded forest habitat for a hotter savannah one. But naked skin actually absorbs more energy in the heat of the day, and loses it more rapidly when it's cold, making it the worst of both worlds when it comes to heat management. A more recent theory, put forward by two British scientists in 2003. is that we lost our fur because it harbored disease-carrying parasites, and because of sexual selection. To potential mates, bare, smooth, and bug-free skin would have been the equivalent of the mandrill's multicolored rump or peacock's showy plumage: irresistible 9

Parasites, funnily enough, have also been exploited by scientists to work out *when* we began wearing clothes. Body lice feed, unsurprisingly, on human bodies, but live exclusively in clothing. Finding out when these lice evolved from their forebears, head lice, would indicate when humans began habitually wearing clothing. Going by this method, evidence suggests we only donned clothes sometime between 42,000 and 72,000 years ago, or around the time that humans began migrating out of Africa, implying that we remained naked for around a million years.¹⁰

Not all clothing has to be made of woven materials, of course. It's likely that for a very long time people made do with draped animal pelts and then began roughly sewing these together (although they would perhaps have used fibrous thread to do so). Ultimately, though, the advantages of using woven fabric for clothing would have become obvious. A thick fur pelt offers excellent thermal protection if someone is sitting still or lying down, but once on the move or in strong winds, this is less true, because pelts aren't shaped close to the body. The more air gets between the body and the clothing, the less effective it is at trapping an insulating layer of air close to the skin. In fact, the isolating properties of clothing decrease by half when walking briskly. Clothing also needs to be breathable, because damp clothes are also bad at keeping the wearer warm and become very heavy. Woven fabrics are more breathable than fur and, when specifically tailored to the body, also make excellent internal layers, preventing cold air from getting direct access to the skin's surface. Thus the ability to create woven clothing would have offered material advantages to our early ancestors once they had left Africa for cooler climes.¹¹

The need for effective protection from the elements would have been even more pressing then than it is now. Over the past 130,000 years there have been several severe temperature swings, with cooler periods accompanied by strong winds. During the colder phases of the last ice age, it is estimated that the average temperature during the winters would have been below -4° in some of the areas humans were living. These harsh conditions, together with knowledge of human physiology and the survival of many tools that are likely to have been used in the production of clothing, from scraping tools to blades and even eyed needles, are compelling evidence of clothing, even if the articles themselves are elusive. Clothing would have been one of a suite of skills—including the ability to make shelter and fire—that humans would have needed to thrive in diverse regions.¹²

From Bast to Worsted

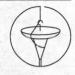

27

A modern woman sees a piece of linen, but the medieval woman saw through it to the flax fields, she smelt the reek of the retting ponds, she felt the hard rasp of the hackling, and she saw the soft sheen of the glossy flax.

Dorothy Hartley, The Land of England, 1979

The threads found at Dzudzuana were made from flax—the plant that is still used to make linen. It's a tall, willowy annual, its yard high stem strewn with spear-shaped leaves and, when it flowers, an abundance of blooms, sometimes pink or purple but more often periwinkle blue. The variety that we use now is domesticated: *Linum usitatissimum*. Its probable progenitor—*Linun angustifolium*—originally grew wild in the Mediterranean, Iran, and Iraq, and it was people in these areas, naturally, who were the first to use and domesticate it. The linen used by the weavers of Dzudzuana was of the wild variety. The cave-dwellers who wanted to make use of it would have had to go out, find it, and gather it. But even once a sufficient stock had been gathered, that was far from the end of the matter: flax needs to go through a series of elaborate steps, each with its own time-worn terminology, before it can be used to make thread.¹³

Bast fibers are found in hemp, jute, and ramie as well as flax.¹⁴ These fibers are composed of long, thin cells strung together end-toend to form strands—like tubular beads on a thread—that run from root to tip and are held together in bundles. A single stem can contain anywhere between fifteen and thirty-five bundles, each containing up to forty individual fibers. These are long (anywhere from 18 to 40 inches), narrow (around 0.00008 inches), soft, and strong. They feel heavy and slightly silky to the touch and have a pearlescent sheen. In the plant, they are used to protect and support the channels that bring nutrients up from the roots, so they need to be tough. They are encased in the flax plants' woody central core, or xylem, and are held together by pectinous gums, waxes, and other substances. All these layers make the bundles of fibers very difficult to extract from the stems. To begin with, the flax needs to be uprooted (not cut) at the desired age. When the stalk is young and green, before the seeds develop, the fibers are very fine: perfect for delicate fabrics. Later, as the stalks turn yellow, the bast becomes coarser but also stronger, making it better suited to hard-wearing work clothes and, at their ripest, the tough fibers can be used to make rope or string.¹⁵

Once uprooted, the stems are sorted according to size, and the leaves and blossoms are stripped: a process known as "rippling." The plants are dried and allowed to ret—gently rot or ferment—either slowly on a roof or more quickly in the stagnant water of specially maintained ponds or rivers. This process softens and eats away the woody outer stalk, exposing the bast and making it easier to extract. Once sufficiently tenderized, the flax is dried and then scutched and heckled (beaten and combed) to remove any lingering unwanted stalk. What remains are the bast fibers: long, subtly sheened, and ready to be spun and transfigured into linen.¹⁶

Almost all the earliest known man-made fibers have been made using flax, rather than wool. (Even when only microscopic fibrous evidence remains, it is easy to tell the difference between the two. Wool is scaled, rather than smooth like bast fibers, it has far more stretch, and tends to be kinky rather than straight.) This mystifies archaeologists, because it seems counterintuitive. Sheep—even in their ancient incarnation, which would have been rather less fluffy than modern variants—flaunt their fibrous, woolly coats and their wool is very easy to turn into thread. Wool also has the advantage of easily being felted. (It is unknown, incidentally, whether felt or woolen cloth was made first, but both are likely to have originated in Central Asia.) Bast fibers, on the other hand, are tricky to extract and work with, even when you know they are there. But they do have advantages: they are long-staple fibers and are lighter and more breathable, better for those in hotter climes and when doing a lot of physical activity.¹⁷

Beyond Dzudzuana

How are we to imagine a loom, which even in its simple form is a rather complicated instrument, among people who don't even know metal? Jakob Messikommer, 1913

Archaeology has traditionally had a fundamental bias against fabric. Fabrics are after all highly perishable, withering away within months or years, and only rarely leaving traces behind for those coming millennia later to find. Archaeologists—predominantly male—gave ancient ages names like "Iron" and "Bronze," rather than "Pottery" or "Flax." This implies that metal objects were the principal features of these times, when they are simply often the most visible and long-lasting remnants. Technologies using perishable materials, such as wood and textiles, may well have been more pivotal in the daily lives of the people who lived through them, but evidence of their existence has, for the most part, been absorbed back into the earth.

There are exceptions, of course. As with the fibers in the Dzudzuana cave, traces can and do survive, usually thanks to an unusual climate: freezing, damp anaerobic conditions or extremely dry ones. The climate in Egypt, for example, is ideal for preserving all manner of usually perishable things and we subsequently know far more about ancient Egyptian textiles than those from most other regions. As archaeology has matured and diversified, scholars have increasingly looked for—and found—evidence of fine, complex textiles stretching farther back than anyone would have

guessed. Their beauty and the skill needed to make them suggest a very different image of our earliest forebears than the club-wielding, simpleminded thugs of popular imagination.¹⁸

The objects that most commonly survive, and from which archaeologists and anthropologists infer larger-scale textile production, are the tools that were used to make them. Spindle whorls-small weights, often made of stone or clay punctured with a small hole so that they can be jammed onto the end of a spindle-are found in abundance at many sites. They make it easier to draft and twist the fibers and help apply the force of the twist evenly along the length of the thread being worked upon. And, although they are so simple, whorls can help reveal the kinds of fiber being worked and the desired properties of the finished product. Heavier ones are better suited to sturdier raw materials, thicker threads made from long-staple fibers, such as flax, while, conversely, if you are making particularly fine thread from short-stapled fibers, like cotton, then you would use a smaller, lighter whorl. An experienced spinner can use a simple spindle and whorl to superlative effect. Indian hand-spinners were said to be able to stretch a single pound of cotton into gossamer-thin thread over two hundred miles long: our modern machinery isn't capable of such dexterity.19

Looms also leave some traces. They were used to make larger pieces of textile and to help keep threads that were soft and floppy taut. Weaving at its heart involves two elements, the first set of threads, or weft, being inserted through a second fixed set, the warp. The purpose of a loom is to hold the warp in place, leaving hands free to weave the weft (these words, incidentally, spring from the same source). Like spindles and whorls, looms come in different forms, but were presumably often made of wood, so were unlikely to survive. We do know they existed, though: a depiction of a ground loom (one stretched between pegs set into the ground) was found in a dish placed in a woman's grave during the early fourth millennium BC at Badari, in Upper Egypt.²⁰

Another variety is called the weighted or warp-weighted loom. This consists of a tall vertical frame with a high horizontal crossbar from which the warp threads hang and are held taut by little weights attached to their lower ends. Use of this kind of loom has been posited

at Neolithic and Bronze Age sites all over Europe and Asia Minor. One is thought to have been used at Chertovy Vorota ("Devil's Gate"), a cave in what is now Russia, around eighteen miles from the Sea of Japan, that was inhabited around six thousand years ago. When the site was excavated in the 1970s, it was found to have contained some kind of wooden structure, built in the center of the cave and containing a veritable Neolithic trove of shells, bones-human and animaland potsherds. Carbonized fragments of textiles were found too, although spindle whorls were absent, leading researchers to assume that the threads were made, painstakingly, entirely by hand and woven on a warp-weighted loom. More concrete remains were discovered in a house in Troy dating back to the early Bronze Age. The house had been consumed by a fire so quickly that the warp weights were found in a perfect row where they had fallen. Scattered around them were two hundred or so tiny, shimmering golden beads that were likely being woven steadily into the cloth before the fire broke out.21

Other, smaller objects may speak of textile production too Fyed needles—often made from bone and found at sites stretching from western Europe to Siberia and northern China—were not necessarily used to make clothes, still less woven ones. (They could also have been used to make tents or fishing nets, for example.) But the needles found do seem to correlate to colder regions and periods when the need for fitted, secure clothing would have been keenest. The oldest, found in Russia, is around 35,000 years old. Small, pierced circular pieces of stone and bone—occasionally decorated—have been found, which may have originally functioned as buttons. A nice piece of corroboration for this theory has been found at an Upper Paleolithic site in France called Montastruc, where an engraved human figure was found, with a row of neat circles down its front from chest to mid-thigh.²²

One of the first indications of just how far back the threads of fabric production reach came in 1875. A group of Russian noblemen officers, stationed in Crimea near some ancient mounds known as the Seven Brothers, began digging in and around the area in the hopes of finding treasure. Unlike the majority of those who greedily prod the earth seeking easy wealth, the nobles struck rich. The prehistoric tombs contained gold, marble sculptures, and, most astonishing of all, beautifully complex ancient textiles, desiccated and preserved by the dry air. The settlement to which these tombs belonged was a Greek one, called Pantikapaion, founded in the sixth century BC, later damaged by an earthquake and finally snuffed out by a Hun invasion in the fourth century AD. The community had clearly contained skilled weavers. One great textile, which the nobles found draped over a wooden sarcophagus, was made up of around a dozen friezes—mythological, animal, and geometric—with floral borders in a chromatic triumvirate of buff, red, and black. The tomb in which it was found had been filled and sealed up in the fourth century BC, but the cloth had been carefully repaired, and so was probably much older. Other tombs contained textiles depicting birds, stags, and mounted men in a panoply of styles and colors.²³

More evidence of early fabric production followed. Before the discovery at Dzudzuana, the oldest evidence of known fabric dated back 28,000 years. It was of a strangely ghostly, indirect kind. What was found at a site in the Czech Republic, called Dolni Vestonice, wasn't fabric itself but the imprint some fibers had left in clay fragments, both raw and fired. These impressions, however, are sufficient to indicate that these weavers too had well-honed skills. The traces in the clay revealed multiple variations of two-ply and braided threestrand cords, along with a multitude of woven fabrics. More was to follow. During the mid-nineteenth century some Neolithic fragments of brocaded fabric, complete with a fringed border, were unearthed from some Swiss lake dwellings dating back to 3000 BC. The village also contained flax in all stages of preparation, from seed to unworked stalks. In the 1920s two archaeologists, Gertrude Caton-Thompson and Elinor Gardner, conducted the first survey of Faiyum, a site in Egypt, which yielded a scrap of coarse linen together with a small cooking pot and a fish vertebra.24

On September 12, 1940, a small dog called Robot and his human companions, four French children, discovered a hole under the roots of a storm-felled tree. Beneath it was the Lascaux cave complex, the walls of which were covered with a painted, heaving cavalcade of oxen, horses, aurochs, and stags, which date back to around 15,000 BC. While these paintings have become famous, and act as a kind of shorthand for the sophistication of our early ancestors, this wasn't the only craft Lascaux's inhabitants were engaged in. One night in 1953, Abbé Glory, a French pre-historian, idly picked up what he took to be a piece of rubble on the floor of the Lascaux cave. The rubble turned out to be a solidified lump of clay and calcite and it unexpectedly broke open, like a Fabergé egg, in his palm. Inside was a perfectly preserved imprint of a long piece of Paleolithic cord. Around twelve inches of this same imprinted cord has since been discovered, revealing it to be made of two-plied strands of some kind of vegetable fiber, neatly S-twisted together.²⁵

Intriguingly, a 2013 discovery in southeast France has led to tentative suggestions that *Homo sapiens* may not have been the first species to have made string. A tiny sliver of twisted fibers—just 0.028 inches long—was found in a site occupied by Neanderthals 90,000 years ago, well before *sapiens* arrived in Europe.²⁶

Catal Hüyük, a Unesco heritage site in what is now central Turkey, was once a sophisticated Neolithic settlement occupied from around 7400 BC to 6200 BC. This period saw the move from a hunter-gathcrcr lifestyle to a more settled one, and there are signs that the occupiers were proud of their new homes. The rectangular, mud-brick structures contained hearths and sleeping platforms, were entered through holes in the roof, rather than doors in walls, and were painted with geometric designs in crimson and burnt orange using pigments including ochers and cinnabar. Adding to this embarrassment of archaeological riches, during a dig in 1961, a dark, shallow pit in the corner of one of the dwellings was found to contain the carbonized remains of humans and fabrics, dating to the beginning of the sixth millennium BC.

The excavation was problematic. "Climatic conditions made the recovery of the textiles a trying business," Hans Helbaek, the archaeologist who worked on the site, complained. "If one attempted to expose the whole burial in a proper fashion, the surface would dry up immediately in the scorching heat and the textile remains would turn into powder and be carried away by the persistent wind." But the care he took was rewarded. The scattered remains of around seven or eight bodies, including those of several children, were jumbled together, some charred, others with withered muscle still attached. Intriguingly, traces of textiles lay among the bones. Some had been reduced to dust, or scant hanks of thread, but larger pieces remained intact. It appeared as if the bodies, after being dismembered, had been carefully encased in fabric and parcelled up with string. Some larger limbs were wrapped separately, others bundled with smaller bones. One half of a lower jaw was even found to have been painstakingly immured in several layers.²⁷

The weaving techniques found at Catal Hüyük varied enormously. Some pieces were coarse, others fine; some were of plain, warp-weft pattern while in others the thicknesses and spacing differed. All the textiles, with the exception of the string, were made with animal fiber, probably wool. And they made a great impression on Helbaek. "All these fabrics," he wrote, "display a technical skill which can not but surprise the observer considering their great age—at least eightyfive hundred years."²⁸

Quite apart from wondering *when* humans began to weave, we must also ask *how*. It may have started with basketry using tender leaves and stems, through to matting, netting, and cordage, each step getting the proto-weavers closer to creating flexible lengths of cloth. Remains from these early millennia are scant: new archaeological finds pose as many questions as they provide answers.

Early textiles, woven from fibers extracted from plants or plucked from sheep or goats, were essential survival tools for our earliest ancestors, more vital than weapons. Fabrics could provide shelter, warmth, and, later, visible status. They also proved an outlet for one of humanity's most compelling qualities: creativity. The shimmering cloth being made in the burnt Trojan home and the objects that the Dzudzuana fibers were part of are lost to us. We will never be able to see them, or understand what they meant to their makers. What we can be sure of, however, is that their creators put thought and care into them—why else use golden beads and pink, gray, and turquoise dyes? Even from the earliest point of their creation, fabrics have mapped the ambition and skill of their creators.

2

Dead Men's Shrouds

Wrapping and Unwrapping Egyptian Mummies

Unwrapping the Boy King

One thought and only one was possible. That before us lay the sealed door, and with its opening we were about to blot out the centuries and stand in the presence of a king who reigned three thousand years ago. Howard Carter, *The Tomb of Tut-Ankh-Amen*, 1, 1923

When, on November 4, 1922, Howard Carter discovered some steps descending into the loam of the Valley of the Kings in Egypt, his excitement, relief, and hope must have been painfully acute. The English archaeologist was forty eight years old and had enjoyed none of the glittering finds he had longed for during the better part of two decades. His patron, Lord Carnarvon, had grown so tired of waiting for results that earlier that year he had informed Carter that this season would be the last that he would fund-a bitter disappointment for a man who had yearned for the glamour of Egyptology since childhood. Small wonder that no sooner had Carter seen the steps than he dispatched a telegram to Carnaryon telling him to come to Egypt immediately: he believed that he had just uncovered the hidden descent into a royal tomb. Three weeks later, on Sunday, November 26, the pair stood in front of a doorway at the bottom of that same flight of steps. Carter made a hole in the door's top left-hand corner, and thrust a candle through the gap. The flame flickered as trapped, overheated air rushed to escape the tomb. "Can you see anything?" Carnarvon asked. "Yes," Carter breathed as candlelight glinted off gold in the depths of the tomb. "Wonderful things."1

Excavations of this kind are painstaking. The tombs constructed by ancient Egyptians for their priests and rulers from the early dynastic period (from around 3100 BC) were built to foil attempts to exhume their occupants and their possessions. They are riddled with false doors, hidden passageways, and doorways sealed with solid blocks of stone.² Earlier smash-and-grab style excavations by westerners had given way to more

professionalized expeditions. By the 1920s, archaeologists exploring a fresh tomb were obliged to move methodically, room by room, so that every object could be photographed, mapped out, catalogued, recorded, and finally cleared before the next room was entered. This was especially difficult in Tutankhamun's tomb. It had been partially looted sometime during antiquity; objects were jumbled together where they had been hastily stuffed back into chests and caskets before the tomb was resealed.³ Even those in charge of originally entombing the young king, it seemed, had been rushed and flustered, putting less care into decorations and tomb goods than his status would usually merit. He was only eighteen when he died: they probably thought that they would have more time.⁴

Three years after Carter's candle had guttered in the tomb's breached doorway, his team were finally able to begin picking their way through the linen wrappings swaddling Tutankhamun's body. On October 28, 1925, the lid of the innermost casket was opened to reveal "a very neatly wrapped mummy of the young king, with golden mask of sad but tranquil expression." This final unwrapping required a full eight days, from 9:45 in the morning of November 11 until November 19, with a day's rest on the seventeenth. "The outer wrappings," he later wrote, "consisted of one large linen sheet, held in position by three longitudinal (one down the centre and one at each side) and four transverse bands of the same material." This represented the first of sixteen layers of linen, some of which had deteriorated so much over the millennia that it was the color and texture of soot.⁵

Carter recorded details about the bandages and textiles he encountered. He noted, for example, that the bandages were rubbed on each side of the feet, likely as a result of friction as the body was slowly transported, in its nest of coffins, to the tomb. He also mentioned the "considerable care" that had been taken in achieving the anthropoid form of the finished mummy, the "very fine, cambric-like nature" of the linen, and bemoaned the fact that their friability made them difficult to study.⁶

Despite this diligence it's clear that, at best, he considered the textiles found in Tutankhamun's tomb a lackluster side dish. When the sarcophagus was first opened Carter wrote that the sight that met their eyes was "a little disappointing" because the contents were "covered by fine linen shrouds." Earlier in the excavation he opened a casket filled with what he believed to be rolls of papyri, but later also proved to be linen. (This was also, he wrote, "naturally disappointing.")⁷ At worst, the linens were treated as impediments, to be brushed aside and discarded like dusty cobwebs. One large linen pall, originally a rich brown or possibly red color spangled with metal marguerites, was rolled away only to disintegrate after it was left outside at the mercy of the elements during a dispute between the Egyptian authorities and the archaeologists. The shrouds, pads, and bandages that had been so painstakingly arranged around his body were likely destroyed in the unwrapping; the outer layers of bandages around the body were treated with melted paraffin wax to enable, as Carter put it, "the consolidated layer to be removed in large pieces."⁸

For Carter and many others before and since, the trinkets and amulets seeded among the layers of fabric and the exotic embalmed body beneath them mattered a great deal more than the wrappings themselves. This is unfortunate, because this opinion would have been anathema to the ancient Egyptians themselves. For them, linen was imbued with powerful, even magical, meaning: linen was what made mummies sacred.

Thin Blue Lines

Flax grows from the earth, which is deathless, and yields an edible fruit, proving clothing which is at once cheap and clean; suitable for every season. And is the material, so they say, least likely to breed lice.

Plutarch (c. AD 45-120), Isis and Osiris

Egypt's arid climate and soil conditions are extraordinarily good at

preserving all kinds of evidence about the lives of the people who lived there. This is even true of fabric. Where elsewhere a few centuries would be considered a long time, in Egypt the record stretches back seven millennia to the Neolithic period. The textiles that survive vary. Some were dyed—two red shrouds encased the inner coffins in Tutankhamun's tomb—others were bleached to creamy whiteness. Texture and weight differ too. A specimen examined by the Metropolitan Museum of Art in New York in the 1940s was found to be of exceptional quality, with 200 by 100 threads to the square inch. Another textile, found in the tomb of Hatnofer, an eighteenth-dynasty woman, is 1.7 yards wide and around 5.5 yards long, but is so fine that it weighs just 5 ounces. Other samples, found in equally distinguished burials, are coarser.⁹

The majority of textiles that have survived were found in tombs, so we know much more about shrouds, bandages, and rich robes than we do about everyday linens. Furthermore, the climate of the delta region is less conducive to preserving archaeological evidence than areas farther inland. Another caveat is that many of the methods used to cultivate flax and produce linen are unknown to us. The hints that we do have, however, are tantalizing. As well as the preserved textiles themselves, knowledge of the flax cultivation and linen production is stitched together from preserved artifacts, such as spindles and whorls, miniature models, and descriptive scenes painted on the walls of tombs. It is this last example, incidentally, that tells us what color the ancient Egyptian flax fields would have been in full bloom: painters from the Old Kingdom (c. 2649–c. 2150 BC) depicted the flowering fields with a thin line of blue paint.¹⁰

Although there is little now to suggest it, Sais, where the Nile filters through its wide delta into the Mediterranean, was once an important city. Herodotus mentioned a festival held there on one night each year, when the city's inhabitants would gather outside their houses holding special lamps that looked like saucers, with wicks floating in fuel made from salt and oil that would burn throughout the night until dawn. It was also a focal point for the cult of Neith, a warlike creation goddess who wore a red crown and gave birth to Sobek, the crocodile god associated with fertility and the Nile itself. The city's location on the delta—which made it more humid—was also responsible for Sais's distinction throughout Egypt as the producer of the country's finest linen.¹¹

In this region, the rhythms of the Nile dictated those of the flax crop. Seed was sown in October or November in the rich, diluvian soil left behind when the river retreated to the confines of its banks. If fine thread was desired the yard-high stems would be uprooted in March, while they were still green.¹² As well as producing linen, which is an exceptional fiber for textiles, flax was also cultivated for its seeds—linseeds—which could be boiled, roasted, or pressed for oil. Farmers needed to work hard for this bounty, however. Flax is fussy: its roots are delicate and so the ground needs to be well tilled and it quickly exhausts the soil so that fields need to be rested frequently. A more loosely sown crop was better for linseed. For a linen crop, seeds would be planted close together, which encouraged the plants to grow taller and produce longer bast fibers.¹³

In traditional but unmechanized flax farming, once uprooted, the flax stems would be left to dry in the fields for a few days, and then rippled-beaten, combed, or shaken to remove the seed heads Next comes retting, to break down the tough outer stem and expose the inner bast fibers; then a drying period, followed by scutching, to remove the bark; and finally heckling or combing the fibers to remove the last traces of woody matter. Although we aren't sure exactly how these steps were carried out in ancient Egypt, it is reasonable to think that their methods went along these lines. Tomb scenes appear to show a retting process and we know that, in the eighteenth dynasty (c. 1550-1292 BC), a rippling board was being used. Fibers obtained today have a diameter of between fifteen and thirty microns; the mean diameter of ancient Egyptian fibers is fifteen microns. Somehow, the methods used by the Egyptians allowed them to separate the bast as thoroughly as the best modern machinerv.14

Satellite images of Egypt make it look like a rough square of fabric through which the River Nile runs like an unsightly dark snag from the wide rent of the jade-green delta in the north to an inky rip in the south. In reality, the river and its waters stitch the country and its people together. In a hymn to the Nile, written around 2100 BC, the anonymous author tells it: "You are the august ornament of the earth." Four thousand years later, Ahmed Fouad Negm, a popular poet known for his biting contempt for his country's political elite, laments that "the Nile is thirsty/For love and with nostalgia."¹⁵

Meketre was chief steward under two Middle Kingdom pharaohs and was buried sometime between 1981 and 1975 BC. His tomb is nestled, like the majority of Egypt's historical sites and modern cities, close to the river's banks. Today this site, part of the Theban necropolis, faces the sprawling city of Luxor. When the tomb was excavated in 1920, it had long since been looted. One room, however, had been left intact. The tomb's builders had ingeniously hidden it beneath the corridor that leads to the main burial chambers, precisely where no thief would ever have paused long enough to look properly. Inside were twenty-four wooden sculptures of people making all the things that might prove useful to Meketre in his afterlife: bread, beer, and, of course, linen.¹⁶

The Meketre model showed women piling up silvery-gold flax fibers, then turning them into longer, loosely twisted roves by rolling them between their thighs and their hands. This process, which splices fibers together, was intensely tactile: the hands and thighs of spinners would become roughened by the repeated friction of the flax fibers against them, and this in turn made the action easier. The splicing itself was likely helped by moistening the two ends of the individual fibers being joined, which would make the cellulose in the flax act like a glue. The roves would then be wound into balls to prevent tangles, and placed in pots, moistened with a little water to keep the fibers pliable. The spinners would then draw the thread from the pots, holding a spindle in each hand and working with one leg raised so that they could roll their spindles down their thighs to begin adding twist. This made linen fibres finer, which we have already seen was a desirable characteristic, as well as stronger and less elastic.

Almost all Egyptian linen fibers are S-twisted—counterclockwise perhaps because flax naturally spins in this direction as it dries. Interestingly, while many cultures used distaffs to hold threads and prevent them from tangling, these appear to be unknown in Egypt until Roman times. Until then, thread was wound around the spindle or into balls instead.¹⁷ The prepared thread was now ready for weaving. The small figures in the Meketre model use wooden ground looms: beams fastened to pegs in the floor with warp threads stretched between them. Such horizontal looms are believed to have been the only option available until around 1500 BC, when vertical looms were introduced. They remained distinct from their Greek cousins, however, perhaps as a hangover from the ground looms—Egyptian vertical looms used a second beam to pull the warp threads taut, rather than weights. This likely made the process both more cumbersome and more sociable: the walls of the tomb belonging to Neferenpret, a weaving overseer, show two women operating a large vertical loom together. Plain tabby weave—a basic, one-over-one-under style—was the most frequently used, although basket weave, which produces a more robust cloth, has also been found.¹⁸

Lives Lived in Linen

Your face is illuminated with this white linen. Your body is blooming with the green linen. You unite with the seshed-linen and overthrow your foe. You hold the red linen in its moment . . . These clothes woven by Isis and spun by Nephthys, they fit you, they cover your body, they remove your opponents from you.

Offering inscription at the Temple of Horus, Edfu, first century BC

Flax occupied a special place in ancient Egyptian culture and society. At a basic level, it was essential to the country's economy. The walls of one Old Kingdom tomb were proudly adorned with the

43

harvest yields of flax in bundles: 20,000, 62,000, 78,000. It was used by ordinary people to store wealth because it kept its value and could be exchanged like money in return for other goods or services. The Report of Wenamen, compiled around 1100 BC, shows that linen cloth, ropes, mats, gold, and silver were traded for cedar wood from the king of Byblos. During the eighteenth dynasty (c. 1550 BC-1292 BC) the king of Alashiya received ebony, gold, and linen in exchange for copper. The Phoenicians grew rich trading Egyptian linen and, according to Herodotus-admittedly not always the most reliable witness-the bridge that the Persian king Xerxes built across the Hellespont in order to invade Greece was forged in part from ropes made from Egyptian flax. In fact, Egypt remained the leading producer of linen until the nineteenth century, when a French botanist discovered a variety of cotton well-suited to the muggy climate of the Nile delta, and the interloper became the country's principal fiber crop.19

While other kinds of textiles have been found in ancient Egyptian contexts, they were clearly in the oppressed minority. Of the several thousand fragments recovered from the Workman's Village, an archaeological site at Amarna, for example, around 85 percent were made from flax. Evidence of sheep and goats has been found in Egypt dating back to the Neolithic period, and they were certainly capable of using wool: forty-eight samples of it were also found at Amarna. Part of the answer may be quotidian. In *Isis and Osiris*, the Roman writer Plutarch praised linen's cheapness and the feel of it against the skin. It is true that linen conducts heat extremely well, making it feel cool against the skin, which is why it is associated with summer months and warmer climates. It is also one of the strongest fibers, twice as strong as cotton and four times as strong as wool. It ages well too, growing softer with wear and laundering.²⁰

The clothes worn by the ancient Egyptians were simple, visually much more obviously related to loom and field, allowing them to appreciate the fabric's natural attributes. Many garments were simply rectangles of cloth, draped and tied around the body. Where sewing was used, it was a minimal intervention: linen rectangles would be folded in half and stitched up the sides, leaving a few inches for armholes, and a hole cut at the fold for the head. It is likely that ancient Egyptians were attuned to minute differences in the texture, color, weight, and weave of various linen textiles. While surviving wall paintings show women wearing tunics of linen so sheer that the tint of their skin peeps through, much more robust clothing was valued too and can be found in the richest tombs.²¹

In addition to its practical charms, linen seems to have been culturally associated with cleanliness. This idea certainly struck foreign visitors. Herodotus described the freshly washed linen garments that the priests habitually wore when "engaged in the service of the gods"; other fibers, he suggests in *Histories*, were considered impure, a belief echoed by Plutarch. Apuleius, writing in AD 170, called flax the cleanest and best production of the field. Interestingly, although linen could be dyed, the majority was bleached to a creamy color using natron—the same substance used in mummification—and the sun's rays. Perhaps this preference for white was also about cleanliness: white was associated linguistically with purity, too. It doesn't feel like too much of a stretch to imagine a connection between the linen and whiteness; neither is it surprising that this fiber's importance in society found an echo in religion.²³

In January 2011, when the fire of the Arab Spring burned brightest, a human chain formed around Cairo's Egyptian museum, a large, rose-pink building in Tahrir Square, trying to protect the treasures it contained. Their efforts were in vain: nearly fifty artifacts were looted. A pillow-lipped statue of the pharaoh Akhenaten, believed to be Tutankhamun's father, was later found nearby, discarded in a pile of rubbish. Another, a gilded wooden statue of a goddess bearing Tutankhamun, has also since come to light and, like other items damaged during the unrest, has been restored and is once again on view to the public. The looting of the museum was considered by many to be an act of sacrilege. Nevertheless, it is arguable that in the eyes of those who had originally created and worshipped the statues, they had been denuded long before: from the very instant their fabric coverings were loosed, in fact.²³

All the statues and many other objects found by Carter in Tutankhamun's tomb had been painstakingly cocooned in linen. A

bundle of staves, for example, found in the first shrine were wrapped with a very dark brown, basket-woven linen; the veil that was draped over the guardian statues was a rich cream and had a texture that Carter described as filmy. Although this was the first time this practice had been observed, as it were, in the flesh, it was already known from surviving rites and paintings. These indicate that the wrapping of cult statues was an important part of worship. They were kept in special shrines deep within temples and were dressed, in private, with fresh linen at least once daily by priests. Linen was closely bound to the secrecy, seclusion, and ritualized concealment that was key to ancient Egyptian religiosity. In Unwrapping Ancient Egypt, Christina Riggs argues not only that the textiles used to cover sacred images and objects were an intrinsic part of their sanctity and meaning, but that this was in turn renewed and strengthened during each ritualized wrapping ceremony. The linen, in other words, was part of the point, not just a protective layer. "The act of wrapping a body or a statue in linen had the power to transform mundane, or even impure, matter into something pure and godlike."24

The Linen-Wadded Heart

Within the body itself is the heart—the heart of Senebtisi, a woman of the twelfth dynasty; the heart that, fortunately, stopped beating centuries before the mortal remains in which it pulsed, were laid out to be gazed upon by the barbarians of the Western World.

"A Lady of the Twelfth Dynasty," The Lotus Magazine, January 1912

When the mummy of Senebtisi,²⁵ a slender woman of fifty or so who died around 1800 BC, was found in a tomb in a pyramid at Lisht, it was clear that she had been entombed with care. She lay at the center of three coffins, one nested inside the other like a series of Russian dolls. Her innermost coffin was draped with around a dozen fringed linen shawls, each neatly folded, and her wrappings clasped a host of treasures, including a gold circlet decorated with ninety-eight gold rosettes and a gold, carnelian, and beryl necklace. Her body had originally been supine, but as the coffin had been moved it had shifted, and now she lay on her left side. Her limbs had each been wrapped separately; her arms placed straight down over her body; her hands were clasped in her lap. The priests had enclosed her entire form in linen, alternating layers of bandages and larger sheets. The "several thicknesses of cloth," as Arthur Mace and Herbert Winlock put it in their excavation report, were very badly decayed when she was found in 1907, but they were nevertheless able to see that the innermost wrapping, the one that lay against Scnebtisi's skin, was particularly luxuriant, with around fifty by thirty threads to the half-inch. Inside her was yet more cloth: her body cavity was stuffed with it. Finally, it was found that, at some point during the mummification process, her heart itself had been removed, the ventricles and atria stoppered with wads of linen, and then carefully replaced.26

Given its importance in Egyptian life, it should hardly seem surprising that linen played a crucial role in death too. Textiles were valuable, representing a significant part of a person's wealth. Special chests, with elaborately pitched lids, were used to store them and, although it seems as if cloth was occasionally made especially for burials, more often it appears to have been collected over a lifetime or more. Many are well worn, with darned patches, or bear names or inscriptions identifying them as belonging to relatives of the deceased. A tunic found in Tutankhamun's tomb, draped over the statue of a jackal, bears the name Akhenaten, believed to have been his father. A textile's provenance was clearly of importance. The linen used to re-wrap Ramses III was inscribed with text declaiming that it had been woven by the daughter of the high priest Amun Piankh.²⁷

Burial practices were not stable in ancient Egypt. In the Neolithic periods, bodies were simply lowered into shallow graves, draped in

either animal skins or loose linen folds. It was during the early dynastic period that the powerful, royal, and wealthy were buried deeper, in specially constructed graves, fully encased in linen. The wrappings became increasingly elaborate over time. Limbs began to be swathed separately; one nineteenth-century commentator marveled that: "Each limb, nay, each finger and toe, had a separate bandage next to the skin." Tutankhamun was wrapped in sixteen distinct layers, as well as three coffins and a stone sarcophagus. Sources claim to have found pharaonic burial cloths a thousand yards long, so that they were wrapped around the body to a depth of forty thicknesses. Artemidora, who died in the late first or early second century and was buried at Meir, was encased in so much linen that the finished mummy was nearly two yards long—a third taller than Artemidora herself. The wrappings around her feet were carefully elongated, so that they appeared nearly a yard long. The finished mummy looked like a supine "L."²⁸

One of the most complete Egyptian texts available on mummification is the *Apis Embalming Ritual*. Sadly, since it came from a bull cult, it instructs embalmers to begin at the horns and work down to the tail: complications embalmers specializing in humans wouldn't have had to deal with. There are other sources, including the mummies themselves and Herodotus's account. (Although he clearly reveled in some of the gorier aspects: "First, with a crooked iron tool they draw out the brain through the nostrils . . ." In fact, brains were not always removed.) Whatever the details of the embalming process, speed—because of the hot climate—was of the essence. Bodies would first be washed and then internal organs were usually removed through an incision in the abdomen and—if the brain was removed another through the bone at the back of the nasal cavity. Afterward, the body would be covered with natron salts, oils, and resins and left to desiccate for seventy days before being washed again.²⁹

The wrapping itself was elaborate, secretive, and highly ritualized. Cleanliness and purity were paramount. It would take place in a special room, whose floor had been covered with several yards of desert sand, on top of which would be laid a papyrus mat and linen sheet. A vast quantity of materials—from salves to bandages—were needed. All of those involved had to purify themselves before work could begin; they would shave, wash, and dress in fresh linen. The priests who undertook the physical bandaging were given the respectful moniker of "masters of secrets" and would usually try to ensure that the numbers of layers and revolutions used were multiples of three or four, numbers that held a special significance. Amulets and other significant objects would be embedded within the layers of fabric, and sometimes the wrappings themselves had ritual knowledge written on them. A Ptolemaic mummy unwrapped by Thomas Pettigrew in April 1837 in London yielded about fifty-five yards of carefully inscribed bandages. The various textiles—bandages, sheets, and pads—were built up one by one, with the finest linen usually reserved for the innermost and outermost layers. In the case of the bulls, the wrapping alone would take up to sixteen days.³⁰

Fatted Candles

I recollect with pleasure the sensation which the demonstration of the various parts of the mummy, at the time it was first opened, excited amongst upwards of an hundred scientific and literary characters, who in the course of six weeks honoured me with their presence at my house to witness the dissection.

Augustus Bozzi Granville, "An Essay on Egyptian Mummies," 1825

Mummies have occupied a special niche in the western imagination for centuries. The word "mummy" comes from the Persian *mumiya* meaning bitumen, which was highly valued as a medicine. Although we know now that not all mummies contained bitumen, they were soon being dug up, traded, powdered, and used as everything from toothpaste to cures for epilepsy. Later, it was used as a pigment too, under various aliases, including "Egyptian brown" or "*caput mortuum*," Latin for "dead man's head."

Interest in mummies became scientific. In 1652 Giovanni Nardi, court physician to the Grand Duke of Tuscany, published a book complete with engravings of a partially unswathed mummy for a curious western readership.³¹ By the mid-nineteenth century mummy unrollings had become fashionable spectacles in London and elsewhere in Europe; Thomas "Mummy" Pettigrew became so famous for them that newspapers covered them as if they were theatrical productions. At one unrolling in 1909, recounted by the French novelist Pierre Loti, the audience became so geed up that the affair ended in slapstick. The royal mummy was "wrapped thousands of times in a marvelous winding sheet ... finer than the muslin of India," Loti recalled. This cloth was over four hundred yards long and took a full two hours to unwind. By this time the tension had mounted to such a pitch that, "after the last turn, when the illustrious figure appeared, the emotion amongst the audience was such that they stampeded like a herd of cattle, and the Pharaoh was overturned."32

One of the most famous mummies in history, aside from that of Tutankhamun, is known not by its own name but by that of the man who unwrapped it. Augustus Bozzi Granville had lived a life worthy of biography. An Italian-born physician, he had survived the Napoleonic wars, bouts of malaria and bubonic plague in Greece and Turkey, and a stint in the British navy before settling down and setting up practice in London. He was clearly an energetic man with diverse interests: while in London he developed a passion for Egyptology. In 1825 he delivered a paper to the Royal Society about a mummy that he had publicly unwrapped some time before. Granville's mummy, as it is now known, had been given to him in 1821 by Sir Archibald Edmonstone. (The latter gentleman had acquired it for four dollars on a trip to Thebes in 1819.)³³

In his paper, Granville described what is believed to be the first modern autopsy of mummified human remains—his methods set the standard for such studies at the time. He kept scrupulous notes of the procedure, noting, for example, the dimensions, angles, and conditions of individual bones, as well as publishing detailed illustrations. So fully had the body been enveloped with cloth that it resembled an elongated oval rather than a human body. The bandages, which were of a "very compact, yet elastic linen," had been "most skilfully arranged," Granville informed the Society, "and applied with a neatness and precision, that would baffle even the imitative power of the most adroit surgeon of the present day." In all, the linen removed by Granville, over the course of an hour-long unwinding, weighed 28 pounds. As a physician he recognized styles of binding that he was familiar with, including "the circular, the spiral, the uniting, the retaining, the expellent, and the creeping roller."³⁴

The autopsy, conducted at Granville's house in London and overseen by an ever-changing array of visitors, lasted a full six weeks. His report veers from the brusquely professional to the morbidly personal. The body was found to be that of a woman of around fifty with a closely shaven head—he passed his hand over her scalp to feel for stubble. Although the mummification seems to have been a rather cut-price one, since all her organs remained inside her, this faot allowed Granville greater scope for his medical knowledge. He oaro fully described her breasts, which, he thought, "must have been large during life, for they were found to extend as low down as the seventh rib." He also mentioned the deep wrinkles on her belly: "this part of the body must have had very considerable dimensions." The cause of death, he believed, was a large ovarian cyst; more recent tests suggest tuberculosis or malaria to be more likely culprits.³⁵

His success at the Royal Society was such that Granville went on to give a talk about his findings at the Royal Institute. To add some dramatic flair, he lit the room with candles made from a pale, crumbly "resino-bituminous substance" he had harvested in great quantities from around the mummified corpse and which he took to be beeswax. Granville was wrong about this too, however. As bodies decompose, fats and soft tissue break down into a grayish substance called adipocere or "gravewax." Unbeknownst to him, Granville was probably enlightening his audience in a room lit by candles made from human flesh.³⁶

There is an old linguistics saw that the Inuit have dozens of words for snow, from *matsaaruti* (slushy stuff used to ice the runners of a sled) to *pukka* (the fluffy, crystalline variety). If breadth in vocabulary can be

used as a rough stand-in for cultural significance, it is probably worth noting the wealth of words used for and about textiles and mummification. The *Apis Embalming Ritual*, for example, used three different verbs for applying textiles to a body: *wety* meant to wrap, *djem* or *tjam* indicated covering, while *tjestjes* was fastening with a knot. *Hebes* were large, rectangular textiles used in mummification; narrow bandages were *pir*; long, torn bandages were *nebty*. Priests could also make use of *seben*, *geba*, and *seher* bandages and *sewah*, *benet*, and *kheret* cloths. From around 1500 BC a body was referred to as a *khat*; an embalmed body was a *djet*, a homonym for "eternity"; and a wrapped figure wearing a divine head covering got another word: *sah*.³⁷

The most common explanation for mummification is that it preserved the body so that it could remain relatively intact—lifelike, even—for the afterlife. This is a rather sweet way of looking at it, as if the mummified body were an Old Master painting that has been carefully cocooned before being shipped off to its new home after auction. But such a schema has drawbacks. Most crucially, it prioritises what is within the wrapping and trivializes the bandages and other textiles used in mummification. The linen, in other words, is reduced to a mere protective covering for the vital inner kernel.

This idea isn't new: Herodotus, writing in the fifth century BC, believed that mummification prevented the dead "from being eaten in the grave by worms." Similarly, Granville wrote that the bandages were used to secure "the surface of the mummy from external air." Even Gaston Maspero, a veteran French archaeologist who was director general of excavations and antiquities in Egypt and later introduced Howard Carter to his benefactor Lord Carnarvon, was not immune to this way of thinking. He began unwrapping the mummy of Ramses II at 9 a.m. on June 1, 1886. After he had removed a series of bandages and shrouds he came to "a piece of fine cloth stretched from the head to the feet . . . This last covering discarded," he wrote, "Ramses II appeared." His protégé saw the relationship between wrapping and wrapped similarly: Carter was disappointed when, on opening the sarcophagus of Tutankhamun, "[t]he contents were completely covered by fine linen shrouds." He was only satisfied when the "golden effigy of the young boy king" beneath the shrouds and then, finally, the body itself, were exposed.³⁸

Mummified bodies were valuable because they could be minutely examined and autopsied. In the late nineteenth and early twentieth centuries those examining them were preoccupied with race. Maspero, when finally face to face with Ramses, noted the "long, thin nose, bent like that of the Bourbons" and the "thick, fleshy lips." Granville closely examined the pelvis of his mummy and contrasted it with that of the Medici Venus and "a well grown Negro girl," explaining that "in a female skeleton, it is the pelvis that presents the most striking difference in different races." In modern times, too, mummified bodies mirror contemporary concerns. When pieces of Granville's mummy were found in a chest in a storeroom at the British Museum in the late 1980s, they were immediately reprised for a fresh round of autopsies, leading to a rash of articles in 2008 about the real medical causes of the mummy's death.³⁹

Our preoccupation with the bodies and treasures hidden within the linen, however, fails to capture the value and significance of the linon itself. Enormous effort and great quantities of linen went into even comparatively simple mummifications. Granville was right to note the various wrapping styles: illustrations and surviving examples show astounding intricacy and skill in arranging the strips to create visual effects. Contemporary sources also placed extraordinary weight on the textiles, used a wealth of words to describe them and regarded those empowered and authorized to wield them-the "masters of secrets"-with the greatest of respect. Wrapping did help to preserve bodics, but this doesn't seem to have been its primary purpose. The special, mummiform shape of the sah, with its headdress and mask, was associated in Egyptian art with the divine. Humans were sculpted, using linen, into this form in order to be imbued with divinity. As a body was embalmed and enfolded, it was being transfigured into something worthy of veneration.40

In the introduction to Howard Carter's *The Tomb of Tut-Ankh-Amen*, he took care to emphasise the importance and gravity of his mission. "We have here for the first time," he wrote, "a royal burial very little disturbed in spite of the hurried plundering it has suffered at the hands of the ancient tomb-robbers." His work, it went without saying, was emphatically not grave robbing. After his work was done, he assured

readers, "the King's remains ... will be reverently re-wrapped and returned to the sarcophagus." That may have been the intention, but if it was then something-perhaps the rumors of the curse or, more likely, all the treasures Tutankhamun's mummy had secreted about its person-got in the way of Carter's intended care. When the sarcophagus was re-opened in 1968, the body of the Egyptian ruler was found to be in a parlous state. "The mummy was not in one piece," the researchers later wrote. "The head and neck were separated from the remainder of the body, and the limbs had been detached from the torso ... Further investigation showed that the limbs were broken in many places."41 These breaks had been the work of Carter and his team, who had employed ever more violent methods to get at the body, amulets, and jewelry among the bandages; heated knives were slid inside the golden mask to prize it from the decapitated skull. The boy king has been laid to rest again inside his tomb, but in a base, broken khat incarnation, rather than the linen-sculpted and sacred sah image that the masters of secrets created around 3,360 years ago. Tutankhamun has since been re-buried unwrapped.42

Gifts and Horses

Silk in Ancient China

3

Woven Words

My star gauge poem dreams of you, wounding thoughts with delight,

- Such countless star glimmers: they contain all your grief and love,
- In the midst of my grief, your face: such countless star-glimmer delights.

Su Hui, an extract from Star Gauge, fourth century AD, translated by David Hinton

Sometime during the fourth century, Su Hui took the pain from her wounded heart and spun it into something remarkable. Her beloved husband, a government official, had been sent into exile in a remote desert many days' travel from their home. To make matters far worse, he had, almost the moment he arrived, taken another woman as a concubine, despite the deep feelings he professed to have for Su Hui. She was both furious and distraught. A stew of wounded pride, grief, and humiliation might seem poor nourishment for creativity, and yet somehow Su Hui managed to transfigure these emotions into the *Star Gauge*, a silken poem with a structure whose intricacy wasn't equaled for five centuries.¹

The work originally took the form of a grid, twenty-nine characters by twenty-nine characters, painstakingly embroidered in different colors onto a silk panel. It is both part and the apotheosis of a type of Chinese poetry called *hui-wen shih*, or "reversible poems." This genre relies on the fact that, unlike western languages, Chinese characters can be read in any direction. Reversible poems, as the name suggests, can be read both forward—starting top right and moving down—and backwards. Su Hui's *Star Gauge*, however, goes further. Its unique structure allows the reader to wander in any direction through the text horizontally, vertically, or diagonally, stumbling across different readings as they do so. In all, it contains over three thousand possible poems.

It would have been a striking visual object too when Su Hui first created it: a silken paean to an obsessive love. "Dreams are wearing my beauty thin," reads one line; "I thrash through wounded passions, it is just the way thoughts feel." The original has long since been lost, but it was a large square, covered with characters embroidered in five colors to map out separate sections of text, each of which followed distinct rules. The poem's name was taken from an armillary sphere, an instrument used to gauge the movement of the stars. Armillary spheres were composed of concentric metal rings, each of which corresponded to a different celestial meridian, and it was perhaps this structure that gave Su Hui the idea for her own work. The backbone of Star Gauge is the seven-character phrases that act almost like a grid over the visual structure of the poem and correspond to the rings of an armillary sphere. These can be read in any order and, whenever the reader encounters a junction between these phrases, they can head off in another direction. (Readings of these phrases alone generate 2,848 possible poems.)²

What makes this work even more remarkable is the context in which it was written. The era was turbulent. A century later, Chinese historians dubbed the period from AD 303 to 439 the Sixteen Kingdoms, because of its dizzying succession of short-lived dynasties. Many of these rulers were foreigners—Tibetans, Mongolians, and horse-riding Xiongnu from the Asian steppes—who brought with them alien customs and culture and yet more unrest as they tried to subdue rivals and either capitalize on or overturn the complex Chinese government operated by entrenched officials and elites. It was conspicuously not a time that valued women, so much so that it is remarkable that Su Hui was able to write at all, still less create thousands of literary compositions as she is said to have done. Of this canon, *Star Gauge* is all that survives. (For this we should be grateful: it was excluded from collections for centuries and at one point even lost entirely.)³

Its rediscovery and resurgence are perhaps due to its lovelorn creation, which became a kind of folk tale, retold in plays, novels, and poems. In the most popular rendition of the story, Su Hui's motive for creating *Star Gauge* was to seduce her errant husband back to her. In this telling, once she had finished the final stitches, she sent the poem to him and he, realizing that she was incomparable, renounced his concubine and the pair were happily reunited.

While this cleaves most closely to conservative values of womanly fidelity, it seems at odds with the materiality of the *Star Gauge* itself. The poem is, above all, fiendishly ambiguous. This was deliberate: Su Hui herself described her poem as "linger[ing] aimlessly, twisting and turning." This seems an unlikely lure for a clever woman to use in so conservative a society. If the *Star Gauge* was indeed a silken plea for her faithless husband's return, it was laced with no small amount of venom: not only was she superior to the other woman with whom he was involved, Su Hui was also, even in the depths of her grief, superior to him.⁴

The Sound of Rain on Leaves

In the silkworm month we strip the mulberry branches of their leaves, We take those axes and hatchets, Luxuriant are those young mulberry trees. The Book of Odes, eleventh to seventh century BC

It is said that silk production began with that most Chinese of things: a cup of tea. This particular cup was grasped by Xiling, the young wife of the Yellow Emperor,⁵ who was sitting under a mulberry tree in the gardens of the palace. With a soft "plink" and a little splash of hot liquid, a cocoon fell from one of the branches above the empress directly into the cup. Naturally enough, Xiling's first instinct was to fish the offending object out, but she found to her amazement that the tea had dissolved the cocoon. Instead of a solid cream-colored lump, what emerged was hank upon unbroken hank of silk thread, so much that the Empress Xiling was able to spread it over the gardens so that it looked like shimmering mist.

This Chinese legend is only one of many woven around the production of silk. China, particularly the areas around the Yangtze and Yellow River basins, is the natural habitat of both the *Bombyx mori* silk moth and its principal food, the white mulberry. It is also where the insect was first domesticated. This has rendered the moth flightless and disinclined to move around much. Their life cycles have also been sped up artificially. In the wild they would normally reproduce once a year—possibly up to three times in the tropics. Now, commercial silk-producers are able to raise up to eight generations in the same period.⁶

B. mori goes through four stages: from egg (ova), to caterpillar (larva), to chrysalis (pupa), before finally becoming a moth (imago). The whole show lasts between forty and sixty days. The adult moths are moon-pale and hirsute with wings too weak to bear them in flight. Newly hatched females are born already fat with eggs. They release pheromones to attract males and then mate. (In domesticated settings, this happens within minutes.) Soon afterward, the female will lay up to five hundred eggs. Healthy ones are bluish-gray and oval-shaped, small enough to fit inside the letter "O" on a dime, and after ten days or so will hatch into wavering caterpillars that can barely be seen with the naked eye.⁷

In the wild, eggs would be laid on the leaves of living mulberry trees; domesticated silkworms are kept in well-ventilated, stacked trays. Here they loll and eat vast quantities of mulberry leaves brought to them by humans. (So frenetic is this feeding that a shed full of silkworms sound, even from several yards away, like a torrential rainstorm in a forest.) They use this gluttony to power an incredible transformation. Their bodies will increase up to ten times in weight, molting four times to accommodate their rapidly expanding girth. By the time they are ready to pass on to their next life stage, the silkworms will be a creamy ivory, sometimes banded with darker rings of gray-brown, and around the length and breadth of a lady's pinkie finger.⁸

A silkworm that is ready to pupate will become restless, moving more than usual until it finds a suitable place to build its cocoon. Spinning one can take up to three days, during which time the caterpillar will move its head continuously to and fro while it excretes silk from two pairs of spinnerets below its mouthparts. The silk proteins, produced in glands, are liquid in the silkworm's body, only becoming solid once they are forced through the spinnerets. Even though they are only a few inches long, each silkworm can create a continuous thread up to 1,100 vards long and 0.001 inches wide, around half the width of a human halr. As they spin the silk, they coat it with sericin, a kind of gum-raw silk is sometimes known as silk-in-the-gum-that stiffens the cocoons. (It is this substance that was dissolved by the hot tea in Empress Xiling's cup.) Although they vary greatly from individual to individual, cocoons are generally ovoid, roughly the size of a quail's egg, and range in color from creamy white to a rich yellow orange. If left to its own devices, once the cocoon is complete the silkworm within would become a chrysalis and then, some fifteen days later, would tear its way out of both structures having transformed itself into a moth.9

Although the legend of the empress and her tea makes the production of silk sound like an easy distraction for a lazy afternoon, nothing could be further from the truth. B. mori are delicate and difficult to raise at each and every stage of their lives. Females will lay many eggs that simply will not hatch; these are often blackish in color. During the month when they are caterpillars they are voracious. Their foodmulberry leaves only-must be replenished every three to four hours, day and night. If your own stocks of mulberry leaves are exhausted, new sources must be found and neighbors negotiated with to ensure a continuous supply. This is no mean feat: twelve thousand caterpillars consume around twenty sacks of mulberry leaves each day. It has been estimated that producing a single pound of silk requires 220 pounds of mulberry leaves. (Indeed, the need for mulberry leaves was so acute in antiquity that it was forbidden to fell mulberry trees in the spring when the silkworms naturally bred.) The leaves must be clean, dry, and not too hot. Those picked during the heat of the day have to be left to cool in the shade, otherwise the caterpillars that eat them might die.

Silkworms are also prone to diseases. Scarlet disease can be discerned the moment they emerge from a molt: their bodies will have a reddish tinge and they will die shortly afterward. Another disease turns the caterpillars black and smelly before they die. More gruesome still, when afflicted with yellow disease their skin stretches tight over their swollen heads and a yellow liquid oozes from their mouths.¹⁰

If, however, you manage to feed your silkworms enough and they don't fall prey to disease, the result of your labors will be a crop of fat cocoons. A few of these will be left to hatch, ensuring future generations of silkworms, but most will be harvested for their silk. The first step of this process is to remove the outer layer of floss, which has a low tensile strength and can be used to pad out winter clothes. The cocoons are then steamed, baked, or soaked in a saline solution—killing the chrysalis and preventing it from damaging its own silken sarcophagus when it emerges as a moth—and then immersed in hot water to remove the gummy sericin. Once this is done, the silk will have lost between 20 and 30 percent of its weight. The silken filaments will be pulled out of the water and reeled to straighten them and prevent tangles. These skeins are then usually twisted together to make thicker thread for weaving—and dyed. For thousands of years these skeins were a uniquely productive raw material.¹¹

5,000-Year Monopoly

Men plough; women weave.

The twelfth-century Emperor Huizong was an ineffectual ruler but a skilled artist. Talent certainly shines through in *Court Ladies Preparing Newly Woven Silk*. Painted with ink, pigments, and gold on a long scroll of silk, it shows three groups of women all engaged in

various stages of processing textiles. In the far right, four women pound the silk; in the center, two ladies sit and sew on a jade-green rug; to the left, another group stretch out a length of fabric. They are likely imperial concubines, then among the most elite women in Chinese society. They are attired in patterned, empire-waisted gowns in harmonious colors—cerulean, greens, apricot, and pinkish reds with their hair teased into elaborate shapes and held in place with combs. To the uninitiated the scene is about as decorous as could be imagined but, as it happens, all three of the steps in silk processing shown are also tropes in erotic poetry. Pounding cloth, for example, was often used as a euphemism for a woman's desire. The emperor, using a silken canvas, was implying that these glamorous, silk-clad women were working out their frustrated longing for him by making yet more silk.¹²

Like other natural fibers, silk usually leaves few traces behind to be unearthed by archaeologists, so pinning down precise origins is a little like trying to catch a moth in flight while blindfolded. Sericulture likely first appeared between six and seven thousand years ago, where it helps form a picture of sophisticated cultures with a wide range of skills. Xivin village, a Neolithic site, yielded a cocoon that had been neatly sliced in half sometime between 2200 and 1700 BC. In Oianshanyang, in southern China, a piece of tabby-weave textile was found that dates back to around 2750 BC. Another Neolithic settlement, Jiahu in central Henan, provides still earlier evidence of silk production. Jiahu is famous for the richness of its cultural remnants: bone flutes, the earliest playable musical instruments, were found there, as were the remains of a fermented drink made from rice, honey, and fruit. Traces of silk proteins-the material itself had long since degraded-were discovered in a group of tombs that were around 8,500 years old. Even then, it seems, silk was something special, something that people wanted to take with them.13

Remarkably, China remained the only place where silk from *B. mori* was produced for around five thousand years. And while the material itself has decomposed, other artifacts relating to its production—needles, looms, and shuttle-like creations for bearing thread—remain. An ivory basin, decorated with what appears to be a pair of

silkworms, and dating back to around 4900 BC, was found at a Neolithic site called Hemudu. During the Shang dynasty, which lasted from around 1500 to 1050 BC, an oracle bone script was developed, the earliest writing system in East Asia. Oracle bones were usually made from the scapulas of oxen or sheep, or occasionally the shells of turtles, which had questions incised on them and were used in divination. Around a thousand have been translated and 10 percent of these include silk-related words: "mulberry tree," "silkworm," "silk goddess."¹⁴

Multifaceted uses of silk in China first began to emerge during the Shang dynasty. As is so often the case, the role in which it has been best preserved is its role in death. Grave goods, such as jades, bronze vessels, and axe heads, were wrapped in silk, just as ancient Egyptian cultures wrapped theirs in linen. At Mawangdui, an archaeological site in Changsha, central China, a series of elaborately decorated coffins were found nested one inside another. In Tomb One, the outermost of the four coffins was painted black without and red within-a pairing highly significant in mourning rituals-and the exterior with clouds and monsters. The innermost coffin had the same color scheme but was also wrapped in a feathered brocade covered with geometric designs. Silk manuscripts and a diagram illuminating the mourning-dress system were also found, carefully wrapped, in another Mawangduian tomb. Centuries later, when senior grand master Shao Two was buried in 316 BC in Hubei province, his tomb contained seventy-seven different textiles including fifteen silk shrouds. Grave inventories sometimes stretched the truth of the silks actually included in the tombs. One such document, included in a tomb sealed in 548, lists 1,000 pieces of brocade, 10,000 of damask and a piece of yarn 1,000,090,000 feet long, which it airily explained would be used "for climbing to heaven."15

Silk was woven into other religious rites. Ssu-ma Ch'ien, a Chinese historian from the Han dynasty (206 BC to AD 220), spoke approvingly of the Feng and Shan sacrifices that were traditionally carried out by rulers, which included the ceremonial receiving of three kinds of silk as well as lambs and wild geese and pheasants. According to Ssu-ma Ch'ien, Emperor Yü's failure to practice these rituals led to his downfall: "[T]he two dragons, sent to his court from Heaven, took their departure." Later Buddhist texts were wrapped in silk, as were statues. One seventh-century Chinese pilgrim made a ritual robe to exactly fit a large Buddha carving at the Mahabodhi monastery in northern India. The robe was made entirely from silks donated by devotees from Shandong. Silks were also given by emperors and elites as rewards for religious services. Amoghvajra, a Tantric teacher who arrived in China around AD 720, received so much silk that you could apparently climb the pile like a sand dune.¹⁶

The production of silk was bound up, from at least the time of Confucius, with ideas about women's appropriate place in society. As early as the Xia dynasty (c. 2070–1600 BC) women were expected to stay at home and devote themselves to weaving. A text from the fourth century BC was explicit on this point. "Early in the morning the women rise, late in the night they go to bed, spinning and weaving... That is their share in the work." The association between women and silk was further strengthened by the emergence of a silk-worm spirit or silkworm goddess as early as the Shang dynasty (1500–1050 BC). (This was often personified as Xiling, the wife of the Yellow Emperor whose mythic cup of tea launched the silk industry.) Worship of her can be traced, in one form or another, right up to the factory workers of nineteenth century Shanghai.

The goddess may owe the persistence of her cult over the millennia to a certain resistance against traditional cultural norms in spaces dominated by women. Confucian values meant that it was difficult to have cultural heroines but this goddess, like Su Hui, prevailed. Annual rituals and offerings—often in the form of woodblock prints were pegged to the seasons when the silkworms hatched and became an important part of the cultural calendar. During the Ming dynasty, a building dedicated to Lady Xiling was erected in Beihai park, an area just north of the Forbidden City in Beijing, and her birthday was celebrated on December 12 each year.¹⁷

One of the signature uses of silk, and the one with which we can readily identify with today, was as a mark of status. The *Book of Rites*, which is said to have been compiled by Confucius (551–479 BC), proclaims that "The coffin of a ruler is lined with red [silk], fixed in place with nails of various metals; that of a Great officer is lined with black [silk], fixed with nails of ox-bone; that of a common officer is lined but has no nails." During the Shang and Zhou eras (c. 1600– 256 BC), jade and silks were the most treasured gifts exchanged among the aristocracy. Just as jade could be inscribed with symbolic forms, silk could be woven or embroidered with patterns that held significance. Fabrics produced around the lower Yellow River were given enticing names such as "auspicious pattern," "four clustering clouds," "mirrored flower," and "nimble waves." Weavers responded to demand by creating ever more elaborate designs that varied enormously over time. Bright colors were popular during the Tang dynasty, for example, while a muted palette was preferred during Song times. Songdynasty Hanzhou weavers also produced special silks for social occasions: "spring streamers," "lantern globes," and "boat racing" are three of the most picturesque. When the Silk Roads brought outside influences into China, the silks reflected this. Symbols from Greece, India and Persia all left their mark on fabrics woven in China.¹⁸

Emperors were particularly preoccupied with the prestige of luxurious silks. A yolky yellow shade, which was very labor-intensive to achieve, was reserved exclusively for emperors by law from the seventh century. Palaces had silk dyeing and weaving facilities; reigning empresses presided over a silkworm department. When Emperor Zhangzong ascended the throne in 1190, he employed 1,200 weavers to produce prestigious patterned damasks.

Sumptuary laws restricted certain silk fabrics to specific classes. A garment made from silk that had been dyed before it had been woven, for example, could only be worn by someone above ordinary officer level. Dragon robes were among the most exclusive silk fabrics in imperial China. These robes, which fastened at the side and were worn with a collar, were favored by courtiers, often given as gifts by the emperors, and their decoration was rich in symbolism. During the Qing dynasty, medium-ranking officials wore robes with eight dragons, while those of a higher rank had an extra dragon, often hidden underneath the outer layer near the fastening. In the palace, care of these garments was exclusively entrusted to a director of the imperial wardrobe.¹⁹

Providing the silk for such diverse uses required a great deal of work and innovation. The backstrap loom, a very early form of weaving technology that used the weight of the weaver's body to produce the necessary tension on the warp threads, was in use at least seven

67

thousand years ago. Demand soon ensured many other and often highly specialized looms were invented and put to use. To ensure a steady supply, silk production was ruthlessly organized with quotas and production qualities that went into granular detail. During the Zhou dynasty, an official bureau was set up to deal specifically with sericulture throughout the kingdom.

For hundreds of years there were, broadly speaking, three different strands of production. Firstly, women in farming households produced silk that was used to pay annual taxes. (Although it was small-scale on the individual level, this accounted for a great deal of the silk produced in China: in 1118, for example, a total of 3.9 million bolts of silk were produced for taxation purposes.) There were also professional weaving households, who crafted fashionable, technically difficult silk fabrics and whose livelihood depended on their selling them. Thirdly, there were state-operated and palace-run workshops that made silks for court and imperial robes. These were large-scale affairs. During the reign of Empress Wu Zetian (AD 685-705) the Imperial Manufactories employed 5,029 people, including twenty-seven stock-keepers, seventeen scribes, and three accountants. The palace manufacture alone employed eighty-three damask workers and forty-two highly skilled artisans. Much later, during the Ming dynasty (1368-1644), an imperial decree set up an official silk production center in Nanjing with 300 looms and instructions to make 5,000 bolts of silk each year.20

As well as having deep cultural resonance, as can be seen from its three-layered role in *Court Ladies*—substrate, subject, and innuendo—silk was an important source of wealth. By 1578 about 10 percent of the annual state revenue was spent on the production of silk by the central government. But even well before then the production of silk was vital economically. A Qin statute punished anyone who stole mulberry leaves with thirty days' forced labor, "even if the stolen goods are not worth a single coin." Rivalries between states could flare up over silk production. This sensitivity can be seen in the negotiations that followed the 589 BC invasion of Lu (in today's Shandong province) by the Chu state. Peace was only declared after Lu agreed to part with a hundred wood carvers, needleworkers and weavers: workers who would bring their skills to Chu.²¹

Most simply, silk was, in many instances, used in place of currency. An inscription on a Zhou-dynasty bronze tripod records the exchange of a horse and some silks for five slaves. During the reign of Wang Mang-from AD 9 to 23-a plain bolt of silk could be exchanged for around 130 pounds of rice, while finer silk might be exchanged for eighty. And, although the domestic market dominated production, it would be a mistake to think that the Chinese weren't concerned with foreign trade at all. Aurel Stein, who explored the region in the early twentieth century, discovered silk strips at a ruined watchtower on the edge of the Gobi Desert, an important trading waystation. One strip bore the incredibly helpful inscription: "A roll of silk from K'ang-fu in the kingdom of Jen-ch'eng; width two feet and two inches; length forty feet; weight twenty-five ounces; value six hundred and eighteen pieces of money." When the Song dynasty collapsed in 1127 a new workshop for making rich damask was founded with the specific aim of making silks that could be traded with Tibetan tribesmen in return for horses. Later, silk lent its name to the network of trade routes that spread across Central Asia: the Silk Roads. While the majority of these exchanges were animated by the spirit of commerce, others were motivated by fear.²²

Gifts for Enemies

The Xiongnu live in the desert and grow in the land which produces no food. [They] are abandoned by Heaven for being good-for-nothing.

Discourse on Salt and Iron, 81 BC

To those living in northern China in the centuries before and after AD 1, there were probably few things as terrifying as the Xiongnu.

These tribesmen, who ruled the Mongolian steppes, were renowned as tough, skilled, and brutal warriors. More unnerving still, their nomadic way of life was anathema to the Han Chinese. The *Shih-chi*, written between 110 and 90 BC, calls them "Mountain Barbarians" and characterizes them as little more than savages.

[They] have no walled cities or fixed dwellings, nor do they engage in any kind of agriculture ... They have no writing, and even promises and agreements are only verbal. The boys start out by learning to ride sheep and shoot birds and rats with a bow and arrow, and when they get older they shoot foxes ... Thus all young men are able to use a bow and act as armed cavalry in time of war.²³

Their boldness in battle also made them terrible neighbors for the Han, and the two skirmished for centuries, playing tug of war over the same ground. During this period, the tribesmen launched raid after raid on their southern neighbors, stealing livestock, taking them for slaves and then melting back into the steppes before Han forces could be mustered and counterattacks launched. What the Chinese lacked in martial force, however, they were determined to compensate for with cunning. Their plan for subduing the unruly Xiongnu required a great deal of time and a secret weapon, one which they were confident would ultimately deliver them victory. That weapon was silk.

The strategy was diplomatic in nature. The first step was to come to an agreement with the Xiongnu. In practical terms, this agreement, now known as the tributary system, had four tenets. Firstly, a Chinese princess would marry the Shan-yü, the Xiongnu leader. Secondly, the Great Wall would mark the border between the two sides; crossing over the wall without permission constituted a breach of the agreement. Thirdly, the two parties would be equal, "brotherly" states, with neither one subservient to the other. (Later, the Xiongnu had to submit to being a tributary state rather than an equal one, but this didn't nullify the other three parts of the agreement.) The fourth part was where the silk came in. Legal trade was encouraged between the two nations—special markets were set up for the purpose near the wall and stocked to the brim with all the goods that the tribesmen had been so eager to steal. Furthermore, the bonds of friendship between Xiongnu and Chinese leaders would be renewed annually with exchanges of gifts. Nominally, these were the exchanges of gifts between "brotherly" leaders; in practice, it appears to have been little more than a protection racket.²⁴

The first agreement of this kind was reached in 198 BC, but it was continually being broken and re-brokered. In the year AD 135, for example, steppe horsemen held up a caravan of over a thousand ox-drawn carts. More infuriating still, these carts were likely bound for one of the large border markets set up specifically to entice the Xiongnu to abandon their marauding ways in favor of legal and profitable trade with the Chinese. Earlier, in 177 BC, the Xiongnu invaded some Han allies. Peaceful relations were renewed three years later when an envoy was dispatched to Emperor Wu apologizing on the one hand while on the other boasting of the strength of the Xiongnu forces and of their many recent military victories. The emperor got the hint. He sent ten rolls of embroidery, thirty of brocade, and forty rolls each of red and light-green silk as well as some of his own robes. "Your envoy tells us that you have led your troops in person," he replied, "and won merit, suffering great hardship on the field of battle. We therefore send you from our own wardrobe an embroidered robe lined with patterned damask, an embroidered coat and lined underrobe, and a brocaded coat."25

As time passed the gifts the Xiongnu court demanded grew ever larger. While in 51 BC they received 6,000 catties of silk floss (a catty is a unit of measurement then roughly equivalent to 1.3 pounds) and 8,000 pieces of silk fabric, by AD 33 they were getting 16,000 and 18,000 respectively. Silks were an important status symbol for the tribal leaders and were, as in China, often buried in the tombs of elites. A large number of such fabrics have been excavated in northern Mongolia. Noin-ula, for example, a site with over two hundred burial mounds belonging to elite Xiongnu, is brimming with Chinese goods including precious damasks likely given as part of the tributary system.²⁶

Given the mounting costs of the tributary system, and the regularity with which the pact was broken, it might be wondered why the Chinese persisted. It was partially expediency: the Xiongnu certainly valued the gifts and the special markets that were set up for them. These were part of their diplomatic requests when the two nations patched up their differences after the raid in AD 135. The Han likely hoped that these agreements would discourage, if not completely stop, the aggression. More deviously, they believed that trade would weaken their foes financially. The Chinese produced more desirable luxury goods than the nomadic tribesmen did, so it was likely the balance of trade would always be in their favor. What the Xiongnu did have to trade were pack animals like camels, donkeys, and horses. Since these were vital to the Xiongnu's military success, the more of them that passed into Chinese hands, the better. As one Han official put it in 81 BC:

A piece of Chinese plain silk can be exchanged with the Xiongnu for articles worth several pieces of gold and thereby reduce the resources of our enemy. Mules, donkeys and camels enter the frontier in unbroken lines: horses. dapples and bays and prancing mounts, come into our possession.²⁷

But there was an even longer-term and more insidious motive behind the Han tolerance of the expensive tributary system. They believed that by giving the Xiongnu fine textiles, food, and other trappings of their own civilization, they would weaken them militarily. Their hope was that they would become so economically and culturally dependent on China and their luxury goods that the Han would have achieved through shrewd diplomacy and patience what they couldn't with warfare. Chia I (201–169 BC) articulated this scheme—he picturesquely called it the "five baits" strategy—early on. The delicious foodstuffs, entertainment—music and women buildings, granaries, and gorgeous clothes, he argued, would act on the Xiongnu as the haircut did on Sampson.

The Xiongnu, in turn, were aware of the danger posed by the gifts they were being sent. A Han official who defected to them told them bluntly that they were being played for fools:

The strength of the Xiongnu lies in the very fact that their food and clothing are different from those of the Chinese . . . From now on,

when you get any of the Han silks, put them on and try riding around on your horses through the brush and brambles! In no time your robes and leggings will be torn to shreds and everyone will be able to see that silks are no match for the utility and excellence of felt and leather.²⁸

Silk bound the aggrieved wife Su Hui, the vain Emperor Huizong, and the leaders wrestling with the aggressions of the Xiongnu together. Each used it as the medium for their narrative of seduction. It allowed Su Hui, a woman in a misogynistic age, a voice. Silkmaking was explicitly reserved for women in Confucian thought. Not only was it one of the things that they were able to materially contribute to society, but embroidery and textiles were one of the arenas in which they could excel. Ding Pei, the author of the Treatise on Embroidery in the nineteenth century, told her readers that "The needle is your writing brush," and spoke of it explicitly as a worthy art form. It should, she wrote, be "imbued with emotions . . . [so that] a many-storied tower can appear in an inch of cloth without seeming small." Su Hui used both her brain and her skill with the needle to create a silken text that, depending on what you believe, either won her lover back through the force of its brilliance or cowed him into submission.29

Emperor Huizong used a different silken canvas to talk about love. He deployed his talents to paint a scene that showed others desiring him. Moreover, the women—likely imperial concubines—were among the most powerful and influential women of his day. Their sumptuous clothing adds to their allure and, indirectly, to his own virility. Emperor Huizong was, in a sense, using the shared cultural value and language of silk to mythologize himself as a desirable, powerful man, no matter what the opinion of his contemporaries.

The seduction of the Xiongnu was more insidious. The Han were confident in the power of their fabrics to dampen the tribesmen's ardor for battle. Silk was, after all, treasured by the nomads because of its texture and because it was lightweight, making it easier to carry on horseback. The tribesmen, particularly the elites, began to use it for their clothing and bedding and incorporated it into their burial rituals. Just as in China, the ownership of precious silks became a

73

talisman of prestige. It was an important part of the way the Shan-yü cemented his position, just as in China where sumptuary laws delineated one class from another using the color and quality of silken fabric. Silk was power.

4

Cities That Silk Built

The Silk Roads

The Library in the Cave

And yet, while China holds our friendship, And heaven remains our neighbourhood, Why should you linger at the fork of the road, Wiping your eyes like a heartbroken child? Wang Bo (AD 650-676), Farewell to Vice-Prefect Du, setting out for his official post in Shu

Sir Aurel Stein remained an enigma to his friends, although they always appreciated the exotic gifts he sent home. Born to Jewish parents in Budapest on November 26, 1862, by the time he was twenty-one he spoke German, Hungarian, Crook, Latin, French, English, Sanskrit, and Persian, Although only five foot four inches, he had the kind of wiry physique and tenacity that lasts long after those with the ruder sort of power have gone to seed. While on a walking tour of the hill country in northwest India in his sixtics, his young local guide made the serious mistake of underestimating his charge's vigor. "Stein Sahib is some kind of supernatural being," he complained to his commanding officer. "He walked me off my legs in the mountains; I could not keep up with him. Please do not send me to him again, Sir." (It's also possible the guide had his eye on a larger tip.) Many decades previously, however, Stein's talents and energy had been concentrated elsewhere: unearthing treasures that had been covered by time and the wind-traveled sands of the Gobi Desert for centuries.1

The region, not much of a tourist hotspot now, was even more forbidding in the opening decades of the twentieth century. Stein, who returned there again and again, traveled frugally. At night, when temperatures dropped precipitously, he would sleep under a thick pile of pelts, pulling his fur coat over his head and breathing through the sleeve to protect his face from frostbite. During the day, his ponies' feet would sink in the sand—it is a region best traversed by camel—as would those of his dog Dash, dressed in a custom Kashmiri fur coat to save him from freezing, but who eventually submitted to being borne along in a camel basket with a hole in the lid.

On December 18, 1900, Stein came upon the remains of Dandan-Uiliq, abandoned in the late eighth century, and marked only by the sun-bleached tops of a few dead fruit trees in what was once an orchard. Seven years later, he saw some even more remarkable traces of the trade route that had once stitched the desert together. This time, however, the triumph of actual discovery belonged to someone else.²

While Stein scoured desert regions for archaeological treasure, Wang Yuanlu, a Taoist monk, was the lone guardian of a series of remarkable shrines. Known as the Mogao Caves or the Temples of the Thousand Buddhas, they were situated near Dunhuang, an oasis in northwest China, on the rim of the Gobi Desert. The first ones were carved out in the fourth century; by the seventh century, there were over a thousand, lavishly decorated and, at their peak, attracting thousands of wealthy and influential worshippers.³

In the centuries since, as the Silk Roads had fallen into disuse, the shrines had largely been forgotten, and Wang Yuanlu's vigil was a lonely one. One day-in the very same year that Stein was making his way from Kashgar and Yarkand on the journey that would lead him to Dandan-Uiliq-Wang was sitting smoking in one of the larger caves, when he noticed something rather odd. The smoke from his cigarette was not curling straight upward or being sucked toward the entrance (as you might expect), but was instead determinedly drifting toward a back wall and disappearing, phantomlike, into the mural that covered it. Perplexed, Wang examined the area closely and realized that what he had always taken to be solid stone was in fact a cunningly rendered wall. He carefully pierced a hole and squeezed through. Behind the eleventh-century wall lay a room filled with long-forgotten and dust-furred manuscripts and scrolls, piled up so high that the tops of the stacks were lost in the gloom. When he told the local officials, hoping to secure a grant to help conserve these newly discovered treasures, they were dismissive: "Seal the room back up again."⁴

Despite their seeming indifference, the officials must have been curious enough to gossip. The fact of the hidden cave's existence began to seep out like water from an ill-glazed clay pot. When Aurel Stein organized an excursion to the region in 1907, it was to Dunhuang that he bent his footsteps. "I confess," he later wrote, "what kept my heart buoyant were secret hopes of another and more substantial kind." Two months before "vague rumours about a great hidden deposit of ancient manuscripts" had reached him, and he was impatient to test their veracity. He was not disappointed. Having overcome Wang's objections, he was shown through the aperture the Taoist priest had made. "Heaped up in layers, but without any order, there appeared in the dim light of the priest's little oil lamp a solid mass of manuscript bundles rising to ten feet from the floor and filling, as subsequent measurement showed, close on five hundred cubic feet."⁵

The contents of that room were one of the greatest archaeological discoveries of the century. The Library, as it was reverently known thereafter, contained documents in seventeen languages and twenty-four scripts, many of which have long since expired. The collection includes the *Diamond Sutra*, a copy of one of Buddha's sermons and the oldest known printed book. There were also countless works of art and silken textiles. Opening one packet, Stein found it "full of fine paintings on silk and cotton, ex-votos in all kinds of silk and brocade." He bought around ten thousand documents and artworks for the British Museum for the beggarly sum of £130. Scholars the world over—particularly since the scattered collection was digitized and virtually reunited in 2013—have through this one remarkable find gained a window into the lives lived and goods traded along the Silk Roads many centuries before.⁶

79

Trade and Tribulations

These men all uphold the law of Mohammed. In the city are industrious merchants; they make robes of silk and gold of various fashions, and raise also plenty of cotton.

Marco Polo, on the people of Persia, The Travels of Marco Polo, c. 1298

One of Stein's most evocative discoveries was a wooden panel intended as an offering to Buddha. On it were painted scenes of the popular legend of how the long-guarded secrets of silk-making escaped from China, breaking their 5,000-year virtual monopoly.⁷

The tale, although it has many different versions, has at its heart a princess from Loulan. At the moment she turned from a girl to a young woman, she was promised by her parents to the ruler of the nearby kingdom of Khotan. Because the practice of sericulture was well known in the princess's home, she had spent her entire life swaddled in silken robes. There was no silk to be had, however, in the lands of her betrothed. Despairing of a silkless future, the princess defiantly snatched up some of the soft white cocoons from their special trays in the palace and tucked them into the piles of her elaborately dressed hair so that she could smuggle them to her new home.

This tale reinforces a certain long-held view about the Silk Roads: that goods flowed—sometimes illicitly—generally westward out of what is now China (it wasn't unified until the third century BC). The truth is rather more complicated. The term "the Silk Roads" was coined in German by a nineteenth-century geographer called Baron Ferdinand von Richthofen.⁸ The plural form is important: the roads were a constantly shifting network of well-trodden land routes that spread, like questing plant roots, throughout Central Asia.

The principal east-to-west artery ran from Chiang-an along the Kansu corridor, crossed the Tarim basin and the Pamirs, through Turkestan-usually via Samarkand-and then through modernday Iran, Iraq, Syria, and finally to the shores of the Mediterranean. However, it would be wrong to think that most goods started at one end and determinedly made their way to the other. While China began to open up more fully to trade with the Central and Western Asian states in the second century BC under Emperor Wu, trade networks between these states existed beforehand. There was also a long and flourishing tradition of Sino-Indian trade. Evidence appears in the Arthashastra, the devious Indian treatise on statecraft written as early as the fourth century BC, before the unification of China. Then, as later, silk was only a tiny fraction of the goods that were being traded, but it was certainly an important one. The text contains the word "cinapatta," meaning "a bunch of Chinese silk." Many of the exchanges that took place along the Silk Roads would have been local. And most of those living along these routes would have been nomadic or involved in agriculture, for the most part independent of the business of trade, only occasionally exchanging furs, fruits, or horses for tools or other objects or substances made or collected elsewhere 9

But the roads were used by more enterprising traders also. Merchants' caravans criss-crossed the region, along a multitude of paths, bearing all manner of goods back and forth. And, even if they did not know it, they were also spreading ideas, artistic styles, religions, and even diseases.¹⁰ Letters and news also traveled along these channels: the first event of world history recorded in both western and Chinese sources was the fall of the Greco-Bactrian empire in 130 BC. The Silk Roads were not constant over time: they waxed and waned, broke up and re-formed in response to demand and unrest across the region. Roughly speaking, after pushing east into China in around the second century BC, they were at their most influential from around 100 BC until around AD 1; the second and third centuries; in the eras of the Tang and early Islam-the seventh and eighth centuries-and during the thirteenth and fourteenth centuries when the Mongol Empire ruled swathes of Eurasia, allowing trade to flourish.11

Traveling the Silk Roads was no easy matter, even during the twentieth century. The rough terrain the roads crossed included the Gobi Desert, infamous for its extreme temperature fluctuations as well as storms that unleashed clouds of choking sand. The Bactrian camel was perfectly suited to these harsh conditions and was therefore highly valued by traders. Far hardier and better adapted to the desert landscape than other pack animals, they could also sense approaching sandstorms, which, if they caught travelers unawares, could be deadly. Before any human could discern anything amiss, the Bactrian camels would "immediately stand snarling together," according to one writer. The travelers, taking the hint, would "cover their noses and mouths by wrapping them in felt."¹²

But even caravans of experienced traders could suffer mishaps. Court documents dating from AD 670 reveal the case of an Iranian living in China who was asking for the court's assistance in recovering 273 bolts of silk owed to his brother.¹³ The brother had, after lending the silk to his Chinese partner, set off into the desert on a business trip with two camels, four head of cattle, and a donkey. The party was never heard from again. So many goods and people attracted robbers, too. One report from a Silk Road city specifies that "seven strings of pears, one mirror, a lastuga [a kind of gown] made of many-coloured silk, and a sudi ear ornament" were filched. The thief was later caught and confessed, but had apparently had time both to sell his loot and to spend the money, as he was unable to pay back his victim.

Such dangers were usually amply rewarded for those willing to run the risks. Armenians, who were successful long-distance traders, would buy an eighteen-pound bale of silk for twenty crowns and sell them at thirty. A single horse could carry around thirty bales, while a hardy camel might manage fifty-five, meaning a handsome profit for every load. Sogdians, hailing from a Central Asian civilization near today's Samarkand, were also expert longdistance traders. In a ruined watchtower near the Thousand Buddha shrines, Aurel Stein found a packet of letters likely penned in the early fourth century by Sogdians living in China. A couple are full of panicked descriptions of famine and unrest, and the destruction by the Huns of important Silk Road cities. But the letters also reveal the network of trades being done across the region by the Sogdian diaspora and the systems of credit they had set up and could call upon to conduct business.¹⁴

The Vikings and the Viking Rus', an early medieval people who lent their name to their homelands of Russia and Belarus, were also indefatigable long-range traders of wax, amber, honey, and especially silk gleaned from cities threaded along the Silk Roads. Rather than using the land routes, they used rivers-the Oder, Neva, Volga, and Dnieper-sailing in longboats adapted so that they could be carried between rivers and lakes if necessary. Although more recent research has done much to transmute the Vikings' warlike reputation into something rather more mercantile, descriptions of the Rus' from their own day suggest the former reputation was well deserved. A generous Muslim contemporary noted their "great stamina and endurance." Others accused them of taking part in orgies and treachery to their fellows, robbing or murdering them if they were given half a chance. "They never go off alone to relieve themselves," wrote another observer, "but always [go] with three companions to guard them, sword in hand, for they have little trust in each other." They were particularly mistrusted by the Byzantines. After a surprise raid on Constantinople in AD 860, their access to the city was limited. No more than fifty Rus' were allowed into the city at any one time, and they had to enter by a particular gate, register their names, and submit to being closely monitored until their departure.¹⁵

The Silk Roads, and the caravans, traders, goods, and money that flowed through them, had tangible effects on the countries they traversed. Wealth collected in pools around popular trading posts and oases: Palmyra, on the edge of the Syrian desert, was one such place. Greek, Persian, Roman, and Islamic cultures had all left a visible patina on the city's monuments and it was, at one time, known as the Venice of the Sands. (Many of the ancient sites that embody the city's rich and multicultural heritage, including large sections of a Roman theater and an arch of triumph that had stood for 1,800 years, have been destroyed by Isis since they captured the city in 2015.)

Such cities made deep impressions on those who saw them. In the tales of his wanderings along the Silk Roads in the thirteenth century, Marco Polo lavishes praise on them. The Middle Eastern port of Cormos, we learn, is full of ships from India, bearing "all kinds of spiceries, precious stones, and pearls, cloths of silk and gold, elephants' teeth and many other articles." Farther east, the cities of Ta-in-fu and Pi-an-fu are not only "the only part of Cathay where wine is made," but also yield "much silk, abounding in the trees on which the worms are fed."¹⁶

Because the Silk Roads, when they were busy, made the countries through which they cut more porous by their very existence, beliefs as diverse as Islam, Zoroastrianism, and Christianity brushed shoulders with one another and even coexisted in one place. In Palmyra, these influences were emphatically rendered in stone, but they left their mark elsewhere too. Mesopotamian Jews were involved in the Silk Road trade. The *midrash*, the commentary that runs alongside Hebrew Scriptures, contains a parable of sorts that involves the setting aside of some valuable silk by one man after another has promised to buy it. Although the buyer doesn't come for his purchase for a long time, the seller keeps faith. "Thy word," he says when his customer does eventually arrive, "is stronger in my eyes than money."¹⁷

Buddhism flourished in China in part because of the exchange of ideas facilitated by the trade routes, eventually becoming one of the country's three major religions. Silk embedded itself deeply within the faith's religious practices. Silks were used to wrap important relics and scriptures-a practice later borrowed by other beliefs, including Christianity. (Benedict Biscop, the English abbot of Wearmouth and Jarrow, made five trips to Rome in the mid-seventh century and he returned to his Northumbrian monasteries bearing books, relics, and rich silks with which to wrap them.) At least one Buddhist monastery fined monks a set number of bolts of silk when they transgressed. Buddhist relics flowed into the country from India, Buddha's birthplace and the cradle of the religion. The Thousand Buddha shrines, in which the Library Cave was found, were just one instance of this religious flowering. The city of Dandan-Uiliq was imprinted with Buddhism too. Over two weeks from Stein's discovery of the city on December 11, 1900, he exposed and excavated over a dozen structures, both temples and dwellings. Much of the art he found was inflected with Indian characteristics; the Buddhist texts he unearthed were written in Sanskrit.¹⁸

Buddhist monks and pilgrims were just as likely to use the Silk Roads as traders. They were less likely to be robbed or attacked and, since it was believed hosting them was a form of devotion in and of itself, they could be a useful addition to more commercial caravans as well. Such was the experience of seven Khotanese princes whose travels were outlined in some of the Library Cave documents. They traveled with three monks and, when the group was mistreated by the local ruler of Dunhuang, an emissary claimed to have reproached the ruler, who then apologized. "How I did harm upon the monks," he was reported as saying, "and brought about a bad name for myself." One of the most famous religious travelers of the age was the Chinese pilgrim Xuanzang, who journeyed through the region during the early seventh century. It was the name of this man-a hero to many Taoists-that Aurel Stein invoked to persuade Wang Yuanlu, the guardian of the Thousand Duddhas shrines, to let him see the library cave and, later, to buy and carry off some of its contents.10

The Business of Silk

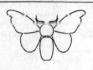

Beyond this region, by now at the northernmost point, where the sea ends somewhere on the outer fringe, there is a very great inland city called Thina [China] from which silk floss, yarn and cloth are shipped by land via Bactria to Barygaza and via the Ganges River back to Limyrikê.

Periplus Marls Erythraei, c. AD 40-70

85

Although it was far from the only thing merchants traded, silk was among the most consistent, valuable, and easily portable products humped across deserts and mountains in the swaying caravans. Most came from China, which was the natural habitat of both the *Bombyx mori* moth and its food, white mulberry, and was, naturally enough, where sericulture had first emerged.²⁰

The Chinese had thousands of years to perfect the craft, grow the lush mulberry orchards needed to feed the silkworms, and develop many of the specialized looms needed to make particularly complex and luxurious fabrics. Silk wasn't officially exported outside China before the first Han dynasty, around 140–134 BC. Before then, if anyone was caught smuggling silkworms—either as eggs or cocoons or even mulberry seeds or saplings, they could be executed. When it did reach other regions, it was highly prized. Silks from China were known in Egypt in the first century BC. The "Sidonian" robes that Lucan describes Cleopatra as wearing—and which he lasciviously noted revealed her breasts—certainly sound like the sheerest of silks. These robes, made "by the skill of the Seres, the needle of the workman of the Nile has separated, and has loosened the warp by stretching the weft."²¹

Such reworking of imported silks was not uncommon. In Western Asia, there was a tradition of buying plain Chinese silk to embroider or to unravel and re-weave into special damasks and gold-embellished fabrics. Soon enough, however, the knowledge and practice of sericulture took root there also. Justinian I, who ruled the Byzantine Empire from AD 527 until 565, is said to have encouraged two monks to smuggle cocoons out of the east on their travels. Knowing the punishments, the pair cleverly hid their illicit cargo in hollowed-out walking canes. Whether or not this picturesque tale has any truth to it, we do know that once silk production took hold in Persia, they proved themselves to be adept. It helped that Persia was the home of a black variant of mulberry tree that the silkworms were able to eat-although this diet apparently made the resultant thread slightly less fine. Nevertheless, the production of silk in the region subsequently reached annual levels of ten thousand zooms (a measurement equal to two bales, each of which weighed up to two pounds). The Persians specialized in rich fabrics inlaid with precious metals or intricately decorated with figures, beasts, and plants.²²

Silk made an excellent gift. After winning a compelling military victory in AD 997, Mansur, a Muslim ruler, rewarded his supporters-Christian and Muslim alike-with 2,285 pieces of tiraz silk, two robes perfumed with ambergris, eleven pieces of scarlet cloth, seven brocade carpets, and various other textiles. Two centuries previously, silk performed a similar function for the famous Chinese pilgrim, Xuanzang. When he stopped in the Central Asian state of Gaochang, the king there, who was a devout Buddhist patron, presented his guest with so many silks and other gifts that the pilgrim needed thirty horses and two dozen laborers to carry it all away. The king also wrote twenty-four letters of introduction to the various kings whose land Xuanzang would need to pass through on his onward journey. Each letter was attached to a bolt of damask and, to the most powerful-and possibly most fearsome-king, Yagbu Khan of the Western Turks, an additional incentive of five hundred bolts of damask and painted silk and two cartloads of fruit were cont.23

The rich stew of ideas and cultures facilitated by the Silk Roads left their mark even in the designs of the silks being produced and traded. Animals not native to or revered in China—lions, elephants, peacocks, winged horses, and even camels—began to creep into the motifs of embroidered silks. Helios, the Grecian sun god, gained ascendency in Central Asia after the conquests of Alexander the Great from around 334 BC, and depictions of him began to appear too. Similarly, Buddhist symbols were adopted as the religion itself began to gain a foothold in China. And, as China's trade with the Sasanid Empire—which ruled much of Central Asia from AD 224 to 651—increased, they began adapting their sophisticated, colorful woven *jin* fabrics to suit Sasanian tastes. Persian *jin* fabrics were common enough after around AD 455 to be given their own name *bosijin*. This term appears again and again in Chinese literature as a particular favorite of elites.²⁴

Despite, or more likely because of the popularity of these foreign weaves in China, there were repeated attempts to push back against the interlopers. In the year AD 771, for example, Emperor Daizong banned their production in China. Half a century later, presumably after the measure failed miserably, Emperor Wenzong renewed it, this time trying to ensure compliance by ordering the special looms required to make the particularly fashionable *liaoling* twill damasks to be burned. By this time of course it was far too late: foreign influences were too deeply embedded into the production of Chinese silks to be picked out. The truth of this can be seen from a single silk fragment from the Eastern Han era (AD 25–220). At the center of the design sits Helios, the Greek god of the sun, cross-legged in a recognisably Indian style on a Buddhist lotus throne. The pearl roundel in which Helios is enthroned—indeed, the entire composition—shows Sasanian influence. And yet there are also homegrown elements, such as dragon-headed banners; the weave too is recognizably Chinese.²⁵

No matter where silk went, or the weaves or designs used to decorate it, it was always a potent status symbol, a valuable trading good, and a potential source of income for any country that could produce it. An account of the "Black Tartars," written in 1237, notes that: "The Mongols' robes fasten on the right and have square collars. They were originally made of felt and sheepskin, but now they are made of satin with gold threads." Kublai Khan (1215–94), the Mongol ruler who also founded the Yuan dynasty in China after his conquest in 1271, was apparently especially enamored of silk. One writer, who no doubt heavily embroidered his tale for effect, wrote that the Khan's banquets were attended by 40,000 people and that those waiting on the guests had their noses and mouths "swathed in fine napkins of silk and gold, so that the food and drink are not contaminated by their breath or effluence."²⁶

Farther afield, lust and longing for silk was just as pronounced. Crusaders of the knights of St. John of Jerusalem, an order active from 1099, were traditionally given a silk cloak after a tour of duty. King John of England, who died just one year after the Kublai Khan's birth but a world away, shared the Mongol ruler's legendary appetite for silk. An inventory taken in 1216 of Corfe Castle in Dorset, his favorite residence, found no fewer than 185 silk shirts.

James I (1566–1625), who ruled England centuries later, was similarly afflicted. So much so, in fact, that he made a concerted but ill-fated attempt to establish the production of silk in his kingdom. He offered 10,000 subsidized mulberry trees to his subjects so that the insects would have sufficient food and employed a couple at an estate southeast of London to make "Greenwich Silk" for an annual stipend of sixty pounds. He also appointed a special governor of the chamber, whose duties included carrying a couple of the wriggling insects "withsoever his majesty went." Consignments of silkworms and mulberry saplings were sent by His Majesty to the settlement named after him in the New World—Jamestown, Virginia—in the hopes of establishing a silk industry in Britain's colonies. The experiments continued for some years with little success. A miserable 249 pounds of silk was all that was reaped from Virginia between 1731 and 1755. And although some English silk was made—Queen Anne of Denmark wore an English silk taffeta gown on James I's birthday one year—the experiment was eventually quietly abandoned.²⁷

Silk also made its way to early medieval Scandinavia. Chinese silks have been found in graves in Sweden, Denmark, Finland, and Norway; fabrics from Byzantium and Persia have also been found in Viking graves. Perhaps the most prestigious silks found in Scandinavia, however, were in the Oseberg ship. Buried as part of a grave mound for two women in AD 834, when it was unearthed in 1904 in Vestfold, Norway, this vessel was found to contain over a hundred scraps of silken fabric.²⁸

The majority were samite, a rich fabric interwoven with gold and silver, that had been cut into narrow strips and sewn onto garment hems as decoration. A dozen pieces of embroidery—likely made with imported thread—were also found, along with some locally produced textiles woven with both wool and silk. Most were woven using a sophisticated technique that requires a special loom native to Central Asia. On at least one of the pieces was a motif known as the *shahnokh*—literally "king-bird"—a hawklike creature gripping a pearl tiara in its beak that in Persian mythology represents royal blessing. Other symbols include deadly-looking cloverleaf axes and a Zoroastrian symbol taken from the zodiac. The Oseberg find was the oldest known cache of Viking-age silk in Norway, and it was initially assumed that the silk had been looted from Britain or Ireland on a raid. Since then, however, more silk of a similar age has been found, making it more likely that silk was being traded directly into Scandinavia.²⁹

Immodest Apparel

Petronius, Satyricon, first century AD

During the late first century AD, Roman society became infamous for its excess. It was during this period that Petronius, a courtier to the Emperor Nero, wrote *Satyricon*, an angry satire that had at its heart the nadir of vulgar, ostentatious dinner parties. Trimalchio, an extravagantly nouveau riche former slave, tries in vain to impress his highborn guests with one showy excess after another.³⁰ His servants sing instead of speaking; they serve honeyed dormice sprinkled with poppy seeds, dishes that represent each sign of the zodiac, and a roast pig stuffed with live birds. Guests' hands are washed with wine; an accidentally dropped silver dish is casually thrown away; and Trimalchio finally directs his entire household to act out a dry run of his funeral. The entire household is dressed in extravagant silks.³¹

At the time *Satyricon* was written, wealth was flowing into Rome from foreign conquests—most notably Egypt, after the defeat of Cleopatra at the Battle of Actium in 31 BC. Interest rates fell from 12 percent to 4 percent, meaning that suddenly even ordinary citizens were able to indulge their tastes for exotic goods. Although full of bawdy wit, *Satyricon* is near anthropological in its skewering of the over-the-top fashions Roman citizens were suddenly obsessed with. One particular affectation, to the author's eye, was silk.

It came to the empire along the Silk Roads in exchange for grain

91

from Egypt, gold from Spain, topaz from the Red Sea, coral, glass, wine, and wool. We do not know when precisely it arrived. Dio Cassius claims that Romans first saw high-quality silk at the battle of Carrhae in 53 BC, when the Parthians unfurled their snapping banners. (If this is true then it wasn't the most felicitous introduction as the Romans were promptly defeated.) To the Roman mind, China was firmly associated with this one product: the Latin name for China is "Serica," silk is "sericum." Since they were so far away, however, and were likely hearing about sericulture through a very long-distance version of Chinese whispers, it isn't surprising that their understanding of silk production was initially rather eccentric. Pliny mentions a "woollen substance" obtained from the trees in Chinese forests in one section of his Natural History, but in the chapter on insects he seems better informed. Silkworms, he writes here, "weave webs similar to those of the spider, the material of which is used for making the more costly and luxurious garment of females "32

Nor was it just ordinary citizens putting silk to use. Desorative textiles were employed to add drama and color to public buildings. When Julius Caesar paid for silk awnings to be hung throughout Rome to provide shade for all the spectators at his military triumph, it was seen as a clear statement of not just his wealth but his intention to seize power. Emperor Nero is said to have hung star-spangled blue awnings over amphitheaters and commissioned a textile—likely also made from silk—that was dyed purple and decorated with an image of him standing in a chariot, the Roman equivalent of commissioning a portrait of yourself driving a sportscar.³³

Murals at Herculaneum and Pompeii—most famously those in the blood-red room at the Villa of Mysteries—show elite women wearing translucent fabrics that look very much like fine, loosely woven silk. The fabric even reached Roman Britain. Near Hadrian's Wall there is an inscription commemorating a merchant from Palmyra who apparently supplied silk banners to the legions stationed nearby.

Despite this reach it retained its glamour, which, coupled with exorbitant prices, gave ostentatious Romans of the sort that Petronius skewers so precisely in *Satyricon* ample opportunity for showing off. Martial, the satirical poet, offered the gift of a gold hairpin with one of his verses. "Insert a pin to hold up your twisted hair so that your moistened locks may not damage your bright silks."³⁴

There was, naturally enough, a backlash. Contemporaries bemoaned the huge sums being spent on this foreign fabric. According to Pliny the Elder, each year emperors spent about 100 million sesterces (100,000 ounces of gold) buying silks from the East. This was a huge amount, roughly equivalent to 10 percent of the annual budget. And it wasn't just the emperors, he complained, but ordinary people and—this last with particular venom—vain women. All this money was being spent purely to "enable the Roman lady to shimmer in public." Such vast sums would be far better spent, according to him, on worthier and, preferably, Roman goods. Pliny of course ignored the fact that trade was flowing both ways.³⁵

Silk was also regarded as decadent. The poet Horace, who died in 8 BC when silk was still probably relatively novel, described prostitutes as early adopters. ("Through the Coan silk it is as easy for you to see as if she were naked, whether she has an unshapely leg, whether her foot is ugly; her waist you can examine with your eyes.") If this was the case, then perhaps it goes some way to explaining the fuss made by more conservative commentators when silks were taken up by other Roman women. "I see silk clothing," Seneca fumed, "but how can this be called clothing when it offers nothing that could possibly afford protection to the body or provide any modesty ... Silk is imported so that our married women can show as much of their bodies to people in the street as they display to their lovers in the bedroom."³⁶

Women wearing silks was bad enough, but the deepest opprobrium was reserved for men who did the same. A decree was passed—"*Ne* vestis serica viros foedaret"—that forbade men from wearing silk. This was one of a raft of measures against unmanly conspicuous consumption: the use of gold plate for private banquets, for example, was also prohibited. Scorn is heaped upon the fictional Trimalchio for his love of silk dyed a deep purple at Tyre with molluscs: the priciest fabric of the ancient world. According to Suetonius, admittedly a scurrilous gossip, Emperor Caligula (AD 12–41) liked to appear in public in bracelets, silken tunics, embroidered cloaks encrusted with jewels, "and at times in the low shoes which are used by females."

Conservative Romans were worried that such luxurious garb would blunt the martial spirit that had won them their empire and wealth in the first place (an echo of the hope that the Chinese harbored that their silks would blunt the threat posed by the Xiongnu forces). Such fears roil through a passage from Pliny:

Now even men will wear silk clothing in the summer because of its lightness and they do not feel ashamed. Once we used to wear leather cuirasses, but our fashions have become so bizarre that even a toga is now considered to be unnecessarily heavy. Yet we have left Assyrian silk dresses to the women—thus far.³⁷

The Romans were not the only ones who saw seeds of destruction in the luxuries that ran through the Silk Roads. In 1900, when Aurel Stein began searching the Gobi Desert for the lost city of Dandan-Uilig, a local warned him against the endeavor. The city was still there, the man told Stein, and it was indeed filled with treasure gold and silver lay thick among the sand smoothed stones. The problem was the spell that had been cast over it all. Over the centuries, many had traveled there with caravans hoping to carry away fortunes. One by one they loaded up as much as they could, so that their mules and camels groaned under the strain, but as each set off they found that they were unable to leave. Every attempt to strike out into the desert led the caravans back to the dead orchards and tumbled walls of Dandan-Uiliq, until at last men and beast collapsed in exhaustion. The only way to escape the curse, according to this tale, was to unload every gem and ingot, leaving the city as empty-handed as they had arrived.38

Surf Dragons

The Vikings' Woolen Sails

5

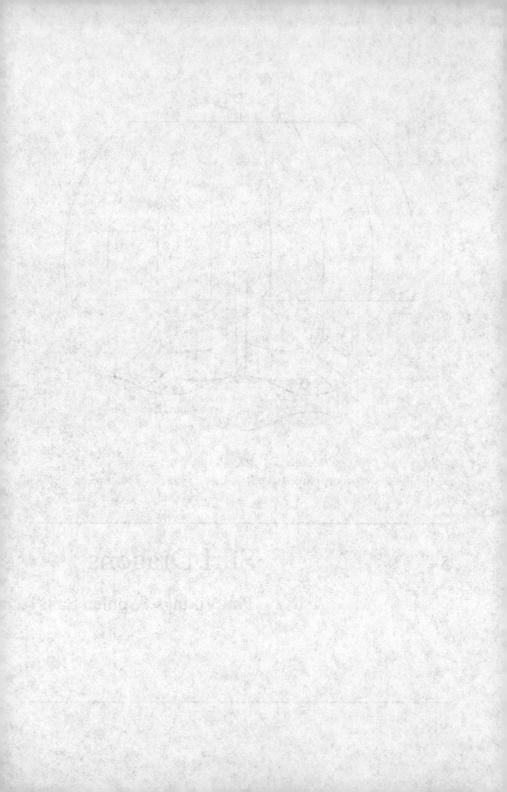

The King's Mound

My mother once told me She'd buy me a longship, A handsome-oared vessel To go sailing with Vikings: To stand at the stern-post And steer a fine warship Then head back for harbour And hew down some foemen. Egil's Saga'

Sometime during the autumn of 1879, two teenage boys finally gave in to temptation. They had lived their entire lives on their father's farm in Sandefjord, a quiet coastal region 62 miles south of Oslo in Norway, and every inch of it was familiar to them. But an area in one of the fields had long piqued their interest. The *Kongshaugen*, or King's Mound, as it was known locally, was an area of raised ground, or tumulus, around 148 feet in diameter and, by then, some sixteen feet high. (It had likely been worn down by centurics of ploughing.) The King's Mound, according to legend, contained treasure—or at least had at one time. The boys collected a couple of shovels and started to dig.²

The mound was indeed filled with treasure, although not the kind that they expected. Buried under layers of loamy soil were the thick oaken planks of a large and exceedingly old ship. After word of their discovery reached the University of Oslo, antiquarians swooped in and took over the excavation site. What they uncovered, after painstakingly brushing away the ship's earthen shroud, were the wellpreserved remains of an enormous Viking longship.

The Gokstad ship had been built around AD 850 and, after some

ten or fifteen years at sea, it had been hauled ashore to play a central role in a lavish funeral. A burial chamber, clad in birch bark, had been built inside it. A bed contained the body of a tall, powerfully built man of middle age, who—despite suffering from either arthritis or gout—had died a violent death, likely in battle. Some of his bones and many of the treasures that had been piled around his body had been looted long before by grave robbers (who seem to have known precisely what they were looking for: a hole had been bored through the side of the mound directly into the burial chamber). They left behind the bones of twelve horses, six dogs, and a peacock that had been laid around the body.³

In normal circumstances, the structure of the boat would have been consumed by decay centuries ago. The secret to the Gokstad ship's longevity was the substance used to cover it. Once the royal occupant and his possessions had been interred, a thick layer of blue clay was plastered over it like marzipan on fruit cake, acting as a powerful preservative. The ship, now on show at the Viking Ship Museum in Oslo, is just over 76 feet long, 17 feet wide, and about six feet deep from the gunwale amidships to the bottom of the keel.⁴

She has been called the most beautiful ship ever built, and she is indeed quite something to look at: lithe, almost sculptural. Over the course of the centuries spent under the earth, the sweeping lines of the wooden planks have darkened, so that they now appear almost charred. They are also surprisingly thin, making the ship light and flexible—not usually a desirable quality in a boat, but apparently intentional. The hull weighs just seven tons. Each flank is pieced with sixteen oar holes—suggesting a muscle-bound crew of thirty-two—but she also originally had a stout pine mast to help propel her across the waves. Inside the Gokstad shreds of white and red double-thickness cloth were found: the ghostly remains of a woolen sail.⁵

Ships were integral to the Viking way of life. One expression of their importance was their use in death rites. Many ships were buried; it was perhaps believed that they would bear their inhabitants to the afterlife. Borre, to the west of Oslo Fjord, but still within sight of the sea, is now home to seven mounds and a cairn; in antiquity there were many more. Other ships were used as funeral pyres. Ibn Fadlan, a tenth-century traveler fascinated by the Volga Vikings—he called them "perfect physical specimens, tall as date palms, blond and ruddy"—left an intense description of a cremation ceremony in *Risala*, an account of his wanderings. Once the body of the dead man was sequestered in the ship's belly, one of his slave girls was summoned and, in a gruesome ritual only half understood by Fadlan, raped by his attendants and stabbed to death before being laid by her master's side. This being done, the whole blood-soaked vessel was set aflame. "[T]he fire took hold of the pyre, then of the ship, then of the tent and of the man and of the girl and of all that was in the ship."⁶

Ships took pride of place in Icelandic sagas too. They were given evocative, animalistic monikers: "oar-steed," "surf-dragon," "fjordelk," "occan-striding bison," and "horse of the lobster's hearth"; a flotilla was sometimes a fleet of the otter's world. They were objects of pride and power. According to legend, an enormous vessel was built for King Ólaf in 998: *Long Serpent* could carry two hundred armed men and had room for thirty-four pairs of oarsmen. Other sagas talk of ships with seventy-foot masts. A century or so ago such tales were scoffed at; now that ships have been found by archaeologists measuring about 130 feet from bow to stern, this seems less preposterous.⁷

The queen of all the Viking ships, however, never existed. *Skithblathnir* was, according to Norse mythology, built by dwarves for the god Frey. Of course, she was also magical: large enough to carry the entire Norse pantheon with all their weapons, she had been so cunningly wrought that when not in use Frey could fold her up like a fine piece of cloth to be carried in a pocket. *Skithblathnir*'s greatest attribute, however, was her sails. No matter when and where the ship lay when the sails were hoisted, a strong, powerful wind sprang up ready to take her precisely where she needed to go. Art was imitating life, here: while there are many aspects of Viking longships that make enthusiasts go weak at the knees, it was the sails that lent these ships their power and their reach.⁸

Violent, daring raids on defenseless towns and monasteries have become a leitmotif of stories told about the Vikings. Certainly, they used their prowess as seamen to outmaneuver and surprise their enemies. Longboats, which sat high up in the water, didn't need harbors and could be beached almost anywhere, making many more places vulnerable to attack. But Vikings were also traders, nosing their longboats up rivers to reach important trading ports around Europe and into the Black Sea, and played an active role in the western fringes of the Silk Roads. Bustling back and forth between trading posts, their ships weighed down with ivory from walrus tusks, amber, falcons, human slaves, or furs from the far north—marten, beaver, and winter squirrel were especially prized in continental Europe. Numerous silken textiles have been found in Scandinavian graves that were woven as far afield as China and Persia. In fact, there is evidence that Arabic patterns and text—or even designs that appeared Islamic in origin—were popular status symbols.⁹

Using ships packed with preserved food, such as pickled herring, lamb smoked over reindeer droppings, and fermented salmon, Norse people were able to travel vast distances. These boats weren't always sailing vessels. Ancient Scandinavian people used dugouts or skin boats, and rowed warships allowed the Angles to reach England in the fifth century. Nevertheless, the sail allowed the Vikings to get farther and travel faster, laying open much more of the world. Because of their skill as boatbuilders and sailors, waterways became roadways rather than obstacles. They settled new lands, and invigorated cultures by importing new art forms and customs. Vikings populated Iceland and Greenland. The number of people living on the former jumped from zero to seventy thousand over just sixty years, as boatloads of people arrived seeking better lives. They conquered Normandy and parts of Italy, and also reached Ireland, England, Fair Isle, Shetland, the Black Sea, even America.¹⁰

Archaeologists are best known for using tools such as brushes, trowels, and buckets. Sarah Parcak has another, rather unconventional piece of equipment in her armory: satellites. Using imagery taken from cameras 383 miles above the earth's surface, she searches for irregularities in the soil and in the growth of vegetation: tantalizing evidence of structures that once stood there. Using this technique, she has been able to pinpoint previously undiscovered and undisturbed cultural sites in Egypt, Peru, and the old Roman Empire, even identifying the site of an ancient lighthouse near Rome. In 2016, however, she trained her satellite's lenses a little closer to home.

Most of what we know about the Viking journey to America and their time there comes from the Icelandic sagas. As sources, these aren't ideal. They tend to emphasise things that made the Norsemen or even the individual poets and families that told them—look particularly brave and daring. Lavish descriptions are given to battles and heroic deaths; the work of women is all but invisible. Two sagas mention Vinland, a place west of Greenland with excellent hunting, plentiful timber for boatbuilding, well-stocked rivers, and juicy, laden vines—hence the name. This paradise, in fact, only had one metaphorical serpent. The *skraelings*, or "wretched people" as the Vikings called them, were the land's original inhabitants, and they bitterly resented the incursions of the newcomers, shooting at them with bows and arrows. So violent did their attacks become that after just a few years the new colony was abandoned entirely and, according to the sagas, the Norsemen sailed home.

Suspicions that Vinland was, in fact, America, were rife in the nineteenth century. In 1893, an exact replica of the newly unearthed Gokstad—christened *Viking* to hammer home the point—was made by a shipbullder determined to prove that a journey from Norway to America by longboat was possible. Captained by Magnus Andersen, the *Viking* set off westward from Bergen on Sunday, April 30, with a dozen men, thirty tons of cargo, and a thousand bottles of beer. They reached Newfoundland on May 27, and were greeted by curious crowds and a punch toast in New London on June 14. It had been a hair-raising and stormy voyage, but it nevertheless seemed to confirm that the long-speculated journey from the land of the Vikings to America in a longboat was at least possible. "In a strong head-sea the keel could move up and down as much as three quarters of an inch," Andersen later wrote, "but strangely enough the ship stayed completely watertight."¹¹

More definitive proof that the Vikings really did reach America has followed. In 1960 a pair of archaeologists found the remnants of a Viking settlement at L'Anse aux Meadows in Newfoundland that dated back to AD 1000. A copper coin, discovered in Maine, had been struck in Scandinavia sometime between 1065 and 1080 during the reign of King Olaf III.

Using her satellite technology, Sarah Parcak has been searching for other potential Viking outposts in the New World. One promising location was Point Rosee in Canada, a windswept and seemingly inhospitable peninsula stretching out into the Gulf of St. Lawrence in Newfoundland, 400 miles southwest of L'Anse aux Meadows. Parcak zeroed in on this area because of odd areas of discoloration in the images that appeared to show the outline of a previously unnoticed man-made structure. When she and her team began digging in 2016, immediately they almost found what appeared to be a hearth. Although it didn't look like much more than a blackened rock, further digging showed that it may have been used to roast iron ore: and twenty-eight pounds of slag were found in a nearby pit.¹²

Point Rosee may not be another Viking settlement in North America—research is ongoing but so far no conclusive evidence has been found. One thing that is no longer in doubt, however, is that the Viking mastery of ships and sails enabled them to reach America 500 years before Christopher Columbus.

Ship-Shape

The high wind out on the fjords scraped the windblown sail in the difficult conditions.

Sigvatr the Skald, eleventh century

During the mid-eighteenth century, Captain James Cook traveled around the globe, visiting Pacific Islands nations that had previously been unknown and invisible to the western world. Cook owed a great

103

deal of his success on this leg of his journey to a Polynesian man he met along the way. Tupaia was a leader from Raitea who joined Cook's crew and soon became indispensable, helping to mediate between the western sailors and the islanders whom they encountered. One of the most incredible things he did, however, was to draw a map from memory that showed nothing less than the entirety of his known world. Although it was far from perfect-and it certainly didn't help that the English officers helping him kept on mixing up the Tahitian words for north and south-Tupaia's map showed almost every major island group in Polynesia and Fiji. Its range, in fact, extended some 2,600 miles, well over the width of the United States, and contained a wealth of information essential to navigation: currents, weather, swells, and winds. More incredible still, the area Tupaia was able to depict far exceeded the voyaging range, at that time, of his people. In reality, Tupaia's map was not his: it was a distillation of knowledge accumulated over many generations and gained during countless long and dangerous sea voyages that had long since ended.

History is full of miraculous journeys accomplished thanks to lengths of fabric fashioned into sails and the boats bobbing beneath them. Over the past 50,000 years, man has used them to reach even the most isolated islands scattered like lost beads over the world's surface. It is believed that the relatively short journeys—island hopping—normal during the Late Pleistocene age gave way nearly twelve thousand years ago to longer, more ambitious journeys. The remotest islands were colonized by humans only during the last millennium.¹³

How exactly this happened, however, and what the crafts used by the earliest seafarers looked like, is often unknowable. In the absence of evidence, attempts have been made to recreate these exploits. The most famous example is that of the Kon-Tiki expedition. On April 27, 1947, the Norwegian writer and explorer Thor Heyerdahl hoisted sail on a crude raft made of balsa logs and set off from Lima headed for French Polynesia. His aim was to test a theory that the Polynesian islands had been settled by people from South America rather than Asia. Although he was able to make the journey—it took 101 days, during which he passed the time catching sharks—and the raft held together, his theory has now largely been debunked.¹⁴ Others have used linguistic clues to make inferences about these earliest journeys. When Captain Cook visited the Pacific he speculated that many of the Polynesian islands he visited were colonized by the same wave of peoples, because of the similarities in their languages. More intriguingly still, the words for "mast," "sail," and "outrigger boom" appear to be the oldest in the Austronesian spoken in the most isolated Philippine and Indonesian archipelagos, further suggesting that it was the technology of sailing boats that spread humanity over some of the remotest stretches of the globe.¹⁵

Neither the boats nor the sails we are familiar with today sprang fully formed from a single mind: they are the products of millennia of wisdom and experience, slowly accreted, like coral reefs or indeed Tupaia's map. The earliest boats were likely made from bundles of reeds, and their sails animal skins drawn over a framework of sticks, or hollowed-out logs. The oldest known vessel is the nine-foot-long Pesse canoe, thought to have been hewn from a scots pine log ten thousand years old in what is now the Netherlands. Such simple craft, however, would have been unable to cope long with the sea conditions. Longer, rougher journeys required better boats that were more stable and able to hold together when lashed by waves and wind.¹⁶

Sails were a separate innovation. Their function is to harness the wind to drive a craft over water. But from such a simple premise, a million possibilities bloom. Indeed, the flock of historical sails is so densely populated it requires an entire language to describe it. They come in myriad sizes and shapes—claw, square, and lateen—some of which are unique to a particular class of ship, such as the traditional Indonesian *pinisi* or the latest monohull racing Moth.

Modern sails are usually made of synthetic fabrics such as Dacron, nylon, or Kevlar. However, the sails used to make all the near-miraculous voyages up until the invention of the steamship in the nineteenth century, and many more since then, were woven from natural fibers: linen, cotton, hemp, and wool. Without the production of fabrics to make sailcloth, daring voyages from Zheng He's fifteenth-century expeditions around Southeast Asia to Roald Amundsen's conquest of the Northwest Passage would have been impossible.

105

For a long time, Egypt seemed the most likely birthing place for sails. Ancient Egyptian civilization clustered around the Nile, a river that flows from south to north while the prevailing wind usually blows in the opposite direction. This means that while it was possible to drift down the Nile, sailing back up it would have been advantageous. It was speculated that the notion of using a square of linen came from the practice of hoisting ceremonial shields in the center of boats, a practice depicted in antiquity. These would have caught the wind and helped to move the boat against the flow of the water. Corroborating evidence for such a theory comes in the form of hieroglyphs. One meaning "sail upstream" shows a boat with a sail; the one meaning "head downstream" shows a craft with a steering oar but no sail.¹⁷

Newer findings, however, seem to have eclipsed this neat theory. Mesopotamian pottery dating from the sixth and fifth millennia BC has been unearthed in many sites in east Saudi Arabia, Bahrain, and Qatar, usually along the coast. For years archaeologists have seen this as a tantalizing indication of travel by sea, but direct evidence was lacking. Until, that is, As-Sabiyah, an archaeological site on what was once a sheltered Gulf bay, yielded barnacle encrusted fragments believed to come from a reed-bundle boat, a ceramic model of a similar boat, and a painted ceramic disc, 2.75 inches in diameter, depicting a vessel with a bi-pod mast: the earliest known evidence for the use of a mast and sail in the world.¹⁸

Although the classic longboat of popular imagination always has a sail, they were a rather late addition to Scandinavian ships. Tacitus, who lived in the first century, mentioned the unusual Norse boats in *Germania*. "The form of their vessels varies thus far from ours, that they have prows at each end, so as to be always ready to row to shore without turning *nor are they moved by sails*, nor on their sides have benches of oars places, but the rowers ply here and there." [Emphasis added.] It wasn't until some centuries later that sails were finally adopted, likely because they made it easier to propel larger cargoes of goods and men from one port to another, something that the Vikings—as traders or raiders and certainly as colonizers—increasingly found pivotal to their way of life. The Gotland picture stones, found in Sweden, show rowing boats in the sixth century, and simple craft with masts and square sails from the seventh, often with plaited or chequered patterns, techniques that may have been decorative but which some hypothesize made the sails stronger. Elaborate sailing ships are shown by the eleventh century.¹⁹

As is the case with many late adopters, the Norsemen proved to be zealous converts. This was natural enough: sails dramatically expanded their horizons, allowing them to travel farther, with larger loads, and giving them a crucial edge against their rivals. By the time of King Canute's North Sea Empire during the first half of the eleventh century, the fleet—encompassing everything from the grandest warship to the humblest fishing vessel—would have required around one million square miles of sailcloth. The majority of this would have been made from wool.²⁰

From Flock to Fleet

And then, by the mast, a certain sea-raiment—the sail!—was made fast by a rope; the sea-timber groaned, the wind did not hinder that buoyant craft in her journey over the waves—the sea-goer fared. Beowulf, c. AD 975-1025

> During the late autumn of 1989 the small church in Trondenes, a small parish on a ragged spit of land in northern Norway, was finally renovated. It was long overdue. White, with a steep-sided red roof, the church crouches right at the water's edge; it has the distinction of being the northernmost medieval stone church in the country. As the workmen repaired the roof, they found odd wads and pads stuffed

between the wooden boards in the roof and in gaps in the masonry. These proved to be pieces of cloth so old and dirty and stiff that they resembled strips of leather. Upon closer examination, however, it was discovered that the scraps that had been used to fill the gaps in the roof were pieces of *wadmal*—coarse woolen cloth—that had once served a very different purpose. Several hundred years earlier this cloth had been made to catch and hold the wind as a sail on a Norse ship.

Wool doesn't seem an obvious material from which to fashion sails. Its natural warmth—the quality for which it has traditionally been prized—isn't of use in this instance. Indeed, part of what gives wool its warmth are the crimps that occur in the individual fibers, which help to trap insulating pockets of air when woven together. But the crimps also mean that woolen fabric is full of tiny holes through which air can escape: not ideal when trying to harness the wind. And, as anyone who has ever washed a woolen sweater can attest, it will absorb a lot of water, becoming very heavy, and takes a long time to dry. Given such disadvantages, it seems amazing that anyone ever thought of using wool to make sails. And yet not only were such sails standard issue for longboats, but they were also used by the Vikings when they traded goods across Europe and, most likely, made the long voyage to and from America.

It might be tempting to believe that the moment alternatives were readily available, wool would have been abandoned. Quite the contrary, as it turns out. Square woolen sails were still being made in Scandinavia and in the Faroe Islands into the twentieth century.

That the Trondenes scraps of fabric survived to be studied is something of a miracle. Woolen sails were worn out and then disposed of, so without the Trondenes pieces, the archaeological record for Viking sails would be scanty indeed. And, although they don't look like much now, they have provided shoals of researchers rich insights into the making and performance of Norse vessels. We know from what kind of sheep the wool originated, and how it was processed, woven, and stitched together. We can answer many questions about how well such sails performed in practice, and what the sensory experience of sailing beneath them might have been. One shred that had been wadded up in the church roof even proved, when smoothed out, to contain a perfectly preserved eyelet through which a rope would once have run, carefully sewn by unknown hands sometime between 1280 and 1420.

The story of how the Viking sails were made begins—as tales about woolen things usually do—with sheep. The islands that lie between Norway, Scotland, and Iceland have been known for their sheep and for the quality of their knitters for hundreds of years. Fair Islanders, for example, have been bartering woolens with passing seamen since the 1600s, and even fulfilled a special order of 100 sweaters for a 1902 Antarctic expedition.²¹

Although most of the people buying Fair Isle sweaters today don't know it, the breed of sheep from which this bounty originates are unusual. "Primitive" sheep are smaller and provide a good deal less wool (and meat) than their burly, modern rivals such as the Romney and Merino that produce the wool used in most clothing and furnishings today. But what these North Atlantic sheep lack in heft, they more than make up for in hardiness and stubborn adaptability. They can, for the most part, fend for themselves, without the cosseting their modern kin require. They can also survive, even thrive, on a very rough diet. Those native to North Ronaldsay, the northernmost of the Orkney Islands, have adapted to eat seaweed almost exclusively, picking their way over the slippery rocks near the seashore and shunning lusher, greener fare.²²

These hardier sheep would have been approved of by Vikings, whose Old Norse, short-tailed breeds they resemble. Viking sheep too would have been around the size of a large dog—half the size of more popular modern breeds—grazed on rough heather moorland, rather than grassy pasture, and would have lived semi-wild, only coming into close contact with their owners once or twice a year. Most flocks were likely small, perhaps around a dozen animals, kept by smallholders who also farmed or fished. (This was certainly the case in 1657, when a tax list was drawn up that included all the sheep in Norway, some 329,000.) Their wool is crucially different too. Not only did their coats come in a variety of colors—black and brown as well as white—but their fleeces were made up of two layers, a wiry outer one covering a soft, highly insulating underwool. This isn't common in the most widely farmed sheep today. Another oddity of the wool of the Old Norse sheep was its high lanolin content, which makes it more water-repellent: an excellent quality for making sails.²³

Because of the small scale of sheep farming, procuring sufficient quantities to supply a large vessel with sails would have required sustained and coordinated efforts from several households. Doublecoated sheep shed their wool naturally in the late spring and summer when the weather warms up. The flocks would have been rounded up around midsummer and the loose wool pulled-or rooed-by hand. This is hard work. At the Fosen Folk High School in Rissa. where traditional skills are still taught, it takes four or five people ten minutes or so to pull away all the loose hanks of wool from a single sheep. While more time-consuming than shearing, rooing has its advantages. Plucked wool is more water-resistant, and less cardingor combing-needs to be done to get rid of the short, new-growth woolen fibers that shearing includes. The wool would have been sorted as it was gathered. The finest wool comes from a sliceu's neck-this would be reserved for luxurious shawls-while wool from the thighs is best for hard-wearing mittens or socks. Especially prized is the wool from unmated three-year-old sheep, said to be especially tough and thick. Once the rooing and sorting were complete, the wool would be twisted into hanks and stored in animal-hide bags cured with fish oil until later in the year.24

The bulk of the real work would be conducted during the autumn and winter months, when the days are short and time is best spent indoors and out of the cold. First, the entire family would likely have gathered to tease out the long outer fleece from the softer underwool. (This was of particular importance when sail-making.) The latter would then have been sprinkled with fish oil and set aside, so that the oil would have time to penetrate the fibers, making them softer still.

Next came the work that was predominantly done by women: spinning, weaving, and finishing. The long coarse fibers would be combed out and, using a drop spindle, spun tightly clockwise to create very strong yarns. These would be used for the warp, which needed to be waterproof and withstand the tensile stress and strain of the wind. The underwool was given gentler treatment and loosely spun counterclockwise. This softer, looser thread would be used for the weft: when fulled—a process by which the fibers are rubbed so that they begin to clump together—the soft fibers would then create a denser and more windproof surface. Making these two kinds of thread required skill and a good deal of time. Someone with particular expertise can produce between thirty and fifty meters of yarn each hour using a spindle and distaff. Even so, a large sail of ninety meters square or so represents the labor of around two and a half modern working years.²⁵

When it came to weaving, there was a good deal of local variation. The looms used were likely simple, warp-weighted ones and while most sailcloth was some variation of a twill—which makes the finished fabric look as if it has diagonal lines going through it—sail-makers from Iceland favored a two/two twill, while those from Sweden and Denmark used a two/one or *tuskept* variant during the Viking era.²⁶

The weight of the cloth varied according to the size of the intended sail. For one of around a hundred meters square, a heavy cloth would be woven; smaller boats would require something far lighter.²⁷ It was time-consuming work: a single meter of sailcloth would take around twenty hours to weave. The cloth was then fulled, which stabilized its size: something that is important if making a piece of cloth that will be used in wet, windy conditions. Fulling was sometimes done using special felting boards; or the cloth would simply be placed just within the tideline and weighted down with stones, letting the ebb and flow of the water do the job. The fulled cloth would then be stretched and dried and, because the looms were usually far narrower than the sails needed to be, several pieces of cloth-known as webs-would be sewn together into the final iconic square shape. (Although here too there was regional variety: on the Faroe Islands looms were able to weave cloth lengths of about five yards, enough to make a Faroese square sail.)28

The finishing touch was a two-stage process known as *smörring*. First the fabric would be brushed with a mixture of water, horse fat or fish oil, and ocher, a naturally occurring reddish earth. When this had dried, hot liquid beef tallow or fir tar would be smoothed into the sail. The greasing helped smooth out differences between individual webs, so that the air would flow easily over the joins, while the particles of ocher plugged the gaps between the woolen fibers. Modern tests on cloth made to the Vikings' exacting standards show that while fulled but untreated fabric has around 30 percent less air permeability than its un-fulled equivalent, the finished, *smörred* cloth had an airflow close to zero, dramatically increasing its effectiveness as a sail. So well were these sails crafted that, if maintained correctly, they might be expected to last forty or fifty years.

Making the textiles, and particularly the technically challenging sails, would have required more effort than making the ship itself. While it has been estimated that it would take two skilled shipwrights a fortnight to make a longboat, creating a sail would take two equally skilled women a full year or more, depending on the size required.²⁹

Although we cannot be sure exactly what the Trondenes builders were thinking when they caught up the old woolen sail when plugging the gaps in their roof, we do know why it was there in the first place. Just as the making of sails was a communal affair, so too was their maintenance. In 1309 King Håkon V passed a law that made different regions responsible for maintaining and equipping one ship for use in times of war. According to this law, "the sail and other equipment used in the protection of the country shall be kept in the church in keeping with ancient tradition." The picture this gives is of small communities working together to outfit a ship and local sailors. This also explains why there was a wealth of regional variety in sailcloth and, perhaps, why the work was done so well: clothes and sails made at home on winter evenings would likely come to be used by brothers, sons, husbands, and fathers.³⁰

Recent attempts at experimental archaeology—building and making ships to Viking specifications using clues gleaned from the Trondenes scraps—have given fascinating insights into what it might actually have been like sailing in a ship powered by wool. For one thing, it was assumed that the square sails usual for Viking longboats would be inefficient, only allowing boats to sail downwind. This is not the case. Faithful recreations have been able to operate at around fifty degrees into the wind, some five degrees off what would be expected from a modern sailing ship.³¹

Sail Away

A furore normanorum, libera nos, O Domine. From the Norsemen's fury, deliver us, Oh Lord. European prayer, ninth and tenth centuries

In July AD 793 disaster struck a Northumbrian monastery in the northeast of England. "And they came to the church of Lindisfarne," a chronicler wrote afterward, "laid everything to waste with grievous plundering, trampled the holy places with polluted feet, dug up the altars and seized all the treasures of the holy church." Even the holy brothers themselves were not inviolate: some were killed, others drowned in the sea or taken away in fetters, presumably bound for a life of slavery. The villains of the piece, of course, were Viking raiders. And the shock of their attack on Lindisfarne reverberated throughout Christendom. Alcuin of York, an English scholar, wrote outraged letters to all the powerful people he could think of. "Never before," he thundered in his missive to King Æthelred, "has such terror appeared in Britain, as we have now suffered from a pagan race."³²

Christian Europe was to suffer many more such affronts in the coming years and panic quickly spread. What made these attacks all the more galling was that up until then the sea had been seen as a protective barrier rather than a means of transportation. Alcuin hinted at precisely this in his letter to Æthelred: "nor was it thought that such an inroad from the sea could be made." So unshakeable had this belief been that many religious houses had, like Lindisfarne, been built on rather desolate spits of land with the sea lapping close by on all sides. But these made perfect locations for Viking raiders, whose longboats didn't need deep harbors and who, if the fight turned against them (although presumably it rarely did), could make fast getaways. More attacks followed. The next year, religious houses at Wearmouth and Jarrow, where Bede the Venerable had once lived, were raided. The monastery on the island of Iona was attacked the year after that, and then again in 802 and 806, so that it was almost utterly despoiled. At Portmohomac in Scotland—now a small fishing village but then the home of a prosperous religious community excavations have revealed evidence of another violent assault. As well as a layer of sooty ashes and fragments of smashed sculptures, a piece of skull was discovered that bears a deep cleft likely made by the blade of a sword. Although we cannot know for sure, it is a fair guess that the arm wielding the sword belonged to a Norseman.³³

It is odd, bearing in mind the angular fierceness of the Viking image, to remember how crucial soft woolen yarns were to their way of life. Without them, in fact, Vikings would have been quite different. Ships and sailor warriors may have been the ones romanticized and celebrated in poetry to this day, but woolen cloth—and those who made it—underpinned their success. Well into the twentieth century, Norwegian seamen headed out for three months' sailing would take three changes of underwear, a shirt, five pairs of sea mittens, two pairs of ordinary mittens, and similar numbers of leggings and stockings, mostly made using a kind of crochet or single-needle knitting technique known as *nâlebinding*. All of these garments were traditionally made of wool and needed frequent darning and replenishing. Especially lucky sailors—those who could afford it—might also have a luxuriantly thick sailors' blanket called a *sjørya*, each one of which demanded the wool of seventeen sheep.

Many explanations have been proffered as to why the Vikings exploded out of their home nation to explore the world. Some have suggested that an expansion in the production of iron allowed better tools to be made. Others have pointed to a rising population, growth in international trade, and even a period of global warming resulting in better harvests. Another theory centers on wool itself. As the Vikings began to travel and trade more, their need for wool would have increased correspondingly. More boats meant more sails and sailors' clothing: more textiles, more sheep, and land to pasture them on. In fact, the spiraling need for land, sheep, and wool is argued by some, including textile historian Lise Bender Jørgensen, to be at least partially responsible for their aggressive expansion into new lands such as Normandy, Greenland, and, indeed, America.³⁴

Outfitting an ordinary Viking cargo ship and its crew, including sailcloth, sailors' clothing, and bedding, is estimated to have required over 114 pounds of wool and the equivalent of ten years' labor. For a particularly large warship with a crew of perhaps seventy men, the figures are monstrous: one and a half tons of wool and up to sixty years' labor. The production of such immense quantities of fabric represents a huge investment by a large community of people, the majority of them women. Given that the annual yield of one Old Norse sheep is only between 2 and 5 pounds, with only perhaps 18 ounces suitable for sailcloth, the number of sheep needed would also have been staggering. By some estimates, the sailcloth of the Norwegian Viking-era fleet would have required wool from up to two million sheep.³⁵

6

A King's Ransom

Wool in Medieval England

Clothed in Lyncolne Grene

If I should die today, I'd dread it terribly; I don't know my "Our Father" perfectly as the priest says it But I do know rhymes about Robin Hood.

William Langland, Piers Plowman, 1367-86

Everything we know—or think we know—about Robin Hood is pieced together, quilt-like, from ballads, literary mentions, and other miscellaneous references reaching back as far as the fourteenth century. He is a contradictory figure. In one ballad he is a tattered gentleman, happy to give the proceeds of his righteous lawlessness away to the poor; in another he keeps it all for himself. In one he is a devout follower of the Virgin Mary, in another enamored of Maid Marian. Sometimes it is King Edward he meets in the greenwood, at others it is King Richard. Two relative constants, however, are his hostility to corrupt monks and officials and his costume of Lincoln Green.

Today it is simply a color, but the term meant far more to medieval audiences. Lincoln was a major center of the wool trade, renowned for its wealth and the quality of its cloth. As Michael Drayton, an Elizabethan poet, put it in *Poly-Olbion*, his 15,000-line poem describing England and Wales: "Lincoln anciently dyed the best *green* in England."

In a time when the boundaries between classes were rigid, clothing defined who you were, what you did, and your social status. Despite living in the forest, Robin always seems to have a plentiful supply of the best fabrics on hand to supply new clothes to those in need, in exchange for favors and for disguises. In one of the earliest surviving ballads, *A Geste of Robin Hood*, written down in the late fifteenth century, Little John is referred to as a draper and Robin as the richest "marchaunt in mery Englond." The comic climax of this work comes when Robin gets an unexpected royal visitor—"Edwarde, our comely kynge"—who begs Robin to sell him thirty-three yards of "grene cloth." When Robin obliges, the king and his retinue ride into Nottingham "clothed in Lyncolne grene," terrifying the townspeople, who initially mistake them for the outlaws looking for revenge.¹

Wool and the wool trade suffuse the landscape of the Robin Hood stories, just as they would have done the world of the storytellers and listeners. Steep prices for certain kinds of fabrics, backed up by sumptuary laws, ensured class, status, and even character could be divined by a glance at the quality and color of someone's clothes. Rich and ostentatious churchmen, for example, might appear in fine scarlet cloth, a fabric beloved by the elite. A humbler and more sympathetic one might wear coarser russets: the cloth of cowherds and peasants. But clothing wasn't just down to personal preference. One law, passed in 1337 during the reign of Edward III, limited the import of luxury cloth and fur, possibly in a bid to stimulate the British cloth industry. Another, passed nearly thirty years later, was aimed specifically at ensuring social differentiation, castigating "the Outragious and Excessive Apparel of divers People, against their Estate and Degree." The clothing of servants couldn't contain gold or silver embroidery; gentlemen beneath the rank of knight couldn't buy cloth costing more than 41/2 marks (about £3); craftsmen or yeomen could not wear silk, nor could their clothes be embroidered at all. These laws worked as well as the ones against silk in ancient Rome. Toward the end of the century the chronicler Henry Knighton was still complaining that "the lesser people were so puffed up ... in their dress and their belongings . . . that one might scarcely distinguish . . . a humble man from a great man."2

Whether or not they were effective, the resentments these laws stirred up can be heard roiling through tales of Robin Hood and even the rhyme at the heart of the 1381 Peasants' Revolt: "When Adam delved and Eve span/Who was then the Gentleman?"

A Staple Diet

O Wool, noble dame, thou art the goddess of merchants . . . O fair, O white, O delightful one, the love of thee stings and binds, so that the hearts of those who make merchandise of thee cannot escape. John Gower, *Mirour de l'Omme*, c. 1376–1379

In the thirteenth century, a poet from Artois in northern France used the expression "carrying wool to England" in the way that we might say "carrying coal to Newcastle." Wool was the commodity that England was most famous for. It was relatively affordable, comfortable, and could be dyed a multitude of colors. Alone it could be spun and woven into outer garments; mixed with linen, it could be made into under-things and worn against the skin. (Indeed, illuminated handbooks from the period specifically linked the wearing of fine woolen cloth to good health.) England's flocks mottled her hillsides; the rooms of her poorer dwellings would have been furred with errant staples of wool in various stages of preparation: oiled, spun, woven. The walls of larger homes would have been clad in richly colored tapestries; her ports clogged with soft, plump sacks of it bound for Flanders, France, or Florence.³

The Normans (whose name reflects their Norse Viking roots) had conquered England in 1066. Like their forebears, a principal goal was the wealth created by its rich woolen industry; unlike them, however, they were impressively organized. The Domesday Book—their countrywide survey of every settlement and how profitable it was—took twenty years to compile. The labor was worth it: the text provided a thorough picture of the economic landscape of their new possession and how much tax they could squeeze out of it. A thousand years later, a number of the hulking castles they built to remind the local population who was in control still stand. The best land was divided between the Norman barons and the Church, and they immediately set about reorganizing the way wool was farmed.

The largest landowners had flocks that numbered in the tens of thousands. The Bishop of Winchester, for example, had 29,000 sheep on his estates in the early fourteenth century; Henry Lacy, the Earl of Lincoln, owned 13,400. Although it has been argued that the primary purpose of sheep in the Middle Ages was their milk—used to make cheese—surviving price lists show how crucial their wool was to their value. Sheep that produced particularly fine fleeces would cost 10 pence each, enough to pay a skilled tradesman for a few days' work; a coarser specimen was worth only 6 pence.

Merchants, who dealt with the wool once it had parted ways with the sheep, would have thought about wool in measurements of sacks and sarplers. Somewhat confusingly, the former is a medieval measurement of around 360 pounds; the latter a sack or more of wool repackaged for shipping. One consignment from this period that we know of consisted of 113¹/₂ sacks. At this time a single fleece weighed between one and two pounds, so this one shipment contained the wool of up to 37,455 sheep.⁴

Many places in England in the twelfth and thirteenth centuries raised flocks and sold wool. Regions jostled with one another to brand theirs as the best quality. A price list from 1343 has the most expensive originating from the Welsh border; another, drawn up a century later, indicates that "Lemster" (Leominster) had taken the accolade. This specialization also carried on to the making of cloth. Lincoln was as famous for its reds as its greens. "Lincoln Scarlett" was so sought after that the name was deployed similarly to the way a designer label is today; it was among the most expensive and desired fabrics in Venice in the mid-thirteenth century.⁵

Two consistent areas during this period were the Cotswolds in the south and, in the north, the triangle between York, Lincoln, and Stamford. York, in fact, owed a good deal of its ongoing prosperity to its position as a collecting point for the wool produced in the surrounding area. Its merchants became wealthy by acting as the middlemen between farmers and those involved in trading the wool abroad from the port at Hull. (Both cities suffered greatly when, in the thirteenth century, North Sea pirates began targeting ships stuffed with sarplers of fluffy, white gold, which encouraged traders to move their product laboriously by land down to London.)

Traditionally, most northern wool was coarse, or "hairy," but as wealthier landowners—including many Cistercian monks—became more prominent in the area from the twelfth century, they brought with them more sought-after stock and better husbanding techniques, leading to finer wool. Nevertheless, quality continued to vary considerably. The best Yorkshire wool ranked sixth in the country on price lists from the thirteenth and fourteenth centuries, while the coarsest cost very little.⁶

Coppergate sits hunched on the bank of the River Ouse in York. Over the centuries river water has trickled into the surrounding soil, keeping it peaty and moist, preserving artifacts that would normally perish in so unfavorable a climate. A dig on this site between 1976 and 1981 uncovered six centuries of textile production, stretching back as far as the ninth century. In all, Coppergate—an area 10,764 square feet and 30 feet deep—yielded 1,107 artifacts relating to textiles.⁷

Although small quantities of flax and even some strands of silk were unearthed—likely imported either ready woven or as a yarn wool reigned supreme. Twenty-five raw staples (the defined locks into which a fleece naturally falls) were found, as well as one hundred and twenty textiles and fifty-eight yarns and cords from the Anglo-Scandinavian and medieval periods. There were also tools purpose-made for handling wool, and everywhere quantities of parasites endemic to fleeces. This unglamorous assortment has nevertheless allowed researchers to build up an intricate picture of what happened in the medieval wool trade.⁸

The majority of the wool—around two-thirds—was white, providing evidence of careful selective breeding in the surrounding farms. This is a greater proportion than has been found elsewhere, and is interesting because white fleeces are easier to dye and therefore more valuable. Sure enough, Coppergate's soil also yielded traces of a great number of dye plants. Weld, which produces yellow; woad, blue; and madder, a fine, and relatively showy, red. During this period Britain was renowned for its incarnadine dyes. In an eleventh-century poem written by Winric of Treves (c. 1068–97), the narrator, a sheep, praises the green cloth of Flanders, Rhineland's black dye, and Suavia's tawny red before turning to the most illustrious color of all: "Not blood, not sun, nor fire, glows as red as you, Britain, glow ruby in my coat."⁹

Here, as in Viking lands, the first stage of processing fleeces would have been sorting them into grades. In this case, however, since a great deal of the wool would be traded and exported, this stage took on an extra financial dimension. Factors such as staple length and color would be taken into account, as would provenance. (The lowest of the low—called *morlings*—was the wool plucked from dead sheep.) Breeds native to certain regions might have longer or shorter staple lengths, making them suited for different uses. The finest wool would be earmarked for luxury markets—Florentine clothmakers and traders, for example—while slightly lesser grades might end up in London or be bought up by richer local merchants.¹⁰

Stuff destined for local markets, or which merchants wanted to transfigure into cloth then and there, would be dealt with on site. First the wool would be washed to remove the natural oils and lanolin that coat the fibers and inhibit their ability to absorb colorants. If being dyed, the wool would be dipped into the appropriate vats and then re-oiled by hand to soften it. One writer from 1683 recommended "best Rape Oyl, or for want thereof, either well-clarified Goose-grease or Swines-grease."¹¹

The wool would then be carded, if it was a short-staple variety, or combed if it was a longer-stapled one. This drew out tangles and ensured the fibers in the floss were packed together less densely, making them easier to draw out when being spun into yarn. The tattered remnants of a wool-comb, probably dating back to the eighth century, were unearthed at Coppergate. It had a double row of iron teeth set into a wooden base and, on the reverse, a hole into which a wooden handle would originally have been set, so that it would have looked like a particularly vicious broom. Also found were over 230 spindle whorls, the bead-shaped weights that were wedged onto the end of spindles and which help both with adding twist to fibers and in keeping them evenly spun, so the finished thread isn't lumpy. Of these, fifty-six were made of bone, thirty-six of local stone. One tenth-century example—incredibly—was found to have been carved from a piece of Roman-era ceramic.

Once spun, cloth could be made from the thread. Again, many different considerations would have come into play when deciding what grade of wool to turn into what kind of cloth. Different weaves create different effects, making the cloth more or less warm or hardwearing, for example, and therefore more or less suitable for certain garments. This required foresight and knowledge of likely buyers: there would be no point in a weaver using an ultra-fine, ice-pale wool to produce coarse-textured cloth unlikely to appeal to someone with a plump purse. Different cloths also used varying amounts and weights of thread. Coarcer ones, such as russet, blanket, and burcl. would be made using scratchy wool and thicker, lumpier throud. Superfine variants suitable for, say, a courtier, would need a great deal of very even, thin thread that, when finished, would have a smooth surface on which the weave would be almost invisible. A length of good broadcloth, for example, required between two and three thousand warp threads, each around thirty yards long, and would take around twelve days to make.

Warp-weighted looms, consisting of a high horizontal bar from which the warp threads are suspended using weights to keep them taut, were still common during this period: thirty-three clay loom weights were found at Coppergate. But newer and more efficient looms, such as treadle and two-beam designs, were becoming increasingly popular.¹²

Woven cloth, especially the finer kinds, would then be fulled. This serves a couple of functions: firstly, it helps remove oils introduced during weaving that might hinder dyeing if cloth is to be dyed at this stage. It also fluffs up the individual fibers of a woven fabric and matts them together, making cloth thicker and less porous, and the meshes of the weave less visible. It had been done since Roman times by people physically trampling the cloth in tubs of urine or in rivers, but it was also one of the first steps to be mechanized. Mills powered by water began replacing feet from around the twelfth century. Fulled cloth would then be stretched on a large, frame-like device, called a tenter, covered with hooks, which ensured the finished product was the correct size and shape. Finally, good cloth would be brushed by teasels to raise the nap and sheared to create a smooth finish.

Although spinning and weaving was still done in private homes by women throughout this period, professionalized workshop production rapidly became more common. A guild called the York Weavers appears in the Pipe Roll (the official financial record) of 1164. They were highly paid and later exported cloth directly to Italy and Spain. The Alberti of Florence, a rich and influential family, were in 1396 employing three of their ships full-time to ferry wool from England to Porto Pisano in Tuscany. Active workshops or mills could perform some or all of the processing of raw wool into finished cloth for a fee. There were even cases of tenants being contractually required by mill-owning landlords to use the latter's mill. At each and every stage of production, wool was a money-spinner.¹³

White Gold

I praise God, and ever shall, It is the sheep hath paid for all.

Motto engraved into the windows of a wool merchant's house, fifteenth century

In AD 796 Charlemagne, the first Holy Roman emperor, wrote to King Offa of Mercia regarding a kind of large woolen cloak peculiar to the north of England. "With regard to the length of cloaks," he wrote, "you may order them to be as they used to come to us in old times." Offa's reply sadly hasn't survived, but Charlemagne's confident expectation of high quality reflects the reputation of English wool. The legendary king was far from the only one who admired the quality of England's wool, although he was unusual in his mention of a finished product rather than the raw one.

In fact, for much of the Middle Ages, the places in Europe most famous for producing luxury cloth were not those known for the fineness of their wool. The Flemish and Florentine cloth industries, for example, relied on wool from Burgundy. Spain, and, above all, England. The Florentine cloth industry was particularly voracious: Villiani, a local chronicler, estimated that it employed around 30,000 people in the early fourteenth century. England had been shipping wool to Florence since at least the time of the Norman Conquest, and by the thirteenth century was the city's most reliable source of fine wool. Bills of exchange, a relatively new financial instrument, encouraged such long-distance trading. By the early fourteenth century Florentine merchants were using bills of oxohange to import the finest English wool directly from Southampton, rather than through middlemen, giving this otherwise relatively insignificant island a notable economic role in Europe and guaranteeing a reliable source of revenue.14

The wool trade could make people rich. During the thirteenth century the export trade grew to about 33,000 sacks stuffed fat with the fleeces of around seven million sheep, and accounting for about 60 percent of total production. One famous thirteenth-century merchant, Nicholas of Ludlow, had claims in the trade amounting to £1,800 in 1274—a fortune. Wool also enriched the de la Poles of Hull, one of whom, William, later became the Lord Chancellor. Even royalty became involved. Edward IV, who retained a keen mercantile interest in the industry throughout his reign, paid twenty Italian craftsmen to instruct their English counterparts in the latest techniques of finishing and dyeing cloth. Later he even used his own ships to export cloth and tin himself. It was also crucial financially for those lower down the social order: smaller freeholders and tenants, unable to raise much coin, might pay some or all of their rents in wool.¹⁵

The wealth and influence that could be accrued through wool

were instrumental in the formation of many powerful guilds, such as the Drapers, Mercers, and Merchant Taylors. Guilds shored up their reputation by policing and punishing petty misdemeanors by their members, such as shoddy craftsmanship and mismeasuring cloth, and were often granted monopolies, ensuring their members' unfettered power in the marketplace. York's guild of wool merchants, founded by royal licence by Edward III in 1356, were exporting an average of 3,500 cloths each year, most commonly broadcloths that were sold at the quarterly fairs at Antwerp.

Guilds had a special, elevated position in society. At events involving pageantry, such as royal weddings, guild members wore particularly eye-catching clothing. When Edward I married Margaret of France, 600 guildsmen rode in a red and white livery. The Drapers' guild ordinances mention a "violet in grayne cloth" gown and "cremesin in grayne" hood for their livery of 1483, while that of 1495 was parti-colored murrey (dark reddish purple) and violet. These recall the Lincoln green "lyveray" that Robin Hood offered King Edward. This idea, while romantic enough in the Geste, wasn't wholly fanciful: kings did indeed become honorary members of guilds. King Richard II and his queen were admitted to the Merchant Taylors for the princely sum of twenty shillings each, and in return were either given or sold-the records are unclear-several yards of eight-shilling cloth and a piece of "Tartain" worth thirty. Kings, particularly those who flattered and helped the guilds, could in return hope to be generously bankrolled. Between 1462 and 1475, for example, the crown was loaned over £35,000, three times the sum Edward IV's predecessor Henry VI had received from the same source. And even this pales in comparison to the sum of £369,000 that three monopoly companies loaned the crown between 1343 and 1351.16

The money tied up in the wool trade, and its reliability as an investment—it could earn profits of 20 percent—greased financial wheels and provided the bedrock on which credit could be extended both within the kingdom and across borders. Clergy were involved in the wool trade as producers, but some—including, in York, Dean Scarborough, Canon Robert Gra, and Canon Nicholas Ellerker—also invested in the trade for personal profit. When the Jews were expelled in 1290, many Italian bankers—whose business relations with England had been forged by the wool trade—stepped into the breach by providing credit. Florentine bankers, like the guilds, loaned large sums to the English crown, with wool tax revenue being used for collateral. Debts, against ordinary merchants if not royalty, were diligently pursued. When, in 1280, five dealers from Banbury failed to pay back five sacks of wool that they owed the Riccardi bankers, they were sued.¹⁷

Naturally this trade, and the wealth being accrued by English subjects, didn't escape the notice of the crown, which, during a period of almost continual warfare, was thirsting for lucrative revenue streams. While Kings Richard I, Edward I, and Edward III occasion-ally directly appropriated or "loaned" the wool of their subjects when in need, most other monarchs contented themselves with taxing it. In fact, this was later at the heart of an early constitutional crisis. In 1297, the earls who made up the fledgling parliament contended that wool, which they estimated amounted to half the value of the entire country, was being too highly taxed. "The whole community feels itself hurdened by the tax on wools," they wrote, before repeating the point for emphasis. "which is excessively burdensome."¹⁸

They were right to be concerned: royal meddling in the wool trade could and did have dismal consequences. From 1270 until 1275 Henry III, flexing his diplomatic muscles with all the subtlety of a preening Victorian strongman, banned the export of British wool to Flanders to demonstrate their economic dependence on England. In the 1290s, when Edward I invaded France, he increased taxes and sent a lot of coin abroad, making it difficult for his subjects to get credit. As a result, for three consecutive years the quantity of wool exported from England was halved and fetched lower prices. When the crisis was resolved, the producers of wool and woolen products suffered far more than the merchants, because the export duties sharply divided their interests. The maltote (evil toll) of five marks per sack of wool was first levied in 1294; it depressed the prices paid to the producers while raising the price it was sold for. "And so it is those who own the wool," lamented the Abbot of Meaux in the fourteenth century, "who pay this tax to the king, and not the merchants to appear to make the grant to him; for wools are sold at a lesser price the greater the tax payable to the king for them."19

Monks' Habits

"Oh, brother, beware those fools!" he said. "Christ himself warned of such, and called them false prophets in the faith: 'They come in sheep's clothing but inside they are wild werewolves who wish to rob the folk.'"

Pierce the Plowman's Creed, late fourteenth century

Two notable features of the Cistercian Order, which was founded in France in 1098, pertain to wool. The first, which led to their being nicknamed the white monks, was that they wore habits of pale, undyed cloth, distinguishing them from other, dark-clad orders. The second was their preference for remote, lonely, even inhospitable sites for new abbeys. William of St-Thierry said that the site of Clairvaux—"between dense forests in a narrow gorge of neighboring hills"—recalled the cave of St. Benedict, the founding father of the Benedictines. Rievaulx, founded early in the twelfth century in the northeast of England, was described by another writer as "a place of horror and dreary solitude." Such remote locations were often ideal for rearing sheep. So integral did this activity become to the order, and so great their successes in the wool trade, that the Cistercians developed a rapacious appetite for land suitable for their flocks.²⁰

One quick method of getting more land quickly was to buy up the estates of those who had become encumbered by debt, even if it meant becoming indebted themselves. The wool they would get from raising sheep on the extra land, they gambled, would soon help pay off the moneylenders.²¹

In the fourteenth century Francesco Balducci Pegolotti, a Florentine merchant, drew up a list of wool-producing monasteries.

Eighty-five percent were Cistercian and they were getting more for their wool than other producers. In part this was an indication of their good husbandry-better-nourished sheep produce fuller, heavier fleeces-and processing, but it was also down to economies of scale: their flocks were so large that they could send out wool in bulk and reduce costs. They also invested in their industry. Michael Brun, the eighth abbot of Meaux, built a new stone wool-shed with a lead roof; the other buildings were made, according to the Chronicle of Melsa, of "incorruptible oak." At Meaux the monks' woolen habits were stitched at the abbey from cloth also made by the lay brothers. Of course, practices and standards varied from house to house, but the order seems to have shared knowledge and resources between its houses for their mutual benefit. Kingswood Abbey, in Wiltshire, was particularly successful, producing an annual surplus of twenty-five high-quality wool sacks. It bought rams from another Cistercian house in Lincolnshire in 1241 and gave gifts to the abbots of Diculacres in Staffordshire and Dasing work in Flint."

Although the wool trade made the Cistercians of the twelfth and thirteenth centuries wealthy, it also made them worldly. The more they trafficked in white gold, the farther they strayed from their monastic ideal. Recognizing this, the Cistercian General Chapter continually attempted to control the order's participation in the trade.

One oft-broken rule, which dates back to 1157, prohibited the monks from trading wool that they had bought for profit. In 1262, however, Lincolnshire traders presented a petition to the king accusing the Cistercians of illegal wool trading, which they alleged was resulting in "the impoverishment of the King's city of Lincoln." Their petition shrewdly spelled out the effect this would have on the king's own purse: customs were not charged on monastic wool deals as they were on secular ones. It worked. Or, at least, the king sided with the traders; the Cistercians, however, seem to have carried on regardless. In 1314 another enquiry was launched into the English lay brothers' illegal trading for profit.²³

The selling of a wool crop in advance—a kind of speculation could also result in disgrace. In 1181 the General Chapter decreed that "The wool of one year is allowed to be sold in advance in case of necessity. It shall not be done beyond a single year." There was an attempt to enforce this more strictly in 1277, but the General Chapter was forced to back down a year later. Wool could be sold in advance for more than one year in a row, "provided that payment be made only for the wool of a single year." Robert de Skyrena, the tenth abbot of Meaux, provided a cautionary tale. He borrowed heavily against the house's wool and, when he stepped down, his successors were saddled with debts of £3,678 3 shillings and 11 pence.²⁴

A Lionheart for Sheep's Wool

Look to yourself; the devil is loose.

King Philip II of France, letter to Count John, brother of King Richard I

The story of Robin Hood is often entwined with that of the other English hero of the era: Richard the Lionheart. The denouement of the classic version is usually heralded by the return of the errant king from the Holy Land just in time to prevent the execution of Maid Marian, to officiate at her wedding to Robin and to save England from the usurious misrule of his younger brother John.

Legends, of course, have a way of smoothing over inconvenient details. Richard I does seem to have been beloved by his people—he is often referred to as "Good King Richard"—but he wasn't really a very good king at all. For one thing he spent most of his reign away fighting. When in England, a good deal of his energy was expended in finding ways of raising more money to fund all this warfare. In his birthplace and home province Aquitaine, his nickname was the far less glamorous Richard "Yes or No" because of the terse way he spoke. Richard's three languages were Occitan, a regional dialect spoken in Aquitaine; Latin, used in official and foreign correspondence; and

131

French. He would have needed a translator to understand his English subjects.

Like so many European Christians, Richard was entranced by the glamour of the Third Crusade, an attempt to recapture the Holy Land. Troubadours and preachers stirred up enthusiasm and those who took up the cross were offered indulgences—absolution for all wrongdoings, both past and to come—and a guaranteed entry to heaven. Those who didn't were given distaffs and wool, the implication being that if they wouldn't fight then they might as well be women and take up spinning.

Richard I was already famous for his recklessness in battle. The Third Crusade was imbued with the feeling that history was being made and that Richard was determined to be the one gilded with the glory of the hour. Individual skirmishes, such as the Siege of Acre, were immediately turned into ballads. The three most prominent contemporary Muslim historians, Baha al-Din, Imad al-Din, and Ibn al-Athir, told tales of his bravery and daring too. Battles like the one outside the walls of Jaffa—where Richard, some seventeen of his knights and around three hundred foot-soldiers faced down the far larger army of the sultan—reverberated around Christendom. But the English king's arrogance maddened his allies, already furious at the attention and booty he was getting, and when an opportunity arose for them to take revenge—despite the threat of excommunication for attacking a fellow crusader—they were only too willing to seize it.²⁵

According to a letter Henry VI, the German emperor, sent on December 28, 1192, to King Philip of France, Richard's difficulties started with a shipwreck near Venice. It meant that he had to travel by road through hostile territory controlled by his rivals with very few men. After twice evading capture, King Richard was finally apprehended "in a disreputable house near Vienna" by Henry's own cousin, Leopold, Duke of Austria. "He is now in our power," the Emperor concluded. "We know that this news will bring you great happiness."²⁶

Richard would be held hostage in Austria for a total of one year, six weeks, and three days. His long-negotiated release, when it came, was crushingly expensive. The price of his freedom, agreed at Würzburg on Valentine's Day 1193, was £100,000, to be paid in two installments, as well as the loan of fifty galleys and two hundred knights for one year. This was an astronomical sum: well over twice the total annual royal income.²⁷

Paying it required extraordinary measures. In a letter to his wife in April 1193 he exhorted her and his justiciars to do all they could. They themselves should give generously, he said, even suggesting that they borrow money to pay the ransom, so "that you may give an example to our other subjects to do the like." They immediately levied a 25 percent tax on income and the value of movable property, demanded the silver and gold plate from the churches, and finally seeking every possible means of raising sufficient funds—they turned on one of Richard's favorite religious orders, the Cistercians.²⁸ "Even the monks of the Cistercian order," wrote the chronicler William of Newburgh, "who had hitherto been exempt from all royal exactions, were at this time more heavily burdened . . . For they were taxed and compelled to give up even the wool of their sheep, which is their chief means of support."²⁹

When the news broke of his captivity, a great council of the realm sent two Cistercian envoys to Germany to track down the errant monarch. When they succeeded, finding him at Ochsenfurt, a small, undistinguished town not far from Würzburg, they were received by the king "affably and cheerfully," passing on to him vital news of his brother's perfidy and King Philip's designs on his continental lands.

His need for funds was such, however, that it overruled any gratitude he might have felt. On his return to England he took that year's yield also. "For, when we were released by the emperor," he told the principal abbots who later came to visit him, "we returned in great poverty to our own country, and confiding in you in our most urgent necessity, we took from foreign merchants the value of your wool for our needful purposes."³⁰

The Cistercians were livid. Thomas of Merton, a chronicler and an abbot of Meaux Abbey in the West Riding of Yorkshire, alleges that even after his house "had given three hundred marks in money and value, to wit, in wools, chalices and other treasures," more was taken "by violence and fraud—for they promised to return everything to us." Higden clips his words short in his fourteenth-century history known as the *Polychronicon*: "all the wolle of white monkes and of chanouns was i-take." This was serious indeed: the Cistercians, more than any other religious order in England, relied upon wool. Making the loss more painful still, this wool had likely been sold in advance to foreign merchants in return for coin. The buyers would not have been sympathetic, and the failure to live up to the deal was likely to have saddled abbeys with debts it would have taken decades to repay. William of Newburgh was disgusted by the king's behavior. "In this manner," he wrote, "despoiling those religious persons, under the appearance of flattery, reduced the most celebrated of their monasteries to an unusual state of poverty."³¹

Wool was the engine of England's finances. It encouraged speculation, profiteering, and the extension of lines of credit. It also played a part in a transfer of wealth, widening the gap between the richest and poorest, and accelerating the fall of the smaller landed gentry, all the while giving Britain a foothold in wider European affairs. Without the wealth generated by the buying and selling of wool, for example, it is unlikely that Richard the Lionheart would have been able to take so pivotal (or expensive) a role in the Third Crusade. And so it was only natural that wool became a means of paying the ransom for his return. The handling, production, and trading of this raw material were major occupations for many, from individual smallholders to guilds and workshops, like the one on the banks of the River Ouse. So ubiquitous was it, that tell-tale wisps of white floss are caught on the barbs of otherwise disparate incidents: the clothing of a fictional outlaw; Italian bankers' interest in extending credit to the Cistercians; and, finally, that monastic order's horror when two years' worth of wool was confiscated to ransom back a king.

Later monarchs, mindful perhaps of the loans that both the guilds and the monks might extend them (and perhaps more afraid of going to hell), proved more respectful. In 1364 King Edward III introduced the Woolsack, the large, wool-stuffed red seat reserved for the Lord Speaker in the House of Lords: an explicit reminder of the crucial role wool played in England's prosperity. It remains in pride of place to this day.

7

Diamonds and the Ruff

Lace and Luxury

The Lacemaker

Greek, Sir, is like lace. Every man gets as much of it as he can.

Samuel Johnson, James Boswell's The Life of Samuel Johnson, 1791

A girl looks down at the work between her hands, utterly absorbed. She's seated in a spare, pale room—so bereft of detail that it's difficult to say whether it is a room at all or a void, hollowed out by her singular focus. Her dress is a glowing lemon shade; her hair is gathered away from her face in a coif of plaits and large ringlets. Our eyes follow hers: down between her fingers to the "V" formed by a pair of bobbins she is using to oroate a piece of lace. The girl—we do not know her name—was painted by Johannes Vermeer toward the end of his career in 1669 or 1670, possibly for Pieter Claesz, a fellow artist of the Dutch Golden Age. The painting is known, simply, as *The Lacemaker*.¹

Two years after it was painted, the artist was ruined by the financial collapse set off by the invasion of the Netherlands by King Louis XIV of France. Vermeer's luminous canvases, previously so sought after, furred with dust in his studio as the wealth of his erstwhile patrons evaporated like puddles on a hot day. He died after a short illness in 1675, leaving his wife and eleven children severely in debt.²

The Lacemaker, however, was painted at a time when Vermeer was prosperous: assurance oozes from every brushstroke. The canvas reflects the confidence of a well-to-do age and nation. The artist passed the majority of his life in Delft, a bijou city hemmed in between The Hague and Rotterdam and, during the seventeenth century, brimming with merchants, Delftware factories, and tapestry ateliers. Although one of the smallest canvases that Vermeer produced—just 9.5 inches tall and 8.25 inches wide—when it was first displayed in the Louvre in 1870, it greatly impressed an ambitious twenty-nine-year-old painter. Auguste Renoir proclaimed to anyone who would listen that it was the most beautiful painting in the world.³

The palette largely conforms to Vermeer's preferred triumvirate of pearly gray, yellow, and blue. (Vincent van Gogh, another fan, wrote that these colors were "as characteristic of him as the black, white, gray, pink is of Velázquez.") It was one of a series Vermeer worked on between 1669 and 1672 that tenderly showed women absorbed in simple domestic tasks.⁴

Contemporaries would have seen the painting as a comment on feminine virtue: needlework was considered a worthy engagement for women, keeping them at home, occupied, and out of trouble. In a slightly earlier treatment of the same subject by Caspar Netscher, another Dutch genre painter, the idea of virtuous industry is hammered home with additional symbols. Again, the young woman is sitting absorbed in her lacemaking; she is angled away from us, her face modestly in shadow. A broom against the wall speaks of housework and an ordered home, mussel shells at her feet suggest safe enclosure, and a pair of discarded clogs imply that the woman has no intention of going outside—she is content to remain within her natural sphere.⁵

Vermeer dispensed with such allegorical props. His subject is positioned very close to the viewer, angled three-quarters on, yet unaware of being observed. There are several depths of field within the painting, which Vermeer manipulates to pull us into the middle ground. In front of the girl and slightly to her right, in the extreme foreground, is a table covered with a carpet that falls in heavy folds and is topped with a blue-and-white sewing box, slightly ajar, and spilling a confusion of vermillion and white threads. The treatment of the loosened threads, and of the gold and red design of the carpet, is diffused and out of focus, drawing the viewer's eye to the painting's pin-sharp center: her hands deftly working the bobbins. Vermeer's use of light heightens the effect: highlights fall on the simple linen collar on her left shoulder, the left side of her forehead, nose, and finally those poised, precise fingers.

The painting's size, its foreground filled with a profusion of intriguing objects, and, finally, the captivation of its subject in her task,

139

all work in concert to make the viewer lean forward toward the canvas.

The Lacemaker can also be interpreted as a meditation on craft, creativity, and the human capacity to spin beauty out of the humblest materials. White linen lace, after all, originates from humble seeds sown in the earth. Conversely, however, it is also one of the best examples of a decorative luxury fabric: it serves no function other than advertising the status, taste, and wealth of its wearer. It provides no warmth and is exceptionally delicate, liable to snag and tear, leaving a careless wearer disgracefully tattered. And yet during this period, European society—men and women alike—were consumed with the desire for this frippery, to the point where its lack would elicit comment. As a result of its popularity and the price it could command, it provided so much prestige and employment that diplomatic relations between countries could be strained by the ebb and flow of production and consumption.

Stitches in the Air

I consider lace to be one of the prettiest imitations ever made of the fantasy of nature . . . I do not think that any invention of the human spirit could have a more graceful or precise origin. Gabrielle Chanel, L'Illustration, 1939

If we were able to disturb the assiduous lacemaker in Vermeer's painting so far as to ask her the origins of her craft, and why it was so sought after, she would likely have struggled to answer. Lace evolved, rather than appearing from thin air. It is also, for similar reasons, difficult to define. Calling it "a non-woven fabric made with a needle and thread or threads wound onto bobbins," as some do, would mean that knitting and macramé are also forms of lace. The earliest ancestor is perhaps filet, a needlecraft of square meshes made with a shuttle or needle. It was known in antiquity but began to be embroidered to make necessarily geometric but distinctly lace-like designs during the sixteenth century. Lace's real progenitors, however, were embroidery—which was increasingly being used to decorate the edges and seams of the fine linen beloved of Europeans during the fifteenth century—and passementerie, ornamental trimming made of braid or cord.⁶

Its evolution is reflected in a hopeless muddle of descriptive terms. There are references to "lace" during the fifteenth century, but these are probably cording, rather than true lace. And, although the terms did become less fluid as lace became more established, relying on terminology alone is unwise. Take, for example, the trimmings used by English royalty during the sixteenth century. "Pasmens of gold" and "passmeyn riband" worn by Mary I and Edward VI respectively were likely braid, but the "Passmeyn lace of bone work of gold" that appeared in 1553 in the Lord Chamberlain's accounts was probably the real thing. By the mid-sixteenth century, lace had taken a firm grip on fashionable dress for both sexes and, with a surprising degree of consistency, across Europe.⁷

Initially, it was produced as much by skilled amateurs for their own consumption as it was by professional needleworkers. Printed pattern books have survived from as early as 1524—single-sheet designs were likely being published earlier—that show lace designs women could copy. Adrian Poyntz wrote in 1591 that "these works belong chiefly to Gentlewomen for to passe away their time in virtuous exercises." Most lace-workers, and certainly those producing the bulk of the lace sold in the open market, probably learned organically, from their families, or by watching others. Nevertheless, such printed guides may have had a role in the rapid diffusion of various forms and styles of lace through Europe. One book, for example, Mathio Pagano's catchily titled *Giardinetto novo di punti tagliati et* gropposi per exercito e ornamento delle donne, which was originally published in Venice in 1542, was reprinted around thirty times elsewhere in Europe. Technical instructions were rarely included: it was taken for granted that those consuming these guides would be proficient with the stitches required to build up the often fiendishly complex designs.

Needlework, in fact, was one of the few occupations that women of all classes were encouraged to develop. Mary Queen of Scots and Catherine de' Medici were both famous for their love of needlework. The estate of the latter included thousands of pieces of elaborately embroidered filet that she had made, including some complete bed furnishings.⁸

The raw material for all this industry was usually fine linen thread. This is what was used to create the pearlescent white laces that encircle necks and wrists in nearly all sixteenth- and seventeenth-century portraits. It is also the variety most likely to survive in collections, but other materials were also used.

Black lace, made from silk rather than linen, became very fashionable during the mid-seventeenth century. While, with white lace, the desired effect was a strong visual contract between the lace and the surrounding fabrics, black lace was more often used with equally dark fabrics, lending subtle texture only noticed by discerning eyes. The effect can be appreciated in a grand portrait of Laurens Reael painted by Cornelis van der Voort sometime around 1620, shortly before the artist's death, and now on view at the Rijks Museum in Amsterdam.

Laurens Reael was an important commission for van der Voort. He had recently returned to the Netherlands after a three-year stint as the governor-general of the Dutch East India Company, one of the most prestigious posts of the age; this portrait was a carefully crafted record of his triumph. Van der Voort was possibly chosen for his skill as a painter of luxurious fabrics. Reael certainly put thought into his clothing. He wears elegant lace cuffs and a ruff *à la confusion*—a style with intentionally irregular folds or sets, rather than with a regular "SSS"-shaped configuration. His sleeves are braided with gold and there is a little puff of gold lace behind the knees of his breeches. Both these and his doublet are made of a rich, sheened fabric—likely silk—decorated with textured stripes of black lace or cord. Although used extensively in clothing and interiors during the seventeenth century—the 1624 will of Lord Dorset, husband of the well-known peeress Lady Anne Clifford, even mentioned the "greene and black silke lace" that decorated his coach—black lace is often overlooked. In part this is because it is less striking in portraiture, but another, more prosaic reason is that very little has survived to be studied. The mordant used to fix the black dye to the silk was acidic, making it brittle and fragile and, in most cases, eventually consuming it altogether.⁹

Fragility was less of a problem for another kind of lace coveted during the sixteenth and seventeenth centuries, however. The idea of using thin metal threads or wires to create delicate and decorative meshes was not new—Homer picturesquely refers to "veils of golden netting" in the *Odyssey*—but laces woven from metals became particularly popular during this period with those who wanted to make their consumption even more conspicuous.¹⁰

When in 1577 King Henry III of France sought to intimidate the Estates-General (a legislative, advisory assembly made up of groups of his subjects), he turned up to a meeting wearing 4,000 yards of gold lace. The wardrobe of Queen Elizabeth I must have been stiff with the stuff. She bought a great deal and used it lavishly: a single petticoat had eight yards of gold and silver worked onto it. Because they were so expensive, gold and silver laces were beloved of royalty and the richest aristocracy; those lower down the social scale might make do with stuff fashioned from copper instead.¹¹

Moralistic contemporaries, predisposed against all lace as a symbol of vanity, were particularly appalled by metal laces. Philip Stubbes, in his fulminating tract *An Anatomie of Abuses*, written in London in 1583, railed—seemingly caught between disgust and admiration against ruffs "clogged with golde, siluer, or silk lace of stately price, wrought all ouer with needle work, speckled and sparkled heer and there with the sonne, the moone, the starres, and many other antiquities, straunge to beholde."¹²

As with the black kind, relatively few examples survive. Although they were usually too precious to become corroded, these laces were often melted down so that the metals might be re-used. (In France, they were outlawed outright at certain times, since the metal was

143

desperately needed to make coins.) In his diary of Friday, August 12, 1664, Samuel Pepys, whose career success is mirrored by his increasingly extravagant lace purchases, mentioned going "to Stevens the Silversmith to change some old silver lace." Presumably the exchange was for money: his next stop was to "buy new silke lace for a petticoat."¹³

Lace was always a luxury deployed to display wealth, taste, and rank. Its value as a signifier of social status lay in its delicacy, its manufacture, and its expense. So potent was it as a status symbol that its wearing was regulated by law to prevent commoners from using it to masquerade as their social betters. One English proclamation, passed in 1579, forbade "Ruffes made or wrought out of England" to be worn "under the degree of a Barons Sonne, a knight, and Gentleman in ordinarie office, attending upon her Majestics person." In Venice, the population of the Jewish ghetto were forbidden to wear white needle lace, gold and silver laces, or any bobbin laces wider than the breadth of four fingers ¹⁴

Flax was a difficult and time-consuming crop to grow and process; spinning and weaving it, particularly if the end result was to be of the best quality, required great skill. Lace was a continuation along the same trajectory of luxury consumption. Constructed from miles and miles of pearlescent linen thread, both the design and execution demanded consummate dexterity, forethought, and no small amount of mathematical acumen. Only five bobbins are visible in Vermeer's painting, but the most complex laces might require six hundred. Scrupulous planning was needed to ensure the right number of bobbins would be available throughout the execution of a design.¹⁵

The desired effect was of lightness. The perforations allowed glimpses of the fabric or flesh beneath. Initially this was achieved through cutwork—a form of embroidery where a design on linen is reinforced with buttonhole stitch and then the enclosed areas are cut away—or drawn threadwork, where weft threads are removed from woven cloth and the remainder arranged into patterns and decorated with embroidery. Soon enough, however, a greater airiness than either of these two methods could produce was desired, and so skilled needleworkers in Flanders and Italy—debate about the country of origin has raged ever since—began approaching the problem from the other direction. That is, rather than removing fabric, either by pulling out individual threads or by cutting out sections, it made more sense to start from scratch, building up a design stitch by stitch.¹⁶

There are, broadly speaking, two ways of making lace: with bobbins or with needles. The former has much more in common with passementerie-the kind of decorative trimming common on formal military uniforms-while the latter was descended directly from embroidery. Bobbin laces are traditionally built up over a pattern-during this period often made of parchment-which would be pinned to a pillow firm enough to keep the design taut as it was created. (In The Lacemaker, the printed pattern is visible as a thick pink line over the cerulean sewing cushion on which her hands rest.) The design would be marked in the pattern by a series of pricked holes, which indicate where the stitches need to be to create the design. The threads, which are wound onto pairs of small wooden spindles, or bobbins, are then plaited, twisted, knotted, or woven together over the printed pattern. As the work progresses, pins are placed in the holes to hold the stitches in place while the next series of threads are manipulated. Eventually, these pins can be removed.

Needle laces, as the name suggests, are made using needles rather than bobbins. Lacemakers would also use parchment patterns to guide them in making needle laces, but the designs would be drawn out, rather than indicated by holes. Needle laces are made up of rows of detached buttonhole stitches, which are cast between an outline structure made from thicker threads. *Punto in aria* was an early Italian variant of needle lace; its name means, literally, "stitches in the air."¹⁷

Both types of lace—and the many variations born of them were highly responsive to the whims of fashion and demand. Regions across Europe would perfect an idiosyncratic new design that would capture the hearts of the elite, only to fall from favor and suffer a crash when a new darling was discovered. During the sixteenth and seventeenth centuries, designs veered from the geometric and impersonal to the voluptuous and baroque. Laces could be specially designed and made or commissioned to show symbols or words that had special meanings to their owner. A bed cover dating from 1588, for example, was decorated with a siren combing her long hair while gazing at her reflection in a mirror. The words *Vertu pas tout*—"virtue isn't everything"—are emblazoned across it. It likely belonged to a courtesan.¹⁸

No matter who the owner, cuffs, undergarments, and furnishings of so impractical a material betokened wealth. Not only did you have to buy it in the first place, but lace also had to be maintained and replaced: this implied staff and fastidiousness in an age where cleanliness and grandeur were virtues available only to the few for a hefty sum. Decency in Georgian England, for example, demanded a clean linen shirt for each day of the week, necessitating a great deal of labor and expense. During the sixteenth and seventeenth centuries soap was a luxury item. In continental Europe, fine, expensive kinds were made from vegetable oils, in England the common kind was made from tallow, or rendered beef fat, which was also needed for candles. Soap was therefore heavily taxed, to prevent tallow candles from becoming exorbitant, so keeping laces clean was supremely difficult. In 1753, an English parson dreaded the arrival of his stepmother and sister for a visit precisely because of all the extra washing their visit would necessitate. [1]hough she offered to hire washerwomen, and pay for soap," he wrote, "yet coals (especially with us) is a very great article . . . besides the continual fuss and stir there would be with wet clothes."19

The practical pointlessness of lace was picked up on by contemporaries. Thomas Fuller, a seventeenth-century English writer, called it "a superfluous wearing, because it doth neither hide nor heat." But those who expressed such beliefs generally carried on wearing lace regardless. It was as much a part of fashionable dress as breeches; besides, as Fuller admitted: "it doth adorn."²⁰

Ruff Diplomacy

Out of the way! We are in the throes of an exceptional emergency! This is no occasion for sport—there is lace at stake!

During the mid-1660s Jean-Baptiste Colbert, the French minister of finance and trade, had a grave problem: the extravagance of his king and court were threatening the financial well-being of the nation. It is no accident that today Louis XIV, also known as the Sun King, is a by-word for extravagance. His childhood, marred by political unrest and several humiliating flights from Paris, was largely spent bathing in the intense glow of his mother's devotion. Possibly something in this mixture—devotion and excess seasoned with fear and intrigue was responsible for the king's appetites when he came into full possession of his throne. For example, he gave Athénaïs de Rochechouart de Mortemart, his blonde-haired, witty, and exceedingly fertile mistress of nearly a decade, apartments at Versailles on the same floor as his wife's, as well as a chateau. (Not to be outdone in frivolous expenditure, Athénaïs employed gardeners to plant 8,000 daffodils for a single, spectacular season.)²¹

Naturally, this extravagance was also expressed in purchases of lace. Louis favored a style of collar, known as *col à rabat*, which resembled two large rectangles fastened with a knot under the chin, worn with matching cuffs and *rhingrave* (very full, blousy breeches, gathered at the knee with a frill) or *canions* (little lace collars worn around the knees). Nor was the king's enjoyment of lace confined to wearing it: an inventory of royal goods taken in 1667 reveals that the pleasure barks he used to sail around the grand canal at Versailles all had peekaboo curtains over the alcoves.²²

The problem from Colbert's perspective was that almost all this profusion of lace was imported from Venice. Venetian *gros point*—or *point de venise*—is one of the easiest kinds to distinguish. Coming from the baroque aesthetic tradition, it is characterized by heavy, scrolling motifs sometimes incorporating "oriental" flourishes like pomegranates. What made it exceptional, however, was that some of the motifs were picked out with a core of thicker threads over-sewn with buttonhole stitches, giving a lush, three-dimensional effect, quite unlike anything being produced elsewhere. It became the most highly prized style in Europe in the mid-seventeenth century, taking over from Flemish lace, which was pearlier and more delicate.²³

Each large purchase of Venetian *gras point* the Sun King made, while no doubt adding to his fashionable cachet, was money that Colbert felt would be far better spent on French craft. The problem was that while France did have some lacemaking centers, particularly in the north of the country around Normandy, it didn't have a clearly defined style and was therefore not in much domand. Colbert, though, was a man of action, and so on August 5, 1665, he announced that "factories for all kinds of threadwork, made either with the needle or on the cushion, in the manner of laces which were made in Venice" were to be set up in a number of French towns, including Arras, Rhelms, Château Thierry, and Alençon. He called on the royal designers and painters to contribute fresh designs that would only be made by the official royal factories. This new French lace, he declared, would be called *paint de France*²⁴

This alone might have been enough to irk the Venetian state, for whom lace was an important source of revenue, but Colbert went farther. He called on nccdlcworkers from Italy and Flanders to emigrate to France, enticing them with promises of citizenship. He kept in close contact with the French ambassador in Venice. Most of their letters were in code, so sensitive had diplomatic relations become; those that aren't, however, reveal that the French were deliberately siphoning off detailed information about the industry, quoting figures for levels of production and prices. This was, in other words, state-sanctioned industrial espionage, which the Italians weren't prepared to take lying down. Venice promptly issued a counter-decree, commanding those tempted by Colbert's offer not to take it up, and those who had already done so to return immediately, on pain of execution for treason. It was too late. In a few years the French lacemakers had acquired a distinctive style of their own, more austere and regular than Venetian *gros point*, and full of symbols alluding to Louis XIV: suns, sunflowers, fleurs-de-lys, and crowns. Seven years after Colbert's proclamation, the inventory of a merchant who specialized in Venetian laces included laces *alla Colberta*; these were among the most expensive of his stock. It was very much in tune with the tastes of the French court and particularly those of Louis himself. In a single month, July 1666, the French king bought *point de France* worth 18,491 livres. Colbert, eyeing the growing heft of the national purse, must have been delighted.²⁵

The Lace Wars between France and Venice during the late 1660s were not the only international squabbles caused by lace. In 1662, an act originally passed some three decades earlier that forbade "the selling in England or the importation . . . of any foreign bone lace, cutwork, fringe, buttons or needlework made of thread, silk, or any or either of them," was reinforced. Charles II, just back from poverty-stricken exile in Europe, refused to be baulked by his own prohibition, circumnavigating it by licensing a single merchant (his own) to import the muchcoveted Venetian lace. The merchant responded to the royal favor by charging his client vast sums thereafter. A single bill from July 2, 1668 shows the king was charged £80 8 shillings and 1 pence for lace, which included some "fine point de veniz" at 32 shillings per yard.²⁶

Lace-producing regions and cities in Italy, the Netherlands, and France vied with each other to create new designs. This acted like an engine, driving changes in fashion, expertise, and innovation, but also provided a canvas for cultural, political, and nationalistic ideas. During the early part of the seventeenth century, for example, the towns of Flanders were among the most prosperous in Europe, thanks to the foundation of their East India Company in 1602. Flemish lace, which was particularly fashionable at this time, was filled with naturalistic motifs of flowers like carnations, narcissi, and tulips, blooms that held special significance in Dutch culture, whereas French laces were more likely to contain motifs that referenced the Sun King.

Differences were also discernible in consumption. When Fynes Moryson, a gentleman from Lincolnshire who traveled around much of Europe during the 1590s, visited Poland, he noted that the queen,

149

who was Austrian by birth, "was attired like the noblewomen of Germany." Her new countrymen, on the other hand, appeared most odd, having "no ruffes nor any bands of linen about their necks." In Switzerland Moryson sniffed that, since most of the inhabitants were merchants, they dressed modestly in "grave colours . . . little beauti-fied with lace."

Italians never took to ruffs with quite the same gusto as the English, French, and Spanish, who allowed them to grow as enormous as prize pumpkins. The largest kinds, which puffed out all around the face like halos, were perfect for displaying particularly intricate laces. To show them off to their best advantage and prevent them from drooping under their own weight, wire frames were made to support them.²⁷

Thick, multi-layered ruffs had another effect: so much lace was required that it could no longer be consistently supplied by the ladies of the household themselves. By the final decades of the sixteenth century, lace had become a commodity, traded, bought, and sold by habordashers, who sourced it from workshops, convents, and orphanages, and dealers who traded internationally. Habit de Lingère ("Clothes of the Linen-Merchant"), a 1695 engraving by Nicolas de l'Armessin. gives some idea of how consumers would have encountered such choices. The subject is a woman-the linen-seller of the title-wearing a very tall frilled cap, standing in her shop and looking out at the viewer as if they were a favored customer. In a somewhat surrealist touch, however, her body is being subsumed by her own wares, so that it's almost impossible to tell where one ends and the other begins. Her bodice contains drawers, each labeled with a different variety of lace-Flanders, Mechlin, Rabat, and Dutch. On the table from which her cabinet-body emerges, there is yet more lace, this time from Le Havre, nestled among the linen stockings and shirts.

French lacemakers had Colbert to thank when *point de France* became the height of European fashion. Unfortunately for them, however, his successors were a good deal less assiduous in their care. As a relatively fledgling endeavor, it didn't have a long-standing reputation on which to rely, and soon began to suffer as the incentives Colbert had used to entice and encourage it were stripped away. A decisive blow was dealt by the Edict of Fontainebleau in 1685, which

struck down the religious protections the Protestant Huguenots had enjoyed in France since the Edict of Nantes nearly a hundred years previously. Since the Huguenots had traditionally played a vital part in the industry, it was a devastating blow when so many left the country, taking their skills with them. In Normandy alone, the number of lacemakers fell by half.²⁸

Other countries wrestled with different issues. The Italian lace industry, particularly in Venice, was bolstered by its reliance on wealthy patrons and the nimble, lacemaking fingers of nuns in Italian convents, whose prices were relatively low since they did not have houses to run or families to look after. Lacemakers in Flanders, however, had no such insulation from economic shocks. The same financial crash that felled the fortunes of Vermeer resulted in profound hardship for even the most skilled of Flemish lacemakers.²⁹

Wearing It Well

But the Queen being in mourning for the Duc d'Alençon and the Prince of Orange, was dressed in black velvet sumptuously embroidered with silver and pearls. Over her robe she had a silver shawl, that was diaphanous like a piece of gossamer tissue. Lupold von Wedel, December 27, 1585

> In 1593, Sir John Fortescue, the English chancellor of the exchequer, was quizzed by the House of Commons about Queen Elizabeth I's expenditures. "As for her apparel," he said, "it is royal and princely, beseeming her calling, but not sumptuous or excessive." Although

during the centuries since her reign, the depth and richness of Elizabeth's wardrobe has become notorious, in fact she was in line with her near-contemporaries, such as Mary Tudor, Catherine of Aragon, and Christina de Lorena. Clothes were important words in the language of social interactions: queens of small European countries being eyed up by much larger and wealthier rivals needed an expansive vocabulary. Lace, like a rhetorician's *elocutio*, provided persuasive final flourishes.³⁰

Queen Elizabeth I certainly did possess an awful lot of lace, though. In the famous Pelican portrait painted by Nicholas Hilliard, she is cobwebbed with it. There are narrow bands of gold lace mounted in stripes over the queen's blackwork-embroidered linen sleeves and partlet (a kind of yoke or dickie, worn to cover the neckline), which is also edged with black needle lace. Her cuffs and ruff are made of fine cutwork with delicate lace points. Hilliard went to a great deal of trouble to depict it all: when seen in a raking light, it's clear he thickened the white paint he used to do the lace especially, so that it's slightly raised, like the veins on the back of a leaf.

The Gheeraerts portrait, painted around 1592, depicts her in so stiff a white gown and cloak that she looks less like a human than some kind of strange, pale crow. Adding to the inhuman effect is the very large cutwork ruff encircling her neck, further distorting the proportions of her body. This fashion, incidentally, was a special target for the kind of Englishmen who so enjoyed fulminating on the topic of sartorial modesty. "Great and monstrous Ruffes," wrote Philip Stubbes in *An Anutomie of Abuses*, "whereof some be a quarter of a yard deep, yea some more, very few less." Not only were they immoral, they occupied time and thought that, many believed, would be better spent in prayer. "A ship is sooner rigged by far," Thomas Tomkins complained in 1607, "than a gentlewoman made ready."³¹

A hefty proportion of Queen Elizabeth's laces were supplied by Alice Montague, a London silk-woman who also dealt in fine linen. On Lady's Day 1576, for example, a list of items supplied by Alice for the queen was issued that ran to forty-three separate items, including ten ounces "of lase of venise golde and silver." Over the next six months, the queen bought yet more metal laces. The Michaelmas list includes "sixe poundes one ounce of riche venice lase made by hande" as well as twenty-seven "pounds of bone lace and loume lase of venice golde and silver of sundrye sortes."³²

It was also a popular gift: quantities of lace and lace-trimmed clothing arrived from subjects and courtiers trying to curry favor. In honor of the New Year of 1578, for example, she received "a cushynclothe of lawne wrought with white work of branches and trees, edged with white bone-lace wrought with crownes." The following year the Countess of Lincoln gave her a long cloak of "murry velvet, with a border rounde aboute of small Cheyne lace of Venis silver." Perhaps the most extravagant example of the genre came when she visited Kenilworth in 1584 and a suite was redecorated, in eyewatering style, in her honor. "Fyve plumes of coloured feathers garnished with bone lace and spangells of golde and of silver standing in cups, knit all over with golde, silver and crimson silk adorn the bedstead, of which the five curtains are striped down with a bone lace of gold and silver."³³

Nor was the queen alone in her tastes. Her great rival, Mary Queen of Scots, went to the scaffold in 1579 wearing white linen bobbin lace. Two decades earlier Sir Thomas Wyatt, another traitor to the crown, was beheaded wearing "a faire hat of velvet, with broad bonework lace about it," while the Comte de Cinq-Mars, the leader of French fashion, left more than three hundred pairs of lace-trimmed boot hose behind him when he was beheaded in 1642. The sensitivity of contemporaries to the nuances of lace can probably be judged from the row that developed between the artist Diego Velázquez and a young noblewoman of Zaragoza. She refused to accept the finished portrait because, she said, the artist had failed to properly depict the quality of the lace—"*puntas de Flandes muy finas*"—of her collar.³⁴

Frans Hals' *The Laughing Cavalier* is a curious painting in many ways. It depicts a man who is neither a cavalier, nor, indeed, is he laughing. The face of the twenty-six-year-old sitter—his age is inscribed, with the date, 1624, on the portrait—is ruddy with health. His moustache curls irrepressibly upward, following the full lines of his cheeks. His lips and dark eyes, meanwhile, have the tilt of someone caught in the aftermath of a joke of which he is inordinately proud. Nor is his wit the only thing this young man is pleased with.

His clothes—from his vast black hat to his foaming ruff and the richly embroidered doublet, slashed over the upper arms to show the fine linen beneath—all telegraph wealth, status, and not a little vanity. But he was far from the only man of his era proud of his sartorial panache. In fact, despite the feminine connotations that lace has now, for much of this period it was worn far more by men.

During the late sixteenth and seventeenth centuries men habitually wore lace at their necks and wrists. Indeed, male clothes, particularly during the mid-seventeenth century, offered far more opportunities for display. There was, for example, a vogue for wearing lace collars over armour. The effect of the delicate linen spread over the gleaming riveted metal-which can be seen in some Van Dyck portraits of the era-must have been very striking. Once ruffs had vanished from fashionable necks, men took to wearing exceptionally large, flat collars of delicate needle lace. Lace might also peek from the tops of boots, the seams of breeches and coats or doublets and even, while canions were in fashion, in little fills around the knee. The masculine influence on lace extended to the motifs contained within it. A design of a surviving lace cravat end, which is thought to have once belonged to Louis XIV, contains stylized martial imagery: drums, standards, canons, and two victorious, trumpeting angels.35

Over the Channel, King James I was even more extravagant sartorially than his female predecessor. While the wardrobe expenses for the last four years of Queen Elizabeth's reign were £9,535, during the first five years of his James I spent £36,377 annually. A good deal of this was incurred on lace. On the marriage of his daughter Elizabeth to the Elector Palatine in 1613, for example, a warrant was sent to the Great Wardrobe for "sixc hundred fower skore and eighteen ouce of silu" bone Lase with spangles, fower hundredth three skore and seven ouce of gold and silver byndinge lase, Thirtye eight ouce of golde and silver loope Lace ..." The list goes on. In all, over 1,100 pounds of laces were listed.

Nor was it just the fashion for royal men. During the 1590s a vicious lawsuit played out between Lord Berkely and his tailor. The former alleged that the latter had swindled him by using far less silver lace on one of the Lord's suits than he had reported and

pocketing the difference. (It was actually a servant who noticed the discrepancy in the bill, which had included "fower score ounces' more lace than were actually found on the finished suit.) In 1632 it was discovered that Charles I's taste for lace and fine linen was costing the realm £2,099 per annum: the public outcry following this revelation resulted in a plan being drawn up to reduce the expense of the Royal Wardrobe and a rather sulky monarch. (He needn't have worried: the plan was never implemented, and the king was very soon beheaded.) Royalist opponents, despite their protestations of sartorial humility, weren't immune. Oliver Cromwell, who died in 1658 and famous for his direction that he should be painted "warts and all," was nevertheless buried in clothes trimmed with costly Flemish lace.³⁶

Lacemakers

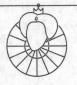

A little thread descanted on by art and industry. Thomas Fuller on lace, The History of the Worthies of England, 1662

> At first glance, the story of lace is one of luxury, but of course there is always another side to be considered. The lace that garnished the throats of the wealthiest individuals in Europe and still gleams whitely from their portraits was often made, stitch by candlelit stitch, by some of the poorest.

> In some instances, needlework could function as a financial lifeline. On September 1, 1529, the City of Amsterdam decreed that "[A]ll poor girls, old or young, who are unable to do any lacework or earn their keep" were to meet every morning before 6 o'clock and be taught, free of charge, "spinning and other handiwork, whereby the same will be able to be kept and remain off the parish."³⁷

155

Throughout this period, although the discovery of the New World and the exploitation of new trade routes swept a great deal of wealth into the coffers of the Old World, the gap between the rich and the poor widened. And although the wealthy were prepared to pay vast sums for lace, as we have seen, this money stubbornly refused to trickle down to those who made it. Part of the reason was that the lacemakers, who were overwhelmingly female, didn't form corporations or guilds. This mattered because guilds functioned to give status to craftspeople who might lack it on an individual level. Without banding together, it was difficult to demonstrate the economic importance of their work or to demand higher wages and status in the same way passementiers and dyers were. (The strictness of guilds could also stymie or restrict economic opportunity, however. Passementiers, for example, saw humble linen thread as beneath them, because working with precious metal was a guild privilege, and therefore missed out on lacemaking work.) Lacemakers, who often plied their needles and bobbins in informal family workshops, were too diffuse to organize.38

Gender also played into the low status and wages of lacemakers in other ways. So many women were taught needle skills as a matter of course that the potential workforce was very large, which depressed wages. The governor of Le Havre estimated that there were 20,000 lacemakers in the region in 1692. Lord Dorset gave a similar figure for all English lacemakers, although this seems a little low. Lorenzo Magalotti, who traveled through England with Cosimo de Medici, wrote of Devonshire that "There is not a cottage in all the county nor in that of Somerset where white lace is not made in great quantities; so that not only the whole kingdom is supplied with it, but it is exported in great abundance."³⁹

In 1589, magistrates in Ghent passed a law to prevent servants from giving up their positions to become lacemakers: only children under the age of twelve who still lived at home were permitted to continue making bobbin lace. A similar law was passed in the southern French city of Toulouse in 1649. So many women were engaged in making lace, the lawmakers grumbled, that finding domestic servants was becoming impossible. Moreover, they reasoned, lacewearing had become so widespread that it was no longer possible to confidently distinguish between "*les grandes et les petites*."⁴⁰ But although wages were clearly tempting, particularly in regions whose lace was suddenly buoyed by the whim of fashion, it was rarely secure employment. The industry expanded and contracted dramatically in response to changing tastes and economic conditions. When Colbert poured resources into the French lacemaking centers in the 1660s, the Italians who had been busily engaged making Venetian gros point found, almost overnight, that there was a good deal less demand for their wares. Lacemakers were also continually in danger of being undercut by the reservoirs of cheap, plentiful labor pent up in orphanages and nunneries.

The gap between wages and the amounts that even the moderately well-off were paying for lace was vast. The account book of James Master, an English country gentleman, shows that while on October 7, 1651, he was happy to pay £3 for a little over a yard and threequarters of "Flanders lace to make me a band and cuffs," three days later he paid his man Richard just £1 and 5 shillings for his quarterly wages. This gulf goes some way to explaining why—contrary to the expectations of the City of Amsterdam—imparting bobbin-lace skill to women did not inoculate the parish from the demands of the poor. A 1597 survey of the poor in Ipswich contained a forlorn entry for Elizabeth Grimstoune, a widow in need of relief from the parish. "She maketh bone lace," the entry reads, at a rate of nine pence a week.⁴¹

Solomon's Coats

Cotton, America, and Trade

8

Runaways

One of our sins as a nation [is] the way we indulged [the slaves] in sinful finery. We let them dress too much. It led them astray. We will be punished for it. A southern lady, overheard in a South Carolina hotel, 1862

In early August 1851, Solomon ran away. At forty-five, he was nearly twice the age of the average runaway, but still strong enough to survive the rigors of the cross-country route from Hollow Springs, Georgia, to a free state farther north. Well-built and of medium height at around five feet eight inches, he had neither noticeably light nor dark skin. He lacked the conspicuous features, such as missing teeth or toes, scars on shoulders or cheeks, that slave owners usually remarked upon. He was, therefore, relatively incognito in his own skin. He had other advantages. As a "first-rate smith" he was likely to find a job elsewhere with ease. Solomon was also taciturn by nature, saying little—"except when intoxicated"—and so less likely to betray himself. He had also planned ahead, taking his entire wardrobe: "two pair new copperas pants, one black jeans frock coat, one red and black sack [coat], one walnut-died [*sic*] sack coat, one black fur hat, one pair store shoes."¹

We know about Solomon and his coats because of a notice the slave owner John Duncan placed for his capture in the *Southern Banner* on August 7, along with the offer of 100 dollars to the person who returned him. The pages of American newspapers during the eighteenth and nineteenth centuries were peppered with such runaway notices, especially in the South. They were generally signposted with a small image of a vagabond with a bundle slung over his back, or a seated black woman wearing a white dress, and were scattered over pages advertising goods, services, or yet more slaves for sale. At first they were placed for any apprentice, servant, or dependant who absconded. (In 1855, the fond husband of Anna Maria wrote that "Whoever returns her will get his head broke.") But soon enough they were dominated by the hunt for the black men and women determined to head north or east, either back to Africa or, later, to England, where they hoped they might find refuge and freedom.²

Runaway ads make curious sources, at once intimate and impersonal. One oddly consistent feature is their preoccupation with clothing. They teem with minute details about the slaves' garments. Preston, sought by John H. Smith in March 1847, was wearing a "gray cloth overcoat, negro cloth pantaloons and a new cloth velvet cap" when he absconded. Another man wore "a very good hat, a pair of white homespun pantaloons, a copperas grounded vest with a blue piece in the back"; one wore shoes with unmatched buckles, another a waistcoat with pewter buttons up one side. Bonna, who ran away the week before Christmas in 1772, was a "new Negro"-that is, had only recently been taken from "Ibo Country, in Africa"-and wore correspondingly "new Shoes and Stockings," the latter being "knit, and spotted black and white." Clothing, in fact, was specified in over three-quarters of the runaway advertisement and was the most popular thing for runaways to take with them, over seemingly more fundamental items such as tools, weapons, money, even food.³

Some of the reasons why runaways like Solomon, Bonna, and Preston preoccupied themselves with clothing were highly practical. Slave owners, if they bought clothes or fabrics for their slaves, looked for two things in their purchases: longevity and price. And, as a rule, they bought in bulk. John Ray, an owner who kept meticulous records in a plantation book, was likely typical in purchasing slave clothing yearly. For example, he bought thirteen pairs of "Negro shoes" at \$1.06 a pair in 1853. Frequent advertisements tempted slavers with "NEGRO CLOTHING ... sold low, for cash," bales of "cheap Negro cloth" or "very cheap Cotton pantaloons" at "cheapest prices." As a result many slaves, particularly field hands, wore a distinctive and near-identical array of drab, hard-wearing clothing. (A notice in 1767 for a slave less well-prepared than Solomon specified only that the runaway wore "the usual clothing of labouring Negroes.") In a city or a free state, such meagre, low-status garb would mark the wearers as runaways at a glance.⁴ Clothing could also function as a form of currency, either exchanged for other garments or for cash, helping to finance a slave's flight.⁵

But the clothing also served a subtler function. This was an era with a rich visual culture-perception, seeing and being seen, were key to consumption. "Our sight," wrote Joseph Addison, the English essavist and politician, "is the most perfect and delightful of all our Senses." Those of lower social status were, on the one hand, supposed to be visually distinct from those higher up the social orders, while, on the other, remain inconspicuous. In paintings and prints, where they are included at all, slaves are either scattered around picturesquely doing their work, or depicted in obviously secondary, subservient roles. Take Edouard Manet's Olympia, painted in the midnineteenth century and first exhibited in Paris in 1865. While it transgressed conventional mores in one way-depicting a prostitute boldly meeting the viewer's gaze-the black servant remains in the background, uncomfortably crouched so as not to loom over her white mistress, humbly offering her a bouquet of flowers. A majority of written sources share this skewed vision. Travel journals, diaries, and letters consumed and composed by wealthy whites skim over servants and slaves, mentioning them most frequently when they transgressed, becoming, by these "lapses," suddenly visible.6

It was during this period, and in part because of the economics of the slave trade, that cotton became the preeminent fabric of the west. From this time until the late 1970s, when synthetics gained ascendancy, cotton accounted for the majority of fibers used globally. From the workaday T-shirt and jeans of the beatniks to the most inflated thread-count sheets in luxury Tokyo hotels, cotton is a default fabric choice and one of the most common mediums through which we materially express our status and identity. This was also the case for the people taken from Africa to the Americas to be slaves: it gave them a means to claw back some measure of self-respect and individuality. Cotton—one of the cornerstones of the Atlantic slave trade—was simultaneously a medium through which identities were crafted and asserted.⁷

Cotton was a common crop throughout Africa. The great Andalusian Arab traveler Al-Bekri, who visited Mali as early as 1068, wrote that "Every house had its cotton bush ... [and] cloths of fine cotton" were traded by locals for salt, millet, fish, butter, indigo, and meat. Olaudah Equiano, who purchased his freedom in 1766 after years of enforced labor and went on to become an author and a prominent antislavery advocate, wrote one of the few accounts that mentions his clothing prior to capture. The garb of both sexes in Guinea, he wrote, consisted of "a long piece of calico, or muslin, wrapped loosely round the body, somewhat in the form of a Highland plaid." Then, as now, there was a great variety of cloth and clothing across the continent, with garments determined by means and custom. In the 1930s, an African American called Chaney Mack recalled that "it went purty hard" with her father, brought over at the age of eighteen, "having to wear clothes, live in houses and work"-the implication being that he was used to wearing nothing at all. (This is likely her own interpretation of living conditions in her father's home country, rather than the reality.) Elsewhere, just as some Europeans embraced chinoiserie, some African elites, particularly those living near coastal trading posts, wore European-style clothes as a status symbol, signaling their own knowledge of exotic foreign tastes.8

Once slaves, however, no matter what their preferences, they were stripped and forcibly dressed in the clothes suited—in the minds of those who traded them—to their status. The clothes a slave officially wore thenceforth depended on the means and inclinations of the owners. One large plantation routinely gave adult field hands seven yards of coarse osnaburg, three of check cloth, and three of woolen baize each October, leaving them to actually make the clothes themselves. Slaves destined to work inside (and who would therefore be more visible) were generally better dressed. Some owners bought ready-made clothes; others all but left their slaves to fend for themselves. "In hottest summer and coldest winter," Frederick Douglass recalled after his escape to freedom, "I was kept almost naked—no shoes, no stockings, no jacket, no trousers, nothing on but a coarse tow linen shirt, reaching only to my knees. . . . My feet have been so cracked with the frost, that the pen with which I am writing might be laid in the gashes."⁹

In 1735, a law was passed in South Carolina that limited the materials slaves could wear to the cheapest, meanest available. While this was often flouted, it's true that the same fabrics crop up in descriptions again and again. "Negro cloth," mentioned frequently, generally referred to white Welsh plains, a cheap woolen cloth imported from Britain, sold at around eighty cents per yard in the early nineteenth century. Other common fabrics for men's clothing included broadcloth, jean, and osnaburg. Broadcloth was, like plains, made from wool, but jean and osnaburg were usually made from cotton. The latter was a coarse, plain-woven fabric; jean was a twill weave, making it more durable and giving it characteristic diagonal ribs. (Confusingly, jeans as we know them today are usually made of denim, a different fabric.) The most frequently mentioned fabric, however, was homespun. This, as the name suggests, was made either by the slaves themselves on the plantation or by a nearby supplier and was a plain weave of either wool or cotton, depending on what was most readily and cheaply available. Women wore gowns of homespun or of calico, another plain woven cotton usually decorated with a small-scale pattern, stripes, or checks. The commonest colors were brown and blue-both of which could be obtained from dyectuffe available nearby, such as indigo and walnut-the latter used to color one of Solomon's coats-and white.10

Writing in the Southern Watchman in 1855, for example, a Dr. Terrell contended that, while a slave was provided for, a laborer "must save enough to buy his clothes . . . and he must have his clothes washed and mended." This neatly ignored the dehumanizing effects of an imposed uniform made from the dreariest and cheapest fabrics available. White Americans, for all the rhetoric about modest dressing and the sin of vanity, eschewed these materials whenever they could.

Clothing was, in other words, another landscape over which the dynamics of power were played out. Rough and coarse rather than smooth; loose rather than fitted; dingy rather than brightly colored; scratchy rather than soft; lustreless rather than sheened, slave clothing as procured and defined by whites visually demarcated their low status. At least, that was the intention. In practice, slaves not only proved eminently capable of obtaining clothing theoretically forbidden to them, but also of carefully and intentionally carving out an aesthetic altogether their own.¹¹

Doing so meant getting their own clothes or at least visually

distinguishing themselves. Many, for example, were disinclined to wear white because it was so associated with slave clothing. (This was leveraged by perceptive slave owners. In the 1780s, the Reverend Henry Laurens wrote that any "Negro who has behaved remarkably well" should be given "something better than the white plains.") A similar prejudice existed against shirts made from osnaburg, this being the archetypal garment of field hands. Those emancipated reveled in their sartorial as well as their literal freedom. Olaudah Equiano immediately began giving and attending dances, to which he wore "superfine blue cloathes," in which, he wrote proudly, he "made no indifferent appearance."¹²

Those still enslaved expended considerable energy to collect desirable clothing of their own. Some came from the owners. Cast-offs were given or loaned for special occasions to reward favorites and to distinguish "house" slaves from field hands. While officially such practices were disapproved of, and even expressly outlawed, in practice it was commonplace. Harriet Jones wore "one of my Mistis dresses wid a long train," accessorized with a scarlet sash, for her wedding. Preston, a slave who featured in a runaway advertisement in March 1847, was the owner of a "new cloth velvet cap," which may well have been a gift.¹³

Others, figuring they may as well be hanged for a sheep as for a lamb, took whatever they could lay their hands on when they escaped. Rosa, an eleven-year-old from New Orleans, made off with her owner's white silk hat, some handkerchiefs, lace tippets, and "infant's clothing," most of which she may have intended to sell for cash to fund her flight. In other cases, it seems more likely that the garments taken were ones that had long been coveted. In 1814 Celia, a slave from Tennessee, took two calico frocks, one blue and the other yellow, a white cambric dress, two homespun dresses, a checked gingham bonnet, and, most intriguingly of all, a pair of "red morocco-eyed slippers" tied with yellow ribbons. Bacchus, a personal servant who fled Gabriel Jones's Virginia plantation on June 13, 1774, went all out.

[He] had on, and took with him, two white Russia Drill Coats, one turned up with blue, the other quite plain and new, with white figured Metal Buttons, blue Plush Breeches, a fine Cloth Pompadour Waistcoat, two or three thin or Summer Jackets, sundry Pairs of White Thread Stockings, five or six white Shirts, two of them pretty fine, neat Shoes, Silver Buckles, a fine Hat cut and cocked in the Macaroni Figure, a double-milled Drab Great Coat, and sundry other Wearing Apparel.¹⁴

That so many black men and women owned and wore good clothing was a source of consternation to whites, upsetting their sense of the settled order of nature and society. Slave owners scoffed at slaves who they believed showed too fond an interest in their appearance. But they were unnerved too. An anonymous correspondent writing for the *South Carolina Gazette* in November 1744 complained that "many of the Female Slaves [arc] by far more *elegantly* dressed, than the Generality of *White Women* below Affluence."¹⁵

Plantations were filled with black women obliged to make thread, dye, fabric, and clothes for themselves and the other slaves who worked there. Tempe Herndon Durham, a former slave who was interviewed as part of the North Carolina Narratives project, vividly recalled their skills:

De cardin' an' spinnin' room was full of niggers I can hear dem spinnin' wheels now turnin' roun' and sayin' hum-m-m-m, hum-mm-m, an' hear de slaves singin' while dey spin. Mammy Rachel stayed in de dyein' room. Dey wuzn' nothin' she didn' know 'bout dyein.' She knew every kind of root, bark, leaf an' berry dat made red, blue, green, or whatever color she wanted . . . an' when she hang dem up on de line in de sun, dey was every color of de rainbow.¹⁶

What could be a source of pride to those working on plantations, however, was rarely appreciated by whites, who found the effect—often a mix of colors and styles—discordant and garish. Differences were accentuated at large, celebratory social occasions, such as dances, church-going, and weddings, when black people were observed indulging in sartorial display suited to their own tastes. At a carnivalesque slave festival in Albany in the late 1790s "King Charles," a slave who officiated these events, paired a British scarlet military jacket decorated with gold lace with yellow buckskin small-clothes and blue stockings.

Patching and darning-a necessity when slave owners usually

only provided one or two sets of clothes for their slaves each year became stylish among slaves. Solomon's "red and black" sack may well have been parti-colored because it had been patched or mended. Certainly, the adding of sections to let out clothes with no attempt to use a matching fabric was too common to be unintentional. One runaway ad, for example, mentioned a jacket "with more blue in the fore part than back."¹⁷

White observers were unsettled to see an entirely separate set of rules in play. Fanny Kemble, wife of a Georgia plantation owner in the late 1830s, recalled the "sabbath toilet" of their slaves as a "ludicrous combination of incongruities . . . every color in the rainbow, and the deepest possible shades blended in fierce companionship."¹⁸

In buying, acquiring, coveting, adapting and styling clothing, slaves were participating in a cycle of consumption and display parallel to that of white Americans and often incomprehensible to them. But this was not the only way in which slaves like Solomon were enmeshed in a global industry centering on the growth and production of cotton.

Vegetable Wool

Wild trees bear fleeces for their fruit surpassing those of the sheep in beauty and excellence, and the natives [of India] clothe themselves in cloths made therefrom.

Herodotus, 445 BC

Although eighteenth-century Europeans thought of cotton as an upstart, it already had a long history. Using DNA sequencing, scientists estimate that cotton—or *Gassypium*—has grown on earth for between ten and twenty million years. It is a very particular plant. It

prefers warm temperatures of around sixty degrees with little to no frost and around twenty to twenty-five inches of rain each year, pref erably concentrated in the middle of the growing period. These preferences limit it, for the most past, to a band around the globe roughly between thirty-two degrees south to thirty-seven degrees north, taking in arid regions in Africa, Australia, Asia, and Central and South America. In total, there are around fifty *Gossypium* species, which vary in height and size. Different strains are native to different regions: *G. hirsutum* in Central America, *G. barbadense* in South America, *G. herbaceum* in Africa, and *G. arboretum* in Asia.¹⁹

Whatever its other attractions, humans usually focus on one part of the cotton plant. Between 160 and 200 days after being planted, each plant produces a seed-pod or bol, in which the seeds are encased in pale strands of cellulose fiber. When ripened, the bols break open to flaunt fluffy white innards like giant kernels of popped corn.

It is likely that humans first worked out that they could use these fibers to make textiles and cordage in the Indus Valley. The calliest proven intentional use we know of was, like the flax fibors in the cave at Dzudzuana, stumbled across accidentally. Archaeologists were examining minute beads found in a Ncolithic grave at Mehrgarh, in what is now central Pakistan. Lying between the mountains and the Indus River, the site was a strategically important one, continuously occupied from the seventh millennium until the first millennium BC. The beads thought to be the remains of a bracelet—were only a couple of millimeters in diameter and made from copper. When they were examined through a microscope tiny traces of mineralized organic fibers were found snagged around the apertures. The metal had reacted with the threads that had been pulled through them, preserving microscopic traces of cotton that had been woven during the sixth millennium BC.²⁰

Sophisticated cotton textiles have been produced in Asia, Africa, and the Americas for millennia. In 2016 fragments of indigo-dyed woven cotton textiles, some of which were up to 6,000 years old, were found at Huaca Prieta in north Peru, preserved by the hot dry air. Cotton was so relied upon for the fiber it produced that it was one of the first plants to be domesticated, some 7,000 years ago. Domestication, as is its wont, changed the form of the plant itself. Sprawling, tall, wild species became, over time, smaller, more compact, and easier to harvest. Notwithstanding such adaptations, cotton remains difficult to farm. Not only does it have exacting requirements, it is also—particularly up until the invention and wide-spread use of machinery—incredibly labor-intensive to harvest.²¹

Traditionally harvesting and sorting was done by hand. Fibers too short to be useful—called fuzz—are discarded, while the longer ones—lint—are ginned, a process that removes the seeds from the cotton without breaking the delicate fibers.²² Knots and dirt are then removed and the fibers struck with a wooden bow to soften and make them more flexible. They are then carded, or combed, to separate and make them lie parallel, before being spun onto a distaff using a spindle. The thread is then ready to be woven into fabric. In almost every culture globally, it was women who were in charge of spinning cotton; weaving was less strictly gendered. In India and southeastern Africa, for example, it was often done by men.²³

One of the seeds for the great American cotton plantations was sown with Vasco da Gama's discovery of a direct sea route to India in 1497. Circumnavigating the Cape of Good Hope, although difficult and dangerous, was lucrative: it gave European traders direct access to Indian weavers and their wares rather than relying on the more expensive and dangerous overland trade routes. The delicate patterns and use of color characteristic of Indian textiles became immensely fashionable among Europeans. Daniel Defoe, who was not a fan, bemoaned it in the *Weekly Review* in 1708. Indian calicoes, he wrote: "crept into our houses, our closets and bedchambers; curtains, cushions, chairs, and at last beds themselves." By 1766, muslins and calicoes were so fashionable that cotton constituted 75 percent of the British East India Company's exports.²⁴

Cotton fabrics were also being used by traders as grist in the mill of another market: the slave trade. The newly established and largescale plantations of the Americas desperately needed cheap, abundant labor to make them profitable. With local populations decimated by disease and the remainder openly hostile to would-be farmers, a fresh labor had to be found. Slaves taken from existing trading posts on the west coast of Africa were deemed the ideal solution. Between 1500 and 1800, over eight million people were transported from Africa to the Americas by the Spanish, Portuguese, French, British, Dutch, and Danish to serve as slaves. The British merchant Malachi Postlethwayt was hardly exaggerating when in 1745 he wrote: "Is it not notorious to the whole World, that the Business of *Planting* in our *British colonies*, as well as in the *French*, is carried on by the Labour of *Negroes*, imported thither from *Africa*? Are we not indebted to those valuable People, the *Africans*, for our *Sugars*, *Tobaccoes*, *Rice*, *Rum*, and all other *Plantation Produce*?"²⁵

While it is often assumed that the currencies used to buy slaves were weapons or precious metals, a great many more were exchanged for cotton cloth. A study of the trades done by Richard Miles—a British slaver—between 1772 and 1780 for 2,218 slaves found that textiles amounted to over half of the value of goods exchanged. At first the cloth was bought from India; later, raw cotton was imported to Europe where it was woven with designs tailored for the African market. This was big business. Between 1739 and 1779, for example, Manchester's export trade expanded from a negligible \pounds 14,000 to \pounds 300,000 per annum: roughly a third of this was bound for Africa to be exchanged for slaves.²⁶

At first, Europeans found it difficult to satisfy African traders' demand for cloth themselves. They were discerning buyers, valuing bright, striped, checked, and patterned cotton cloths of the kind traditionally made in India and very different from those produced in Europe. It was a steep learning curve. Europeans scrambled to create saturated, colorfast dyes and designs that could pass muster. (The imitations they did create were often called, disingenuously, "*indi-ennes.*") Key to their eventual success was a steady stream of technological innovations that made spinning and weaving faster, more efficient, and, crucially, cheaper, finally allowing them to compete with and eventually supersede Indian-made cotton textiles.

An early example of such innovation was the flying shuttle, invented in 1733 by John Kay. This very small, aerodynamic piece of wood quickly propelleded the shuttle from one side of the loom through the serried ranks of the warp—to the other, dragging the weft threads with it as it went. This increased the speed of weavers so dramatically, that afterward it took four spinners to supply just one weaver. To correct this imbalance, inventors focused on improving the speed of spinners. In 1764 James Hargreaves created the spinning jenny; five years later came Richard Arkwright's water frame; and a decade after that, the steam-powered mule was set in motion by Samuel Crompton. All exponentially improved the quantity of spun yarn. In 1785, Edmund Cartwright's power loom became the first steam-powered weaving machine.

So much labor- and time-saving mechanization meant that, for the first time in history, cloth-making was being taken from hands and homes and transferred to machines and factories.²⁷ For industrialists and merchants, of course, this made financial sense. While Indian spinners needed 50,000 hours to spin 100 pounds of raw cotton into thread by hand, a mule could accomplish the same task in a fiftieth of the time. The cost of yarn and cloth was therefore driven down, making European cloth competitive in the international market. Britain in particular invested heavily in new technology for cotton manufacture. By 1862, the country was home to two-thirds of the world's mechanical spindles; between one-fifth and one-quarter of her population was involved in the industry and almost half of all her exports were yarn or cloth. In 1830 a pound of British No. 40 yarn (a fine grade of thread) was three times cheaper than its Indian counterpart. Eventually, it became cheaper for subcontinental weavers to buy and use thread imported back from England.28

Fortunes were made by manufacture and trade of cotton. Samuel Touchett, for example, blossomed from Manchester cotton-cloth manufacturer to wealthy and influential MP and political operator, able to contribute £30,000 to a government loan in 1757. His wealth and career were largely founded on producing checked "Guinea cloths" for the African slave market.²⁹ His home city also prospered, even as its proliferating factories coughed out ever more smog. Alexis de Tocqueville, a French diplomat and social commentator who visited the city in 1835, encapsulated the paradox: "From this filthy sewer," he wrote, "pure gold flows."³⁰

The only limiting factor on this tide of wealth was the supply of raw cotton. For most of its history, cotton farming had been an addendum to household incomes. Farmers planted cotton alongside other crops, usually foodstuffs, which spread their risk: if one crop was attacked by blight or succumbed to some other natural menace, another might still

survive and sustain them. And, if their cotton failed entirely, then they would at least still be able to feed themselves. This made perfect sense for individual farmers, but it also meant that the transformation of the cotton lint into fabrics was usually done on a small, uncoordinated scale, fitting in around other household priorities and seasonal rhythms. Weavers and spinners controlled their hours, who they worked for, and the prices their work commanded, even if they had to give over some of their work as payment in kind for taxes or tributes. This did not suit colonialists, whose cotton-hungry factories needed reliable, large-scale farms dedicated to producing this one crop that could then be transformed into cloth and exchanged for money and slaves. Mills in Manchester and elsewhere continued to work efficiently only while there was a steady supply of cotton. Prior to the 1780s, achieving this supply had meant shipping it in from all over the world. Liverpool's docks were chocked with cotton from India, the Levant, the West Indies, and Brazil.31

Winners and Pickers

The increase of that new material [cotton] must be of almost infinite consequence to the prosperity of the United States.

George Washington, letter to Thomas Jefferson, 1789

On March 4, 1858, a Democrat from South Carolina took to the floor of the United States Senate and gave a speech still remembered to this day. "[W]ould any sane nation," he asked, "make war on cotton?... England would topple headlong and carry the whole civilized world with hcr, save the South. No, you dare not make war on cotton. No power on earth dares to make war upon it. Cotton is king."³² The use of power to force concession from those weaker than yourself was something James Henry Hammond was familiar with. He was fifty-one, balding, double-chinned, and, despite his position in the Senate, a social pariah. Fifteen years earlier it had been revealed that he had abused four teenage nieces. (Their reputations were ruined thereafter; none ever married.) There was an unusually high mortality rate on his plantation. In the ten years from 1831 to 1841, seventy-eight slaves—over a quarter of those inherited from his father—died. He had a long relationship with Sally Johnson, an eighteen-year-old he had purchased, and, once she turned twelve, Sally's daughter Louisa. Both bore his children; all remained enslaved. "In all social systems there must be a class to do the menial duties," he told his Senate peers during the same piece of oratory, "to perform the drudgery of life . . . Fortunately for the South, she found a race adapted to that purpose to her hand."³³

It has been estimated that in 1862, four years after Hammond gave his King Cotton speech, twenty million people worldwide—one out of every sixty-five people living—were involved in the cotton trade, either growing or transforming it into cloth. Even as Hammond spoke, raw cotton constituted just over 60 percent of the total value of all American products shipped abroad and Britain, as he pointed out, had become hopelessly hooked on this supply. By the late 1850s nearly 80 percent of the cotton consumed in Britain came from America.³⁴

Cotton was grown in the Americas well before Europeans set foot there. One of the reasons why Christopher Columbus was so convinced that he had reached India in 1492 when he was, in fact, in the Caribbean, was that the islands were filled with cotton shrubs. On his first encounter with Arawak men and women, he wrote in his log that: "They brought us parrots and balls of cotton and spears and many other things." Francisco Pizarro too, when he reached the Inca Empire in what is now Peru in 1532, was impressed by the quality of textiles they produced, remarking that they were: "far superior to any they had seen, for fineness of texture, and the skill with which various colours were blended."³⁵

As elsewhere, however, up until the late eighteenth century, cotton remained one of many crops grown on a relatively small scale. Then American plantation owners, sensing opportunity in England's voracious appetite for raw cotton to supply her factories, began giving over vast new areas to intensive cotton farming in anticipation of equally

vast profits. An earlier limiting factor for such large-scale farming had been the relatively small area suitable for Sea Island Cotton. This variant grew well only in coastal regions and the Caribbean and had a long staple length that was easy to harvest and gin. The cotton that grew best inland, however, was G. hirsutum, now known as American Upland. At only two or three feet this is a shorter shrub than Sea Island, and has capacious, well-filled bols. The problem is that the fibers these bols contain are shorter and very tightly bound to the seeds, making the use of traditional gins time-consuming and unprofitable. A solution, however, was soon proffered. Eli Whitney, a young Yale graduate, learned of the difficulties of ginning American Upland while staying on a friend's plantation in Georgia in 1793. Within a year he had created a new kind of gin that efficiently combed out the seeds without breaking the delicate cotton fibers, secured a patent, and set up a factory in Connecticut to manufacture them en masse. With one hand-operated gin, a single person could clean fifty pounds of Amorioan Upland cotton in a day.36

The effect of the expanded planting of cotton and the introduction of the new gin was dramatic. In 1790 South Carolina was exporting just under 10,000 pounds of cotton; in 1800, seven years after the invention of the gin, this had increased to 6.4 million pounds. More cotton plantations, each with the capacity to produce and process a far bigger crop, meant more slaves. The slave population of Georgia nearly doubled in the 1790s to 60,000 and in South Carolina the number in the new cotton-growing regions more than tripled, swollen by the addition of 15,000 shipped from Africa. The trend continued. Soon enough, the white farming population of the South was completely dwarfed by that of their slaves. In 1860, the fifteen Southern states had 819,000 white male farmers, set against a slave population of 3.2 million. In some South Carolina districts, slaves made up 61 percent of all inhabitants.³⁷

For the author of an editorial in *The American Cotton Planter*, written in 1853, slavery and cotton formed the warp and weft of America's success. "[T]he slave-labour of the United States, has hitherto conferred, and is still conferring inappreciable blessings on mankind," they wrote. "If these blessings continue, slave-labour must also continue, for it is idle to talk of producing Cotton for the world's supply with free labour."³⁸

Of course, cotton had been produced for many thousands of years without slave labor and would, after the abolition of slavery, endure. But it was certainly the case that from the 1790s until the 1860s, the lives of many millions of American slaves were determined by the demands of king cotton.

John Brown was one of them. He was born around 1810 in Virginia. He was known sometimes as Benford—the name of his father's owner—and sometimes as Fed, but John Brown was the name he later took for himself and under which he published his memoir. His entire life was threaded through with cotton and the money to be made from it. He was nine when he and his siblings were split up by lot and he was sent to work on the plantation of James Davis, a small, thin man with "a very cruel expression" and a disposition to match. "He would make his slaves work on one meal a day, until quite night, and after supper, set them to burn brush or spin cotton." He later wrote, "We worked from four in the morning till twelve before we broke our fast, and from that time till eleven or twelve at night.³⁹

Not long after his arrival at Davis's plantation, "a considerable rise in the price of cotton" led to a corresponding "great demand for slaves in Georgia," and he was sold to a dealer. Prices were determined by weight: he fetched 310 dollars. Sometime later he stayed with one man—"a very bad master, but a very good preacher"—famed for having "the fastest cotton-picking negroes in the whole county." (This dubious accolade was earned by being set against their peers at rival plantations while owners bet on the outcome.) During his time as a slave he ploughed the fields for cotton, sowed it, plucked the worms from it, hoed around it, and picked the fluffy bols from it.

Although he never saw the profit from his labor, the money to be made from cotton determined the rhythm of his days. "When the price rises in the English market," he wrote, "even by half a farthing a pound, the poor slaves immediately feel the effects, for they are harder driven, and the whip is kept more constantly going."⁴⁰

Field hands like Brown would work for long hours on short rations, work that was particularly punishing at picking time when the fields suddenly appeared snow-bound and the crop was at its most vulnerable. Great speed was required, so the length of the working day increased. Moving down the rows, each soft white ball needed to be firmly grasped and twisted to detach it from the outer bol, now split open and star-shaped. Women, according to John Brown, picked faster than men, "their fingers being naturally more nimble," but since all were forced to carry what they picked, as the baskets got heavier, the women would lag behind under their weight. Each basket shaped like a hamper—could carry between 85 and 125 pounds.⁴¹

In 1863, during the Civil War, Abraham Lincoln signed the Emancipation Proclamation, which—on paper at least—granted over three million enslaved African Americans their freedom. Despite the fears of many in the South, the cotton industry continued to grow and those growing it continued to prosper. One reason for this was the continuation, in one form or another, of enforced labor. Another was the development of a home-grown cloth industry. By the time of the Civil War, many plantations had begun to turn their own cotton crop directly into textiles, rather than exporting it and letting British mills reap the profits. Planters-turned-mill owners could sell finished cloth far cheaper than that chipped over from England. Soon enough, as the domestic market began to grow and flourish, American cotton gained its own independence from British merchants and the Atlantic slave trade.⁴²

The Canadian Tuxedo

I wish I could invent something like blue jeans. Something to be remembered for.

Andy Warhol, 1975

The city of Elko, Nevada held their fourth annual Silver State Stampede rodeo on June 30, 1951. It was a boisterous affair. The breeze carried competing scents of sugar, hot oil, horse sweat, and bravado. In the crowds, women in heeled sandals and cotton dresses linked arms with khaki-clad servicemen; small boys in collared shirts and turned-up Levi's ogled the bucking cowboys they hoped they would one day emulate. When it came time for speeches, Bing Crosby, the singer, actor, and guest of honor, strode through the crowd grasping a pipe between his teeth and wearing a broad smile, an even broader cowboy hat, and an extraordinary jacket made from indigo-dyed cotton.

The jacket was brand new and so stiff that Bing had to wrestle onehanded with the buttons as he walked: it was too warm to wear it closed. Although he wore it with pride, its creation had been precipitated by a social humiliation. On a recent hunting trip to Canada, Crosby had been asked to leave a Vancouver hotel by a desk clerk because of his casual attire: he had been wearing Levi's waist overalls or, as we would call them today, jeans. (Luckily, he had finally been recognized by a bell-hop whilst being firmly escorted off the premises.)⁴³

The brand, hearing of the incident and ever-mindful of a marketing opportunity, made the singer a playful take on a tuxedo jacket, with thick, pale lapels, a corsage fashioned from their trademark red tabs and copper rivets, and a tongue-in-cheek label inside:

NOTICE TO HOTEL MEN EVERYWHERE. This label entitles the wearer to be duly received and registered with cordial hospitality at any time and under any conditions. Presented to BING CROSBY.

Denim occupies a special place in the modern psyche. The anthropologist Daniel Miller began an informal experiment each time he went abroad for a conference—his work took him to places as culturally diverse as Seoul, Rio de Janeiro, Beijing, and Istanbul—he would count the first hundred people he saw on the street and make a note of how many wore blue jeans. It was usually over half. More rigorous studies confirm his findings. In 2008, people globally wore jeans three and a half days each week. Germans were particularly keen, wearing them, on average, a little over five days a week and owning nearly nine pairs. Americans had an average of seven or eight pairs and wore them for four days each week. In Brazil, where 14 percent of respondents said they had ten or more pairs, 72 percent of respondents looked forward to wearing them. Even in India, where denim doesn't have nearly the same reach, 27 percent admitted that they loved donning their jeans.⁴⁴

The attraction to blue jeans is complex. Crosby likely wore them because they were comfortable and casual—his Nevada ranches were his escape from Hollywood glitz—but they also had deep cultural resonance. They evoked cowboys, the western states, and a certain kind of rugged individualism that bespeaks hard work, democracy, and freedom: a uniform in which one might attain the American Dream. Simultaneously, as the attitude of the Canadian desk clerk suggests, they also made fine targets for snobbery.

The reason for this prejudice lies in their origins as the humblest and hardiest of workwear. Levi Strauss, the man responsible for their commercial success, emigrated to New York from Bavaria in 1846. He traveled west to San Francisco as part of the Gold Rush six years later, and set himself up as a merchant under his own name selling dry goods to miners and other manual laborers. His big break came courtesy of a tailor from Reno called Jacob Davis, who had begun using metal rivets to reinforce the weakest points of his overalle at the edges of pockets and the bottom of the fly—where they would otherwise rip with prolonged wear and rough usage. "The secratt of them Pents is the Rivits that I put in those Pockots. I cannot make them up fast enough . . . My nabors are getting yealouse of these success."⁴⁵

On May 20, 1873, the pair were granted patent #139,121 and their extra-tough overalls went into production. At first they were offered in two fabrics: a heavy brown cotton similar to canvas, and denim, a tough, twilled fabric with a sturdy white warp over-woven with a weft colored with indigo. (This is why denim is paler on the reverse, where the warp threads show.) It was already a well-established favorite for work clothes and the more popular of the two.

The name likely comes from its place of origin: it was originally a thick woolen serge cloth from the French city of Nîmes. Over time, the cloth was increasingly made elsewhere using cheap cotton and the words "serge de Nîmes" were mumbled down to "denim." It was an early favorite of American mills: in 1864 East Coast wholesalers advertised ten varieties, including "New Creek Blues" and "Madison River Browns."

Levi's waist overalls were an immediate success. The firm made

much of their toughness: the leather patch sewn on the rear showed two horses trying and failing to pull a pair apart. By the 1920s they were the leading men's work clothes in the western states: in 1929, the same year the stock market crashed, Levi's posted sales of 4.2 million dollars. It was during the 1930s that the cultural capital began to accrue. Romanticised Westerns featuring stars like John Wayne captured the American and even global imagination: jeans were an essential part of the cowboy wardrobe. East coasters, nostalgic for a Wild West and noble ranch life they had never known, would buy them as souvenirs. Abroad, jeans were equally sought after. British teenagers clustered at the docks when merchant navy ships arrived, hoping to persuade American sailors to part with a precious pair of Levi's.

It was during the late 1940s, as soldiers began returning from war in Europe, that jeans became more subversive. In a prosperous, conformist era when everyone was expected to settle down and procreate in the suburbs, there was growing anxiety about rough young men who showed no desire to be penned behind picket fences. Hollywood once again played a pivotal part. After 1953, jeans topped with leathers suddenly evoked town-terror Marlon Brando in *The Wild One*. Paired with a T-shirt and red windbreaker they were James Dean in *Rebel Without a Cause*; with a humble cotton shirt they became the uniform of the turbulent, troubled ranch man Dean played in *Giant.*⁴⁶

Denim was transfigured in the public imagination from the wardrobe of the Marlboro man into an emblem of motorcycle boys and juvenile delinquents: editorials scaremongered and schools rushed to outlaw jeans. Fearful that the bad-boy reputation might depress sales, in 1957 Levi's ran an on-the-nose advertisement in newspapers showing a clean-cut lad—the inverse of Dean's rebel—wearing jeans above the slogan "Right for School." The firm received hundreds of complaints. "While I have to admit that this might be 'right for school' in San Francisco, in the west, or in some rural areas," one woman from New Jersey wrote, "I can assure you that it is in bad taste and <u>not right for School</u> in the East and particularly New York . . . Of course, you may have different standards."⁴⁷

Levi's needn't have worried. In 1958 a newspaper reported that "about 90 percent of American youths wear jeans everywhere except in bed and in church." Sixteen years later, in an essay for *Rolling* Stone, Tom Wolfe noted a similar phenomenon at Yale. Where once the college had been a bastion of preppy slacks and jackets, in 1974 there were "more olive-green ponchos, clodhoppers, and parachute boots... bike leathers and more jeans, jeans, jeans, jeans, jeans, more prole gear of every description." To further ram the point home, the article was illustrated with a design of a stitched back pocket, complete with Levi's tab.⁴⁸

In decades since, the allure of jeans has remained undimmed, even while styles and the fortunes of individual companies have changed dramatically. Levi's nimbly rode the first youthquake wave: their sales increased tenfold—from 100 million to 1 billion dollars—between 1964 and 1975. Thereafter, as successive subcultures put their own spin on the jean, customers proved fickle and the essence of cool more elusive. In the mid-1990s, underestimating the lure and longevity of baggy styles, the world's biggest purveyor of jeans experienced a 15 percent sales decline, forcing them to close factories and lay off staff. "Our role," the company's forty-year-old youth-marketing expert told the *New York Times* during a public-relations blitz in 1999, "is to be what's cool at that particular moment. The problem, however . . . is that what's cool to one kid is not necessarily cool to every single other kid."⁴⁹

One concrete effect of the production of so many styles is the voracious consumption of cotton. Even now, when synthetics occupy a greater proportion of all the fibers used globally, cotton retains a 25 percent share. And while the tide is beginning to turn against plastics of all kinds—including fabrics—cotton retains a natural allure. But scratch the surface and cotton is hardly the stuff of environmental dreams. In the 2016–17 season, an estimated 106.5 million bales of cotton, each weighing 480 pounds, were produced around the globe, requiring nearly 3 percent of the world's arable land. In 2011 demand outstripped supply, leading to an acute shortage. Cotton prices rose to \$1.45 per pound, the highest in the history of the New York exchange, higher even than the price reached during the embargo imposed by the South during the Civil War in the 1860s. In response, farmers planted more, but not before speculators had caused a panic on the stock market.⁵⁰

The economics of cotton continue to have a profound effect on the lives of many people worldwide. The United States is the world's third largest producer—behind India and China—producing 3.7 million metric tons in 2016–17. Forced labor persists under the fig leaf provided by the thirteenth amendment, which forbids slavery and involuntary servitude, "except as punishment for crime whereof the party shall have been duly convicted." With just over two million people currently incarcerated in America, this makes for a large, cheap, and racially skewed labor force, a proportion of whom care for cotton crops, almost entirely unremunerated. Prisoners, in other words, can be compelled to work, uncompensated or for a token amount, and, if they refuse, punished. The financial incentives are clear. A federal program earned 500 million dollars in sales in 2016; a Californian scheme generated 232 million dollars.

Transmuting cotton into usable fabric is also wasteful: a single pair of jeans requires 11,000 litres of water. Moreover, the majority of indigo used is now synthetic: chemicals used and released during manufacturing and dyeing often end up in rivers and streams.⁵¹

In his 1976 essay "Lumbar Thought," the Italian philosopher Umberto Eco argued that the modern obsession with denim was limiting, rather than freeing. He found that the fitted shape of his jeans, and the way they constricted his movement, changed the way he carried himself. "As a rule I am boisterous, I sprawl in a chair, I slump wherever I please, with no claim to elegance: My blue jeans checked these actions, made me more polite and mature. I lived in the knowledge that I had jeans on . . . It's strange that the traditionally most informal and anti-etiquette garment should be the one that so strongly imposes an etiquette."

To him denim was an armour, which made its wearers focus on how they appeared in the world around them: on exterior things rather than interior. He empathised with any woman "enslaved chiefly because the [constrictive] clothing counseled for her [by society] forced her psychologically to live for the exterior . . . And this makes us realize how intellectually gifted and heroic a girl had to be before she could become, in those clothes, Madame de Sévigné, Vittoria Colonna, Madame Curie, or Rosa Luxemburg."

The story of cotton is varied, from the part it played in the slave trade to technological revolutions; we may have domesticated cotton millennia ago, but perhaps in the final reckoning, it may be that cotton has had a greater impact on us.

9

Layering in Extremis

Clothing to Conquer Everest and the South Pole

Of Fur and Burberry

Polar exploration is at once the cleanest and most isolated way of having a bad time which has been devised. It is the only form of adventure in which you put on your clothes at Michaelmas and keep them on until Christmas.

Apsley Cherry-Garrard, The Worst Journey in the World,1 1922

"The worst has happened," Robert Falcon Scott wrote in his notebook on Tuesday, January 16, 1912, "or nearly the worst." The day had started well: Scott and his four companions had managed a respectable 71/2 miles through thick onow and temperatures 10°F below freezing. They had been hauling, skiing, and dogsledding in poor conditions for two and a half months and over 1,800 miles. They were frostbitten and fatigued, drawn on only in the hopes of being the first men to reach the South Pole. On that day their goal was just a scant handful of miles away and it seemed as if the commendations of history were within their grasp. During the afternoon, however, their wearied footsteps brought them to a dreadful sight: "[A] black flag tied to a sledge bearer; near by the remains of a camp." The Norwegian team had reached the Pole before them, and the race was lost. "Great God!" Scott wrote, "this is an awful place and terrible enough for us to have laboured to it without the reward of priority." They walked the final miles in the month-old footsteps of the victors. Ten weeks later all five men were dead.²

The very existence of Antarctica remained unproven until the late eighteenth century. The idea of a hypothetical southern continent, *Terra Australis*, had been posited in antiquity, and its imagined geographical features were sketched onto maps merely to balance the land mass of the northern hemisphere. In the age of empire, however, the idea of new expanses of land was too tempting not to be explored. An expedition led by James Cook sailed from Plymouth in the summer of 1772 in two ships named *Resolution* and *Adventure*. By December 10, he sighted his first "ice island"—an iceberg—and on January 17, 1773, the *Resolution* became the first ship known to have plunged its bow through the Antarctic circle, a feat it would achieve twice more before returning home. Although the two ships had been kitted out with all the latest equipment to deal with extreme weather, the men aboard had not. As the ship moved farther south it became so cold that the entire crew seemed in jeopardy. Around the time the first iceberg was seen Cook "caused the sleeves of their jackets (which were so short as to expose their arms) to be lengthened with [coarse woolen] baize; and had a cap made for each man of the same stuff, together with canvas." Once the existence of a southerly land mass was established, its call—siren-like—sounded in the ears of ambitious explorers the world over.³

The fate of the British Terra Nova expedition is one of the most tragic in the sorry annals of doomed adventure. Many have laid blame for the poor performance of Scott and his companions relative to the Norwegians on their choice of clothing. In this view, the British fatally underestimated the demands of the Antarctic climate. This isn't quite true: Scott was alive to the vital importance of clothing and equipment. He had led a previous expedition-the Discoveryfrom 1901 to 1904, and was the first to admit that mistakes were made. "[F]ood, clothing, everything was wrong," he wrote on his return, "the whole system was wrong." He was determined not to repeat his mistakes. He therefore set about the matter methodically, using his men as guinea pigs in the early parts of the expedition, putting each on a different ratio of fats and carbohydrates, varying their clothing to see which performed best, and weighing them before and after shorter trips to ensure they hadn't lost too much weight. He stressed the importance of each man learning the skills to take care of and improve their own clothing: "Every minute spent in keeping one's gear dry and free of snow is very well repaid." By Sunday, September 3, 1911, he felt confident that "our equipment is the best that has been devised for the purpose."4

Like all explorers of the heroic age, a period that lasted from the late nineteenth century into the 1920s, the *Terra Nova* expedition

185

were reliant on natural fibers—wool, cotton, silk—and fur. Indeed, the British and Norwegian teams had a lot of clothing in common. Both had woolen long johns and vests, for example, as well as layers of sweaters, shirts, and corduroy trousers to trap multiple insulating layers of air.⁵ Even some of the brands were the same. Wolsey, a British woolen manufacturer, provided both teams with their patented "Unshrinkable" woolen underwear, mittens, and socks. (The firm used a photograph of Scott and his companions wearing their products in an advertising campaign, and he provided them with a personal testimonial.⁶) Wolsey was still supplying woolen underwear to Antarctic expeditions as late as 1949, when it was chosen for a Norwegian–British–Swedish expedition, along with hand-knitted Shetland jumpers.⁷

Both teams also wore Burberry gabardine suits, a popular choice among early-twentieth-century explorers and mountaineers.8 Shackleton wore Burberry for the 1901-4 Antarctic expedition and returned to the firm when planning his next assault on the South Pole, which left in 1907. For that trip he chose one of the brand's top coats over a double-breasted woolen suit made from sturdy pilot cloth and lined with Jaeger fleece. Invented in 1879 by Thomas Burberry and inspired by Hampshire shepherds, who treated their smocks with lanolin to waterproof them, gabardine was at this time the most windproof and innovative cloth available. In essence, it was a tightly woven, light cotton fabric, each thread of which had a weatherproof coating, making it wind- and water-resistant, but also allowing for some breathability. However, if it rained consistently or if the snow became slushy, water could leak through the weave to the woolen layers beneath: this was such a problem that many alpinists considered an umbrella essential.9

The biggest difference between the two teams were their outer layers. The British relied exclusively on the gabardine cloth trousers and coats, while Amundsen's topped these with reindeer or seal parkas and trousers. Amundsen had picked up this style of coldweather clothing from the Netsilik Inuits while staying in the Arctic years previously and wrote that any expedition without it would be "inadequately equipped." But then he was also relying on dogsleds, so that for a greater part of each day the five-man team would be sitting down. This meant that they would get colder faster, and the huge weight of the fur suit didn't much matter. For the British team, using other, more labor-intensive forms of transport and who for the most part hauled their sleds themselves, fur would have had serious drawbacks.¹⁰ "All furs are far too impervious," wrote Edward Wilson, who accompanied Ernest Shackleton and Scott on the *Discovery* expedition, "and, instead of allowing the free evaporation of moisture from the body, collect and absorb it all, and become heavy and wet when frozen . . . It is a golden rule to avoid anything but wool as far as possible." Scott evidently agreed.¹¹

Plus Fours at 28,000 Feet

Because it's there.

George Mallory, when asked why he wanted to climb Everest, New York Times, 1923

On May 1, 1999, a body was found high on the north face of Everest. In itself this was not unusual: the world's highest mountain has reaped the lives of over two hundred mountaineers and Sherpas in the past century. Most lie where they fell: buried under snow or stone-piled cairns if they're lucky, prominently displayed like grisly sculptures on increasingly busy paths if not. (The body of Tsewang Paljor, a young Indian climber, has been nicknamed Green Boots by the many climbers who, since his death in 1996, have stepped over his neon-clad remains to reach the summit.) The body found on this occasion, however, was different.¹²

He lay—face down, head uphill—in a pile of scree at 26,760 feet. Strong wind had stripped the layers of fabric from the back of the body, and sun and time had scoured and bleached the exposed flesh as white as the surrounding snow. The arms were outstretched toward the peak, gloveless fingers gripping into gravel, as if to halt his slide. The muscles of his back, still defined, stood out still with the effort. Gravel had gathered around the body and frozen marble-hard, immuring it in the mountainside. One hobnail-boot-shod leg lay outstretched; the other—terminating in a bone-pale naked calf and heel—lay gently crossed over the first, scraps of thickly knitted sock caught between them.¹³

It was the boot that gave the team of seekers a clue as to the agc of the body. Hobnail boots hadn't been used much after the mid-1930s, and no climbers, that they knew of, had died this high up between 1924 and 1938. The murmur of the boots and tattered clothes, made from natural fibers, gave way to a shout of certainty as Tap Richards, an American mountaineer, leafed through the thin layers of fabric still intact at the nape of the neck: a laundry label neatly sewn to a shirt collar: G. Leigh-Ma...¹⁴

The last man to see George Mallory alive seven decades previously and live to tell the tale was Noel Odell, a follow mountaineer. He wrote on his return with pride and porhaptal little only that on June 4, 1924, Mallory and his twenty-two-year-old climbing partner, Andrew "Sandy" Irvine, climbed from Camps III to IV in a mere two and a half hours, pushing themselves and their new-fangled oxygen equipment to the limit in preparation for the final assault on the summit. Although the weather conditions had been unsettled, it promised to be perfect for their climb to the summit on the 8th—Mallory told Odell so in a note delivered by a porter the day before, apologizing for having upset his cooking stove as they left Camp V. (It had rolled off down the mountain, leaving Odell to chew a chilled dinner and breakfast.) His final sighting of the pair was at 12:50 p.m. on the day of their bid to be the first men to climb Everest. He was far below them doing some climbing of his own when there was a break in the cloud:

I saw the whole summit ridge and final peak of Everest unveiled. I noticed far away on a snow slope leading up to the last step but one from the base of the final pyramid, a tiny object moving and approaching the rock step. A second object followed, and then the first climbed to the top of the step. As I stood intently watching this dramatic appearance, the scene became enveloped in cloud.¹⁵

At this point the pair were, Odell estimated, around eight hundred feet below the summit and should have reached it between three and half past. The timing troubled Odell: Mallory's schedule had put them at these steps at 10 a.m. at the latest. They were hours behind, making it impossible to reach the world's peak and return to Camp VI before being overtaken by the gloaming. To make matters worse, when Odell reached the camp in the early afternoon the wind picked up and "a rather severe blizzard set in," which lasted for nearly two hours. Odell spent years wondering if Mallory and Irvine had in those final hours reached the summit of Everest.¹⁶

The 1924 attempt was Mallory's third and, at thirty-seven, he felt it was likely to be his last. He was charming, handsome, and a teacher at a British school as well as an impressive amateur climber. In a flirtatious letter to a young admirer, he wrote: "We've got to win the top next time or never." Perhaps realizing how final this sounded, or perhaps to impress his correspondent, he added a more flippant line: "Anyway it will be a tremendous struggle."¹⁷

This was certainly true. Even the journey to the foothills would involve months of arduous travel and a five-week trek across the Tibetan plains, made even more difficult because golden-age Royal Geographical Society and Alpine Club expeditions rarely packed light. Among the twenty-odd tons of luggage borne up the mountain by three hundred pack-beasts and seventy porters, were four cases of Montebello champagne and sixty tins of quail and *foie gras*.¹⁸

Luxurious food and drink aside, preparation and equipment were vital to the attempt, and bids for the summit were planned (and spoken of) like military campaigns. "The lack of a cooking pot, an oxygen tank, a canteen or a rope," wrote one *New York Times* journalist, "may doom the expedition." As experienced climbers, Mallory and his companions knew this. Nor were they ignorant of the dangers, humiliations, and disappointments such a trip could pose. The first attempt had cost £6,000 but only managed a relatively ignominious 21,000 feet (although they did find a viable approach); the second had stretched to 27,235 feet at a cost of £11,000 and the lives of seven porters, who had been lost in an avalanche.¹⁹ The previous attempt had been halted by frostbite and exhaustion. And although more care and more experience attended the 1924 expedition, danger was never far away. Days before Mallory's climb in 1924, Howard Somervell—his friend and fellow survivor of the 1922 expedition reached 28,117 feet before the sore throat and hacking cough that had plagued him throughout the trip nearly ended his life. The mucous membrane lining of his throat had frozen and broken away, become stuck in his windpipe, and was choking him to death. Hc gave himself the Heimlich maneuver, coughed up "the obstructing matter along with a lot of blood," and survived.²⁰

To tackle the extreme cold—the lowest recorded summit temperature is -42°F—the climbers used the best they believed was available. This meant layer upon layer of natural-fiber clothing: silk and handknitted wool—very much a continuation of the style of sporting gentlemen in the Peak District. Photographs of the Mallory team high up in the Himalayas in 1924 show them bundled up in smocks or tweedy jackets with fiddly buttons bulging over thick woolen scarves, Jaegor trousers, and an eccentric assortment of hats— a rakish uilby here, there an astrakhan cap—that fail to cover fragile on tipu. They were elbowlength rib-knitted mittens, thick knee-high socks, and hobnail boots. Higher up the number of layers increased.

From the remnants found on his body, we know that for the final ascent Mallory wore cotton and silk underwear, a flannel shirt from Paine's outfitters in Godalming, a brown, long-sleeved pullover, and a woolen waistcoat lovingly knitted by his wife Ruth. Over his base layers, Mallory wore a Burberry jacket and plus fours made from a sheened green and relatively lightweight gabardine. It's difficult to determine what he made of his garb: he was inculcated with the heroic ideal and in his writing dwelt more on awe-inspiring vistas and his feelings for his wife and children than on his own physical condition. But perhaps this description from his teammate, Edward Norton, gives an impression: "The weather was ideal, with very little wind. Even so, clad in two suits of windproof clothing and two sweaters, I found it very cold. Sitting in the sun I shivered so much that I once thought I had fever on me."²¹

Lightness and breathability, however, were crucial. Firstly, the weather could turn on a dime, from blazing sunshine to icy blizzards in minutes. Winds at the summit have reached 175 miles per hour: enough to pick a man up and hurl him off the mountain like a toddler with a disfavored rag doll. In a letter to his wife Mallory described "a scorching mist" encountered high on a glacier. "One seemed literally at times to be walking in a white furnace," he wrote. "Morshead, who knows the hottest heat of the plains in India said that he had never felt any heat so intolerable." Secondly, clothes that were easier to move in meant a faster assault on the summit. This is still vital today.

The extreme altitude of the mountain, particularly above 25,000 feet, is deadly. Brain cells die, capillaries burst, the heart beats faster and blood begins to thicken. At this altitude the body is also vulnerable to hypothermia, frostbite, cerebral and pulmonary oedema—all of which can be fatal. The risks are vastly increased without the use of additional oxygen.²²

By 1924 Mallory had grudgingly accepted the need for gaseous aid to climb Everest. Even today many climbers believe climbing without it is aesthetically preferable; previously Mallory had believed that it was unsporting and, worse, un-British. But the life-giving canisters had drawbacks of their own. They were rudimentary, temperamental, and, worst of all, heavy: 32 pounds per set. (Mallory grumbled in his final note that it was "a bloody load for climbing."²³)

At this altitude, everything is exhausting and slow, the mind is impaired, and even the slightest impediments to easy movement and speed are undesirable. Mallory knew this. He told the *New York Times* that during his previous trip his companions had been able to climb no more than 330 feet in an hour, every inch of which had been hard won. He chafed against the "dismal weight" of the heavy shoes they wore through thick snow, and very likely chose Irvine as his climbing partner because of the latter's technical skill and inventiveness with the oxygen canisters. The young climber spent the afternoon of June 4 "retesting and putting the final touches to the oxygen apparatus" in order to make them as light and easy to carry as possible. In Mallory's final note to Odell, he said that he planned to only take two oxygen cylinders with him to Camp VI for the final climb, likely as a concession to his desire for speed.²⁴

His clothes reflected his blitzkrieg strategy. The Burberry jacket

191

featured a patented "Pivot" sleeve, specifically designed for the greatest range of movement without displacing the precious pockets of warm air trapped between the layers beneath. And, although he wore a lot of layers, they were all light: they would be perfectly warm high on the mountain when active, but would not do for any length of time if the climbers had to remain stationary. If Odell was right, and a storm did blow in during the early afternoon, Mallory's clothes, coupled with a gritted-teeth diet of patriotism, heroism, and sangfroid, may have been his undoing. Odell hinted of this in the article he wrote on his return to England. "Mallory had stated he would take no risks in any attempt on the final peak," he wrote. "But in action the desire to overcome, the craving for victory, may have been too strong for him.... Who of us that has wrestled with some Alpine giant in the teeth of a gale or in a race with the darkness, could hold back when such a victory, such a triumph of human endeavour, was within our grasp?"25

Blood, Sweat, and Frozen Tears

Men wanted for hazardous journey. Small wages, bitter cold, long months of complete darkness, constant danger, safe return doubtful.

A newspaper advertisement (traditionally) attributed to Ernest Shackleton, 1913

The human body is ill-equipped to handle the cold. The average body temperature is 98°F; even a slight drop can be serious. Many of the chemical reactions central to healthy bodily functions only occur within a narrow temperature range. If the body falls to 95°, it will initiate a range of measures to protect itself and prevent further heat loss. Blood vessels, particularly in the extremities, will constrict: the core must be kept warm, even at the expense of other parts of the body. The sufferer will begin to shiver—an attempt to generate heat—and the metabolic rate will increase, burning up more resources to power yet more shivering. Breathing will slow, blood pressure will decrease, and the heartbeat become irregular. Those suffering hypothermia will feel tired, confused, and argumentative; fingers and toes might start to feel numb, affecting dexterity; they might begin to stumble; their decision-making may become impaired.²⁶

The physical misery of inadequate clothing seeps from explorers' accounts. Every movement is effortful, particularly through deep snow and fierce winds or indeed at high altitudes. In a letter to his wife Ruth on August 17, 1921, Mallory wrote that: "It was only possible to keep plodding on by a tremendous and continually conscious effort of the lungs; and up the steep final slopes I found it necessary to stop and breathe as hard as I could for a short space in order to gain sufficient energy to push up a few more steps." Paul Larsen, who wore period clothing for a recreation of the harrowing 800-nautical-mile journey from Antarctica to South Georgia Island first completed by Shackleton in 1916, found his Burberry-style outer layer was windproof but insufficiently waterproof. Once natural fibers become wet they become drastically less insulating, significantly heavier, and difficult to dry out.²⁷

Perhaps the most persistent and depressing problems were caused by perspiration. With so much physical exertion—tramping through snow, climbing, and trekking—explorers were drenched with it. "The trouble," as Cherry-Garrard put it, "is sweat and breath. I never knew before how much of the body's waste comes out through the pores of the skin... And all this sweat, instead of passing away through the porous wool of our clothing and gradually drying off us, froze and accumulated." Not only did this result in ice forming between layers of clothing, soldering scarves to faces and socks to feet and reducing the insulation of clothes still further, but it could also freeze cloth garments and objects into icy, unusable sculptures. Later in his book he recounts an incident when he emerged from his tent in clothing still wet from the exertions of the day before. "Once outside, I raised my head to look round and found I could not move it back. My clothing had frozen hard as I stood—perhaps fifteen seconds ... from that time we all took care to bend down into a pulling position before being frozen in."²⁸

Edmund Hillary spent the first hours on the morning of his victorious ascent of Everest in 1953 thawing his boots. They were "frozen solid, and I cooked them over the primus stove until they were soft enough for me to pull on," he later recalled. "We were wearing every piece of clothing we possessed." His clothes, though, were relatively modern and made of synthetic materials. The woolen clothing of the earlier explorers was highly absorbent and slow to dry, particularly when too tight-fitting. On a short expedition to Cape Crozier in July 1911, Scott's companion Wilson wrote despairingly that "with all this clothing wet and all frozen stiff it becomes difficult to move with one's customary agility and any climbing up ropes or climbing out of crevasses becomes exceedingly difficult."²⁹

Night made things worse. The sleeping bags of the Scott expedition, made of reindeer skin and eiderdown, became so sodden that they would freeze as hard as iron bars: attompts to roll them up would split the seams. The more sodden they were, the harder it was to dry them out and the colder their occupants became. This inevitably meant wearing even more clothes, which in turn would dampen with sweat and turn icy. The men would wake up with their skin pruned and pale ³⁰

Even getting into them was difficult and time-consuming. The explorers would have to thaw their way in, using their own body heat to soften the sleeping bags sufficiently so that they could ease into them, foot by foot, leg by leg. "[F]irst thing on getting out of sleeping bags in the morning," wrote Cherry-Garrard, "we stuffed our personal gear into the mouth of the bag before it could freeze: this made a plug which when removed formed a frozen hole for us to push into as a start in the evening."³¹

Layers of clothing, no matter what they are made of, are cumbersome and difficult to navigate when suffering the first effects of hypothermia or altitude sickness. Jon Krakauer, who summited Everest in the disastrous 1996 season, spent a morning blasted by a "windchill that dipped to perhaps forty below zero." An extra jumper was in his backpack, but he despaired of the effort this would entail. "I would first have to remove my gloves, pack, and wind jacket while dangling from a fixed rope." Gear lists produced for aspirant climbers spill much ink on the efficacy of vents, pockets, toileting options, and zip placement in down suits, and joust on the merits of different thermal tops, gloves, and socks, many made of complex mixtures of synthetics. Graham Hoyland, who tested replica Mallory clothes at altitude on Everest, found the fly buttons on the suit so impossible to navigate he hypothesized that the earlier climber must have left his flies undone permanently.³²

Lab tests done on these replicas, together with copies of Scott and Amundsen's gear, found that Scott's were so bulky and stiff that they would have required a huge amount of extra energy to move around in. During an enactment of the race in the Antarctic, four members of the team lost between 12 and 25 percent of their body weight, predominantly muscle mass. Another re-enactment, this time taking place over the winter of 2013–14, found that the original Scott team's daily rations of pemmican (a mixture of dried beef and fat), fresh pony meat, biscuits, and chocolate had likely been between two and three thousand calories short. The bodies of Scott and his companions were consuming themselves in an attempt to replenish the energy being expended hauling their clothing through the snow toward the Pole and keeping warm.³³

If clothing fails to such an extent that the temperature of parts of the body falls below freezing the effects are dramatic. Frostbite is caused when ice crystals form in the skin and flesh: the first casualties are usually the tips of the ears and nose, fingers, hands, toes, feet, and male genitals. Numbness is the first symptom; the skin then blanches and mottles as ice crystals form, the afflicted area begins to feel woody to the touch and, if the area is large enough, the blood turns to sludge. Although frostbite can be thawed and, in mild cases, the dead skin is shed and renews as it does under a blister, more serious cases mean amputation, even today.³⁴

The alpinists of the early twentieth century were no strangers to frostbite. Several of the 1922 Everest expedition suffered from it, exacerbated by their reliance on the kinds of clothing they would wear on the Alps. This was a mistake: the lack of oxygen, coupled with wind chill from the fierce gales that nearly always blow through the Himalayas above 21,000 feet, make it much harder to stay warm.

Tragically, one solution had been discovered before both Mallory and

Scott's expeditions but, perhaps because it looked decidedly unheroic, it had been rejected. Although the down of ducks and geese had long been used in quilted petticoats and bedding, no one had ever considered using them for cold-weather clothing until George Finch had a suit made up to his own design consisting of an "eiderdown lined coat, trousers and gauntlets" covered in balloon fabric. Finch, an Australian, was ridiculed by the snobbish Alpine club and his contemporaries refused to adopt the style, even when it proved far warmer than their own gear. Finch stuck to his guns, emphasizing the need for special clothing above this altitude in a 1923 Alpine Journal article. He suggested six or more layers of silk and wool, topped with a windproof layer, preferably lined with flannel and covered with oiled silk. To protect hands, both so vulnerable and so vital for climbers, he suggested three layers: a woolen inner glove, a lambskin pair, and finally a waterproofed canvas pair.

Today, when climbers wear down suits and synthetic fleece layers specifically designed for Everest, frostbite continues to stalk those who venture up the mountainside. During the 1996 climbing ocason, when eight people died in a single day in a blizzard at altitude, Boolt Weathers, a Texan pathologist and amateur mountaineer, became so weak and impaired that he was left for dead with his face and hands exposed. He survived, but lost a third of his right arm, all five fingers on his left hand, his nose, and portions of both fect.³⁵

Nearly all the members of the Scott expedition suffered from frostbite, making them more vulnerable to it later on and the attacks more severe. At first, even though members of the team had Antarctic experience, they seemed blasé about the risks. In February 1911 Scott mentioned in his diary that one morning Bowers ventured out into temperatures of -6°F wearing "his small felt hat, ears uncovered." After traveling just one mile his ears had turned white with frostnip, and while he was relatively speedily thawed, his chief emotion was "intense surprise and disgust at the mere fact of possessing such unruly organs."³⁶

Negligence of this kind was potentially life-threatening. During the long march back from the South Pole the men were slowed by the deplorable condition of Oates' feet and, tired, defeated, and rapidly wearing through their socks and finnesko (soft fur boots), all began to develop symptoms, slowing them down still further. Scott succumbed too just ten days before his death: "My right foot has gone, nearly all the toes—two days ago I was proud possessor of best feet." This was March 18 and hopes of reaching safety were being snuffed out one by one. The next day things were worse: "Amputation is the least I can hope for now, but will the trouble spread?"³⁷

Gear Lists

The coldness cuts through as though we were naked. Fingers are soon numb but still alive enough to hurt, which is good. Toes and nose likewise. The others wear the Eskimo wolfskin parkas which still smell of bad mackerel.

Sir Ranulph Fiennes, To the Ends of the Earth, 1982

Since those first stumbling, silk-and-wool-clad climbers mapped routes up Everest in the 1920s, tens of thousands have reached base camp and just under seven thousand climbers have reached the peak that cost Mallory and Irvine their lives in 1924. The price of a permit for foreigners is \$11,000 and some pay up to \$90,000 to firms that will help them attain this goal. Everest is now an industry: the government reaps over £3 million annually from climbers' permits; 16.5 tons of climbers' rubbish has been removed in a six-year cleanup; 12 tons of frozen excrement is carted away annually. Similar pressures bear on Antarctica. Explorers and amateurs vie for ever obscurer accolades: the first person to cycle to the South Pole, the first Indian woman to ski there. The ability of more people to reach these areas is due in part to the huge step change in fabrics available.³⁸ Mountaineers and explorers have, for the past fifty years, heavily relied on synthetics unavailable to Mallory and Scott. For his ascent of Everest in 1996, for example, Jon Krakauer "zipped [his] body into three layers of fuzzy polypropylene pile underwear and an outer shell of windproof nylon." When George Finch created his prototype eiderdown and balloon-silk suit, he was laughed at; by the time Edmund Hillary made his ascent in 1953, down suits were considered essential.³⁹

Down insulation is made from the fine, fluffy plumage that keeps geese and ducks warm, sandwiched between two fine layers of fabric. It works by trapping layers of insulating air among the feathers, but it is still light and breathable. The major drawback of down is that, once wet, the feathers clump together, losing their loft (fluffiness) and therefore their ability to trap heat. Synthetic down is made from polyester fibers that mimic the air-trapping qualities of the natural stuff. It's more resistant to moisture and dries within hours—unlike the natural version—but it is heavier and more cumbersome. The ideal, therefore, is a waterproof, windproof layer over a down suit, but ulis too, for a long time, proved difficult to create.

Gore-Tex has, since the late 1970s, become the near-ubiquitous answer to the problem of clothing that is both breathable and waterproof. Created by the American father-and-son W. L. Gore firm in 1969, Gore-Tex is made from a layer of finely stretched Teflon (polytetrafluoroethylene on PTFE) bonded to nylon or polyester. At a microscopic level the stretched PTFE resembles caramel honeycomb: the pores are large enough to allow water vapor out but too small to allow liquid droplets in.⁴⁰

W. L. Gore sells their fabric to outdoor apparel firms like Berghaus, Mountain Equipment, and North Face and, for the moment, reigns supreme. Paul Larsen, the Australian sailor who set a new nautical speed record in 2012 and participated in the recreation of a Shackleton sea voyage the following year, swears by it. "Modern clothing," he said of the latter experience, "would have made the trip a doddle. A modern Gore-Tex drysuit is a very comfortable piece of kit that you can easily spend a lot of time in." Instead he was encased in a coated Burberry-style cotton smock: "bit by bit the water got in until you had to admit you were simply drenched from head to foot." Worse still, the smock took three full days to dry properly.⁴¹ Gore-Tex does, nevertheless, have its drawbacks. Like all synthetic "shells," it can be a little slow to allow sweat to evaporate, a problem for those working hard who don't want to soak, and therefore compromise, their base layers. For drier conditions, or when breathability is paramount, there is a strong incentive to cast around for an alternative.⁴²

Perhaps the only place where natural fibers are still preferred in the world's least forgiving environments is next to the skin. Even this concession was hard won. Although still commonly used in the 1950s, by the mid-1960s synthetics had conquered the market after something of a rout.

While in 1953 Edmund Hillary's layers still included a woolen shirt, underwear, and Shetland wool pullover, by the 1990s this seemed so old-fashioned as to be eccentric, even dangerous. Synthetic velour, championed by brands including Helly Hansen and Patagonia, was becoming the norm. To Conrad Anker, the American climber who found Mallory's body in 1999, the latter's natural-fiber underlayers were anathema. Even as late as 2006 Graham Hoyland, the climber who used Mallory-era clothing at altitude on Everest, was surprised by his experience of using natural fibers. "Like most mountaineers," he wrote, "I am used to synthetic outdoor clothing: polypropylene underclothes and outer fleeces.... They are unforgiving in stretch, and begin to smell unpleasant if worn for more than a couple of days." For him, Mallory's silk, cotton, and wool layers were a pleasant revelation.⁴³

The past two decades, however, have seen a reversion. Icebreaker, a New Zealand brand, was founded in 1995 specifically as an antidote to the synthetic fibers that had in just a few decades swallowed the outdoor clothing market whole. The firm specializes in merino wool base layers and is now recommended on several Everest gear lists. The sailor Paul Larsen generally chooses to wear natural-fiber underwear under his Gore-Tex during his expeditions; his current favorite base layers are made of yak wool.⁴⁴

This renewed acceptance of natural fibers has run parallel to a reappraisal of the Mallory and Scott expeditions. Although they were both considered tragic heroes by their own generation, the dominant narratives since have been less kind.

Mallory's legacy has come to be defined by two things. The first is the unproveable, "what if?" speculation that he may have been the first man to reach Everest's summit. The second is the photographs of his naked, unburied body taken and sold to the press by members of the expedition that found it in 1999.⁴⁵ Scott has also fallen from grace. In a 2011 National Geographic article on Scott's rival entitled "The Man Who Took the Prize," the author pointedly wrote that while he was prey to the ambition, dreams, and impulses that drive all explorers, Amundsen's greatness-her word-is that "he mastered them." Scott, on the other hand, is often caricatured as foolish, ill-prepared and-mired in an outdated colonial world view-ignorant of or too quick to dismiss the fur clothing favored by indigenous people. This last point is something Scott addressed directly. An entry in his journals, written in August 1911 before the start of the final journey, foreshadows his end, ill-equipped and poorly clothed, in the least hospitable environment on carth

One continues to wonder as to the possibility of fur clothing as made by the Esquimaux, with a sneaking feeling that it may outclass our civilised garb. For us this can only be a matter of speculation, as it would have been quite impossible to have obtained such articles.⁴⁶

10

Workers in the Factory

Rayon's Dark Past

Resistance

Better Things for Better Living . . . Through Chemistry.

DuPont advertising slogan, 1935-82

"Why are there some days," wrote Agnès Humbert, "when we just feel happy, for no particular reason? When everything looks wonderful and we are pleased with the whole world, including ourselves?" For Agnès, April 15, 1941 began as one of those days. As it turned out, her happiness was misplaced: later that same day she was arrested by the Gestapo.¹

Agnès may not have looked the part of an insurgent: she was a respectable, middle-aged Parisian art historian with soft, round eyes, a large, handsome nose, and marcel-waved hair. But she was also intelligent, courageous, determined, and obstinate, with an incorrigible wit in even the direst of circumstances. Hers was not a character that could long endure injustice or the heavy hand of the Nazi occupation. "I feel I will go mad, literally, if I don't do something," she wrote soon after the fall of Paris. Together with an unlikely band of colleagues from the Musée de l'Homme—Egyptologists, archaeologists, and librarians she formed the first organized Resistance group. Printing a newspaper to counter the pervasive official propaganda, they began covertly passing information to the British. What they started, ad hoc and in whispered conversations in the museum's corridors, rapidly grew into a large network. Too large: they were soon betrayed by a double agent.

The plain-clothes officers found her at the bedside of her sick mother. When they searched Agnès's apartment they found a copy of a rousing speech by Roosevelt and a draft front page of the group's newspaper. At the top of the page, in bold, incriminating type, was the newspaper's name: *Résistance*.²

The group was tried and found guilty by a military court. The men

were shot; the women imprisoned and deported to Germany to work as forced labor. When Agnès heard precisely what kind of work she would be doing she was elated—"We won't be doing war work!" her principal determination being not to aid the Nazi cause. "We'll be working in a factory making artificial silk, spooling the rayon onto bobbins eight hours a day... for making lingerie and stockings."³

It is difficult to track down the voices of those who make the fabrics we wear and use each day. Historically, few factory workers have written books or articles about their experiences. When we do hear from them, it is often in the form of a scanty quote or answer to a question posed by doctors, activists, or journalists, and frequently only after a disaster. This is what makes Agnès's account so special. She is a vivacious companion, interested in and sympathetic to the details of her new life and those of the other workers. She is also alive to and enraged by injustice, callousness, and petty cruelties. On one occasion a girl working in the factory has what Agnès believes is a heart attack and is lying prostrate on the floor when the overseer arrives. He "pokes his grubby finger in her eyes" and, seeing she is not dead but merely unconscious, "takes advantage of the opportunity to ogle her breast."⁴

As a prisoner and forced laborer her perspective is different from the many millions who have chosen to produce textiles. Before the war, as a Parisian working in a museum, Agnès knew almost nothing about rayon. She had likely worn it, although she does not say so. Her mother had bought shares in an artificial silk company mercifully not the one that Agnès was compelled to work for citing the good return they gave. Apart from this glancing acquaintance, she enters the factory as an average person might: in near total ignorance of the manufacture of a fabric they routinely wear against their skin.

In the Market

205

Women want men, career, money, children, friends, luxury, comfort, independence, freedom, respect, love, and cheap stockings that don't run. Phyllis Diller

Almost a year to the day after her arrest, Agnès laid eyes for the first time on the place where she would spend the next three years. It was one of the factories owned by a large corporation called Phrix, just outside Krefeld, in north-west Germany, half an hour by car from the Dutch border. As a romantic and as an art historian, she would have been charmed to know the etymological root of the fabric that she was to spend the next three years producing. In the mid-sizteenth century, "rayon" was used to denote a ray of light. And in truth the creation of the first star-pale strand of this first synthetic was rather miraculous, akin to the transfiguration of straw to gold in the fairy tale of Rumpelstillskin.⁵ The raw material for rayon is cellulose, the basic building block of many plants. During the last decades of the nineteenth century, scientists developed several methods for transfiguring cellulose, usually in the form of wood pulp, into fiber they called artificial or imitation silk.

As might be expected, getting from wood pulp—like wood chips only milled a little finer—to a thread soft and shiny enough to resemble silk is a tricky business. To start the process off, the cellulose must first be treated with caustic sodas with a very high pH. Carbon disulphide (CS_2) is added, which liquifies the cellulose without damaging its fundamental molecular structure. The mixture is then churned and left to "ripen" with more caustics until it becomes a thick, almost syrupy liquid known as xanthate. (The honey-thick consistency of this mixture is the origin of rayon's other name: viscose from "viscous.") When sufficiently gooey, this liquid is forced through small nozzles or spinnerets into tanks of sulphuric acid. The acid forces the carbon disulphide out of the cellulose mixture and hardens what remains, so that fine rayon filaments form in the acid bath and sink to the bottom in piles known as cakes. The fibers are then stretched, cleaned, cut, and bleached and, if necessary, dyed before being woven into fabric.⁶

The end result of this process is, perhaps surprisingly, a wonderful fabric. And although few would really think of it as a dupe for silk, it does have similarities. For a start rayon fabric is extremely soft and drapes well. It also has a subtle, silklike luster. Even more tantalizingly, from a commercial point of view, short lengths of viscose fiber, known as "staples," can be mixed with other fibers, such as cotton or wool, before being woven. This has led to the creation of new fabrics to market to consumers, who have also benefited from lower prices.⁷

For western scientists and businessmen, the prospect of finally being able to shake the East's dominance over luxury fabric production was wildly exciting. Dmitri Mendeleev, the Russian chemist who set out the periodic table, warned that because the production of rayon was still "in its first, or embryonic stage of development . . . it is best to talk about it with caution." Notwithstanding such reticence, he continued that "the victory of viscose will be a new triumph of science . . . [freeing] the world in relation to cotton." Some four decades after the discovery, this jubilation had not worn off. In 1925 journalists at *The Times* of London were still smugly proclaiming that "The viscose process stands to the credit of British scientists, and it has laid the foundation of a great industry."⁸

Because of the strong chemicals involved, making rayon was, from the very beginning, a highly mechanized process associated with factories, urban workers, and large, multinational companies. One of the first to become involved was Samuel Courtauld & Co. (later Courtaulds), a British firm keen to produce fabrics on an industrial scale. They opened a rayon factory in Coventry in the first years of the twentieth century and, in 1910, created an American subsidiary with its own factory at Marcus Hook in Pennsylvania, trading as the American Viscose Company. This latter site, building on the lessons learned at the former, was equipped to produce 10,000 pounds of rayon each week with just 480 employees.⁹

207

The efficiency of such large factories, as well as the cheap cost of fabric produced, proved a winning formula, even—perhaps even especially—in troubled economic times. The rayon industry flourished, for example, during the First World War, which disrupted the supply lines of silk and cotton, thereby increasing the demand for synthetics. The Great Depression also helped secure rayon's place in the fabric firmament. The American rayon industry in 1936, for example, was enjoying an 80 percent increase in production compared to 1931. By this time, in addition to the major firms in Britain (Courtaulds) and America (Courtaulds and DuPont), rayon manufacturers had sprung up in Italy (SNIA), Germany (Glanzstoff), and Japan (Teikoku Rayon Company and Toyo Rayon Company), all of which were pumping out ever more rayon fiber.¹⁰

Many of these companies diversified into other synthetic fabrics as well, DuPont being the *ne plus ultra*. DuPont opened their first rayon factory in Buffalo, New York, in 1920 and another in Tennessee. By the mid 1960s it was the leading firm in America's 19.1 billion dollar chemical industry and the world's largest manufacturer of synthetic materials. By this time, by far their most profitable and well-known fiber was nylon, the first to be based on a fossil fuel. (At the time, this meant rayon, produced using wood pulp, was cheaper than its petro chemical-dependent rivals. Since then the latter have come down significantly in price and this relationship is now reversed.)¹¹

Research into the creation of a thermoplastic fiber began in 1930. DuPont had claims to nylon-66—today the standard in clothing while the German chemical company I. G. Farben worked on nylon-6, now commonly used in furnishings. Less than a decade after research began, nylon entered the marketplace. In America, DuPont focused on the hosiery market, a shrewd choice. As hemlines rose during the 1930s, stockings became indispensable. Prior to the creation of nylon versions, most were made of silk, which, although they felt lovely against the skin, were difficult to wash, expensive, didn't stretch, and were prone to snags. Women grudgingly purchased an average of eight pairs each year. DuPont dipped their toe into the market by holding a sale of their stockings for the wives of employees in Wilmington, Delaware on October 24, 1939. Within hours, all 4,000 pairs, each costing \$1.15 (the equivalent of \$20 today) had been sold. The same thing happened when they went on general release on May 16 the following year. Every last one of the four million pairs that the firm had produced was snapped up within forty-eight hours. DuPont created just over 2.5 million pounds of nylon in 1940 alone, earning them 9 million dollars in sales. Within two years they had captured 30 percent of the hosiery market.¹²

Their timing was fortuitous. Most of America's silk was imported from Japan, trade that was threatened by escalating tensions between the two countries. In August 1941, imports were stopped entirely. DuPont rapidly stepped up production to cover the shortfall. But after the attack on Pearl Harbor, nylon too was diverted to the war effort: parachutes, shoe laces, mosquito nets, and aircraft fuel tanks took precedence over consumer luxuries. Women on both sides of the Atlantic suddenly denied stockings were forced to get creative. Cosmetic companies brought out make-up that could replicate the look of stockings: Helena Rubenstein's was called Leg Stick; other popular varieties were called Leg Silque and Silktona. Department stores introduced special make-up bars where you could get paint-on stockings, complete with trompe l'oeil seams and stocking tops drawn on with eyebrow pencils and a steady hand. At home women improvised with gravy browning. By the time nylon stockings went back on sale in 1945, women were frantic, leading to scenes on shop floors later referred to as the "nylon riots." In Pittsburgh 40,000 people formed a line that stretched over a mile to buy one of only 13,000 pairs one store had in stock.13

In other areas of the wardrobe, nylon and other synthetics were at first accepted for their utilitarian virtues. In 1964, an article in the *New York Times* suggested that, after a day of traveling, the enterprising woman "rinsed out her dress along with her stockings and her lingerie before she went to bed" so that she could be "fresh for the next day's tour without touching an iron."¹⁴

Practicality could be profitable. Between 1940 and 1967, nylon alone had earned DuPont 4.27 billion dollars. Other synthetics, such as acrylic—marketed by DuPont as Orlon—polyester—Dacron—and spandex—Lycra—had to work harder initially to win over consumers.¹⁵ By this time, however, consumers were spending more, particularly in America. By 1970 American consumer spending represented two-thirds of GNP and family incomes were higher than ever before. DuPont and other synthetics firms were also adept at marketing. As early as 1897 Courtaulds were exploiting the social conventions of wearing black during mourning to sell their wares. One advertisement listed the "correct periods of ladies' mourning," which ranged from a year and a day for a widow to three months for a cousin. Up the side of this list, in large, bold letters is the helpful legend: "Courtaulds Crape is Waterproof."¹⁶

By the middle of the twentieth century, as more synthetics and fabrics blended from mixtures of synthetic and natural fibers came on the market, the importance of advertising increased. In 1962 DuPont spent 10 million dollars to market their products; by 1970 this had increased to 24 million dollars. Paris remained the epicenter of the international fashion trade and newspapers faithfully reported the shows twice a year: where Parisian designers went, the global mass market would follow. DuPont, therefore, began forging a relationship with the Chambre Syndicale de la Couture Parisienne, the organization that coordinated the biannual couture shows. Designers from the Chambre Syndicale were soon creating their clothes in synthetics, in return, DuPont had them beautifully photographed and generated publicity for the couture houses. In 1953, for example, they invited Hubert de Givenchy to visit their headquarters and the following year he used a blend of Orlon acrylic in a turquoise shirtdress. In 1955 the firm secured a special coup when fourteen synthetics appeared in collections by Dior and Chanel.17

As fashions changed over the following decade, consumers became ever hungrier for stretchy, form-fitting, and casual clothing, an aesthetic that precisely suited synthetic and synthetic-blend fabrics. The biggest obstacle they faced was a persistent snobbery at the higher end of the market, which it seemed no amount of Parisian endorsement could quash entirely. Nylons and other synthetics still needed talking up a decade later. "The lexicon of nylon fabrics has expanded far beyond the careful traveler's puckered nylon of a decade before," readers of the 1964 *New York Times* article were assured. "Brushed nylon fabrics look like velvet, ribbed effects suggest corduroy, fleeces are suitable for outer wear or loungewear, and double knits resemble wool jersey." Evidently the industry was still trying to persuade consumers that synthetics were very nearly as good as the real thing. "At the distance of a few feet," one designer was quoted as saying, "it is difficult even for an expert to distinguish many synthetic fabrics from natural ones."¹⁸

Despite teething problems, synthetic fabrics were cheap, plentiful, modern, and convenient, attributes that all but guaranteed their success. This came at the expense of natural fibers, particularly cotton. In 1960 American mills used 6.5 billion pounds of fiber, of which 64 percent was cotton and 29 percent synthetics. A decade later, the situation was reversed. While the overall amount of fiber used had increased by a third, 58 percent of what was being used was synthetics and cotton made up just 39 percent. Such visible success and large profits attracted competition. In 1955 DuPont controlled 70 percent of America's synthetic fiber market; by 1965 their market share had dropped to roughly half. Nevertheless, their profits continued to increase: consumer appetite for cheap, fashion-led and stretchy clothing was near insatiable.¹⁹

Welcome to the Factory

The enormous machine hall around me, vast as a cathedral. The machines, twenty meters long and perfectly mysterious to me, are all protected by glass constructions, like greenhouses. Everything inside seems to be in perpetual motion, twisting, turning, rising, falling. I am struck by the unfamiliarity of it all, the noise and the appalling stench of the acid. Agnès Humbert, *Résistence*, 1946

There was much about the making of synthetic fabrics that consumers didn't know, and probably still don't. The proliferation of chemical companies making different fibers, all with a penchant for coining new trademarks for each new blend or tweaked formula, made it practically impossible for people to keep track of exactly what they were buying. As an article in the *New York Times* put it in 1964, "most of [these brand names] are meaningless to the consumer, and often are not recognizable to people in the trade."²⁰ Rayon alone has numerous aliases: artificial or imitation silk, art silk, viscose, bamboo, Modal, Lyocell, and viscose rayon.²¹

The suffering of textile workers was also invisible to consumers. Alice Hamilton, an American doctor specializing in occupational health, had cause to mention textile workers and rayon factories many times during her career. In an early review of the hazards facing workers in Pennsylvania, for example, she wrote of "the light fluffy dust" that assailed those working in mills, as well as the "fatigue caused by the noise, jarring, and monotonous work which yet demands constant attention."²² War made conditions worse as demand increased. Enrico Vigliani, an Italian doctor, wrote thut during the Second World War rayon factories in Pledmont increased the working day to twelve hours, oven during blackout conditions, in a bid to ramp up production.²³

During the war, forced labor wasn't uncommon. A Phrix factory near Littenberge used labor from the nearby Neuengamme concentration camp, as did another German rayon manufacturer in the Bohemian countryside at Lovosice. By 1943 one in four Glanzstoff workers was a forced laborer or prisoner of war. When an I. G. Farben factory at Wolfen was liberated by the Allies, the workers who had been forced to work there rioted and set the factory on fire.²⁴

As well as being morally repugnant, the use of slave labor at rayon factories made for recalcitrant, rebellious, inexperienced, malnourished, overworked, and underage workers who were extremely vulnerable to accidents. Agnès herself, despite becoming a grandmother while she was working there and being in poor health throughout, was expected to operate machines on her own for up to twelve hours each day without formal training. She and her fellow workers were also routinely physically abused by their overseers.

For the first few months she worked only with the finished rayon thread. This had its fair share of difficulties. It was thirsty work: "because of the rayon dust that we swallow with every breath." Forced laborers were permitted only two bathroom breaks each day and weren't allowed to use the water fountain at all; indeed they were only allowed to drink at the overseer's discretion.²⁵

Even so, it was clear to Agnès from the very beginning where the conditions were worst: the machine hall where the viscose was being made. When she arrived, this area was staffed by free, paid workers, many of them Dutch and nearly all of them men. They were, she wrote "in a pitiful state":

[Their] overalls are in tatters, eaten away by acid; their hands bandaged; and they appear to be suffering terribly with their eyes, to the point where they often can't manage by themselves. A fellow worker will hold them by the arm, sit them down, put the spoon in their hand. They appear racked by excruciating pains. What sort of work can this be that causes such torments?²⁶

Although she didn't yet know it, Agnès was soon to find out. The free workers were melting away from the factory day by day and refusing to return. After a while, the only people the management could compel to work in the spinning room were women—forced laborers—like her.

On the Floor

Arbeit macht frei. Work sets you free.

Slogan on the entrance to Auschwitz and other Nazi concentration camps

In April 1887 a twenty-seven-year-old man was brought to the Hudson River State hospital for the insane. Twelve days later, another man was forcibly interned. Both, it turned out on further investigation, worked at the same rubber factory. A few months later, in high summer, a third patient arrived at the same hospital from the factory. He was, according to reports, "in a condition of great mental excitement, disturbing the neighborhood by loud noises and violent praying." Frederich Peterson, chief of the Nervous Department at New York's College of Physicians and Surgeons, took an interest and determined that all three had inhaled large doses of the same chemical: carbon disulphide.²⁷

Carbon disulphide is, according to its biographer, Paul David Blanc, "an elegant little molecule," consisting of a single carbon atom sandwiched between two sulphur ones. It occurs rarely in nature volcanic fumaroles are one habitat—but was created artificially by a German chemist in 1796. From the mid-nineteenth century it was used to vulcanize rubber (this method was called cold-process vulcanization; another relied on heat and pressure) to make cverything from bathing caps to tires and India rubber condoms.²⁸

The medical dangers became obvious almost from the moment it was used. Forty years before the three young men were incarcerated at the Hudson Dime. State hospital, a French chemist published a textbook raising the alarm. France at this time was a European center for vulcanization, so its scientists and doctors were the first to recognize the grave risks that carbon disulphide posed to those handling it. This chemist didn't go so far as to say that the use of carbon disulphide should cease, but instead suggested that vulcanization should only take place in the open air. Two years later Guillaume Duchenne de Boulogne echoed the warnings in a presentation to the Medical Surgical Society of Paris. He had observed that people exposed to this chemical appeared to become mentally deranged in a similar manner to those suffering end-stage syphilis, a fearsome venereal disease that had run rampant during the ninetcenth century.²⁹

These warnings were slow to spread and, even once awareness had been raised in the rubber industry, no one thought of assessing the risks involved with its use in making viscose. Part of the problem is the great and diffuse range of symptoms exposure to carbon disulphide causes. A report drawn up in 1941 lists around thirty, ranging from the mild—foggy vision and loss of appetite—to the terminal death from respiratory failure.³⁰ Early medical accounts, almost exclusively conducted on male patients by male doctors, were horrified to note sexual side effects. A French physician reported the case of a twenty-year-old who was suffering constant erections. Another patient, a twenty-seven-yearold, whose case was further advanced, appeared aged beyond his years, and had seen his "sexual desire and erections... abolished."³¹

As well as physical effects, carbon disulphide exposure can cause a range of psychological symptoms. Workers and their wives reported subtle personality changes, violent, disturbing dreams, confusion, headaches, and, in extreme cases, acute insanity. Dr. Thomas Oliver wrote that some of those working with this chemical became so frenzied they "precipitated themselves from the top rooms of the factory to the ground." A study of a Pennsylvania community found that ten workers at the nearby rayon factory had been committed to the asylum one after another. One became so violent he had to be subdued by four policemen; he later died of his injuries. Another man tried to stuff a rock down his own throat.³²

Dr. Alice Hamilton described a couple of men she had examined in 1923, both of whom worked in a well-ventilated treatment room at a rayon factory near Buffalo. The first man was tall and gaunt with "a nervous manner, easily excited and irritated by questions, and unable to bear opposition." He had initially felt weak in the legs and nervous, with a pronounced shake like a palsy sufferer. "His spirits were very depressed, he was drowsy all the time, he could fall asleep at any moment." His colleague was much better physically, but "in a very emotional and nervous state, although trying hard to control himself." He was suffering from hallucinations and, midway through the interview with Dr. Hamilton, "his self-control gave way and he buried his head in the pillow and burst into tears."³³

Problems with carbon disulphide were international and continued well into the middle of the century, despite many cases of misadventure and insanity. In Italy, the Institute for Insurance against Accidents and Occupational Diseases recorded eighty-three cases between 1934 and 1937. In 1938, however, the number of cases suddenly spiked. Eighty-three cases were recorded in that year alone: sixteen involved a permanent disability, one proved fatal. Later, during the Second World War, Dr. Enrico Vigliani, who was

215

fascinated by occupational health, particularly at viscose factories, noted how some factories seemed to be far worse than others at protecting their workers. He encountered forty-three cases of carbon disulphide poisoning of viscose workers at four factories in Milan between 1943 and 1953. Of these, twenty-one came from one factory; eighteen from a second; the third and fourth factories had just two cases apiece.³⁴

Troublingly, the damage done by even brief exposure to carbon disulphide in rayon factories sometimes proved irreversible. Dr. Vigliani saw over a hundred exposed rayon workers in Piedmont between 1940 and 1941. Many had difficulty walking, suffering with knee pain and a continual feeling of heaviness in their legs; five had developed signs of psychosis. When he re-examined some of these patients in 1946, one was recovered, four had improved, five were unchanged, and the condition of ten had worsened.³⁵

While these official and medical reports are horrifying enough, it is clear that they provide an incomplete picture of the situation. Many of those working in rayon factories were poor, ill-educated, and desperately needed to keep their jobs. This made them keen to keep working, even at the expense of their health. The gaunt man that Dr. Hamilton spoke to had been given six weeks' complete rest and, she judged, "had no inclination to exaggerate his disability, rather the contrary for he was keen to work again."³⁶

The medical reports are also often flawed or incomplete. The Italian figures quoted by Dr. Vigliani only include cases where those involved received compensation: it is reasonable to assume that this was the tip of the iceberg. Official reports could also be manipulated by factory owners and overseers unwilling to take responsibility for harm done to workers. Dr. Hamilton once spoke to the manager of a white lead works who exclaimed indignantly: "Do you mean to imply that if one of my men gets lead poisoning I am to be held responsible?"³⁷

A similar attitude prevailed in the textile industry. In both America and Britain, cases of persistent eye problems were routinely described as "conjunctivitis," even after proof emerged that exposure to carbon disulphide was really causing keratitis, a less innocuous condition. In the early 1960s when presented with evidence of the harm that carbon disulphide could do to workers, Courtaulds stalled and prevented research from going forward. As late as the 1990s they sent a sharp rejoinder to a proposed government Health Hazard Evaluation study. DuPont, on the other hand, began studying the effects of the chemicals they were using on workers in 1935, and imposed safety limits on the amount of carbon disulphide that was acceptable in their factories.³⁸

Agnès and her fellow forced laborers had no idea—they were never told—what the chemicals they were handling were or what harm they could do. The term "carbon disulphide" doesn't appear once in *Résistance*: she vaguely refers to nearly all the chemicals that they worked with as "acid." They learn on the job from each other, with very little supervision: each new horror comes as a surprise. Something they discover early is to try to avoid the molten viscose—they were working with open vats, without the safety hoods and equipment normally used to protect workers. It "produces terrible burns, like phosphorus," Agnès writes soon after she has begun working with viscose, "it sticks to the wounds it causes and is impossible to remove, eating the flesh away to the bone." Unlike the civilian workers, who were given safety equipment and gloves, slave labor at the Phrix plant had to manage in fabric trousers and shirts that were quickly eaten away, leaving some of the women in a state of near nudity on the factory floor.³⁹

The disregard shown for their safety is chilling. One day a worker has "a violent epileptic fit at her machine, foaming at the mouth dreadfully while her body arched and jolted from one side of the central corridor to the other." Agnès and the others look on in horror, but the "overseers and wardress found this highly amusing." Within half an hour she is back at her machine. Later, the fits become a weekly occurrence.⁴⁰

As the war drags on, conditions worsen. Rations decrease and the hours they are expected to work lengthen: soon they are working sixty hours each week and are pulling twelve-hour shifts two Sundays out of every three. The consequences for the health of the workers are inevitable. When Henriette, Agnès's friend, is blinded by the carbon disulphide and suffering terrible cramps and leg pain, all she is given is aspirin and some eye drops. Agnès, naturally clumsy, is constantly getting injuries caused by splashes of viscose. Some falls on her foot, eating it away until it becomes infected. She has spilled so much on her hands that the skin becomes "grey and painful." She cannot sleep and soon enough she too begins to suffer from spells of blindness. "First of all you are plunged into a dense fog, then the pain starts: streaming eyes and nose, followed by stabbing pains in the eyes, a splitting headache and excruciating pains in the back of the neck."⁴¹

Agnès and her companions were also—although they were unaware of it—experiencing psychological symptoms. Everyone sleeps badly, and desperate suicide attempts become routine. A young Austrian girl hides behind her machine and swallows a tumblerful of liquid taken from the rayon vat. Later, three women try to end their lives within twenty-four hours. One throws herself out of a window, another down a stairwell. The third, Henriette, slashes her wrists with broken glass.⁴²

Agnès's spirit, however, remained unbroken. When American soldiers liberated the factory and its workers at the end of the war, they were astonished by her energy: she immediately began helping them round up local Nazi officials who remained at large and set up roup kitchens for refugees. At the latter, she insisted that everyone be given a share, including German civilians.

Fast Fashion; Old Problems

This is a story of exploitation.

Abir Abdullah, photographer based in Dhaka, 2015

At three minutes to nine on Wednesday morning, April 24, 2015, a large, eight-story building collapsed as suddenly and completely as if its concrete components had been held together by nothing more substantial than silken threads. There were 3,122 people inside at the

time, the majority of them female garment workers, many of whom had their children with them.⁴³

There had been warning signs. Another factory had collapsed eight years previously, and a few months before a fire had broken out in another garment maker's nearby. This particular building had never been intended to house factories. The foundations, having been built on a filled-in pond, were unable to withstand the weight and vibrations of industrial use, besides which four extra floors had been added without building permits. More damning still, major structural cracks had been discovered the day before. Several other commercial businesses that shared the building, including a bank and some shops, had evacuated their staff, despite the claims of the building's owner that it was safe. The garment workers, however, were ordered back to work; managers at one firm threatened to withhold that month's wages if they refused.⁴⁴

In all, 1,134 people were killed by the collapse of the Rana Plaza building in Bangladesh in 2013, and many more were injured. Some of the survivors remain deeply traumatized from having been trapped for many hours—even days—in the rubble, surrounded by the bodies of colleagues and friends. The last person to be found alive was a woman called Reshma, pulled from the wreckage of her workplace, her face powdered with sticky beige dust, seventeen days after it had collapsed. Many survivors still able to work soon returned to jobs in the garment industry: few other opportunities were available and they needed the money.⁴⁵

Three years later, thirty-eight people, including Sohel Rana, the owner, were charged with murder. Many of the conditions and the wider context, however, remain unchanged. Bangladesh is one of the world's poorest countries. And yet in 2013 it was the world's second largest clothing exporter behind China; some five thousand factories employed 3.2 million workers, many of them women. After Rana Plaza, exports actually rose 16 percent to 23.9 billion dollars.⁴⁶

Cheap and plentiful labor—the minimum wage at the time of the accident was just thirty-seven dollars a month—makes it a popular place for large western brands to outsource production. Labels found amidst the Rana Plaza wreckage included Primark, Mango, Walmart, and Benetton. Despite the presence of such large and profitable companies, redress for those affected by the disaster was slow in coming. It took five months for a committee to be set up to compensate the families of those who died. By the one-year anniversary of the disaster, only 15 million dollars of the required 40 million dollars had been raised. Benetton, who had sourced 266,000 shirts from Rana Plaza over the six months before its collapse, was finally shamed into paying into the compensation fund in 2015. Activists mounted a photograph of a victim of the disaster on a van that was driven around Treviso, Italy, home of the firm's global headquarters.⁴⁷

Today's large, mass-market fashion brands rely on synthetic fabrics. Without them fast fashion probably wouldn't exist. Synthetics are cheap, quick to produce, and can be readily made to order in exact quantities, colors, and prints in time for the fortnightly, weekly, or even daily drops of new clothes that the largest and most successful brands, such as Zara, H&M, and Topshop, demand.

Synthetics make up well over 60 percent of a global fiber market that is steadily growing. Americans increased their spending on clothing and footwear 14 percent over the five years between 2011 and 2016, up to 350 billion dollars in total; similar or greater increases have been seen elsewhere. Rising populations and burgeoning middle classes desirous of having the trappings of wealth means more fabric for furnishings, clothes, and shoes. In 2016, the market for fibers increased 1.5 percent to ninety-nine million tons. We are making far more than we could ever reasonably need. In 2010, for example, it was estimated that 150 billion garments were stitched together, enough to provide each person alive with twenty new articles of clothing.⁴⁸

Environmentally, synthetic fabrics are a disaster. Polyester, one of the cheapest synthetics, is essentially a plastic derived from crude oil. Not only do polyester garments usually end their days as landfill, but they constantly shed plastic filaments: by some estimates, these fibers are among the most abundant environmental debris in the world. Synthetics are also hungry for resources. For most synthetics this is oil; for rayon, it is cellulose. In Canada, the Amazon, and Indonesia, old-growth forests are being cut down for their wood pulp. Canopy, an environmental organization, believes that 120 million trees are felled each year to produce rayon and other cellulosebased materials.⁴⁸ In Indonesia, bamboo is often planted over the site of felled trees to produce fabrics that can then be marketed as being "renewable" and environmentally friendly. Because rayon is made from cellulose, it is ripe for greenwashing, especially when consumers are fuzzy about how it's made. In 2013 Amazon, Macy's, and Sears were among the brands forced to pay fines totaling 1.26 billion dollars for allegedly falsely labeling textiles as "bamboo" when they were rayon. This, according to the Federal Trade Commission, was tantamount to duping consumers who were trying to be environmentally conscious.⁵⁰

For the most part, the dirty work of producing synthetic fibers has been outsourced to areas of the world where labor is cheap and regulations are lax. Around 65 percent of the world's viscose is made in China; India and Indonesia are the world's second and third largest producers respectively. Although now the production of rayon is highly concentrated—just ten companies account for 70 percent of all the rayon produced—which should make accountability easier, problems persist. In West Java, semi-processed viscose waste was found scattered around villages next to one large rayon plant. And factories that have supplied brands including Zara, H&M, Marks & Spencer, Levi's, Tesco, and Eileen Fisher have been caught illegally dumping factory waste into rivers at night, contributing to pollution and poisoning the ground water. In 2016 it was reported that over 80 percent of the underground wells providing drinking water across the Chinese plains were unfit for consumption because of pollution.⁵¹

This shouldn't be news. In 1942 the water of the Roanoke River in Virginia near a rayon plant was tested for cleanliness. Researchers drew off tanks of water from the river that had been contaminated with American Viscose effluent and put fish in the tanks to see what would happen. No fish survived longer than ten minutes. They reached the conclusion that the river was now so polluted that not only was it unfit as a habitat for wildlife and for human recreation, but it was also "injurious to hydraulic machinery."⁵²

The human cost of synthetic fabrics, and the fast-fashion juggernaut that demands that so many of them be made, is high, as the factory collapse in Bangladesh shows. The breakneck turnaround and low prices expected by consumers make it an industry highly susceptible to exploiting workers. The apparel industry is the largest employer of women globally, yet fewer than 2 percent are earning a living wage.⁵³

Employees also continue to be exposed to grave risks. In the rayon industry, those who don't succumb to obvious carbon-disulphide poisoning are still vulnerable. A Chinese study found that exposed male rayon workers have lower semen quality and fewer, less satisfactory sexual encounters. A 1968 study in the *BMJ* looked at the mortality of rayon factory workers employed at three plants in Flintshire. It found that 42 percent of all deaths between 1933 and 1962 were due to heart disease. Among the control group—people who hadn't worked around rayon—heart disease was the cause of death only 17 percent of the time. Chillingly, a former employee of one of these factories, owned by Courtaulds, told Paul David Blanc that women could turn up with their hair in rollers and find their hair permed by the end of the shift because of the amount of sulphur in the air.⁵⁴

For the first time in human history, the vast majority of fabric being made has become disputable, something to be consumed and thrown away within weeks or months of being made. Synthetic fibers have made this possible. Created in factories far removed from the people who will use them and sold for a couple dollars a pound, their value has been worn threadbare. Research is being done into the creation of fibers that are genuinely environmentally friendly to produce and are biodegradable. Fabrics are being grown using mycelium funghi; an alternative to silk is being brewed like beer from genetically modified yeast. Perhaps the biggest change, however, needs to come from those of us doing the buying. It is unlikely that we would ever find ourselves, as Agnès did, working at one of these factories. But perhaps this is a possibility that we should give a little more thought to, each time we go shopping.

11

Under Pressure

Suits Suitable for Space

Suited to the Moon

That's one small step for man; one giant leap for mankind.¹

Neil Armstrong, live transmission from the moon's surface, July 21, 1969

In the early hours of July 21, 1969 (GMT), 528 million people—15 percent of the world's population and 95 percent of America's—tuned in to watch as an ungainly white boot made the first human impression on the surface of the moon.²

For Neil Armstrong himself, it must have been uncanny. The landscape into which he stepped was devoid of color. "It's gray," he told Mission Control, "and it's a very white, chalky gray, as you look into the zero-phase line; and it's considerably darker gray, more like ash ashen gray as you look out ninety degrees to the Sun." Gravity is about one-sixth of what it is on Earth, so each step—however small propelled him up as if his feet were attached to cartoon-style springs. The lunar surface was fine and powdery; it floated up like sooty confectioner's sugar when he scuffed his toe in the ground. He could hear little except the sounds his spacesuit made: the hum of pumps, the rustle of fabric, and the tinny voices of Mission Control. Precisely two hours and eighteen minutes later, Armstrong closed the hatch behind him and prepared to return to orbit and then to the Earth itself.³

These hours had been the result of many years of training and preparation. In the run-up to Apollo 11, each of the aspiring astronauts⁴ had taken on a different area to focus on. Buzz Aldrin—who also walked on the moon that day—had studied mission planning; Ted Freeman—who did not—looked into boosters. The third man chosen for the Apollo 11 mission, Michael Collins, who stayed in orbit as his fellows cavorted in the lunar dust, had taken responsibility for the pressure suits that the astronauts would wear. "I made this choice slightly hesitantly," he later wrote. "Clearly this was not the largest piece of the pie: it was not in the thick of things, such as cockpit design, or guidance and navigation, and therefore it might cause me to be overlooked as an early candidate for flight." It is odd that he saw it this way: as trivial or even as a hindrance. On the contrary, spacesuits—or pressure suits as they referred to them—are critical to survival in space and therefore to the success of the Apollo 11 mission.⁵

Space is the most alien environment in which a human being has survived. The dangers faced there are legion. In space, temperatures fluctuate between -251°F in the shade and as high as 309° in a sunny spot. Because there is no atmosphere through which it is being filtered, there is a great deal of ultraviolet radiation from the sun, which is harmful to our eyes and skin. There is no breathable air and a fair chance of being struck by a micrometeorite. The lack of gravity alters vision and causes nausea and even physical sickness. This may not sound too serious, but in the very small confines of a helmet, globules of floating vomit become much more problematic. (A Subcommittee on Motion Sickness was convened as early as 1944.) Over a longer period of time, zero gravity decreases your bone density by 2 to 3 percent each month, leaving you supremely vulnerable to breaks from even the slightest mishap.

There is also the vacuum to contend with. Contrary to popular opinion, and that of many of the astronauts themselves, exposure to one—if, say, a suit was torn by a rock and began to depressurize would probably not cause the blood to boil. The body would certainly begin to swell, however, and the body fluids directly exposed to the vacuum would begin to sizzle. (This actually happened to one unfortunate man during a faulty NASA experiment in 1965. He passed out in fourteen seconds; the last thing he remembered was the spit on his tongue beginning to bubble.) Deprived of oxygen, brain cells quickly begin to die. The suit must protect its occupant against all these hazards. It is all that stands, wrote Collins, "between the little soft pink body of the astronaut and the hard vacuum of space."⁶

At three-thirty in the morning on the day that the Apollo 11 mission set off, July 16, 1969, the suit technicians were working at fever pitch. Their domain—a humble trailer near the launchpad during the Gemini missions—had been upgraded to a suite with areas in which to test and store suits, helmets, gloves, shoes, hoses, packs, and everything else the astronauts would wear in the spacecraft and on the lunar surface. Oxygen supplies were turned on and off. Suits were pored over to check for leaks and communication bugs. Seams were examined. Zippers were run up and down to check for snags. Finally, everything was laid out in the areas where Aldrin, Collins, and Armstrong would be dressed.⁷ Collins only had an intravehicular suit, to be worn inside the spacecraft; the two others also had extravehicular ones, known as Omega A7-L. Each astronaut had three custom-tailored versions of the suits they needed: one for training, one for flight, and a backup in case of emergencies. Every suit cost between \$100,000 and \$250,000, depending on its weight and complexity. (The Apollo astronauts used to joke that if the pressure suits were priced like steak it would work out at around a thousand dollars a pound. Armstrong and Aldrin's weighed 56 pounds alone, or 189 pounds with their portable life support systems [PLSS].)⁸

The process of dressing for space travel is laborious. First Aldrin, Armstrong, and Collins had to apply a salve over their bodies: the mission would last over eight days and they wouldn't be able to change their clothes except to suit up for the moonwalk itself. Without the salve, their clothes would have begun to chafe. Next, they put on diapers-NASA, which has a special name for everything, calls these "maximum-absorbency garments"-and a rubber bag, tube, and waist-mounted collection sac for urine.9 Over these were stretched pairs of cotton long johns-"constant-wear garments"-and then the suits themselves. Because these were cumbersome and close-fitting, putting them on required assistance and a great deal of time. Last to go were the gloves and headgear. Two pairs of the former: first a nylon, "comfort" pair, then the heavier ones that locked to the suit with aluminum rings-red for the right hand, blue for the left. Tight brown-and-white Snoopy Caps, which contained the communication systems, were pulled on and finally the wide, bubble-head helmet. For the journey from the suit technicians' suite to the launchpad, the astronauts' oxygen supplies were connected to silvery, briefcaseshaped ventilator machines. They looked, according to one writer, "like businessmen on their way to the future."10

Despite the long-winded grandeur of this exit, on the fifth day of the mission, after thirteen orbits of the moon, Armstrong and Aldrin had to strip down to their skin and start again. Different, weightier equipment

would be needed for the moon. Their "constant-wear" long johns were swapped for "liquid-cooling" ones. These were tight-fitting nylon spandex-stretchy fabric of the kind used to make leotards with-which fastened up the front and were covered with a veinlike filigree of thin brown PVC tubes through which cool water was pumped to prevent them from overheating under the *millefeuille* of synthetics. Over this went the thick, white, twenty-one-layer Omega suit. The pair donned helmets, gloves, and the oxygen-and-cool-water-bearing PLSS in the tiny, eight-foot Lunar Module (LM) cabin right before their moonwalk. The gloves had printed to-do lists Velcroed to them: there was so much to do they were afraid they would forget. The visors of the over-helmets were coated with 24-carat gold to reduce the glare and the whole assembly snapped onto the neck-ring of the suit to ensure there could be no leaks. Doing all this in the cabin was a tight fit, and the pair were nervous. The final dressing before they opened the hatch took a full hour longer than scheduled-three hours in total-and, according to Aldrin, was quite a sight. "We felt like two fullbacks trying to change positions inside a Cub Scout pup tent." At the last moment, one of them turned, bumping their PLSS into a knob controlling an ascent engine circuit breaker, and breaking it. Taking off later, Aldrin had to improvise: he stuck a felt-tip pen inside the hole to start the engine.11

Into Thin Air

Ad astra per aspera. A rough road leads to the stars. Apollo 1 Memorial, Kennedy Space Center

> For Michael Collins, the relationship between an astronaut and his suit was comprised of both love and hate. "Love because it is an intimate garment protecting him twenty-four hours a day," he wrote.

"Hate because it can be extremely uncomfortable and cumbersome." Love, naturally, usually won the day.¹²

The need for protective garments in the upper reaches of the sky became obvious with the advent of hot-air ballooning in the eighteenth century. In the late autumn of 1783, the Montgolfier brothers ascended just over a mile above Paris in a gigantic, turnip-shaped balloon fashioned from blue, hand-woven silk decorated with fleursde-lis and the monogram of King Louis XVI. It caused a sensation. A month later, on December 1, Professor Jacques Charles used an inflated hydrogen balloon to reach into the heavens. He ascended 10,000 fect, almost without realizing it, before being dreadfully afflicted with intense cold, and pain in his ears and jaw. He quickly descended and never flew again. Other aeronauts, however, remained undeterred despite the evident danger. On April 15, 1875, for example, all except one crewmember of a balloon that reached 26,000 feet died, their lips horribly slathered with blood-flecked foam. Half a century later, a similar fate befell Hawthorne Gray. The American aeronaut took off from a field in Illinois wearing 57 pounds of protective clothing and carrying a supply of oxygen to counteract the thinning atmosphere at high altitudes. He rose to 44,000 feet but died long before his balloon touched down. "His courage," read the announcement that accompanied the posthumous Distinguished Flying Cross he received, "was greater than his supply of oxygen."13

The American pilot Wiley Post developed a suit with B. F. Goodrich, the tire and rubber company, that allowed him to survive in the stratosphere, an atmospheric layer some six to eight miles above the ground. It was made of a snug-fitting, inflated rubber interior under a quilted cotton layer to hold the rubber bladder in place and prevent it "ballooning" when pressurized. On his head he wore a silver, bucket-like helmet with a porthole through which he could see. (Because he only had one eye, the other having been lost in a mining accident, the porthole was positioned off-center.)¹⁴

During the Second World War, with more people taking to the air than ever before, technology leapt forward. A series of madcap experiments were undertaken to test the limits of the human body at speed and altitude. In June 1943, to see what might happen to pilots if forced to bail out at 40,000 feet, Randy Lovelace jumped from a plane into air that was later estimated to be nearly sixty degrees below zero to test pressurized breathing equipment. He was knocked unconscious by the force of his own parachute's opening, and both his outer gloves and the inner glove from his left hand were torn off. The hand froze nearly solid during the twelve-minute descent. The conclusion drawn was that at high altitudes and at high speeds the limits of human endurance were always close at hand and a moment's misjudgment could prove lethal. Fast acceleration made arterial blood pool in the extremities, and although training helped raise tolerance, even experienced pilots might pass out if exposed to g-forces of four or five. Airmen had to wear layers of shearling, silk, and woolen clothing to protect them from the cold. Later on in the war, gunners in exposed positions often used heated suits to prevent frostbite.¹⁵

Specialist clothing was imperative. David Clark, an American girdlemaker whose first product had been an elasticated knitted shapewear garment for men-"The Straightaway"-became involved early on. His "anti-g" suits used bladders of vinyl-coated nylon that closely fitted the wearer and put pressure on the lower body, helping to prevent blood pooling in the lower extremities and thus avoid pilot blackouts. Their introduction in one fighter group of the Eighth Air Force resulted in a near doubling of the number of kills per thousand flying hours, from thirty-three to sixty-seven. After the war, Clark continued to refine his designs, swapping the bladders for fabric surfaces that could be pulled taut around the body by a series of inflatable rubber tubes. One of these suits, called the T-1, was used by Chuck Yeager in 1941 during his attempts to break the sound barrier. Later, Clark was involved in creating special suits for the pilots of the B-52, designed to fly at 70,000 feet. These suits were fully pressurized and came with an eight-hour oxygen supply, a roll-on urination device and built-in cheese-and-hamflavored pastes so that the pilots could eat while flying. They were also, however, extremely uncomfortable. During a single mission pilots would lose around 5 percent of their body mass due to stress.¹⁶

By the mid-1950s, when the advent of rocket-propelled planes brought the prospect of sending man into space within reach, efforts to create reliable, comfortable pressurized suits redoubled. In 1954, the Wright Lab created "get-me-down" suits, with bladders that automatically expanded at a certain altitude—usually 35,000 feet. They were custom-made for each pilot using around 160 body measurements and relied upon a series of layers. Pilots first pulled on thin long johns followed by a "vent garment," which allowed liquidnitrogen-cooled air to circulate and keep them cool. Over this went a two-piece rubber pressure suit, constrained by a layer of "link-net" nylon mesh covered by silvery nylon. The mesh innovation was a happy accident. David Clark had tried loosely hand-knitting highperformance nylon in 1956 while on board a commercial flight to Alaska to visit his daughter. As a result the suits dropped from 110 pounds to just twenty-five. "Get-me-down" suits were effective one saved the life of an airman when the canopy of his rocket airplane cracked at nearly 80,000 feet during a test flight. But they were also inflexible, difficult to move around in, sweaty, and so snug that it took over ten minutes and a valet to put one on.¹⁷

The first spacesuits were created for the Mercury program. This was America's initial manned-space endeavor and the country's answer to a series of Soviet space-triumphs, including sending the first artificial satellite, animal, and human into space. Because of this the suits played a psychological as well as a physical role. Bruised by their belated entry into the Space Race, the American astronauts needed clothes that made them look and feel the part. In the iconic image of this mission, taken in 1960, the seven Mercury astronauts stand in two smiling rows against a deep cobalt backdrop, resplendent in shiny, asymmetrically zipped silver suits, white helmets, and metallic combat boots: a vision of an optimistic, high tech, and space-age future.

Beneath their shiny, reflective surfaces, however, the suits were of a decidedly evolutionary rather than revolutionary character. Mel Case, who was later involved in producing the Omega suits, sniffed that they were "nothing, really, but a silver high altitude flying suit." (The coloring, incidentally, was a powdered-aluminum coating; beneath lay camouflage-green nylon fabric, which over time began to show through.) As in the later Apollo mission, one of the astronauts, Walter Schirra, oversaw the development of the suit with the manufacturer. In this case the chosen firm was B. F. Goodrich, the rubber specialists who had made Wiley Post's experimental suits nearly two decades previously. The Mercury suits were, in Schirra's eyes, "the center-piece" of the mission's equipment. A "skintight cocoon of rubber and

fabric which we seal ourselves into before each flight or practice mission. . . . It is also tailor-made, and it fits us so snugly that we have to use thirteen different zippers and three rings to put it on." The aluminized fabric was able to withstand temperatures up to 180° —"warm enough," as Schirra put it, "for broiling." When inflated, the suit's pressure ensured wearers could withstand great acceleration. The all-in-one underwear had waffle-weave patches and coiled "spacers" around the torso, thighs, and upper arms to help ventilate the skin.¹⁸

The Mercury suits were worn throughout the mission, and were inflated most—but not all—of the time. And it was here, as ever, that the real difficulties began. While the silvery nylon over-layer was the primary restraint for the rubber, the suit also contained a number of strategically placed non-stretch tapes, cords, and zips to help cage the rubber and prevent ballooning. Schirra admitted that, even deflated, the suits were "cumbersome." When inflated, the suits became—just like their close relative the bicycle tire—"downright rigid."¹⁹

Nevertheless, it was in this suit that Alan Shepard became the first American in space, a brief, fifteen-minute flight on May 5, 1961. Twenty days later, buoyed by this feat, President Kennedy threw down the gauntlet, suggesting that within the span of a decade America should have placed a man on the moon.²⁰

Of Seams and Seamstresses

It was one of the high points of my life, I'd say ... I had come to this company purposefully to work on the suit that flew to the Moon.

Mel Case, Senior Design Engineer, ILC, 1972

The Apollo Omega had a troubled birth. The white suit's soaring serenity, seen by so many millions in July 1969, belied years of

behind-the-scenes wrangling between contractors vying for NASA's affections and dollars. The twin pressures of Kennedy's tight deadline and the fierce rivalry with the Soviet Union meant a decade of huge spending—some estimates put the cost to America between 1960 and 1972 at forty billion dollars—and continual innovation.²¹ The very purpose of the Gemini program, which was announced in January 1962 and ran between 1965 and 1966, was to test spacecraft, the techniques that would be required to land men on the moon, to send someone outside to "spacewalk," and to assess the medical impact—if any—of prolonged trips to space. Given this intensity, it is even more surprising that the final victor was both the last entrant and the most unexpected: Playtex, makers of women's underwear.²²

During the mid-1960s the two principal names in spacesuit manufacture were David Clark Company, based in Worcester, Massachusetts, and Hamilton Standard, who had at first worked with and then succeeded B F Goodrich. Playtex, also known as the International Latex Company (II C), was a small firm no moro than fifty employees in 1962-whose area of expertise lay in latex molding bras and girdles. It first entered NASA's orbit as a subcontractor to Hamilton Standard, much to the disgust of both firms. ILC was bitterly disappointed at not being appointed the sole contractor: it had, after all, submitted a better and more innovative prototype. Its suit's novel feature was that the molded rubber bladder was internally bonded to nylon restraints, which prevented it from ballooning when inflated, and cut down on bulk while allowing for greater flexibility. Hamilton Standard, meanwhile, was annoyed at being trumped by another firm, so much so that they put together an internal tiger team to create a better suit than ILCs, essentially trying to undercut their own subcontractor. The results, however, were poor. On December 21, 1964 a terse NASA memo was circulated. "Tiger suit a bust," it read. "Forget it."23

The problem was a clash of cultures. NASA was made up of engineers and scientists. They required precise technical drawings, scientific explanations, and detailed descriptions of the origins of each component inside every single item that would be sent into space, down to the tiniest screw or wisp of thread. ILC, on the other hand, had a culture that was scrappy and folksy. It relied on teams of experienced seamstresses who read patterns rather than technical manuals, privileging craft and grit over qualifications. Lenny Shepherd, the pugnacious vice president of engineering during the Apollo project, for example, had been a TV repairman when he had been recruited by the firm.

Internal squabbling, coupled with the poor performance of the prototypes that Hamilton Standard and ILC were creating, resulted in a make-or-break second competition for the contract to supply the Apollo suits, to be held in the summer of 1965. ILC, who had to beg to be allowed to compete against the reservations of many at NASA and had long chafed against the unholy matrimony with Hamilton Standard, was given just six weeks to prepare its prototype.

The three submissions—one from David Clark (codenamed Suit B), one from Hamilton Standard and B. F. Goodrich (Suit C), and the third from ILC (Suit A)—were submitted to twenty-two tests in Houston on July 1, 1965. ILC's AX5-L soft suit, and the progenitor of the Omega, won in twelve of the twenty-two tests. "The ILC Suit is in first place," the head of NASA crew systems told his boss. "There is no second place."²⁴

Despite NASA's objections, the making of what was to become known as the A7-L Omega suit ("A" for Apollo, "7" because it was the seventh in the series and "L" for ILC) was much more akin to making girdles than anyone at the space agency would have cared to admit. Each suit was fashioned by hand on a sewing floor populated entirely by women-seamstresses, pattern-cutters, and makersusing adapted Singer sewing machines, standard pattern templates, and the skills both inherent and honed from years of making women's underwear. Those who had been trained to mold liquid latex to create girdles and bras found themselves making pressure bladders instead. Eleanor Foraker, an experienced seamstress, was pulled from Playtex's diaper assembly line in 1964 to work on the Apollo project. The Omega spacesuits inherited other things from the firm's main line of work too. The nylon tricot (a kind of knit mesh) embedded in the rubber to prevent it from ballooning was the same sheer fabric used to make many Playtex bras. Each spacesuit contained a layer of fluffy girdle-liner after complaints were made about the discomfort caused by the rubber chafing against the skin.²⁵

The exactitude required in making the spacesuits, however, was beyond anything that the makers had encountered before. Pins, for example, usually a staple in any seamstress's kit, were strictly rationed and even forbidden. ("To a garment whose reliability depended on an impermeable rubber bladder." Nicholas de Monchaux, author of Fashioning Apollo, explains, "mechanical aids like pins were an inherently risky proposition.") In 1967, after a rogue pin was found between the layers of a suit prototype, an X-ray machine was installed on the sewing-room floor to scan each layer of fabric produced. Sewing machines were modified to only fire one stitch at a time, so that the seamstresses could ensure the seams of these multi-layered garments were precisely straight. To meet NASA's exacting standards, seams could deviate no more than one-sixty-fourth of an inch. Handling the latex and gluing the layers together also required previously unheard-of levels of skill. Only three or four of Playtex's employees, for example, were considered sufficiently deft to fashion the paper-thin layers of latex to make the suit's internal bladder.²⁶

What made all this so much harder was the number of layers and components involved, each of which had to line up precisely with all its fellows. In the end, each Omega suit worn on the moon was comprised of some four thousand pieces of fabric and twenty-one distinct layers of material.²⁷ A cross-section would reveal a symphony of synthetics: Teflon-coated Beta cloth, a kind of fireproof silica cloth similar to fabric fiberglass; Mylar and Dacron, both types of tough but lightweight polyester for insulation; Nomex, a heat-resistant fiber still used by firefighters, and Kapton, a polyimide that is highly resistant to temperature extremes; and Chromel-R, a kind of woven stainless steel.²⁸

The vast majority of these were manufactured by DuPont, the American conglomerate responsible for developing popular polymers including nylon, neoprene, Teflon, Corian, Kevlar, and Lycra. DuPont, NASA, and many of the astronauts involved were keen to see and present the spacesuits as high-tech marvels of modern engineering. For NASA, the spacesuits were part of the myth of the agency's usefulness to the wider public. At one point, for example, it was reported in the *Wall Street Journal* that Teflon, which prevented food sticking to frying pans, was a by-product of space exploration. In fact, it was the other way around: DuPont had created Teflon in 1938, and it was being used in kitchens well before the first spacesuit was conceived.²⁹

This mythology persists. A blog post on the NASA website describes spacesuits as a "one-person spacecraft" and then goes on to use a thick mist of terminology to cloak them with wordy mystique. Suits worn outside spacecraft are called "Extravehicular Mobility Units"; the upper part of the modern suit is the "Hard Upper Torso"; the trouser section is, somewhat confusingly, called the "Lower Torso Assembly." During the Apollo years, this desire led them to become infuriated with ILC's processes, even while they couldn't fault the results. "The subject shipments," one memo from NASA read, "have been arriving unaccompanied by proper shipping documents." Another, from the director of Crew Systems Division, criticized the quality and punctuality of ILC's "reporting and analysis systems."³⁰

For the team at ILC, the efforts made to transfigure their processes into NASA-style technological documents were bamboozling. "We knew all there was to know about suits," Lenny Shepherd told an interviewer for the NASA oral history project, "but we sure didn't know very much about the paper." At ILC, the transfer of knowledge often flowed from the bottom up. Craftswomen were encouraged to suggest improvements to procedures and the firm's engineers took sewing lessons in order to understand the assembly process. In the end, to satisfy NASA's preference for technical drawings and shipping documents over patterns and craftsmanship, a workaround was created. ILC employed a team of trained engineers, whose job was to be both a buffer and translator between ILC's craftswomen and NASA's technocrats. The result was that from then on each suit came with its own stack of onionskin paper a foot high covered with technical drawings and engineering jargon lovingly describing every layer and stitch, which was entirely separate from-and never used bythe women actually making them.³¹

The astronaut Michael Collins, because of his role overseeing the

making of the spacesuits, saw and appreciated the exacting nature of the work. Early on in his memoir *Carrying the Fire*, he mentions his responsibility for the suits as part of the mission and calls them a "fascinating challenge," one combining "rigorous engineering with a touch of anatomy and anthropology," but he also admitted that they contained "more than a little black magic." The craft of the suits was, for him, seemingly both something to be admired and—teasingly disparaged. The "paper-thin bladder" of his favorite suit, which "kept my 3.7 psi oxygen from escaping into the zero psi infinity surrounding me," was "glued together with consummate care by some nice ladies in Worcester." For Collins, who had a keen sense of both the sublime and absurd in space exploration, the making of the spacesuit was a marriage of the two.

When you think of a space walker, you may visualize a chap confidently exploiting the most advanced technology that this rich and powerful nation can provide, but not me, friends. I see a covey of little old ladies humbhod over their glue pois in Worcester, Mass., and I only hope that between discussions of Friday-night bingo and the new monsignor, their attention doesn't wander too far ³²

Under the Skin

A spacesuit is like a one-person spaceship.

For all the labor, research, and technology that went into the spacesuits, they were—and remain to this day—far from perfect. "If it is true that the astronaut ends up loving his pressure suit," wrote Collins, "it is equally valid to note that shock—if not downright hatred—is usually the first reaction to wearing one of these tailored gas bags." Collins himself admitted to suffering from claustrophobia while wearing one, a problem he was too embarrassed to admit during his time as an astronaut. The makers themselves recognized the problem. "You've been raised from a baby to wear clothes," Mel Case explained, "but you were never raised to wear a spacesuit." In his eyes, at least, extreme discomfort was the payoff for safety.³³

Uppermost in the minds of NASA when it sent Armstrong, Aldrin, and Collins into space was how flammable so many things become in an oxygen-rich environment. In the early days of Apollo, suits and spacecraft were loaded with paper print-outs, combustible nylon, and Velcro, which is used everywhere to stop things floating off in zero gravity-it was all so much kindling in search of a spark. On January 27, 1967, midway through the designing of the Omega suit, Edward White, Virgin Grissom, and Roger Chaffee, the crew of Apollo 1, were engaged in routine tests in a stationary capsule. They had been inside for five hours and tempers had begun to fray when a fault in the electrical system resulted in a conflagration. The temperature inside the capsule reached over 1,990°F. In the command center at Houston, where the medical data of the three astronauts were being monitored remotely, the flight director saw White's pulse rise rapidly for fourteen seconds before stopping altogether. The three men were found hours later, their suits and bodies fused together, just beneath the hatch. ILC immediately reworked their spacesuit designs, swapping in fire-retardant materials in place of some of the nylon and plastic features.34

The most maligned quality in spacesuits—obvious even on earth but perilous under pressure in the vacuum of space—was their inflexibility and tendency to balloon. This is an inherent feature of pressurized rubber: the inner tube of a tire, soft enough when empty, becomes rigid and unyielding once inflated. This had been a design challenge from the beginning. Pleats like those in an accordion were inserted at knees and elbows to give early suits flexibility, for example, but even so the problem seemed intractable. What was a theoretical difficulty on earth, however, was much grimmer once in space.

At 11:32 a.m. on March 18, 1965, Alexei Leonov, a Soviet astronaut, entered the void of space. This first excursion was due to be

short, just twenty minutes or so, and his oxygen supply was correspondingly meagre. After nine minutes, however, he'd completed the task he'd been set and was instructed to come back inside by his copilot. It was at this point, however, that he discovered that his spacesuit had swollen rigid. As he repeatedly struggled and failed to bend his besuited body to get back through the small hatch and into the safety of the Voskhod, their craft, his heart rate and breathing accelerated. His oxygen-he only had a forty-five-minute supplybegan to deplete and the salt from his own sweat began to sting his eyes and his visor fogged up. "I can't ... no, again I can't get in," he said into the small microphone in his helmet, "I can't" It took him eight more precious minutes of repeated and increasingly desperate attempts to squeeze himself back through the hatch, and he only accomplished it by reducing his suit pressure manually-a potentially deadly decision-which allowed him to bend at the waist just enough to get in. The bulky suits, which Leonov had likely been roundly cursing, came off in a better light on the pair's equally ill-tated return. Upon reentry into the earth's atmosphere, their autopilot failed. They crash-landed some thousand miles away from their landing site in the snowy Urals, and spent a miserable night huddled in their suitsmade, in part, from leaky, latex-coated canvas-listening to the sound of wolves howling outside the Voskhod.35

Nor were the Americans immune from such problems. A few months after the Russian expedition, Ed White, the first American to spacewalk, suffered nearly identical problems. It took him a panicky twenty-five minutes of straining against the rigidity of the suit before he was able to maneuver himself safely back inside. Serious exertion was required to move around in the pressurized suits at the best of times. Clenching fingers inside pressurized gloves was like trying to squash a tennis ball for minutes on end: a huge problem in fiddly cockpits full of buttons and levers. "We solved this dilemma," wrote Walter Schirra of the Mercury program, "by weaving one finger on the left hand—the middle one—so that it stood out nice and straight and provided us with a fine tool for pushing buttons."³⁶

The liquid-cooling garments used by Aldrin and Armstrong were created specifically because other astronauts had been overheating so badly in the rubber and nylon confines of their spacesuits. Eugene Cernan, an astronaut during the Gemini 9 mission when regular cotton long johns were still in use, saturated his spacesuit with more moisture than it could handle during his spacewalk on June 5, 1966. As the temperature inside his suit rose, his faceplate began to fog up and his heart rate soared to 180 beats per minute. He might have been more nervous still had he known that his copilot was under orders to cut him loose should he be unable to reenter the craft wearing the bulky rocket pack that he was testing. As it was, the suit technician removed a pound of sweat from each leg of the suit when he returned.³⁷

So much sweat, coupled with the lack of space and changing facilities aboard spacecraft, make for poor hygiene. This caused sufficient concern for NASA to conduct nine six-week experiments in the mid-1960s on subjects wearing full pressure suits in a model capsule to simulate the effects of minimal personal hygiene, which the everspecific agency defined as:

No bathing or sponging of the body, no shaving, no hair and nail grooming (unless necessary), no changing clothes and bed linen, the use of substandard oral hygiene, and minimal use of wipes, which were permitted before each meal to avoid contaminating the food and after defecation.³⁸

The results were not pretty. "Socks—very soiled, damp, odorous. Underclothes—signs of decay," read one report. After four weeks of wearing spacesuits, the socks and underclothes of another group had deteriorated so completely that they needed to be replaced. Two Gemini 7 astronauts, who were in space for just two weeks, suffered the effects. Fifty hours into the mission Frank Borman, who had to get out of his suit to replace an electrode, asked James Lovell: "You got a clothes pin?" "What do I need a clothes pin for?" "For your nose," Borman replied. Clothing and clean underwear remain a problem to this day. There simply isn't enough room on board spacecraft to provide for daily clothes changes: underwear is often worn for three or four days. The fate of the dirty laundry is varied. Astronauts have used underpants as plant pots, for example, but most end up being sent back into the earth's orbit in a vessel at a trajectory that will cause it to burn up upon re-entry like shooting stars.³⁹

241

Sometimes the suits developed mechanical faults while they were in use. A continual bugbear is the drink and food bar (the food comes in paste form, similar to fruit roll-ups) installed at chin level inside the helmet. During the Apollo 16 mission in 1972-the fifth manned lunar mission launched by NASA-Charles Duke experienced multiple malfunctions. First the communications antenna stopped working so that all information had to be entered into the aircraft's computer's manually, then he began to experience difficulties with his suit. His request to loosen the laces inside was denied by Mission Control, and then when he put his helmet on, he discovered a leak. "Hey, Jim, on those drink bags," he told his commander at NASA four days and one hour into the mission, "I tell you, it's pretty hard to see things when you've got a helmet full of orange juice in zero gravity." "Well, you've got to drink fast," came the reply. Five hours later, however, the technicians on the ground began fretting about whether so much orange juice floating around in the body of the suit might cause damage. "Most of it, for some reason, floated up under my helmet- I mean my Snoopy hat, and I'm pretty sticky around the temples," Duke said, by way of reassuring them.40

By all accounts, these problems persisted. Cluis Hadfield, the mustachioed Canadian astronaut who visited space for the first time in the mid-1990s and commanded the International Space Station (ISS) in 2013, has joked that the inevitability of the drink tube leaking all over the food means the latter turns into a "gooey mass" that hungry astronauts then smear, toddler-like, all over their faces when they try to eat.⁴¹

As well as eating, astronauts have had considerable difficulty urinating and defecating while wearing spacesuits. Although "maximum-absorbency garments"—or diapers, to anyone not working at NASA—could be worn on shorter missions, on longer ones they are obviously impractical. Instead, a kind of bag with an adhesive rim is used (the adhesive secured to the skin first); the feces then has to be swatted toward the bottom of the bag, since it would otherwise float away, before the bag can be detached and stored. The process is so unpleasant that one astronaut spent an entire mission on Lomotil in order to avoid going at all. Doctors advise foods that produce as little waste as possible. Urination is completely unavoidable, however. Male astronauts were fitted with a special arrangement of plastic bags and tubing in order to pee. This, however, presented problems of its own, one of which was sizing (see footnote number 9). Women—after some false starts involving all-male technicians proposing ill-conceived suction pants—were left with the diapers. An unexpected silver lining was the beauty of releasing urine into space. One astronaut, upon returning from their mission, reported that a "urine dump at sunset" was the most beautiful thing they'd seen on the entire voyage.⁴²

Man Made for Mars

To the rocket scientist, you are a problem. You are the most irritating piece of machinery he or she will ever have to deal with.

Mary Roach, Packing for Mars, 2010

In the summer of 2017, Elon Musk released a concept image for our space-age future. The picture was of the spacesuit astronauts might wear on the manned version of the SpaceX Dragon cargo capsule. It was sleek and fitted and strikingly monochrome—a world away from the Omega, which Armstrong once memorably described as "tough, reliable, and almost cuddly." It appeared to be a two-piece, with elements—high boots, the ribbing at the knees and the shape of the shoulders—borrowed from biker gear. For Musk, the look of the suit was incredibly important. He told Reddit users in 2015 that they were "putting a lot of effort into design aesthetics, not just utility," a message he echoed in the Instagram post revealing the design for the first time: "It was incredibly hard to balance aesthetics and function. Easy to do either separately." It had proved hard enough, in fact, that

243

Musk hired the costume designer who had created the looks for films such as *Spider-Man*, *Wonder Woman*, and *X-Men*, who created the look they wanted, which was then "reverse-engineered to make [it] functional for flight."⁴³

Although this may seem novel, aesthetics have actually been of surprising importance throughout the history of space exploration, even if what eventually reached zero gravity has often left something to be desired. Hubert Vykukal, the lead designer of NASA's AX hard suits, which were tested in the 1980s, swore that he "wouldn't go into space in something made on a sewing machine!" Instead, he preferred the idea of an abstract body, a collection of solid, moving parts. He wanted, he said to "apply basic principles of engineering to the body." The result looked like the outcome of a tryst between a Russian Cubo-Futurist painting and a statue made from stacks of bowls. Appearances were also the driving force behind the first silver suits designed by David Clark. Legend has it that a pilot who visited the workshop to inspect the latest prosoure suit designs sponed a plece of silver lamé on a worktable and acked Clark about it. It was an experiment, he replied, just a piece of nylon "with a vacuum blasted aluminum coating . . . Pretty glamorous looking." The pilot suggested that it be used instead of the kliaki coverall currently used. "A coverall of this material would look real good, like a spacesuit should ... Just to justify it technically we can tell them this silver material is specifically designed to radiate heat or something."44

At some point between the workshops and space itself, however, looks have always given way to safety. In the case of the silver lamé, it was soon swapped for less glamorous but more reliable hightemperature nylons from DuPont. The AX hard suit never left the prototype stage: it was too heavy and was found to be restrictive enough to potentially cause injury to wearers. Indeed, the inclusion of any hard component, even if they do look better, has the potential for injury. (Astronauts with large hands often lose fingernails in the gloves and a 2012 study found astronauts who had performed over five spacewalks in the new suits, which have a solid torso, were twice as likely to have had shoulder surgery compared to those who'd done just one.) The harnesses used in the space station to facilitate exercise also cause injuries: astronauts return blistered and scarred. If this has been a problem on relatively short missions, the risk on a journey to Mars, which would take months, is a potential deal-breaker.⁴⁵

As well as the overriding concerns of comfort and flammabilitybecause the crafts and space stations are oxygen-rich, even materials that would satisfy fire codes on earth are suspect-longer stays in space add extra layers of difficulty. Over long periods, according to Bill Dieter, the president of Terrazign, a company currently making a harness for NASA, "you are essentially dissolving. Your muscle mass is decreasing, because you're not doing anything, and even more hazardously your bone density is dropping dramatically." Astronauts on voyages to Mars, which might take nine or twelve months, would lose anywhere between 18 and 36 percent of their bone density, making them incredibly vulnerable to injury when they arrive at their destination. Space garb needs to remain safe and light enough to allow a much greater range of movement or surrender to suits with mechanically powered joints: something at far greater risk of breaking down millions of miles from the nearest workshop. New competitions have called on designers to answer this challenge.

One fruitful avenue of enquiry is counterpressure. Dava Newman, while working as a professor of aeronautics, astronautics, and engineering at Massachusetts Institute of Technology in 2014, created the BioSuit. Rather than deploying a pressurized bladder, which in turn limits movement, the BioSuit relies on "mechanical counterpressure," in other words, its extreme skin-tightness, to provide the pressure our bodies need to function. (Helmets, of course, would still need to be pressurized so that we have breathable air.) To do this Newman's suit uses elastic fabrics reinforced with threads made from nickel-titanium alloys. Another company is taking a similar approach. Final Frontier Designs, based in Brooklyn, consists of two designers, Nik Moiseev and Ted Southern. (The latter's biggest claim to fame, prior to winning second prize in a glove-designing competition for NASA, was creating the angel wings for Victoria's Secret fashion shows.) Their creations incorporate new materials including dyneema, a high-molecular-weight polyethylene that is stronger than nylon. Their suit, they predict, would be ten pounds lighter than the current model and around a third of the cost.46

A bigger worry, however, now that the era of mass space tourism feels closer than ever, is that companies will dispense with spacesuits altogether, as Virgin Galactic, Blue Origin, and World View have said they plan to do. They argue that since the cabins will be pressurized. there will be no need for cumbersome spacesuits. While all astronauts would likely agree that spacesuits are not the most comfortable pieces of gear, few would advocate trips without them. The most salutary lesson is that of the Soyuz 11, a Russian craft so small that spacesuits were ruled out for the three-man crew. On its return to earth on June 30, 1971, a valve failed, causing the cabin to depressurize rapidly. Autopsies on their bodies, recovered from the capsule when it touched down, found that they had all suffered brain hemorrhages. Their blood contained ten times the usual amount of lactic acid, a chemical released when humans are frightened. They had died, terrified, in full knowledge of one incontrovertible fact: human bodies are not suited to space.47

12

Harder, Better, Faster, Stronger

Record-Breaking Sports Fabrics

Are We Human?

It's changed the sport completely. Now it's not swimming.

The crowd crammed into the tiered seats around the pool knew that something was up. An expanse of baby blue sky presided over the Foro Italico, a grandiose, 1930s Roman sports complex built in Mussolini's honor. It was the third day of the 2009 FINA World Championships and yet fourteen new world records had already been oot one by a shade under two whole seconds faster than its predecessor. The final race of the day was the men's 200-meter freestyle, and the competitors included Michael Phelps, the incumbent world record holder and hero of the 2008 Beijing Olympics Eight swimmers strode out in single file, sunlight gleaming on the smooth surfaces of their caps and besuited legs. The buzz of the crowd increased in pitch: the sound of a freshly poked hive. Phelps was in lane three. His biggest rival, the German Paul Biedermann, was in the next lane. The two studiously ignored each other, looking down the barrels of their own lanes. Phelps-"USA" emblazoned in red on the back of his navy warm-up jacketlistened to music through an imposing pair of black designer headphones.1

On paper, he had nothing to worry about. The American, at six foot four, had a full inch on his German competitor and a more impressive track record. Just a year before, Biedermann had been out of the top twenty swimmers. At Beijing, he had come a distant fifth in the same event, with a time of 1:46:00 to Phelps's world-recordsetting 1:42:96. But a good deal had happened in the eleven months since. Phelps had, for a start, taken several months off after winning eight golds at Beijing, a haul that made him in the eyes of many the most successful Olympian of all time. And then there was the vexed question of the suits.

Four days previously, competitive swimming's governing body, FINA, had decreed that new polyurethane-based swimsuits—such as the Jaked 01 and the Arena X-Glide—were to be outlawed. Future competitors would race in textile swimsuits that would only reach from navel to knee in the case of men, and from shoulder to knee for women. What FINA hadn't decided was a definition for "textile," nor a definite date from which the new regulations would come into force. For the moment, competitions were dominated by athletes wearing the polyurethane suits. Thirteen of the fourteen records set in the Foro Italico pool so far had been claimed by swimmers wearing them. Biedermann would be racing in an X-Glide.²

At the end of the pool, the two athletes carefully wiped their starting blocks with towels to dry them, readjusted their caps over their ears and jiggled their arms by their sides, first one and then the other. Biedermann slipped his thumbs under the sides of his suit, where it cut into the flesh of his shoulders and pectorals. They mounted their blocks, one foot in front of the other, bent double at the waist. "On your marks"-a tinny, female voice. And then a squeaky buzz and a splash as the black-clad swimmers dove forward into the water, almost as one. Almost. Biedermann's start wasn't good, a fraction too hunched, and deep, and slow. It didn't matter: by the first turn he had closed on Phelps-all head, and windmilling arms, and wakeand then he was pulling ahead, the other competitors farther back, but Phelps still shoveling the water toward his body furiously with each stroke, holding on, both swimmers below world-record pace. By the blistering fourth lap, and with just twenty meters to go, Biedermann was a full body length ahead. He won the race in 1:42:00.

Phelps was visibly furious. "Human" by The Killers belted out over the loudspeaker. Biedermann raised an index finger in the air, breathing hard, pink with effort and triumph: he was number one. Almost before he was out of the pool, however, his win was called into question. "I'm done with this," Bob Bowman, Phelps's trainer, told reporters. "The sport is in a shambles right now, and they better do something, or they are going to lose their guy who fills these seats." A threat with bite. The sport was still prickly from years of doping East German athletes in the 1970s and 1980s, but many were upset enough to raise even this ogre of sporting shame. Eric Shanteau, an American swimmer, compared the suits to the use of steroids in baseball. Bowman took a less direct, more barbed swipe. "It took Michael from 2003 to 2008 to go from 1:46 to 1:42:96," he said. "This guy's done it in eleven months. That's an amazing training program. I would love to know how that works." Biedermann, at first ecstatic in victory—"I was there when [Phelps] won his eighth gold medal... and now I'm actually faster than him"—wilted. "I hope there will be a time again when I can beat Michael Phelps without the suit. And I hope it will be the next year or really soon. But I also think it's not about the suit... It's not my problem. It's not the problem of Arena, my sponsor. It's the problem of FINA."³

Floaters

251

I don't want to be just a pretty fish.

Annette Kellerman, inventor of the one-piece bathing suit, who was arrested for public indecency when she wore it in public in 1907

The origin of this ruckus can be traced all the way back to the introduction of full-body suits in 2000, but it really gathered pace almost a decade later. In February 2008, just a few months before the Olympic games in Beijing, Speedo introduced their latest swimsuit technology, the LZR Racer. Eric Wilson of the *New York Times* was underwhelmed. "Some people," he wrote, "do get really excited about the slightest changes to the get-ups that swimmers wear at the Olympics." He didn't think it looked all that different to the brand's previous design, and when Speedo's media reps said the suits made swimmers look like gladiators or comic-book heroes, he turned derisive. "As far as superheroes go, these would perhaps be best suited for Captain SeaWorld, the avenger of Flipper."⁴

However, the LZR Racer was a big step forward. Speedo had partnered with NASA to find the materials that best reduced drag. Drag accounted for around 25 percent of the total force slowing swimmers down as they passed through the water. Less drag: faster swimmers. The fabric chosen was a lightweight, water-repellent, and very smooth blend of polyamide and elastane, although it felt odd against the skin: more like paper than cloth. There were far fewer pieces of it than in the previous model: three down from thirty. The LZR Racer also showcased a new way of joining the pieces together. Traditionally, overlapping fabric is sewn together to create a seam, but this results in slightly bulging lines, which act like tiny brakes infinitesimally slowing the wearer down. The alternative Speedo hit upon was to weld the edges of the pieces of fabric together using the heat generated by ultrasonic waves. This reduced the profile of the seam, which in turn resulted in 8 percent less drag. The suits were to be worn as tight as a corset-getting into the shoulder-to-ankle design required a zip, also low-profile and ultrasonically welded-and featured panels of polyurethane placed at specific points across the body, further helping to streamline it. (The brand had previously used a Teflon coating instead.)5

The results spoke for themselves. Two months after it was introduced, swimmers wearing the LZR Racer had broken twenty-two world records, all but one of those set during that time. Another twenty-six had fallen by August. At the 2008 Olympics themselves, it was everywhere. When Jason Lezak, in a peerless final lap in the four by one-hundred meter freestyle relay, touched the wall wearing a special star-spangled version, he not only won the race but obliterated the previous world record: 3:08:24 down from 3:12:23, a difference of four long seconds. (A later Phelps gold at Beijing was earned by just one one-hundredth of a second.⁶) This was the third world record set that morning alone, and the seventh in three days of competing. Later that day, when an eighth record fell, the number of new records matched the total set during the entire 2004 games in Athens. In the end, according to some counts, 97 percent of the golds won in the pool at Beijing were taken by swimmers wearing LZR technology.7

Many swimmers—especially those sponsored by Speedo—were effusive in their praise. Rebecca Adlington, who won two gold medals in 2008, "absolutely loved the LZR: the shape of it, the full leg, the fit." Dara Torres, who had been modelling it at the launch, said that it helped her move through water "like a knife through butter." She also leapt to the suit's defense when a reporter denigrated the gray-on-black look: "You think it looks dull?" she asked. "We're there to swim fast, we're not there for a fashion show."⁸

But as the records fell, so the hackles of those worried about the integrity of the sport began to rise. One coach called the LZR suits "technological doping," another "drugs on a hanger." (The latter spoke to the New York Times on condition of anonymity, because one of their own swimmers was sponsored by Speedo.) But the problem was never quite as simple as how much faster the suits could make athletes swim. There was a strong belief that it was the best swimmer that should win, not the swimmer with the best technological advantage. Access to the LZR was uneven, which created unfairness in training for races as well as in the pool on the day. They only went on sale in May 2008, just a couple of precious months before the start of the Olympics. They were also expensive: each one retailed for \$550 and could only be worn a few times before they began to sag or seams split. Another issue was sponsorship: athletes with deals with other brands could either forgo the advantage of the LZR or risk endangering their lucrative sponsorship deals. Speedo athletes had none of these worries.9

There were howls of protest when a new generation of suits, made entirely from polyurethane, came onto the market. The Jaked 01, Arena X-Glide, and Adidas Hydrofoil were, in one way, a logical evolution from the LZR Racer. While the latter had only had polyurethane panels, the new suits were entirely covered with it. They compressed muscle more effectively, tautened the surface of the skin and, crucially for many in the industry, added buoyancy, by trapping air between the water-repellent fabric of the suit and the skin. The bonded-seam technology was also widely adopted. Traditionalists dubbed the new suits "floaters" because of the way they helped the bodies of the athletes ride higher in the water, which in turn helped them go faster. The fuller-body coverage of the tech-suits meant a greater surface area could be smoothed and tautened. Uncovered, even muscular flesh jounces, dimples, and rolls around dramatically in the water when a swimmer is exerting themselves. All this wobbling creates extra drag, but the tech-suits compressed the skin, drastically reducing movement. For this reason, the fabrics used were usually weaves rather than knits.¹⁰

Suits had to be exceptionally tight-fitting. A journalist who squeezed herself into one described the experience as being akin to "a lobster trying to molt backward." Athletes might spend twenty or thirty minutes donning a suit—welded seams straining in an unseemly manner. Because polyurethane is relatively fragile, the struggle risked the suit tearing or splitting. The reward for all this effort was speed. Swimmers, like seals, understand that sleeker is better. The suits' compression, coupled with strategically placed seams, helped keep legs higher and the core engaged and active, even as the swimmer began to tire, holding them nearer the optimum racing position. "It's the difference," according to Steve Furniss, a former Olympic medalist and the co-founder of the swimwear brand Tyr, "between a barge and a racing boat."¹¹

Another thing that riled swimmers and swimlovers was the belief that the technology rewarded some more than others, and those getting the most benefit were the wrong people. While some athletes' performance was little affected, others, like Biedermann, went from being fifteenth or twentieth to top five during the tech-suit era. "There were some people," Rebecca Adlington says, "who did really well in polyurethane and then were never heard from again." According to Joseph Santry, a former head of research at Speedo's Aqualab, such athletes were likely the ones with softer, pliable bodies with more adipose tissue, which "the suit could squidge... to get them into a more torpedolike shape." In other words, the more honed and muscular you were, the less impact you were likely to get from a polyurethane suit.¹²

Although FINA had quietly gone to and fro on the issue of regulating the suits, the assault of new records set in 2009 proved too much. Phelps's loss to Biedermann turned what had largely been a series of internal debates into international news. The suits, Phelps told the press, had "changed the sport completely. Now it's not swimming. The headlines are always who's wearing what suit." Suits had eclipsed swimmers. Less than six months later, FINA's stricter rules came into force and the tech-suit era was over.¹³

Sports Coverage

255

Nude, clothed only in sunshine and beauty.

Taking sport seriously isn't confined to the modern era. For Pausanias, a traveler and geographer who lived during the second century AD, Olympia was the spiritual heart of his homeland. "Many are the sights to be seen in Greece," he wrote, "and many the wonders to be heard; but on nothing does heaven bestow more care than on the Olympic Games."¹⁴

Held in honor of the god Zeus, the ancient Olympic games were a sporting phenomenon. For nearly four hundred years from around 776 BC, tens of thousands of people would travel across the country every four years to witness them. So important were they, wars were suspended just before and during the festivities so that athletes and spectators could reach Olympia in safety. Once there, they would be treated to events including running and chariot races, wrestling matches and javelin throwing; victors were crowned with laurel wreaths. Apart from the reverence with which they were undertaken, the games had another surprising attribute: the competitors were all naked.

These games were part of a larger Greek culture of nude athleticism. The very word "gymnos"—the etymological root of gymnastics and gymnasium—means "naked." Idealized male bodies can be seen in much of the art from the period: broad of shoulder and trim of waist, they cavort around vases and in friezes taut and engaged in movement so energetic that abdominal and arm muscles bulge. Then, as now, broader cultural anxieties about citizenship, ethics, sexuality, and gender seeped into discussions surrounding athletics and sport.¹⁵

Whatever its purpose, it was a key part of Greek culture by the first half of the sixth century BC. Freeborn men would train diligently, eat correctly, libate their skin with vast quantities of olive oil, and receive regular massages to achieve muscle-bound perfection.¹⁶ A full-body tan, achievable only through regular nude training, was considered highly desirable. There were even special words for a bronzed backside-melampygos-and a white one, leukopygos. (Tellingly, the latter was also used to denote cowardice and unmanliness.) The best and proudest would then compete against their peers in public stadiums, all in the nude. In Sparta, where this found its fullest expression, physical activity was mandatory for young people. Unmarried women as well as men and boys up to the age of thirty were kept busy with training, games, and drills, which involved everything from choral dance to warlike games. Partaking in such events, and doing so with courage and vigor, had a moral component. Xenophon, for example, a Grecian historian in the fourth century BC, wrote that "those who keep in training develop good skin, firm flesh, and good health from their food, whereas the lazy look bloated, ugly, and weak." Those who revealed cowardice were shunned socially.17

Despite this fulsome participation, Greeks were conscious that foreigners regarded exercising in the nude as immoral, and they themselves fretted about the sexual degeneracy it might engender. Both Plato and Thucydides pointedly mention the loincloths worn by foreign athletes. But even in Greece, nude physical activity was strictly reserved for certain members of the citizenry and was only acceptable in certain contexts: the gymnasium and the stadium. All competitors had to be freeborn, and although unmarried women could watch sporting events, at other times they were kept well away from the athletics and from the nudity. Even in Sparta, where girls did compete—possibly in the nude, more likely in short tunics or even shorts—this came to an abrupt halt when they married.¹⁸

Despite the qualms the ancient Greeks had about it, exercising in

the nude (or as close to it as possible) does make practical sense. One popular story then was that nudity became acceptable during running races because a competitor had once been tripped up during an event by their own loosening loincloth. While this is likely apocryphal, it's certainly true that clothes tend to hamper movement and, in combat or team events, give opponents a means of gaining purchase or leverage. Even the thinnest layers will hinder the evaporation of sweat, a crucial physiological mechanism for cooling the body during exertion. Balancing the demands of morality and good taste with practicality has remained sensitive and, on occasion, fraught.

In the late nineteenth and early twentieth centuries when the Olympics were revived, the scale was very much weighted toward morality. Rules in 1908 stipulated that "Every competitor must wear full clothing from the shoulder to the knee (i.e. sleeved jersey to the elbows and loose drawers with slips). Any competitor will be excluded from taking part in the race unless properly attired." During the 1912 Olympics, male athletes wore cotton T-shints and knee-length, button-fly shorts. In terms of coverage, however, very little has changed for many sports between then and now.¹⁹

For women, it was a very different matter. They were excluded entirely from the 1896 event and, when they were permitted to take part, had to do so wearing an extraordinary amount of clothing. Charlotte Cooper, the British gold medalist in both the tennis singles and mixed doubles at the Paris Olympics in 1900, played in a tightfitting, ankle-length skirt, a blouse buttoned up to her neck and down to her wrists, a corset, and heeled shoes. A good many of the surviving photographs depicting female athletes taking part in the 1912 Stockholm Olympics focus on the victorious British freestyle swimmers, who were made to pose again and again in their clinging fabric suits that stretched to mid-thigh. In most images they appear with another woman—possibly a trainer—who stands just behind them like a chaperone, wearing a long pinstripe dress, a demure lace collar, and a scowl directed right down the lens.

This intense focus on modesty meant that technology for the garment women needed the most—a properly supportive brassiere came much later on. On the face of it, the need for a sports bra

257

couldn't be more obvious. When you bounce, your breasts do too, and it can be painful. It gets worse when you run: they jag up, down, and around in a rough and—particularly for women with larger breasts—faintly tortuous figure eight. Before 1977, women had their own, intimate ways of dealing with the problem. Some hacked regular bras with duct tape, others layered one bra atop another. But forty years ago, as the idea of jogging went mainstream, three women at the University of Vermont hit upon a more tailor-made solution: a pair of jockstraps, sewn together. From this prototype the "jockbra"—swiftly renamed the "jogbra" for commercial reasons—was born.²⁰

Resistance—to sports bras, to women exercising, to breasts drawing any attention to themselves in public whatsoever—endured. In 1984, when Joan Benoit won the first women's marathon in Olympic history, her jersey slipped to reveal a simple white bra strap; it was an image captured by the press that scandalized many. Fifteen years later, another bra made it into the public consciousness, this time more deliberately. At the denouement of the FIFA World Cup soccer final between China and America, Brandi Chastain scored the winning penalty and celebrated in the traditional manner: jersey whipped off, she fell to her knees with both fists raised to the sky. Although she later downplayed the moment in interviews— "momentary insanity," she said—the sight of her and her black nylon sports bra made the cover of *Newsweek* and *Sports Illustrated*.²¹

Over the following decades, as social mores and attitudes toward the body have evolved, the clothes worn during sports have too. Clothes have certainly become more form-fitting, but concerns around modesty and exploitation mean there has been a continual renegotiation over what should and should not be exposed to the public gaze. The most notorious example is beach volleyball. While men played in shorts and tank tops, the official Olympic uniform for women from 1996 until 2012 was a bikini with "a maximum side width of six centimeters." The reason for such a dictum was obvious to all involved and had nothing to do with sporting prowess. "The people who own the sport," one volleyball player told the *Sunday Times* in 2008, "want it to be sexy." The rules have since been changed, giving individuals more choice to cover up. Choice, cultural considerations, and the growing heft of the Islamic market—projected to be worth 5 trillion dollars by 2020—also lay behind Nike's recent decision to launch a hijab made from a light, stretchy, and breathable synthetic blend. While it wasn't the first on the market, it has received rave reviews. One woman, who put it and many others through their paces during football, running, and weight-lifting sessions, wrote that she "would have given a kidney to have a hijab like this when I was at school."²²

For male athletes, too, there have been subtle but discernible battles over the use and display of their bodies. When, in 2016, ESPN magazine's annual Body Issue (which contains photos of sports stars in the nude) featured Vince Wilfork-a 325-pound American football player-as their cover star, it was considered daring and controversial. As Wilfork pointed out in a short, behind-the-scenes film that accompanied the photo shoot, male athletes are still expected to conform to a body type similar to that seen on Grecian vases, and those that do are likely to get better sponsorship opportunities. This expectation, as well as the increasing commercialization of sport, has led to ever more fitted clothing. In basketball, for example, a sport in which shorts and jerseys have traditionally been baggy, the latest generation, created by Nike, are much tighter. This sportier, less street-wear aesthetic is now common to many team sports, allowing brand names to be ever more clearly associated with the health and vitality of fit players. Given that close-fitting clothcs would tend to restrict both the movement of the body and the evaporation of sweat, such clothing has only really been practical for physical activity since the development of sweat wicking fabrics.

"Technology," according to sportswriter Leonard Koppett, "has changed the way virtually every game is played. And yet in most cases the effects are almost invisible to spectators." He wrote these words in 1978. Still, it should come as no surprise that the tech-suit controversy in 2008 and 2009 was not the first time such a brouhaha about clothing and equipment has engulfed a sport. It wasn't even the first time it had happened to competitive swimming.²³

Alexander MacRae, a Scotsman who had emigrated to Australia in 1910, launched the first non-woolen swimsuit, and with it the Speedo brand, in 1928. Today, wool seems an unfathomable material in which to swim: heavy, itchy, highly absorbent, and liable to sag and flap around the body with every stroke. But far from being welcomed with open arms, MacRae's Racerback suit, made from silk, was so form-fitting and revealing—as the name suggests, it left a great, titillating expanse of arm, shoulder, and back completely bare that it was banned from some public beaches. Nevertheless, it soon gained ground with competitive swimmers. A Swede, Arne Borg, wore one while winning an Olympic gold and setting a new 1,500meter record in Amsterdam in 1928. Four years later, Clare Dennis, a sixteen-year-old prodigy from Australia, broke another Olympic record wearing a Racerback in Los Angeles, despite nearly being disqualified in the heats for exposing "too much shoulder blade."²⁴

Apart from an unfortunate incident at the 1972 Olympics—when the women's team from East Germany competed in cotton skinsuits that became transparent when wet—the next big thing arrived in 1973. (The 1970s, indeed, proved to be a decade rich in sporting equipment innovations.) The World Aquatics Championships at Belgrade saw the introduction of stretchy spandex suits, worn once again by the daring East German women's team. They won ten out of the fourteen available medals and set seven world records. The suits became known as Belgrads and were soon adopted the world over.

Speedo was less progressive at this point. "These suits are gross," Bill Lee, the firm's North American manager, told *Sports Illustrated*. "You can see everything." In 2000, however, they once again made a splash announcing a new bodysuit made from a material that, they claimed, mimicked the ability of denticle-covered shark skin to help ease the passage of an object through the water. It seemed to do the trick. At the Sydney Olympics, around 80 percent of the medalwinning swimmers were wearing the shark-inspired suits. Years later, however, Harvard scientists discovered that the much lauded Fastskin system wouldn't have reduced drag at all. Denticles—small, toothlike bumps on shark skin—do help sharks reduce drag and increase thrust, but those on the Speedo suits were both too widely spaced and too rigid to be of any use to athletes.²⁵

The tug and pull between sporting purity and technological progress has had noteworthy lurches in many sports. Waves of new

equipment and clothing have helped ensure a steady stream of fastests, firsts, and attention-grabbing world records. But they have also led to complaints, discomfort, and angst such as that experienced by Leonard Koppett in 1978. "The whole idea of a game," he wrote, "is to establish rules that create constant conditions, so that painstakingly acquired skills can be brought to bear in a known framework." If memorable wins, fast serves, and great distances are only achieved with the introduction of new equipment, are they truly valid? Are potentially magnificent athletes going unrecognized because clothing has become a barrier to entry? At what point does enhancement obscure true achievement?²⁶

In hindsight, many technological upgrades seem so natural it's hard to imagine a time when they weren't part of the fabric of a sport. The innovations Koppet was bemoaning, for example, included shoulder pads and helmets for American football players, artificial turf, and dimpled golf balls. Likewise, pearls were clutched and the honor of many was called into question when Prince introduced a new racket with a head over 50 percent larger than the competitors', offering a far bigger surface area with which to hit the hall. ("Secret Weapon or Barn Door?" read the 1976 New York Times Magazine headline.) Wooden tennis rackets of the kind used by Bjorn Borg were used at Wimbledon up until 1987. Today's rackets can be up to 25 percent lighter-precise weight at elite levels depends on player preference-and are usually made of fiberglass, carbon fibre, or graphite. Few today would call for a return to smaller, heavier rackets with elusive "sweet spots." And their return would make for an almost unrecognizably slower game. But there is still robust debate about the precise ratio of wool to synthetic fiber that the felt covering tennis balls should contain, since each company adheres to a different standard, and the fuzziness of a ball helps determine its speed.²⁷

Running trainers too have had material highs and lows. When Roger Bannister broke the four-minute mile on May 6, 1954, he wore black running spikes of very thin leather—jazzed up with white contrast stitching and sturdy cotton laces—made for him by a firm called GT Law & Son. "I could see there was an advantage in having the shoe as light as possible," he said. His weighed a feathery 4.5 ounces.²⁸ In the decades since, Adidas and Nike have become the ones to beat when it comes to high-profile running shoes. Leather is eschewed in favor of fabric: more breathable and better in rain. Although the mile distance has largely been celipsed by the 1,500 meters, the current record holder for the former distance is Hicham el-Guerrouj, a wiry, friendly-faced Moroccan runner. His time, a record held since 1999, is 3:43:13. Nike, who also sponsored him, enlisted el-Guerrouj to help them build a track shoe in 2004 to commemorate the Bannister four-minute mile. Their Zoom Miler spike, which weighed the same as Bannister's, was made of very different materials, including polyether polymers and ethylene vinyl acetate foam cushioning.²⁹

Just before the 2012 Olympics, Nike launched another shoe they hoped would please elite runners and paying customers. The former told Nike's designers that they didn't want a shoe that felt like a shoe; what they wanted was one that felt more like a sock. The Flyknit Racer and Trainer and the ancestor of the latest generation, the Zoom Vaporfly, were the results. (This debuted at the Nike-sponsored attempt to break the two-hour marathon-called Breaking2-in May 2017, worn by athletes including Eliud Kipchoge, a Kenyan long-distance runner.) The Flykit's uppers were made from synthetic yarns-since 2016 these have used polyester gleaned from recycled plastic bottles-continuously knitted to give structure and durability over long distances with as few seams as possible. The upper fits snugly to the foot, because of the knitted fabric's inherent stretch, and is breathable enough to be worn without socks. Although plenty of gushing articles and press releases will assure you the Flyknit also "revolutionized athletic footwear in terms of weight," the Racer is 1.4 ounces heavier than Bannister's 1954 leather pair.

Flyknit and its offspring have proved so popular with runners—and so potent a marketing tool after their prominence at the Olympics that the fabric has since been rolled out across product lines, from Converse Chuck Taylors to sports bras. Although the Zoom Vaporfly Elites were an exclusive "concept car" version only given to Kipoche and other Nike-sponsored runners, a mass market version, the Zoom Vaporfly 4%, have proven to be commercial gold. They're expensive—\$250—but the promise of increased efficiency on race day has proved lure enough for many. Kipoche, for what it's worth, although he loves running in them, is nevertheless conflicted. When asked about the cleanest possible marathon time by a writer for *Wired*, he revealed himself to be, at heart, a purist. "You ask me, *clean*? No technology, no help? That is what Abebe Bikila ran in 1960. That was barefoot. The cleanest."³⁰

Market Forces

Obviously, we love it when people can push innovation a little bit more.

Kate Wilton, Senior director of merchandizing and design, Speedo, 2016

Sports and the clothes that go with them have long been commercial enterprises. The North American sports market, worth 60.5 billion dollars in 2014, was predicted to reach 73.5 billion dollars by 2019. Companies in the industry —Nike, Adidas, the NBA, to name just a few—although harried by drooping live-sports viewer figures and unpredictable global sales, have benefited from vastly increased demand for sports and athleisure clothing. The market for the latter alone, by some estimates, reached 97 billion dollars in 2016.³¹

Increased appetite has led to increased competition. For the traditional players, this has meant attempts to reclaim the space. In part this is about differentiating their products through technology. In 2015, for example, Reebok began offering clothing laced with Kevlar, the ultrastrong material used in bulletproof vests, and Under Armour and Lululemon offer socks, tops, and tights with anti-odor properties. But, given that one pair of leggings is very much like another, companies also rely on sponsorship deals with high-profile athletes and visibility at well-attended, newsworthy events to curry favor with consumers.³²

Like the Zoom Vaporflys and the Speedo LZR Racers, many of the innovations showcased on professional athletes are later offered to the mass market. (In both instances, the athletes leading out the latest sportswear tech for their sponsors were rumored to have been offered bonuses of a million dollars if they made history.) Products worn during medal-winning attempts and endorsed by sporting heroes are endowed with cachet. The money earned from stronger sales goes into the production of innovations designed to give pro athletes an edge over their rivals. This cycle is either virtuous or corrupting, depending on your point of view.

A great deal of the performance of professional athletes in a race, event, or match is determined well beforehand and within the confines of their own skulls. Rebecca Adlington trained in regular swimming costumes, reserving the LZR for race day itself. This was in part because her race-day suits were two or three sizes too small—"You want it super tight," she says. "It needs to be like a second skin. You couldn't wait to get it off"—but there was also a mental component. The feel of the race suit, which was so tight and smooth and paper-thin that she could almost feel the air-bubbles against her skin as she dove into the pool, was something special. "It's the same as why you shave for [race] days, although it barely makes any difference. A lot of it is mental."³³

End of the Lane

Serious sport has nothing to do with fair play. It is bound up with hatred, jealousy, boastfulness, disregard of all rules and sadistic pleasure in witnessing violence. In other words, it is war minus the shooting.

George Orwell, "The Sporting Spirit," Tribune, 1945

Sports are not fair. Some teams have better access to equipment, nutrition, or other resources. Some, by their very nature, are impossible to get proficient in unless you have a great deal of time and money. Some people are born with longer limbs, smaller breasts, better economy of movement, a greater capacity for endurance, or with parents who have the wherewithal to recognize and nurture their talents. Some are men, and therefore more likely to be given better public exposure and sponsorship deals. And yet it is the idea of fairness and purity that lies at the heart of why some technologies cause sporting upset. In an article for the Sunday Times of South Africa, the influential sports writer Ross Tucker argued that performance-enhancing shoes should be banned, "so that we can appreciate running for what it is and not for the unmeasurable aspects provided by technology." Yet all shoes are, to an extent, performanceenhancing, especially when it comes to marathons run through cities on tarmac and concrete. The line between acceptable and performanceenhancing is continuously being tussled over and renegotiated by fans, participators, and brands offering new equipment and technology. For those not interested or invested in sports, this process can be disorienting. Some coomingly small advances can provoke uproar, while others go unuotic ml. 34

This is the conundrum being faced by brands looking to update kit and equipment. In order to appeal to the mass market, they have to differentiate their products by showing consumers that, by wearing and using them, the average person can be faster, stronger, and more likely to win. If, however, their success is too overt, the advantage gained by their sponsored athletes too great, moral outrage ensues.³⁵

Sports themselves also have an incentive to keep things interesting by helping athletes get ever harder, better, faster, stronger. Markus Rogan, an Austrian backstroke specialist, was in favor of the polyurethane suits *because* they made swimmers faster. "We're the most popular boring sport in the world," he said. "And so we only survive on records." After all, very few would argue that swimmers should go back to baggy woolen suits, or suggest that female swimmers should wear costumes with extraneous modesty panels as they did in the early twentieth century.³⁶

In total, 147 swimming world records were forged in 2009 by swimmers wearing polyurethane suits; forty-three of these during the FINA World Championships in Rome. The controversy generated by the suits transcended the swimming world to become part of a wider, ongoing conversation over the role of technology, brands, and sponsorship in sport. One of the biggest fears was that the records set would prove unbreakable unless another round of technological improvements was allowed. Polyurethane suits, it was argued, were the thin end of a wedge that would in time rob swimming of its integrity, much as doping had done decades previously. These fears, at least, have largely proved to be unfounded. Six world records were broken in the first four days of the Olympic Games in Rio. As of January 1, 2018, only thirteen records set during the tech-suit era remain.³⁷

The reasons why these records have fallen with relative ease are complex. Sports science has evolved, leading to greater understanding of nutrition, efficiency, and the ways in which technique can be adapted for individual swimmers. Pools themselves are being adjusted and redesigned to make them better environments in which to compete. They are being made deeper and wider, reducing the turbulence and waves splashing back over swimmers' bodies and slowing them down. They are kept between 77° and 82°F, temperatures deemed to be optimum for racing muscles. Research has been done into lane dividers and the drainage at the sides of the pool too, ensuring water doesn't ricochet around and slow people down. But many in the industry believe that just as the problems of 2008 and 2009 lay in the fabric of the suits, that is where the solutions were found too.³⁸

The generation of suits that followed the FINA regulations were explicitly designed to claw back some of the speed that the designers knew they would be losing with the ban on polyurethane and other non-textiles. Some new suits contain an almost skeletal structure of bonding and seaming to help remind swimmers of and hold them in the best position for racing. Arena have added carbon fiber to their nylon-woven suits. The carbon—configured either in a grid-like structure or in horizontal bands through the fabric, depending on the suit—increases the durability of the suits and helps add compression.

Speedo never created a fully polyurethane suit in 2009, instead focusing on making one that would be in pole position once the ban came into force. They looked at how racing yachts and Formula One

267

cars dealt with resistance and drag, and applied some of the same thinking to the new Fastskin III and Fastskin LZR Racer X suits. (The latter were released for the Rio Olympics.) These used zoned compression—the fabric contained more Lycra and therefore more stretch in some areas than others—to compress the body up to three times more than the LZR. The idea was to create as stiff a "skin" as possible over the surface of the body, moulding it into a more efficient tubular shape and simultaneously preventing the skin from moving around too much. All this, Speedo claimed, meant that the resistance produced by a swimmer's body was reduced by around 17 percent and oxygen economy increased by 11 percent. The only problem, at least for female athletes, was how to get into the suits. Lacking zips, entry is through an armhole; some have reported needing a full hour to get one on. With a bit of practice, they have been assured, it will only take ten to fifteen minutes.³⁹

One of the things the tech-suits made clear to trainers and athletes is the importance of body positioning. Coaches learned a lot about what that perfect positioning looked like and have worked since the ban on recouping the suits' benefits, by working on core stability, for example, and ensuring positioning has more prominence in drills. Some coaches even bought up stocks of the banned suits and have been using them as a training aid, so that their swimmers could get a feel for how the body moves in them, and for how fast it is possible to be when compressed and taut. "That era," according to Stu Isaac, "raised the bar." The suits, in other words, are still breaking records.⁴⁰

13

The Golden Cape

Harnessing Spider Silk

The Cape

Weaving spiders come not here; Hence you long-legged spinners, hence! William Shakespeare, A Midsummer Night's Dream, 1595-6

In January 2012, something new and extraordinary was unveiled at the V&A museum in London: a glossy, calf-length cape the color of country butter, covered with traceries of embroidery. In shape it was something like a priest's chasuble: a long silken oblong folded in half with a hole in the middle for the wearer's head and a cascade of foot-long tassels down the front, all in precisely the same shade. It was an exhibit to remember. Both the color and the craftsmanship drew the eye, up close visitors could see enquisite appliqué flowers and araclinids creeping over its surface. And, as they learned more, they were further entranced: the cape had taken a team of hundreds over three years to make. Most astounding of all, however, was that this cape was made entirely of raw, undyed spider silk.

As the cape's creators explained, this was not the first time they had tangled with this incredible fabric. Simon Peers, a British textile expert, and Nicholas Godley, an American designer, both based in Madagascar, had, some four years previously, completed a rich tapestry using the stuff. It was 132 by 48 inches, spun from the silk of around 1.2 million spiders, and had been put on view at the American Museum of Natural History on the Upper West Side just beside Central Park in Manhattan. There it was billed as a cultural curiosity rather than a milestone in fabric history. Its abstract geometric brocaded patterns echoed those popular in Madagascar in the nineteenth century; it had taken craftsmen five years to make, and had cost over half a million dollars.¹

Perhaps this was in part why the pair were unsatisfied. Yes, they had created something unique from a material that has remained so maddeningly out of reach for centuries, but, to their minds, a question still lingered: what would it be like to wear something made from the stuff of cobwebs? "The idea of being wrapped—cocooned—in spider silk," Peers says, "has a lot of resonance." The idea of a cape appealed too. On a purely pragmatic level it has a large surface area to decorate, which would allow them to demonstrate the skill of the team of weavers and embroiderers they worked with in Madagascar. But there were other connotations that Peers and Godley wanted to explore. Capes are—on the one hand—the stuff of Marvel comic-book heroes, of futuristic super-beings capable of saving the day. On the other, particularly when spun from golden thread, they recall the fairy tales and half-remembered stories and myths of childhood.²

The quest to make the garment shown in the V&A led Peers and Godley to extremes, but in this they are far from alone. The lure of spider silk as a reliable, sustainable resource has been capturing imaginations for centuries. Although you might not think it, the quotidian cobwebs unthinkingly brushed away from countless corners are wonders of engineering. Made entirely of protein, spider silks are incredibly tough and can stretch up to 40 percent of their relaxed length without breaking. This, of course, makes them of interest to those seeking breakthroughs in medical and military bio-technology, and suggested uses have ranged from nerve regeneration to replacements for Kevlar in bulletproof vests, via luxury clothing. Small wonder, then, that in seeking to replicate what the humblest spider can do in the blink of one of its eyes, people have always been prepared to go to extraordinary lengths.³

Arachnids and Arachnophobia

Do you not see how the spider weaves a web so subtle that man's hand cannot imitate it?... This art is born, not taught.

Seneca, Moral Letters to Lucilius, Letter 121

273

The spiders responsible for the raw material used to make the golden cape were *Nephila Madagascariensis*, a kind of golden orb weaver, and, as the name suggests, a native of Madagascar. They are charismatic creatures, as spiders go. The females are the size of a human palm, with long, rather elegant legs that jag out above their bodies. Their plump and rather beautiful yellow-and-gray-spotted abdomens range in size from Brazil nuts to large dates. (The males are reddish brown and a mere fiftieth of the size.) They are also incredible web-weavers, constructing vast nests all around Antananarivo, Madagascar's capital, in trees and at the top of telephone poles, lying in wait for their prey, head down in webs that gleam golden in the sunshine.

The *Nephila* genus is one of the oldest known still around today; their fossil records date back 165 million years, to the Middle Jurassic period. They're popular with collectors and museums because of the females' showy good looks and their habit of displaying gruesome trophies, such as butterfly wings and fly heads, in their webs, as a proud hunter might do with antlers. Subspecies can be found across the world, from the Americas via Asia to Australia. They are notorious for spinning webs across paths, where they are frequently crashed into by joggers.⁴ Errant joggers, however, emerge relatively unscathed—their bites may cause nausea and dizziness but aren't serious—because *Nephila* are after other prey. Insects, usually, but small birds and lizards and even the occasional ill-fated male *Nephila* have fallen to the neurotoxic venom they use to dispatch anything trapped in the web's sticky embrace.⁵

Their name, derived from two Greek words, roughly translates as "fond of spinning," and, as this suggests, *Nephila* are renowned for their silk. Their webs, created exclusively by the females, are vast up to two yards across. They seem rather proud of their silken achievements: they rarcly leave, even when attacked. And although an entirely new web can be woven in little over half an hour if one is destroyed, they generally prefer to mend and make do. As sections become damaged the female will consume the silk and patch up the area with freshly spun thread. Their elegantly structured webs are much admired by scientists for their strength, precision, and distinctive golden color, which is thought to help attract prey. Male spiders spend their lives skittering around the webs' peripheries, anxiously waiting—neither sex lives more than a few months, so time is precious—for an opportune moment to mate without attracting either the ire or appetite of the fairer sex. If mating is successful, egg sacs, wrapped in hanks of yet more golden silk, are hidden a little way away from the webs, ready to unleash hundreds of pin-sized spiderlings that will grow to become the next generation.⁶

Spiders are remarkable. Over the course of a single night and using only a self-generated material, many species can build a vast multipurpose structure. To put it in human terms, it's like making a web the size of a football pitch and then using it to catch prey equivalent in mass to an airplane. Dating back nearly 380 million years, they have evolved into over forty thousand separate species. (For the sake of comparison, humans diverged from chimpanzees just seven million years ago and there are just four hundred different primates.)⁷

All spiders use silk at some point in their life cycles, and individuals can produce different types depending on the use they wish to put it to, from building bolt-holes in the earth and creating cocoons for their eggs to enveloping prey. Even a single web will be made up of different kinds. The radiating spokes are generally major ampullate silk, which is also the type that spiders use when they drop suddenly to get out of harm's way. This is the strongest kind. The spiral is made from flagelliform, which is stretchy but springs back relatively slowly, so that prey doesn't just bounce off; just to make sure, it is usually seeded with special sticky droplets.⁸

Each strand is made from outlandishly long, complex, and repetitive proteins, which the spider creates in the hundreds of translucent glands within their abdomens. These glands are connected to microscopic spinnerets, where the liquid protein is squeezed out at will to become silk fibers. As well as being large, the silk proteins are also unstable. The molecular transformation from liquid to solid takes place at the very moment the spider spins and is due to the shape and pressure in the spinnerets themselves.⁹

Although similar to the silk made by silkworms, the spiders' product is superior. On a molecular level it is finer and more even, making it softer and lighter in thread and fabric form.¹⁰ Although finer than a human hair, some spider silks are—weight for weight—around five times stronger than steel, can be incredibly elastic, don't trigger an allergic reaction in humans, and are able to absorb vast amounts of kinetic energy. This combination of qualities has led those studying it to posit its use in everything from structural blast protection to bulletproof vests and body armor; biodegradable fishing lines to artificial tendons and the finest silk shirts the world has ever known.¹¹

Old Yarns

275

I wove my webs for you because I liked you. After all, what's a life, anyway? We're born, we live a little while, we die.

E. B. White. Charlotte's Web, 195?

Our species has grown up watching spiders. All the while we struggled to master tools that would help us hunt, cook, and sew, we were surrounded by pristine webs, each beaded by the body of its maker. It's no wonder that these creatures are woven so deeply in our psyches. We have had much to learn from their self-sufficiency, their efficiency, their creativity and, perhaps especially, their peerless prowess with silk. Democritus, a Greek philosopher born around 460 BC, suggested that it was watching spiders make their webs and spin their egg sacs that gave humans the idea to spin and weave themselves. It's certainly true that there is a relationship. Some argue that spiders were originally called "spinders" from the word "spin."¹²

Weavers weren't the only ones watching them. It is hard not to speculate, for example, that hunters and fishermen owe the development of nets, traps, and lures in part to studying spiders. Perhaps because of their dual role as makers and destroyers, arachnids appear in the creation myths of cultures including the people of pre-Columbian Peru, the Akan in Ghana, and some Native American tribes. The Hopi and Navajo, for example, have envisaged a spider-woman hybrid who was responsible for weaving the cosmos from clouds and rainbows on an enormous loom, and whose generosity with her wisdom and skill allowed humanity to flourish on earth. Tribal weavers, hoping to tap into the skill of this deity, would rub their hands in spider webs before they set to work. Neith, an ancient Egyptian goddess of wisdom, hunting, and weaving, was associated with spiders, as was Uttu, a Mesopotamian goddess in charge of everything pertaining to women. (So close was their bond that the same symbol was often used to denote both Uttu's name and the word "spider.") In China, spiders were traditionally symbolic of industry and were considered good luck.¹³

Spiders have played positive roles in popular western culture too. The nursery rhyme "Itsy Bitsy Spider" is used to teach children about tribulation and determination. In *Charlotte's Web*, the spider Charlotte is the agent of Wilbur the pig's salvation. Since being launched in the summer of 1962, Spider-Man, the alter-ego of the mild-mannered Peter Parker, has become one of the most beloved characters in the comic-book firmament. Stan Lee, the character's creator, said often that he was inspired by watching a spider climb up a vertical wall. Spider-Man can do the same; he also shoots weblike ropes from his wrists and uses them to pinion criminals and to fly through the urban jungle.

But admiration is often accompanied or even superseded by revulsion and fear. Sympathy for Itsy Bitsy withers the moment we learn about Little Miss Muffet. In a more sinister and bloodcurdling vein is the Swiss writer Jeremias Gotthelf's 1842 novella, *The Black Spider*. In it he envisioned a spider blooming blackly on the cheek of a woman kissed by the devil. Eventually it hatches and wreaks havoc on the area, killing cattle and people indiscriminately. Spider women, despite their association with creation, are not always benign: the *jorōgumo* (literally "whore spider") of Edo-period Japan (1615–1868) would trick naive samurai warriors by appearing as a seductive woman, before wrapping them in silk to devour later. This is echoed by the trope of "black widows"— Debbie from *Addams Family Values*, Betty Lou Beets, Mary Elizabeth Wilson—women who murder their unsuspecting spouses. This is lent both legitimacy and piquancy by the fact that in many spider species— *N. Madagascariensis* included—sexual cannibalism is not infrequent.¹⁴

The ancient Greek legend of Arachne is another example of the

treacherous cultural link between women and spiders. Like any myth worth retelling, this one has several variations, but all start with Arachne, a poor young woman who from a young age showed extraordinary skill on the loom.¹⁵ She was very proud of her talent, though, something that generally bodes ill for women in traditional tales. When a family friend suggests that Athena herself, goddess of reason and the arts, must have taught her, Arachne scoffs. Quite the contrary, she boasts: Athena could learn a thing or two about weaving from her.

Gods and goddesses are quick to punish uppity mortals. Athena appears at the cottage door in disguise and challenges Arachne to a weaving contest. Whoever loses can touch neither loom nor spindle until their dying day. The goddess wins, of course, but takes pity on Arachne, who is distraught at the thought of never practicing her craft again. Athena's mercy, however, is tinged with malice: in order to cheat the terms of the bargain and yet still spin to her heart's content, Arachne is transfigured from beautiful woman into a spider.¹⁶

Going for a Spin

This promises to be a fiber of commerce of the future. J.F. Duthic, 1885

It is a small step from imitation to appropriation, and neither the squeamishness we feel about spiders, nor an endless list of technical difficulties, have prevented people from trying to harness their silk. Islanders in the Southwest Pacific traditionally used it to make fishing lines, and across Africa webs and cocoons have been harvested to fashion everything from purses to hats—there is a Botswanian example of the latter, topped with an exclamatory ostrich feather, at the British Museum. Many cultures have used them to dress wounds, a practice that was well known in Shakespeare's day. "I shall desire you of more acquaintance, good Master Cobweb," Bottom says in *A Midsummer Night's Dream*. "If I cut my finger, I shall make bold with you." (Indeed, the threads do have antiseptic qualities.) Eighteenthcentury Europeans, resenting China's stranglehold on the silk industry and desperately trying to foster a viable alternative, thought that spiders might offer the answer for a silk industry of their own. Individual silken threads, because they are so fine, were even used to make crosshairs in gun sights up until the 1960s.¹⁸

Despite this bounty of applications, ambitious commercial attempts to use them have usually foundered: the problem is that it's extremely difficult to scale up production. To make spider silk a viable alternative to that of silkworms, you need to do more than collect cobwebs and cocoons. You need to get the silk directly from the source, and in large quantities.

François-Xavier Bon, a French aristocrat, was one of the first to seriously explore spider sericulture. A long report, first published in French in 1709 and later translated into English, outlined his findings. He was hampered in his efforts by his lack of basic knowledge about spiders. He wrote, for example, that all spiders were androgynous, believing that it was generally the males that laid the eggs. He also struggled to describe the spinnerets, settling for comparisons from human anatomy: "all Spiders spin their Thread from the *Anus*; about which there are five *Papille*, or small Nipples." Nevertheless, he persisted. By collecting egg sacs (or "bags" as he called them) from "the Corners of Windows or Vaults, or under the Eaves of Houses," he gleaned enough to make a pair of stockings and gloves, which he excitedly presented to the scientific community as proof that the age of the silkworm might finally be drawing to a close.¹⁹

Despite this initial promise, though, efforts soon stalled when the magnitude of the obstacles became apparent. It was estimated, for example, that it would take twelve spiders to produce enough silk to equal the output of a single cocoon of the *Bombyx mori* silkworm, and 27,648 to produce a single pound of silk. It was also discovered that spiders were deeply resistant to being farmed. For one thing, it was well nigh impossible to catch enough flies to feed such vast numbers of them. Worse still was their tendency to attack and kill one another when confined

.

279

together. "Every time I looked upon them," wrote one researcher despairingly, "I saw a small one become the prey of a larger one; and some time after, I had hardly above one or two left in each box."²⁰

Still, the idea refused to peter out completely. Innovators, inventors, and scientists worried at it again and again, often unaware of their predecessors' attempts and each convinced that they had stumbled on the holy grail of the fabric industry: a thread that could rival Chinese silk. Gifts of spider-silk curiosities were given to the rich and powerful in the hope that they would fund further experiments. François-Xavier Bon is thought to have given a pair of stockings to the Duchess of Bourgogne, gloves to the Empress of Germany and Austria, and a waistcoat to King Louis XIV himself.

The closest historical attempts to reach some measure of success were those of the French colonial administration in Madagascar in the late nineteenth century. Jacob Paul Camboué, a French missionary living on the island, pioneered methods of extracting silk from living spiders in the 1000s and 1090s. He had initially tried to just use the cocoons, as is done for regular silk, but found that fifty of them yielded less than half-an-ounce of silk. If a spider was held still and the silk pulled from its spinnerets directly, however, the thread extracted could be anywhere from 260 to 2,300 feet. Mr. Nogué, his colleague, built a contraption that, while it looked sinister allowed N Madagascariensis spiders to be silked in groups without being harmed. Silk collected in this fashion in Antananarivo was made into bed hangings that were displayed, with much fanfare, at the Exposition Universelle in Paris in 1900, before disappearing without a trace.²¹

For Simon Peers, who lived and worked in Madagascar producing textiles, rumors of the island's spider-silk-weaving past were like a fairy tale, often heard but never fully believed. He was both fascinated and enchanted. In the 1990s, he fashioned a Heath-Robinson-style recreation of Mr. Nogué's spider-silking contraption that would hold two dozen spiders safe and still while their silk was pulled out and loosely spun into a thread. It was only years later, with the encouragement and backing of Nicholas Godley, that Peers's efforts to create a spider silk textile began in earnest. Their first textile was completed in 2008.²²

The final goal, making a piece of clothing entirely from spider silk, took three more years. Even with the pair's hard-won experience and the honed skills of their team, it was a laborious endeavor. In part this was because they felt the weight of their predecessors' failed attempts sitting heavily on their shoulders: the realization of hundreds of years of dreams had to be something special. To achieve a suitably impressive garment they used two different types of weaving, and covered the entire surface with intricate embroidery and appliqué; the decoration alone took many thousands of hours of stitching, all done by hand.

While all this certainly helped get the point across, even the humblest of threads woven into the hem was a labor of love. Because spider silk is so fine, it would be near impossible to work with on its own: each thread was twisted together from the silk of twenty-four spiders. And that was just the basic thread; the brocaded ground required far more. Each warp thread was comprised of ninety-six separate strands, while the weft contained twice as many. Bearing in mind that it takes around fourteen thousand spiders to get just one ounce of silk, simply getting enough silk was a huge endeavor. Each morning a small army of between thirty and eighty people would be dispatched to gather up to three thousand spiders from the trees and telephone poles of Antananarivo.²³ These would then be silked, using a machine similar to the one Simon Peers had made years earlier, before being returned to the areas in which they were caught in the afternoon. After being so depleted, it would take the spiders a week or so to restock their silk supplies, after which time they could be caught and silked again.24

When it was finally completed and put on display for six months in the V&A museum in London in 2012, the cape made a lasting impression on those who saw it. For many, though, particularly once the golden cape was packed away back into storage, the impossible lure of spider silk remained undimmed. Of course, a garment had been created, but only one and at vast expense requiring a team that numbered in the hundreds. The bigger challenge remained: to produce the silk in larger quantities, unlocking its potential so that it was no longer in the realm of one-off museum exhibits, but could become part of the fabric of the everyday.

Emperor's New Threads

Spider silk and goat milk, it turns out, aren't all that different.

Dr. Jeffrey Turner, CEO of Nexia Biotechnologies, 2001

In the first month of the new millennium, Nexia Biotechnologies, a somewhat secretive firm operating out of a maple farm in rural Canada, made an announcement. They had finally pioneered a way of producing spider cilk in large quantities.²⁵

Their secret method did not involve an especially docile nor an especially large spider, but another animal entirely: goats.²⁶ Nexia had spliced the silk-making genes of golden orb-weaving spiders into the genetic make-up of the goats. When the females-the three most famous were called Freckles, Pudding, and Sweetie-lactated, their milk contained spider-silk protein. To get at the silk, the goats were milked and then the protein extracted and spun into thread, for which Nexia coined a suitably Marvel-comic-book-sounding name: BioSteel. (Financial backing for the project had come from the American military, whose interest was piqued when they discovered that some spider silks were five times tougher than the Kevlar used in normal body armour.) At first the world was enthralled; finally, it seemed as if people might at last get their hands on a fabric it has taken spiders 380 million years to perfect. Sadly, tales of limitless spider silk spun from the milk of nanny goats turned out to be mirages. Nexia went bankrupt in 2009.27

A fundamental problem for scientists and companies seeking to recreate this silk is the sheer size and complexity of the proteins it is made from. Although they vary enormously depending on the species of spider, diet, and the kind of silk being produced, the molecular structure often includes many different proteins in complicated sequences, making them fiendishly difficult to replicate in a lab. Another hurdle is the instability of spider silk. When formed it is a liquid, constantly teetering on the edge of becoming a solid and only doing so, in spiders, as it passes through the spinnerets, which apply a mechanical pressure in a way that is not fully understood. For arachnids, this liquid-to-solid property makes sense, as the liquid silk dope can be easily stored in their bodies and spun into thread on demand. For human imitators, however, it is a formidable obstacle, and so far has proved impossible to reproduce in machines.²⁸

Despite such difficulties, Nexia is far from the only company willing to risk financial ruin and public ridicule to overcome them. Dr. Randy Lewis, a molecular biologist at the Utah State University, bought the spider-goat herd in 2009 and continued this avenue of research. Not that he has put all his egg sacs in one basket. While Freckles and Pudding might be the most photogenic subjects in his work, Dr. Lewis is also looking at other organisms whose genes might be coaxed into making them unlikely silk producers: potatoes, alfalfa—a member of the pea family—and even *Escherichia coli*, a bacterium that causes food poisoning.

A simpler solution, and one that is being explored by several different firms, involves altering the genes of silkworms. Domesticated silkworms, *Bombyx mori*, are already incredibly efficient silk producers: around 40 percent of their bodyweight is devoted to silk glands and the skills needed to handle them are already widespread. If the genes of *B. mori* could be hijacked to produce spider-type silk successfully, they would slot neatly into existing supply chains.²⁹

Not everyone is as optimistic as Dr. Lewis. Fritz Vollrath is a Germanborn biologist who has been studying spiders and their silk for two decades. Perhaps his most famous piece of research involved dosing spiders with different drugs—LSD, amphetamines, caffeine, and so on—to see what effect this would have on the webs they built. (The caffeinated spider's web, incidentally, was the most haphazard.) The professor now leads the Oxford Silk Group, a research lab that for the past fifteen years has specifically studied the chemistry, physics, evolution, and ecology of silk using a large brood of golden orb weavers housed in a converted greenhouse on a roof in Oxford.³⁰

Unlike Dr. Lewis and many of the other companies involved in producing spider silk products, Professor Vollrath is much more downbeat. "Worse than a pipe-dream," is his opinion of the idea that tendons might be produced using synthetic silk. He's even franker about the notion that it could be used to replace Kevlar: "It's bullshit. People are excited about it because people are stupid." Yes, spider silk would be strong enough to stop a bullet, he argues, but only once it had gone through a body, because silk is stretchy, which would rather defeat the object of the exercise. But his problem with the hype surrounding synthetic spider silk goes beyond the things that some have suggested might be made with it, right to the heart of the product itself.³¹

He contends that scientists, whatever they say in press releases, are unable to replicate the stuff that real arachnids produce, because it is simply too complicated. In his view what they *have* been able to do is copy a few peptide "motifs" from larger spider-silk protein sequences. "Calling fragments of what makes spider silk, 'spider silk,'" Professor Vollrath says, "is what is now called an 'alternative fact.'" Even once you've found a way of getting goats, *E. colt*, or potatoes to express these protein fragments, you still don't have a viable product. Extracting the specific spider-copied protein from something else is a difficult and harsh process, often involving acid baths, and this process denatures the protein, essentially killing it and making it impossible to spin into thread.³²

This tangle of conflicting narratives about the future of spider silk is heightened because the field of study is still new and small, and because the commercial companies working on creating products are relatively opaque. Triumphant press releases are followed by months, even years of silence. It certainly makes sense to remain skeptical, but even naysayers argue that spider silk is still worth studying. The work done by researchers and companies trying to make spider silk greatly expands our knowledge of bio-polymers (those proteins that are made from spider-silk motifs) and might lead to new ones. The Oxford Silk Group has also pioneered a method of silking individual spiders by tethering them on their backs, unharmed, while a slow mechanized winch draws out and winds the spider's silk onto a reel, a process that for some spiders can last up to eight hours of continuous silk-production.³³

Even if Professor Vollrath is a cynic when it comes to much of what is claimed for spider silk, there are plenty of avenues he believes are worth exploring. Most of these are medical. Spider silk is naturally antibacterial and antiseptic—it also has a unique compatibility with human cells, which means that our bodies don't reject it. Oxford Biomaterials, a commercial spin-off from Professor Vollrath's research group, is currently trialing spider silk as "scaffolding" for nerve regeneration and experimenting with using it to help create heart muscle. The ultimate aim is to repair damaged spinal cords.³⁴

Spin Doctors

You can do anything in a test tube; it takes a lot more to do it at scale.

Jamie Bainbridge, VP of product development at Bolt Threads, 2016

Bolt Threads, the most recent and charismatic firm to enter the spider silk-production fray, has other ambitions. Headed by three scientists who met while at university, Bolt's headquarters in Emeryville, California, eschew a textile factory or workshop aesthetic in favor of one that combines the characteristics of a science lab with those of a can-do tech start-up. All the conference rooms are named after different fabrics—velvet, silk, jacquard—and a copy of *Charlotte's Web* sits on the table in the lobby. At their desks, staff wear the Silicon Valley uniform of jeans and hoodies. There's a fridge filled with free bottled drinks, all of them sugar-free. In the labs, clear Perspex specs and personalized white coats must be worn, voices are hushed, beakers clink,

and machines—named for Jupiter's moons in one room, comicbook characters in another—whirr.

On June 16, 2015, Dan Widmaier, the CEO and co-founder, triumphantly announced that the Bolt team had, after six years of research, "cracked one of Nature's toughest puzzles," to wit: making the silk without the spiders.³⁵

They had spurned goats, alfalfa, and *E. coli*, in favor of a combination of sugar, water, salt, and yeast and, although they are honest about the challenges of making spider silk synthetically, are adamant that they have, at long last, managed to do so at a commercially viable scale. For Widmaier synthetic spider silk has been an ambition since his days at UC San Francisco. During his time in academia, he was unable to make more than a hundred milliliters, and he became convinced that to get the resources he needed would require starting a business.³⁶

Now Bolt Threads claim to have succeeded in making about four thousand kinds of spider silk from different species. Their mainstay, though, and the one they use as the basis for most of the fabrics they hope to get to market, is a riff on the dragline silk from another orbweaver from the genus Argiope. This would allow them to create, as Widmaicr put it, "programmable polymers . . . [with] a nearly limitless array of properties." In theory, they could tweak the threads they create to be odor-resistant, antimicrobial, lighter, stronger, or stretchier, depending on the use they were being put to. Price wise, Bolt Threads can't rival cotton or polyester. ("Polyester is down to one or two dollars a kilo," explains Jaime Bainbridge, Bolt's vice president of product development. "Ours is not going to be a commodity product; it's going to be a premium product.") They are understandably cagey about the technical side of what they do, but Bainbridge is confident that they have cracked the thorny issue of protein extraction, and have processes for coagulating the protein from liquid to solid refined to a commercially viable degree. The key to this stage, according to Widmaier, lay in being able to utilize pressures and temperature on the viscous liquid silk in ways that spiders are simply unable to.

In its base form, the silk protein resembles powdered milk. This must then be dissolved in acid before being spun and re-solidified in yet another solution. On the day I visited, the thread that was emerging, inch by inch, was a bright golden yellow. Spools of thread in other colors—teal, pink, and a pearly white—and knitted samples lay on lab surfaces. (Unlike silkworm silk, which is difficult to dye, Bolt Threads' creation is far easier to color.)³⁷

The fibers produced are thick and solid enough to be handled by standard commercial knitting and weaving equipment. The items they have made so far have been knitted—limited edition runs of lustrous ties and wool-blend hats, sold through the Best Made brand that Bolt quietly acquired in July 2017 and a collaboration with Stella McCartney. Backstage at her show in Paris in October 2017 the British designer showed off a bodysuit and trousers in pansy-brown silk knit; another of her designs, a golden dress, is now in the collection of the MoMA.³⁸

However tantalizingly close Bolt Threads might be to producing spider-inspired silk, it is materializing only slowly, and the world is getting impatient. When might people expect to see spider-silk clothes in shops? "That is a question I would pay every journalist not to ask," Bainbridge says.³⁹ The company's research is still ongoing, and science takes its own time. Until Bolt or another company— AMSilk, in Germany, and Spiber, a Japanese company, are inching toward the same goal—succeed, then spider-silk garments will remain the stuff of museum collections and novelty items. The golden cape, the bounty of over a million golden orb weavers, is currently out of the public eye in storage in London, although it will soon emerge for exhibitions in Canada and elsewhere. "That's not the end of the story though," Simon Peers tells, me sounding both reassuring and hopeful. "There will be a future for both the cape and the textile, but it's an ongoing saga."⁴⁰

Golden Threads

A Coda

The threads that touch seem the same, but the extremes are distant, as often after a rainstorm, the expanse of the sky, struck by the sunlight, is stained by a rainbow in one vast arch, in which a thousand separate colours shine, but the eye itself still cannot see the transitions. There, are inserted lasting threads of gold, and an ancient tale is spun in the web. Ovid, Metamorphoses, Book VI, Arachne spins her winning cloth

The legend of the golden fleece was old even in antiquity. It begins with classic ingredients: a king, his two children, and a scheming stepmother. When the king's realm is stricken with a famine, his new wife persuades him that crops will grow again if he sacrifices his children to Zeus. He—perhaps through weakness or a sense of greater duty agrees. But at the last moment his children are saved by a golden ram. The children clamber on its back and grasp its curling golden fleece as it launches itself into the air. The ram is later sacrificed to Zeus and its fleece is hung upon the bough of a tree in a sacred grow. Later, the golden fleece—now guarded by a dragon—is sought by the hero Jason, and his Argonauts, in his quest to reclaim his throne.

Golden textiles—and the stories we tell ourselves and each other about them—are at the most exclusive apex of a rich, global tradition. The legend of the fleece itself may well have been influenced by Mesopotamian religious beliefs that are thought to date back to the twentieth century BC. During ceremonies, statues of deities would be clothed in rich woolen fabrics embroidered with small looped pieces of gold that might, with a little imagination, be said to resemble the thick staples of a sheep's fleece.¹ In fifteenth-century Europe, Philip III, Duke of Burgundy, also known as Philip the Good, used the golden fleece as the inspiration for a new order of knighthood: the Order of the Golden Fleece. Members wore golden collars decorated with depictions of the ram slung over a branch.² Cloth woven from or embroidered with golden threads has been used by elites the world over to inspire awe and cement their exalted place in society. The Common Apparel System, developed in China during the twelfth century under the aegis of Emperor Zhangzong, explicitly used gold-embellished clothing to distinguish between social classes. Third-rank officials, for example, wore black embroidered with gold thread; unmarried girls wore dresses of red, silver, or golden cloth with colorful collars. During the fourteenth century, the Mongol court delighted in intricately woven shimmering textiles, many of which were influenced by Central Asian motifs and techniques, suggesting that east Iranian weavers were lured to China by the promise of work and patronage.³

Fabrics shot with precious metals were traditionally used in Muslim culture to demarcate status and celebrate special occasions. They were given as dowries and their ability to capture and reflect light linked them—and the wearer—with the divine. Gold and silver cloth were carefully deployed by rulers to cement their link with godly power. One chronicler, writing in the early nineteenth century, neatly captured the point: "The embroidered *khilat* [robe] of high value worn by the *Nawwab* [ruler] that day and also the ornaments set with jewels emitted such bright light that the world-illumination sun felt depressed."⁴

Europeans delighted in golden cloth too. France and England had been at war for most of the Middle Ages but in the summer of 1520, two young monarchs, Henry VIII of England and Francis I of France, determined to meet and settle the dispute. The ceremony, involving much jousting, feasting, and lavish gift-giving, was arranged on neutral territory, but the two rulers, each desperate to impress and outshine the other, made extensive use of gold. It adorned their tents, pavilions, horses, and the robes of their retinues. So excessive was their use of it that both kingdoms were nearly bankrupted and the meeting has been known as the Field of Cloth of Gold ever since.⁵

Many textiles of this kind were imported to Europe from the east along flourishing trade routes. For example, when Spanish trading ships arrived in the port of Manila in 1573, golden textiles from China were high on their list of trading priorities. Antonio de Morga, a local official, wrote that Spanish silver was exchanged for silks, including "quantities of velvets... with body of gold and embroidered with gold; woven stuffs and brocades, of gold and silver upon silk of various colors and patterns; quantities of gold and silver thread in skeins . . ."

Parallel to the lavish use of the real thing, there has also been a long tradition of cultivating or creating fabrics that appear to be made from golden cloth. Fibers made from minute strands of glass, invented by the ancient Egyptians sometime around 1600 BC, were used by nine-teenth-century textile makers to create imitation-gold brocades as lustrous as the real thing. A glassmaker from Ohio went so far as to make dresses for the actress Georgia Cayvan and the Infanta Eulalie from glass-fibers that were displayed at the 1893 Chicago World Fair. Ignoring both the supreme fragility and inconvenience of such garments, the *New York Times* confidently predicted a "fad" for glass dresses.⁶

Another golden fiber has proved more enduring. A description of Odysseus in Homer's Odyssey mentions a tunic "glossy like the skin of a dried onion, and as soft; it shone like the sun." Although we can't be sure, this sounds a lot like sea silk, a fubric that may have been worn by King Solomon. Exceptionally rare and airy, the raw material for sea silk or byssus is threads of solidified saliva of Pinnu nobilis, a large mollusc native to the Mediterranean waters surrounding Sardinia. These strands, which P. nobilis uses to attach itself firmly to rocks, are difficult and time-consuming to harvest and weave, but for those who know how, the end result is remarkable for the way the soft brown threads glint golden when exposed to the sun. Today, only one woman is able to harvest and make sea silk. Chiara Vigo, who learned the secret from her grandmother, has in turn passed the secret on to her daughter. "Weaving the sea silk is what my family has been doing for centuries," she has said. "The most important thread, for my family, was the thread of their history. their tradition."7

The majority of people alive today will never see, let alone wear sea silk or cloth of gold. They won't cross seas powered by woolen sails, learn how to make lace or milk goats genetically modified to produce spider silk. And yet textiles of all kinds are intrinsic to our lives and cultures. The invention of clothing is central to the development of cultures and civilizations. When Adam and Eve ate the forbidden fruit of the Tree of Knowledge, they recognized they were naked and immediately tried to fashion clothes out of fig leaves. Our clothes and home furnishing now allow us to survive all kinds of inhospitable climates (even outer space) and act like avatars of our identities and aspirations. The fabrics we choose and where we get them from still have butterfly-effect consequences on the lives of the people who make them and on the world around us. Perhaps it is time to stop being like early Egyptologists, eagerly tearing through mummies' linen coverings to grab at the treasures they might contain, and instead aspire to the care and craft of the ancient Egyptians themselves. We have, after all, been spinning fibers into threads for well over thirty thousand years, and then weaving, knitting, and knotting those threads into all manner of marvelous objects. A little more attention to detail shouldn't be too much to ask.

Acknowledgments

While researching and writing this book it has felt at times as if caring about fabric—what it is, where it comes from, who made it and who makes it now, where it goes when we are done with it—is somehow a niche endeavor. What a pleasure, to receive the following email from Bill Dieter, president of Terrazign, a NASA subcontractor. "I, like you, am always amazed how people take textiles for granted. It has more human contact than any other material and most have no idea what goes into producing it or all of its possible applications." A great part of what has made writing this book so special has been the chance to talk to people like Bill for whom fabrics hold a fascination. You all have my deepest thanks and it is my cincere hope that in writling this book I am able to pass on some of your enthuslasm and wisdom.

There are so many people to thank that I am both fearful of missing anyone and sure that I will do so. Here goes: thank you to Imogen Pelham, my agent; Georgina Laycock, my patient and forbearing editor, who pushed me to make this better, and to Yassine Belkacemi, James Edgar, and everyone at John Murray who has worked so hard to get this book into your hands.

I feel deep gratitude to everyone who lent advice, encouragement, judgment and expertise along the way: Bill Dicter, Piers Litherland, Peter Frankopan, Helen Holman, Hugh Ebbutt, Oliver Cox, Simon Akam, Tim Cross. Thank you also to Paul Larsen, Jo Woolf, and Lucy Owen for sharing your enthusiasm and knowledge. To Niv Allon, for helping me track down an elusive ancient Egyptian lady. To Dan Widmaier, for talking to me about what you do at great length. Fritz Vollrath, Randy Lewis, and Simon Peers: thank you for answering so many questions. Greg Steyger spoke to me from a mountain in Austria; Steve Furniss and Joe Santry gave up family time on Boxing Day; Stu Isaac obligingly pulled over while on the road on Midwinter's Eve. To Becky Adlington, for time on a miserable January day. Thanks also to Judith Noel, Ed Langford, and John Martin. And to the staff in the insect house at London Zoo, especially Ben, Dave, and Paul.

To Marelka, Jonny, Sophie, and Jessica, for letting me stay and keeping me excellently fed and watered. And to Olivier, for always understanding and for reading every word. Thank you!

Glossary

- Acrylic Man-made, fluffy fiber derived from acrylic resins and often used as a substitute for wool.
- Alum A mordant used for fixing dyes, alum was tricky to make. Rocks of aluminum sulphate or other metallic salts had to be roasted and watered for several months, then boiled and finally set into crystals.

Baize Coarse woolen fabric with a long nap now chiefly used for linings.

- Basket Weave Distinctive weave using regular interwoven pattern that resembles basket work.
- Bast The tough, flexible inner fibers of plants such as flax.
- Batik Method of dyeing fabric where some areas are covered with wax or paste to make patterns or designs by keeping the dyes from touching certain areas.
 Bobbin A spool, stick, or another article around which thread or yarn is wound

Boiled Wool A very warm fabric made from felted and knitted wool.

- Bombanine A twilled dress fabric usually made of silk and worsted. Often dyad black and most in mounting dress.
- **Broadcloth** Woven on a broader loom invented in Flanders in the mid-thirteenth century, which was up to three yards in width. Broadcloth had a silky texture after being heavily fulled
- Brocade Fabric woven with a ralsed pattern, often made with gold or silver thread.
- Calico General name for cotton cloth imported from the East and, in particular, India. Also used for fabrics made in Europe in imitation of Indian textiles. Derived from Calicut, the name of an Indian port through which such fabrics often passed en route to the west.
- **Cambric** Light, closely woven linen and now sometimes cotton fabric, originally made at Cambray in Flanders.
- **Canvas** Very strong, durable, and coarse fabric, made with unbleached cotton, hemp, flax, or similar. Often used to make sails, tents, or as a surface for oil painting.
- **Carding** The process of removing knots from wool with special comblike instruments that nevertheless ensure that the fibers remain fluffy. Hand cards made with metal spikes or nails were used on shorter-stapled wools. Finer cards were better able to loosen the wool so that finer thread could be made from it.
- **Chintz** Originally: printed calicoes imported from India. Later used for European fabrics made in imitation of the Indian style: smallish floral designs in multiple colors. The word apparently comes from the Hindi one, *chint*, meaning clear or bright.

- **Combing** Superseded carding as the method of preparing wool for spinning. Continued to be used for longer-stapled wools.
- **Count** Systems of measuring the thickness of yarn. Different fibers originally had individual count systems; this has been replaced by a new metric system.
- Damask A luxurious fabric originally silk but later also made using other fibers, covered with elaborate designs, usually in a variety of colors. The name derives from Damascus, because it was through that city that damask was introduced into Europe.
- **Denim** Originally a kind of serge cloth, famously made at Nîmes (the name is an anglicization of *de Nîmes*), now a hard-wearing twilled cotton used for work-wear and trousers.

Distaff A stick or board used to hold fibers before they are spun.

Fastness The resistance of a dyed fabric to fading or changing color, by exposure to water, soap, detergent, or sunlight.

Fells Sheepskins with the wool still attached.

- Felt A kind of cloth made by rolling or pressing woolen fibers together, usually with the aid of moisture or heat, causing the fibers to mat together. Can be used as a verb also.
- Flax A herbaceous plant, often with sky blue flowers, that originally grew wild but is now cultivated for its seed and for textile fibers made from the inner layers of flax stalks.
- **Fulling** A method of strengthening woolen fabric by trampling it when wet so that the fibers of the woven cloth begin to felt, or mat together.
- Fustian Coarse cloth made of cotton or flax. Now more commonly a thick, twilled cotton cloth usually dyed a dull, dark color.
- Heckling To split and straighten the fibers of hemp or flax for spinning.

Holland Linen fabric from the province of Holland in the Netherlands.

- **Jacquard loom** A loom fitted with a mechanism to control the weaving of figured fabrics. This mechanism was invented by Joseph Marie Jacquard from Lyons in France.
- Jersey Knitted goods from Jersey, especially a kind of tunic. Later used to denote fine knitted fabrics.
- Loom A machine or implement on which yarn or thread is woven.
- Lustring A very glossy silk fabric. The name derives from the word "lustre."
- Mercer A person who deals in textiles, especially luxurious ones including silks and velvet.
- Mordant Used to fix dyes to fabric so that the colorant would stay put after wear and washing. See alum; potash.

Muslin Lightweight and plain-woven cotton fabric.

- Nankeen A pale yellow cloth originally made at Nanking in China from a particular kind of cotton that was naturally golden in color.
- Nap The raised hairs on the surface of a fabric. See pile.

Osnaburg A coarse cloth often used in sacking or for the cheapest of clothing. Originally made at Osnabrück in Germany.

Pile The raised surface of a fabric. See nap.

Plain weave The simplest kind of weaving, in which weft threads pass alternately over and under the warp threads.

Ply A strand of yarn; the number of multiple strands from which something is made.

Polyester Man-made textile made from strong, thermoplastic fibers derived from petrochemicals.

Potash A mordant often used with blue woad dye.

Rayon A man-made fiber made from regenerated cellulose. Also generically called artificial silk, viscose, bamboo, and many other trade names.

Ret To soak flax or hemp in water to soften it.

Rib Raised cord or ridge in the weave of a fabric.

Rippling To pass hemp or flax through a comb to remove seeds.

Rove A sliver of fiber, drawn out and slightly twisted in preparation for spinning. **S-Twist** Yarn spun counterclockwise.

Sack An English measurement of wool weighing around 166 kilograms or 364 pounds.

Sarpler A bale of wool containing, in the Middle Ages, around 192 sacks of wool. By the later fifteenth century a sarpler could contain up to 214 sacks.

Sursence Flue, sort silk material that can be made either plain or twilled. Chiefly used now in linings.

Satin Textile made using a warp-face weave, usually using allk, giving the fabric a very smooth, lustrous texture.

Scouring A method of cleaning woven cloth before dyeing. Traditionally involved stale urine.

Shearing On cloth: cutting the raised nap of a cloth with long, specialized shears. It produced a smoother, more luxurious surface. On sheep: the process of cutting off the fleece, usually just as an undercoat has begun to grow through.

Shed The opening between lifted and supine warp threads through which the weft can pass when weaving a fabric.

Scutching To strike with a stick or whip.

Shuttle An implement used in weaving for passing weft through the warp from one side of the cloth to the other.

Slub Lump on a thread, caused either by a join or a natural defect in the fiber or by poor spinning.

Spin Twisting fibers to make thread.

Spindle A stick used to spin fibers into thread. The thread, in turn, can then be wound onto the spindle to prevent it from tangling while the spinning continues.

Staple Length of wool fiber. This can vary from very short, tightly curled wool of two inches to well over five.

Teasel A spiky plant that was used like a brush to raise the nap of a cloth before it was sheared.

Tenterhooks Iron hooks used to stretch wet cloth over a tenter-frame. Tentering stretched out and reshaped cloth.

Textile Material made from filaments, fibers, or yarns. From the Latin "textere" meaning "to weave."

Tow Short, broken bast fibers, especially from flax. This is where the expression tow-headed comes from.

Tulle Fine net used for dresses, veils, and hats, originally made in Tulle, a town in the southwest of France.

Twill A woven fabric distinguished by the rows of diagonal ridges produced by passing the weft threads over one and under two or more warp threads.

Twine Thread or string made of two or more strands twisted together. Now commonly used to refer to particularly strong, rough string.

Velvet Textile, traditionally of silk, that has a dense and smooth piled surface.

Warp A set of thread in weaving, usually the ones extended lengthwise on a loom, that are held taut so that the weaver can work more easily.

Weave To form material by interlacing sets of thread together.

Weft Threads threaded through the warp to form cloth. From the old past tense of the verb "weave."

Whorl A small bead-shaped weight that is fitted over the end of a spindle to increase, maintain, and regulate the twist being put into thread.

Woolen Yarns made from short-stapled wool. Often well-fulled to produce a stronger cloth.

Worsted A strong, long-wearing thread made from well-combed fibers with very little fluffiness. Also: fine light cloth made from long-stapled yarns, which are strong and a little coarse. Named after a town near Norwich. Because worsted cloth was barely fulled the weave was very evident, in contrast to woolens.

Yarn Spun fiber that can be used in weaving, knitting, and so on. Z-Twist Yarn spun clockwise.

Notes

Introduction

1. Wayland Barber, Prehistoric Textiles, p. 4.

- Muldrew, 498-526; Hobsbawm, p. 34; Riello and Parthasarathi, *The Spinning World*, pp. 1-2.
- Quoted in Levey, Lace. A History, p. 12; A. Hume, "Spinning and Weaving: Their Influence on Popular Language and Literature," Ulster Journal of Archaeology, 5 (1857), 93-110 (p. 102); J.G.N., "Memoir of Henry, the Last Fitz-Alan Earl of Arundel," The Gentleman's Magazine, December 1833, p. 213 https://babel.hathitrust.org/cgi/pt?id=mdp.39015027 525602;view=1up;seq=25.
- Wayland Barber, Prehistoric Textiles, p. 43; Keith, p. 500; Wayland Barber, Women's Work, pp. 33-5.
- For excellent discussions of spinning, weaving, and the tools involved in both I recommend Wayland Barber, Women's Work, pp. 34-7; Albers, pp. 1-2.
- 6. Ryder, "The Origin of Spinning," p. 76; Keith, pp. 501-2.
- 7. Wayland Barber, Prehistoric Textiles, p. xxii.
- 8. Dougherty, p. B4.
- 9. Dwyer, p. A19,
- 10. Handley.
- 11. "Summary Abstracts of the Rewards Bestowed by the Society," p. 33; Petty, p. 260.
- 12. "Leeds Woollen Workers Petition."
- 13. Wayland Barber, Prehistoric Towtiles, p. 102.
- 14. Homer, p. 13.
- 15. Vainker, p. 32; Pantelia; Kautilya, p. 303.
- 16. Freud, p. 132.
- 17 Quoted in Wayland harner, Prohistoric Textiles, p. 287.
- 18. Vickery, "His and Hers," pp. 26-7.
- 19. Muldrew, pp. 507-8.
- 20. Kautilya, p. 303; Levey, pp. 17, 26.
- 21. "Most Bangladeshi Garment Workers Are Women"; Bajaj, p. A4.

1. Fibers in the Cave

- 1. Bar-Yosef et al., p. 335; Hirst.
- 2. Bar-Yosef et al., pp. 331, 338-40; Hirst.
- 3. Balter, p. 1329; Lavoie; Hirst.
- 4. Kvavadze et al., p. 1359.
- 5. Hirst; Kvavadze et al., p. 1359.
- 6. Wayland Barber, quoted in Richard Harris.
- 7. There is some evidence that our bodies can acclimatize and, in the long term, even adapt to consistently lower temperatures. Australian Aborigines native to cooler southern areas, for example, have developed slightly different proportions, which helps prevent heat loss. But even such adaptations offer relatively scant protection. Frankopan, pp. 48–9.
- 8. Gilligan, pp. 21-2; An Individual's Guide to Climatic Injury.
- 9. The authors theorize that selective pressure was stronger on women, which is why they are less hirsute. They also conjecture that we have retained public hair because it helps transmit

pheromones, again making us more attractive to the opposite sex. Pagel and Bodmer; Wade, p. F1.

- 10. Kittler et al.
- 11. Gilligan, p. 23.
- Evidence suggests that humans gained control of fire at least 800,000 years ago. Gilligan, pp. 17, 32–7; Toups et al.
- 13. Blue-flowered flax is thought to produce the best bast fibers. Kemp and Vogelsang-Eastwood, p. 25; Lavoie. The earliest known domestication of flax comes from an area in what is now Iraq around 5000 BC. Wayland Barber, *Prehistoric Textiles* pp. 11–12.
- 14. These other bast fibers need to go through a similar process before they can be used.
- 15. Wayland Barber, Prehistoric Textiles, p. 13; Kemp and Vogelsang-Eastwood, p. 25.
- 16. William F. Leggett, p. 4.
- 17. Wayland Barber, Prehistoric Textiles, p. 41.
- 18. Ibid., p. 3.
- 19. Keith, p. 508; Wayland Barber, Prehistoric Textiles, p. 43.
- 20. Wayland Barber, Prehistoric Textiles, p. 83.
- 21. Kuzmin et al., pp. 332, 327-8; Wayland Barber, Prehistoric Textiles, p. 93.
- 22. Gilligan, pp. 48-9, 53-4.
- 23. Wayland Barber, Prehistoric Textiles, p. 3.
- Lavoie; Soffer et al., pp. 512–13; Wayland Barber, *Prehistoric Textiles*, p. 10; Helbaek, p. 46; William Leggett, pp. 11–12.
- 25. Wayland Barber, Prehistoric Textiles, p. 40.

26. Barras.

- 27. Fowler; Wayland Barber, Prehistoric Textiles, p. 11; Helbaek, pp. 40-1.
- 28. Helbaek, pp. 41, 44.

2. Dead Men's Shrouds

- 1. This is at least what Carter recounted in his later book about the discovery. His excavation diary recorded a simpler response to Carnarvon's question: "Yes, it is wonderful." Carter and Mace, *The Tomb of Tut-Ankh-Amen*, 1, pp. 94–6.
- 2. Some believe this tomb may still hold secrets. In 2015 another British archaeologist, Nicholas Reeves, announced that he thought that there were two doorways still concealed in the north and west walls of Tutankhamun's burial chamber. One would likely lead to a storeroom. The other, he believes, may lead to an even more impressive burial: that of Queen Nefertiti. However compelling the thought of such a find may be, there are good reasons to retain a very healthy dose of skepticism. "What Lies Beneath?"; Litherland.
- 3. More than once Carter complained of the "jumbled state" of the boxes, and the "queer mixture of incongruous objects" that they contained. See for example, Carter and Mace, *The Tomb of Tut-Ankh-Amen*, 1, pp. 170–2.

- 5. Carter and Mace, "Excavation Journals and Diaries," 28 October 1925; Carter and Mace, *The Tomb of Tut-Ankh-Amen*, II, p. 107.
- 6. Carter and Mace, The Tomb of Tut-Ankh-Amen, II, pp. 107-9.
- 7. In the hierarchy of possible finds, linen comes well below caches of papyrus. "All archaeologists," one wrote to me, "would give their eye teeth" to find such a treasure, "particularly relating to the more controversial periods such as the Amarna period. And some . . . would rather find papyrus than 'treasure.'" Litherland.
- 8. Carter and Mace, The Tomb of Tut-Ankh-Amen, II, pp. 107-9, 51; Ibid., I, p. viii; Riggs, Unwrapping Ancient Egypt, pp. 30-1.
- 9. Riggs, Unwrapping Ancient Egypt, pp. 31, 117; Clark, p. 24.

^{4.} Reeves, p. 3.

- 10. Lucas and Harris, p. 140; Kemp and Vogelsang-Eastwood, p. 25.
- 11. Herodotus, II; Riggs, Unwrapping Ancient Egypt, p. 114.
- 12. If left a little longer until the stems yellowed the fibers would be stronger, suitable for work clothes; bast fibers from fully ripe stalks would be used for matting, string, or rope.
- 13. Bard, p. 123.; Kemp and Vogelsang-Eastwood, p. 27.
- 14. Kemp and Vogelsang-Eastwood, pp. 25, 29.
- Thatcher, pp. 79–83; Ahmed Fouad Negm's poem is called "The Nile Is Thirsty" and was translated by Walaa Quisay. Slackman.
- 16. "Tombs of Meketre and Wah."
- Riggs, Unwrapping Ancient Egypt, p. 115; Lucas and Harris, p. 141; Clark, pp. 24–6; Kemp and Vogelsang-Eastwood, p. 70.
- 18. Another peculiarity of Egyptian linen is that most fabric was woven with two-ply yarn, rather than single-spun thread. Of the several thousand textile fabrics found at the Workmen's Village at Amarna, occupied during the second millennium BC, for example, nearly 80 percent were two-ply. Lucas and Harris, p. 141; Riggs, Unwrapping Ancient Egypt, p. 116; Kemp and Vogelsang-Eastwood, pp. 3, 5, 87.
- Kemp and Vogelsang-Eastwood, p. 29; Bard, pp. 843, 208; William F. Leggett, p. 14; Riggs, Unwrapping Ancient Egypt, p. 111.
- 20. Kemp and Vogelsang-Eastwood, pp. 34, 25-6.
- 21. Riggs, Unwrapping Ancient Egypt, p. 20; Clark, pp. 24-5.
- Herodotus, π, p. 37; William F. Leggett, p. 27; Riggs, Unwrapping Ancient Egypt, p. 117; Plutarch, p. 13.
- 23. Riggs, pp. 7-12; Halime; Taylor.
- Cartor and Mace, The Tomb of Tut-Anth-Amon, I, fig. analis, Riggs, Unwrapping Ancient Egypt, pp. 3-11.
- 25 A difficult lady to tuck down, because she was originally known to scholars as Senbtes. I am indebted to Niv Allon, an Egyptologist at the Met Museum, for helping dispel my confusion.
- 26. "A Lady of the Twelfth Dynasty," pp. 104, 106; Mace and Winlock, pp. 18-20, 119.
- 27. Murray, p. 67; Riggs, Unwrapping Ancient Egypt, pp. 119, 121.
- 28. Granville, p. 272, Lucus and Harris, p. 270; William F. Leggett, p. 24; Riggs, "Beautiful Burials, Beautiful Skulls," p. 255.
- 29. Herodotus, II, W. 86; Risso, Unwrapping Ancient Egypt, pp. 77, 79.
- 30. Riggs, Ibid., pp. 78-80, 122; Eaton-Krauss.
- 31, Riggs, Ihid., p. 15.
- 32. Pierre Loti, Le Mort de Philae, quoted in Moshenska, p. 451; Pierre Loti, Le Mort de Philae, quoted in Riggs, Unwrapping Ancient Egypt, pp. 61, 45.
- 33. Pain; Moshenska, p. 457.
- 34. Granville, p. 271.
- 35. Ibid., pp. 274-5, 298, 277; Moshenska, p. 457; Sample.
- 36. Granville, p. 304; Pain.
- 37. Robson; Riggs, Unwrapping Ancient Egypt, pp. 80, 85.
- Herodotus, I; Granville, p. 271; Maspero; Carter and Mace, *The Tomb of Tut-Ankh-Amen*, II, p. 51.
- 39. Maspero, p. 766; Granville, p. 280; Pain; Sample.
- 40. Riggs, Unwrapping Ancient Egypt, p. 85.
- 41. The dismemberment of mummified bodies was not unique to this excavation. Indeed, Carter was, by the standards of the day, taking pains by reassembling the body parts in the coffin at all: as late as the 1960s major excavations were instructed only to keep the long bones and skulls and to dispose of everything else.
- Carter and Mace, *The Tomb of Tut-Ankh-Amen*, 1, p. vii; Carter and Mace, "Excavation Journals and Diaries," 18 November 1925; Harrison and Abdalla, p. 9; Shaer, pp. 30-9.

301

3. Gifts and Horses

- 1. Hinton, Classical Chinese Poetry, p. 107.
- 2. Hinton, Classical Chinese Poetry, pp. 105, 108; Hinton, "Su Hui's Star Gauge."
- 3. Hinton, Classical Chinese Poetry, p. 105.

- 5. The Yellow Emperor, according to legend, reigned from 2697 to 2598 BC.
- 6. Feltwell, p. 37.
- 7. P. Hao, "Sericulture and Silk Weaving from Antiquity to the Zhou Dynasty," in Kuhn and Feng, p. 68; Feltwell, pp. 37, 39.
- 8. Vainker, p. 16; Feltwell, p. 42.
- 9. Feltwell, p. 51; P. Hao, in Kuhn and Feng, pp. 73, 68.
- 10. Vainker, p. 16; Feltwell, pp. 47-8, 40-2, 44.
- 11. Vainker, pp. 16-17. P. Hao, in Kuhn and Feng, p. 73.
- 12. Zhang and Jie; Blanchard, pp. 111, 113.
- 13. P. Hao, in Kuhn and Feng, pp. 71-2; Good; Gong et al., p. 1.
- 14. Vainker, pp. 20, 24-5.
- 15. "Earliest Silk"; G. Lai, "Colours and Colour Symbolism in Early Chinese Ritual Art," in

Dusenbury, p. 36; Kuhn, in Kuhn and Feng, p. 4; Xinru, pp. 31-2.

- 16. Ssu-Ma Ch'ien, Records of the Grand Historian of China, trans. by Burton Watson, 2nd ed. (New York: Columbia University Press, 1962), p. 14; Xinru, p. 30.
- 17. Kuhn, in Kuhn and Feng, pp. 5-6; P. Hao, in Kuhn and Feng, p. 68; Vainker, pp. 6, 8, 11.
- 18. Confucius, quoted in Dusenbury, p. 38; J. Wyatt, in Kuhn and Feng, p. xv; Feng, "Silks in the Sui, Tang and Five Dynasties," in Kuhn and Feng, p. 206; Kuhn, "Reading the Magnificence of Ancient and Medieval Chinese Silks," in Kuhn and Feng, p. 4.
- Kassia St. Clair, *The Secret Lives of Colour* (London: John Murray, 2016), p. 85; Kuhn, in Kuhn and Feng, pp. 17, 23; Vainker, p. 46.
- 20. Lu, p. 420; Kuhn, in Kuhn and Feng, pp. 15, 10, 12; C. Juanjuan and H. Nengfu, "Silk Fabrics of the Ming Dynasty," in Kuhn and Feng, p. 370.
- 21. Kuhn, in Kuhn and Feng, p. 19; P. Hao, in Kuhn and Feng, p. 82.
- 22. P. Hao, in Kuhn and Feng, p. 75; Kuhn, in Kuhn and Feng, pp. 10, 14–15; Stein, "Central-Asian Relics of China's Ancient Silk Trade," pp. 130–1.
- 23. Quoted in Ssu-Ma Ch'ien, p. 155.

24. Yu, pp. 41-2.

25. McLaughlin, p. 85; Ssu-Ma Ch'ien, op. cit., p. 169.

26. Yu, pp. 47-8.

- 27. McLaughlin, p. 85; quoted in David Christian, p. 18.
- 28. Yu, p. 37; quoted in Ssu-Ma Ch'ien, p. 170.
- C. Juanjuan and H. Nengfu, "Textile Art of the Qing Dynasty," in Kuhn and Feng, pp. 468, 489.

4. Cities That Silk Built

- 1. Walker, pp. 93-4; Mirsky, pp. 5-6, 15.
- 2. Walker, pp. 94, 99-100.
- 3. Hastie.
- 4. Mikanowski; Hastie.
- 5. Stein, "Explorations in Central Asia."
- 6. Mikanowski.
- 7. Valerie Hansen, The Silk Road, p. 213.
- 8. The phrase in its original form is: "Die Seidenstrassen."
- 9. David Christian, p. 2; Yu, pp. 151-2; Valerie Hansen, The Silk Road, p. 4.

^{4.} Ibid., p. 108.

- 10. This argument is eloquently made in Peter Frankopan's *The Silk Roads*. As is the idea that the central parts of the Silk Roads were just as important as, if not more so than, the extremities.
- 11. David Christian, pp. 5-6; Li Wenying, "Sink Artistry of the Qin, Han, Wei and Jin Dynasties," in Kuhn and Feng, p. 119.
- The Bactrian camel fancier was the author of the *History of the Northern Dynasties*, quoted in Peter Frankopan, p. 11; Valerie Hansen, *The Silk Road*, pp. 3, 50.
- 13. These were recovered, in scraps from the tomb of another man. Paper was precious and was rarely destroyed. In this instance, these court documents had been recycled to make funerary clothes. Researchers were able to piece them—and the case together when the tomb was excavated and the body disrobed.
- Feltwell, p. 13; "Sogdian Ancient Letters," trans. by Nicholas Sims-Williams https://depts.washington.edu/silkroad/texts/sogdlet.html [accessed 10 August 2017]. Frankopan, p. 57.
- 15. Frankopan, pp. 115-16, 125-6.
- 16. Ibid., pp. 18-19; Bilefsky; Polo, pp. 223, 148.
- 17. McLaughlin, p. 93.
- 18. Vainker, p. 6; Xinru, p. 39; Frankopan, p. 11; Walker, pp. 99-100.
- 19. Quoted in Valerie Hansen, "The Tribute Trade with Khotan," pp. 40-1; Liu Xinru, p. 29.
- 20. Some other countries, including India, are home to other moths whose silk can be spun. *B. mori* silks, however, are much easier to handle, and it was this species of moth that was domesticated as early as 3300 BC.
- 21. Good, p. 962; Yu, p. 158.
- 22. L. Wenying, in Kuhn and Feng, p. 119; Feltwell, pp. 9-10.
- 23. Xinru, pp. 46-7, 29-30.
- L. Wenyling, Slik Artistry of the Northern and Southern Dynasties," in Kuhn and Feng, pp. 198, 171.
- Kuhn, "Reading the Magnificence of Ancient and Medieval Chinese Silks," in Kuhn and Feng, pp. 30–3, 36, 39.
- C. Juanjuan and H. Nengfu, "Silk Fabrics of the Ming Dynasty," in Kuhn and Feng, p. 375; quoted in Feltwell, p. 11.
- 27. Feltwell, pp. 146, 20, 18, 26, 150.
- 28. Frankopan, p. 116. Vogt
- 29. Vedeler, pp. 3,7, 20, 13; Vogt.
- 30. The character of Trimalchio retains a remarkable modernity over two thousand years after his creation. Indeed, F. Scott Fitzgerald's *The Great Gatsby* began its life as a novella named after this character; parts of the original can still be glimpsed in Jay Gatsby's decadent and desperate attempts to win the heart of Daisy Buchanan. Molotsky.
- 31. Arbiter.
- 32. P. Hao, in Kuhn and Feng, p. 65; Pliny the Elder, chap. 26.
- 33. J. Thorley, "The Silk Trade between China and the Roman Empire at Its Height, Circa A. D. 90–130," Greece & Rome, 18.1 (1971), 71–80 (p. 76); Frankopan, p. 18; David Christian, p. 5; Vainker, p. 6; McLaughlin, p. 13.
- 34. Feltwell, p. 141; Yu, p. 159; McLaughlin, pp. 150, 153.
- 35. L. Wenying, in Kuhn and Feng, p. 119; Frankopan, p. 18.
- 36. Horace quoted in Arbiter. Seneca quoted in McLaughlin, p. 149.
- 37. Arbiter, chap. 32; Suetonius, p. 495; quoted in McLaughlin, p. 149.
- 38. Walker, pp. 102-3.

5. Surf Dragons

 The saga covers events between 800 and 1000; the oldest surviving copy dates from the thirteenth century. 2. "When the Gokstad Ship Was Found"; "A Norse-Viking Ship."

- 3. Hogan; Magnusson, p. 36.
- 4. The keel itself is made of a single piece of carved oak.
- 5. Magnusson, p. 37; Correspondent, p. 4.
- 6. Magnusson, p. 44; quoted in Jesch, Women in the Viking Age, pp. 119-23.
- 7. Magnusson, pp. 23, 40; Jesch, Ships and Men in the Late Viking Age, p. 160.
- 8. Magnusson, p. 21.

9. Ibid., p. 17; Frankopan, p. 116; Hussain; Mulder.

- 10. Snow; Linden.
- 11. "Viking Ship Sails"; "Viking Ship Is Here"; quoted in Magnusson, p. 39.
- 12. Linden; Strauss.
- 13. Cherry and Leppard, p. 740.
- 14. Heyerdahl; Cherry and Leppard, pp. 743-4.
- 15. David Lewis, p. 55.
- 16. Cherry and Leppard, p. 744.
- 17. Johnstone, pp. 75-7.
- 18. Robert A. Carter, pp. 52, 55.
- 19. Tacitus; Sawyer, p. 76; Magnusson, p. 93.
- 20. Magnusson, p. 19.
- 21. Now, their colorful knitwear is famous globally, frequently showing up on catwalks for brands such as Chanel and Burberry. The population of Fair Isle has dwindled from four hundred to just under sixty, meaning very few can afford to knit all year round. Most do it only during the winter months in the dark hours, squeezed around other jobs: waiting lists can be three years long.
- 22. Eamer.
- Bender Jørgensen, p. 175; Cooke, Christiansen, and Hammarlund, p. 205; Amy Lightfoot, "From Heather-Clad Hills to the Roof of a Medieval Church: The Story of a Woollen Sail," *Norwegian Textile Letter*, ii.3 (1996), 1–8 (p. 3).
- 24. Lightfoot, pp. 3-4; Eamer.
- Cooke, Christiansen, and Hammarlund, p. 205; Lightfoot, pp. 3, 5; Bender Jørgensen, p. 177.
- 26. Cooke, Christiansen, and Hammarlund, p. 203.
- 27. In traditionally made boats used in Norway today, sails of around a hundred meters square use cloth of between 750 and 1,050 grams per square meter, while for smaller boats the cloth need only be 300–750 grams per square meter. Bender Jørgensen, p. 173.
- 28. "Woolen Sailcloth;" Lightfoot, p. 7; Bender Jørgensen, pp. 173, 177.
- 29. Eamer; Cooke, Christiansen, and Hammarlund, pp. 209-10.
- 30. Quoted in Lightfoot, p. 7.

- 32. Quoted in Magnusson, p. 34.
- 33. Snow.
- 34. Choi.
- 35. Bender Jørgensen, p. 173.

6. A King's Ransom

1. Statutes of the Realm, pp. 280-1, 380; Knighton quoted in Wood, p. 47.

2. Power, p. 15.

3. Ibid., pp. 34-5; Ryder, "Medieval Sheep and Wool Types," p. 23; Walton Rogers, p. 1718.

4. Ryder, "Medieval Sheep and Wool Types," p. 23.

5. Nightingale, pp. 8, 10; Walton Rogers, pp. 1715, 1829.

6. Walton Rogers, pp. 1708, 1710.

^{31.} Holman.

- 7. Ibid., p. 1713.
- Ryder, "Medieval Sheep and Wool Types," p. 19; quoted in Walton Rogers, pp. 1769, 1715, 1766.
- 9. Hurst, p. 82; Ryder, "Medieval Sheep and Wool Types," p. 14.
- 10. Walton Rogers, pp. 1719-20.
- 11. Ibid., pp. 1827, 1731, 1736, 1741, 1753, 1759.
- 12. Hurst, p. 87; Walton Rogers, p. 1720; Fryde, p. 357.
- 13. Walton Rogers, p. 1826; Power, pp. 8-9, 15-16.
- 14. Hurst, p. 57; Power, pp. 59, 17, 73; Ohlgren, p. 146.
- 15. Ohlgren, pp. 124, 157, 176-80, 146.
- 16. Nightingale, pp. 22, 9; Hurst, pp. 61-2.
- 17. Quoted in Power, pp. 64, 73.
- 18. Hurst, p. 63; Nightingale, p. 10; quoted in Power, p. 74.
- 19. William of St-Thierry; "Cistercians in the British Isles."
- 20. Meaux Abbey, Malton Priory and Fountains Abbey, three important northern Cistercian houses, all engaged in this practice. Robin R. Mundill, "Edward I and the Final Phase of Anglo-Jewry," in Jews in Medieval Britain: Historical, Literary and Archaeological Perspectives, ed. by Patricia Skinner (Martlesham: Boydell, 2012), pp. 27-8; R. B. Dobson, "The Decline and Expulsion of the Medieval Jews of York," Transactions & Miscellanies (Jewish Historical Society of England), 26 (1974), 34-52 (pp. 35, 39-40).
- Robin R. Mundill, "Edward I and the Final Phase of Anglo-Jewry," in Patricia Skinner, pp. 27–8; R. B. Dobson, pp. 35, 39–40.
- 22. Donkin, pp. 2, 4; Jowitt Whitwell, p. 24.
- 23 Jowitt Whitwell, pp. 8-9.
- 24. Ibld., pp. 11, 30.
- 25. Gillingham, pp. 22, 17 19.
- 26. Quoted in Gillingham, p. 222.
- 27. The ransom wasn't officially called a ransom, but instead repackaged as a dowry for Richard's niece, who was to be married off to one of Leopold's sons as part of the deal. Jowitt Whitwell, p. 1; Gillingham, p. 252.
- 28 Jowitt Whitwell, p. 2; Gillingham, pp. 239, 247.
- 29. William of Newburgh, History, IV, Chap. 38.
- 30. William of Newburgh, History, v, Chap. 1.
- 31. Quoted in Jowitt Whitwell, pp. 5-6.

7. Diamonds and the Ruff

- 1. Schütz, p. 236.
- 2. Wheelock, p. 7.
- 3. Ibid., p. 3; The Lacemaker.
- The Love Letter and A Lady Writing a Letter with her Maid are two other examples from the same period. Van Gogh.
- 5. It should be noted that others believe the mussels and clogs have entirely different, and far more lustful, meanings. Confusingly, both are also found in paintings of fallen women, suggesting far less innocent ways of passing time. Franits, p. 109.
- 6. Levey, p. 1; Kraatz, p. 27.
- 7. Ibid., p. 6.
- 8. Ibid., p. 6; Kraatz, pp. 12, 14-15.
- 9. Wardle, p. 207; Kelly, p. 246; Will quoted in Williamson, p. 460.
- 10. Venable, pp. 195-96.
- Copper lace was, for example, worn by the pages at the marriage of Princess Elizabeth in 1613. Levey, p. 16; M. Jourdain, p. 167.

- 12. Stubbes, p. xxxi.
- 13. Kraatz, p. 22; Pepys.
- 14. Levey, p. 12; Kraatz, p. 22.
- 15. Levey, p. 2.
- 16. Kraatz, p. 12.
- 17. Levey, pp. 1-2.
- 18. Kraatz, p. 12.
- Soap taxes, in fact, remained in place in England until the mid-nineteenth century, resulting in a thriving black market for soaps smuggled in from abroad. "The Soap-Tax"; Vickery, *Behind Closed Doors*, pp. 29–30.
- 20. Quoted in Appleton Standen.
- 21. Marshall.
- 22. Kraatz, pp. 45, 48.
- 23. Ibid., pp. 42, 45.
- 24. Ibid., p. 48.
- 25. To put this figure into perspective, the annual salary of Charles le Brun, a court artist to Louis XIV and the director of the Gobelin tapestry factory and royal furniture manufacturies, was 11,200 livres. Kraatz, pp. 48, 50.
- 26. Levey, pp. 32-3.
- 27. Moryson, n, p. 59.
- 28. Kraatz, p. 52.
- 29. Levey, p. 9.
- 30. Quoted in Arnold, p. 2.
- Carey, pp. 29–30; Philip Stubbes quoted in Levey, p. 12; Thomas Tomkins quoted in Arnold, p. 110.
- 32. Arnold, pp. 219-20, 223.
- 33. The Kenilworth inventory of 1584, quoted in Jourdain, pp. 167-68.
- 34. Levey, pp. 17, 24-5; Jourdain, p. 162.
- 35. Kraatz, pp. 39-42, 64-5.
- 36. Arnold, p. 2; Levey, pp. 16, 24.
- 37. Levey, p. 17.
- 38. Kraatz, p. 18.
- 39. Levey, pp. 26-7.
- 40. Ibid., pp. 9, 26.
- 41. Ibid., pp. 32, 17.

8. Solomon's Coats

- 1. Southern lady overheard by Mary Chesnut. Quoted in White and White, p. 178; Duncan. 2. "Notices."
- 3. Description of Preston in Smith; quoted in Hunt-Hurst, p. 728; Description of Bonna in Booker; Prude, pp. 143, 154.
- 4. If any more reason were needed to take fresh clothing, garments belonging to runaways were often used to put dedicated scent hounds—known, grimly, as "Negro dogs"—on the scent.
- Hunt-Hurst, p. 736; "Advertisement: Dry Goods, Clothing, &c."; "Advertisement for Augusta Clothing Store" White and White, pp. 155-60.
- 6. The great exception to this rule, the published accounts of former slaves themselves, were often prefaced by white friends and patrons of the author assuring the readers that what follows really *was* written by a black man. Despite these protestations, many whites simply refused to believe that black people, especially former slaves, could have authored such accounts. Southern states explicitly prohibited slaves from becoming literate in case they should get similar ideas. Prude, pp. 127–34.

- 7. The eighteenth century was by far the most prolific in terms of the slave trade, but between 1500 and 1800 an estimated eight million people were taken from Africa to the Americas, at first mostly by the Spanish and Portuguese, later by the British, French, Dutch, and Danish. Beckert. *Embire of Cotton* p. 36.
- 8. Thomas, p. 62. Equiano, p. 34. White and White, p. 152.

- 10. Niles' Weekly Register; "Public Sentiment." Women ran away far less frequently than men, likely because they were encouraged to become mothers at an early age and were unwilling either to leave without their children or to submit them to the hardships of living rough and on the run. Hunt-Hurst, p. 734.
- 11. Terrell.
- 12. White and White, p. 159; Prude, pp. 156, 146; Equiano, p. 138.
- 13. Quoted in White and White, p. 181; Smith.
- 14. Hope Franklin and Schweninger, p. 80; Jones.
- 15. Quoted in White and White, p. 161.
- 16. North Carolina Narratives, ed. by The Federal Writers' Project of the Works Progress Administration for the State of North Carolina, Slave Narratives: A Folk History of Slavery in the United States from Interviews with Former Slaves (Washington: Library of Congress, 1941), xi, p. 286.
- 17. White and White, pp. 164, 168; quoted in Prude, p. 143.
- 18. Quoted in White and White, p. 176.
- 19. Boopathi et al., p. 615.
- 20. Moulherat et al.
- 21. Beckert, Empiry of Coulon, p. nill; Romey, Yin.
- 20. Hundhold roller glus have been used in India since at least the fifth century.
- 23. Beckert, Empire of Cotton, np. 15-16
- 24. Quoted in Riello and Parthasaranthi, The Spinning World, p. 221.
- 25. Quoted in Bailey, p. 38.
- 26. Beckert, Empire of Cotton, p. 249.
- 27 It is important to remember, however, that even during the height of the Industrial Revolution, Britain's mechanized production of cloth was small fry on a global scale. Chinese spinners and weavers were producing 420 times as much cotton as their British counterparts were doing in 1800.
- 28. Beckert, "Empire of Cotton," Beckert, Empire of Cotton pp. 65-7, 80.
- 29. Years later, he inadvertently had a hand in the American rebellion: he advised Charles Townshend, the chancellor of the exchequer, to introduce the taxes that so enraged Americans. Thomas, pp. 285-6, 249, 282.
- 30. Tocqueville, p. 306.
- 31. Beckert, Empire of Cotton, pp. 15, 45.
- 32. Hammond.
- 33. He wrote of these relationships in a letter to his son in 1856, advising him that on his death the two women and those of their children who were his should be kept as slaves "in the family," a situation, he believed, that would "be their happiest earthly condition. I cannot free these people and send them North. It would be a cruelty to them." Bleser, pp. 286, 19; Rosellen Brown, "Monster of All He Surveyed," p. 22. Hammond.

- 35. Beckert, Empire of Cotton, pp. 9, 8; quoted in Zinn.
- 36. Berkin et al., I, p. 259. Bailey, p. 35.
- 37. Beckert, Empire of Cotton, pp. 102-3; Bailey, p. 38.

39. Brindell Fradin, pp. 12-14; Slave Life in Georgia: A Narrative of the Life, Sufferings and Escape of John Brown, A Fugitive Slave, New in England, ed. by L. A. Chamerovzow (London: The British and Foreign Anti-Slavery Society, 1855), p. 11.

^{9.} Schwartz, p. 34.

^{34.} Bailey, p. 40.

^{38.} Cloud, p. 11.

- 40. Chamerovzow, pp. 13, 15, 19, 28-30, 171.
- 41. Ibid., p. 129.
- 42. Randall Miller, pp. 471, 473.
- 43. This is the origin of the phrase "Canadian tuxedo," used to describe an outfit entirely made from denim. Branscomb; DeLeon.
- 44. Miller and Woodward, pp. 1, 6; Birkeboek Olesen, p. 70.
- 45. Lynn Downey, A Short History of Denim (Levi Strauss & Co, 2014), pp. 5–7 < http:// www.levistrauss.com/wp-content/uploads/2014/01/A-Short-History-of-Denim2.pdf>; Davis, quoted in Stephanie Hegarty, "How Jeans Conquered the World," BBC News, 28 February 2012, section Magazine < http://www.bbc.co.uk/news/magazine-17101768> [accessed 23 March 2018].
- 46. Downey, pp. 2-4; Weber; Hegarty.
- 47. Quoted in Downey, p. 11.
- 48. Wolfe, p. 37.
- 49. Espen.
- 50. Farchy and Meyer.
- Benns; Walmsley; "Prison Labour Is a Billion-Dollar Industry." Brown Jones. Cotton and the Environment, p. 1; Siegle.

9. Layering in Extremis

- 1. Although the title might sound melodramatic, it was clearly heartfelt: Apsley Cherry-Garrard originally considered calling his memoir of this expedition *To Hell: With Scott*.
- 2. Scott, pp. 375-6.
- 3. James Cook.
- 4. Quoted in Cherry-Garrard, pp. xxxiv-xxxv. Scott, pp. 230, 283, 129, 260.
- 5. Corduroy was a useful fabric for these purposes. Usually made of cotton, it's woven in such a way that the fibers lie in parallel lines, or cords. It's hard-wearing—it was traditionally used for workwear—and warm, because the ridges help trap insulating air. Havenith, (p. 122).

6. "The materials are excellent for our purpose, and I am very grateful for the careful attention you have paid to all details." "McKenzie's Unshrinkable Mittens."

7. "Clothing: Changing Styles and Methods."

- 8. These were also used in British military uniforms. "Gabardine Swine" became pejorative slang during the Second World War for staff officers safely away from the dangers of the front line.
- 9. Havenith, p. 122; "Clothing: Changing Styles and Methods"; Hoyland, pp. 244-5; Rodriguez McRobbie; Parsons and Rose, p. 54.
- 10. They intended to use a combination of motorized sleds, ponies, dogsleds, and man hauling. The motorized sleds broke down almost immediately; the horses fared badly in the cold and had to be shot relatively early, and the dog teams also suffered in the poor conditions and had to be sent back. Appley Cherry-Garrard believed that the dogs would never have made it over the Beardmore Glacier, but the British were also inexperienced at handling them and inexpert skiers, meaning they found it harder to keep up with them.
- 11. Quoted in Alexander, pp. 19-20; "Journey to the South Pole"; Wilson, quoted in "Clothing: Changing Styles and Methods."

- 13. Conrad Anker and David Roberts, "The Same Joys and Sorrows," in Gillman, pp. 206-7.
- 14. Simonson, Hemmleb, and Johnson.
- 15. Odell.
- 16. Ibid., p. 458.
- 17. Sawer.

^{12.} Nuwer.

18. Mark Brown.

- 19. It engulfed Mallory too. He apparently found himself "swimming on his back" through the crushing snow. "Climbing Mount Everest Is Work for Supermen."
- 20. Norton, p. 453.
- 21. Ibid., p. 453.
- 22. Mallory quoted in Gillman, p. 23; Krakauer, pp. 152, 154-5.
- 23. Parsons and Rose, p. 190; Mallory quoted in Gillman, p. 44.
- 24. Notes found on his body, however, suggest that he may have changed his mind and decided to carry a full load. "Climbing Mount Everest Is Work for Supermen"; Gillman, pp. 22, 44-5, 48.
- 25. Hoyland, p. 246; Odell, p. 461.
- 26. Imray and Oakley, p. 218. "Clothing: What Happens When Clothing Fails."
- 27. Mallory quoted in Gillman, p. 23; Larsen.
- 28. Cherry-Garrard, pp. 243 4.
- 29. Hillary, p. 26; quoted in "Clothing: Changing Styles and Methods."
- 30. Scott, p. 259; Cherry-Garrard, p. 301.
- 31. Cherry-Garrard, p. 250.
- 32. Hoyland, p. 245.
- 33. The British explorer Sir Ranulph Fiennes paid over £4,000 for one of the tough-baked Huntley & Palmer biscuits Scott took with him on his expedition. These biscuits had been created specially for the expedition: they were lighter than normal, providing maximum calories for minimal weight. This particular morsel—now rather crumbled—was found by the rescue team that discovered the tent in which Scott had perished. Owen; Havenith, p. 126.
- 31 Imray and Oakley, p. 219.
- 35. Parsons and Rose, pp 187-9,
- 36. Scott, p. 125.
- 37. Ibid., p. 411.
- 38. Douglas. K. S. C.
- 39. Hillary summited in a down suit made by the New Zealand brand Fairydown, and both he and Tenzing Norgay slept in the firm's sleeping bags. While he admitted that at their highest camp—28,000 feet—they were "a bit on the chilly side," they were nevertheless able to survive. Fairydown changed its name in 2003 to Zone, because they found the name had become "too sensitive for overseas markets." Paul Chapman, "Brand Name That Took Hillary to the Top Goes Back in the Closet," Daily Telegraph, 17 September 2003, section World News http://www.telegraph.co.uk/news/worldnews/australiaandthepacific/newzealand/1441788/Brand-name-that-took-Hillary-to-the-top-goes-back-in-the-closet.html> [accessed 11 June 2017].
- 40. Laskow.
- 41. Larsen.
- 42. Owen.
- 43. Parsons and Rose, pp. 257, 178; Hoyland quoted in Ainley.
- 44. Larsen.
- 45. This expedition and the photographs that came from it remain a source of acute distaste and discomfort in mountaineering circles.
- 46. Chapman, "Who Really Was First to Climb Mount Everest?"; Hoyland, p. 244; Alexander, p. 18; Scott, p. 260.

10. Workers in the Factory

1. Humbert, p. 45.

^{2.} Ibid., pp. 46-7.

- 3. Ibid., p. 117.
- 4. Ibid., pp. 116, 150.
- 5. Rayon is now sometimes classed as "semi-synthetic" to distinguish it from oil-based fibers such as nylon and polyester. I've called it a synthetic here.
- 6. Cellophane is made in precisely the same way, only the liquid is forced through a very narrow slit rather than nozzles. The same gloopy cellulose mixture can also be used to make sponges.
- 7. Blanc, p. 42.
- 8. Mendeleev quoted in Blanc, p. 27; "Artificial Silk."
- 9. "Artificial Silk Manufacture."
- 10. Blanc, p. viii, 44, 57-8.
- 11. Lee Blaszczyk, p. 486.
- 12. Spivack, "Paint-on Hosiery during the War Years."
- "Plans Discussed to Convert Silk"; Associated Press, "DuPont Releases Nylon"; Spivack, "Wartime Rationing and Nylon Riots."
- 14. Blanc, p. 123; Morris.
- 15. Polyester, originally marketed as Terylene, was created in Britain in 1946. DuPont bought the patent rights and by 1953 had a plant in South Carolina dedicated to this one fiber. Blanc, p. 167.
- Lee Blaszczyk, pp. 487, 490, 496; "Advertisement: Courtauld's Crape Is Waterproof," Illustrated London News, 20 November 1897, p. 737.
- 17. Lee Blaszczyk, pp. 496, 508-9; Spivack, "Stocking Series, Part 1."
- 18. Morris.
- 19. Lee Blaszczyk, p. 514.
- 20. "New Fibers Spur Textile Selling."
- 21. Modal and Lyocell are both trademarked by Lenzing, an Austrian company. Lyocell (Tencel) is made without using carbon disulphide. Companies often market rayon using cellulose from bamboo as "100% bamboo fabric" or "bamboo silk"; even if this fabric is made using bamboo cellulose, it is still rayon.
- 22. Hamilton, "Industrial Accidents and Hygiene," pp. 176-7.
- 23. Vigliani, p. 235.
- 24. Blanc, pp. xiii, 148, 159.
- 25. Agnès Humbert, p. 122.
- 26. Ibid., p. 141.
- 27. Hamblin.
- 28. Blanc, p. 1.
- 29. Ibid., p. 10.
- 30. Vigliani, p. 235.
- 31. Blanc, pp. 11-12.
- 32. Ibid., pp. ix, 17, 96-7.
- 33. Hamilton, Industrial Poisons in the United States, pp. 368-9.
- 34. Vigliani, p. 237.
- 35. Ibid., p. 235.
- 36. Hamilton, Industrial Poisons in the United States, p. 368.
- 37. Vigliani, p. 235; Hamilton, "Healthy, Wealthy-if Wise-Industry," p. 12.
- 38. Blanc, pp. 48, 50, 182-3, 198, 123.
- 39. One of the vanishingly rare acts of kindness that Agnès experiences from a civilian throughout her time as a forced laborer is when her shirt becomes so threadbare that one of her breasts is exposed. The management refuse to give her another, but she manages to sneak into the office of a woman working in the factory, who gives her a safety pin. Humbert, p. 151.
- 40. Ibid., p. 157.

41. Ibid., pp. 151, 155, 173.

- 43. "Bangladesh Factory Collapse Death Toll Tops 800."
- 44. Ali Manik and Yardley, "Building Collapse in Bangladesh"; Devnath and Srivastava.
- 45. Ali Manik and Yardley, "17 Days in Darkness"; The Editorial Board; Estrin.

- 47. Ali Manik and Yardley, "Building Collapse in Bangladesh"; The Editorial Board; Amy Kazmin, "How Benetton Faced up to the Aftermath of Rana Plaza," the *Financial Times*, 20 April 2015 https://www.ft.com/content/f9d84f0e-e509-11e4-8b61-00144feab7de [accessed 4 October 2017].
- 48. Schlossberg; Lenzing Group; Scott Christian.

- 50. Tatiana Schlossberg. Federal Trade Commission, Four National Retailers Agree to Pay Penalties Totaling \$1.26 Million for Allegedly Falsely Labeling Textiles as Made of Bamboo, While They Actually Were Rayon, 3 January 2013 https://www.ftc.gov/news-events/ press-releases/2013/01/four-national-retailers-agree-pay-penalties-totaling-126-million> [accessed 19 September 2017].
- 51. Lazurus; Changing Markets. Buckley and Piao.

- 53. Bedat and Shank.
- 54. Ma et al.; "Sulphur and Heart Discase", Blanc, p. xii.

11. Under Pressure

1. Nell Armströng apparently meant to say: "That's one small step for a man," which would have made more sense, but later agreed, on listening to the recordings, that the "a" was inaudible. Despite repeated attempts to hunt for the missing "a" in the waveforms of the original audio transmission, it seems that it was never uttered. It is believed that his foot hit lunar soll at 02:56:15 GMT on 21 July 1969, several hours after landing.

- 3 "Apollo 11 Mission Transcript"; according to Buzz Aldrin, the "amplified breathing" you associate with astronauts is a Hollywead invention, Nelson, p. 273.
- 4. The word "astronaut," incidentally, comes from two Ancient Greek words, *ástron*, meaning "star," and *naútes*, "sailor."

5. Collins, p. 100.

6. "What Is a Spacesuit"; Phillips Mackowski, p. 152; Roach, pp. 84, 46, 139; Interview with Bill Dieter, President, Terrazign Inc., Terrazign's Glenn Harness, 2017; Nelson, p. 269; Collins, p. 192.

7 Nelson, p. 76.

- 8. Amanda Young, pp. 75, 115.
- 9. Urine bags are now collectors' items, fetching around \$300 dollars at auction. When they returned to earth Armstrong and Aldrin left four condom-style collection bags behind on the moon, two in size S, two in size L. They are no longer made in size "S": today's condom-style urine bags for male astronauts come in three sizes: L, XL and XXL.

10. Nelson, p. 77; Amanda Young, p. 88.

11. Amanda Young, pp. 92-4, 84; NASA, Lunar Module; quoted in James Hansen, p. 489.

- Monchaux, pp. 16, 18-20; Robeson Moise, "Balloons and Dirigibles," in Brady, pp. 309-10.
- 14. The suit was so tight-fitting that an early incarnation had to be cut off him while he stood in a golf-ball-storage refrigerator at the Goodrich factory, to prevent him from overheating. Monchaux, pp. 57, 61, 64; Amanda Young, p. 14.

^{42.} Ibid., p. 151.

^{46. &}quot;Rana Plaza Collapse."

^{49.} Meyer.

^{52.} Blanc, p. 173.

^{2.} Monchaux, p. 251.

^{12.} Collins, p. 114.

- 15. Phillips Mackowski, pp. 77, 172, 85.
- 16. Monchaux, pp. 82-3, 85-6, 89.
- 17. Phillips Mackowski, p. 170; Monchaux, pp. 94-5.
- 18. Walter Schirra, in Glenn et al., pp. 31, 47-9.
- 19. Amanda Young, p. 22; Walter Schirra, in John Glenn and others, p. 47.
- 20. Cathleen Lewis; Case and Shepherd, p. 14; Amanda Young, pp. 26, 30.
- 21. Noble Wilford.
- 22. Ibid., p. 15; Amanda Young, p. 40.
- 23. Monchaux, pp. 117, 124, 191.
- 24. Ibid., pp. 191-3; Amanda Young, p. 68; Case and Shepherd, pp. 4, 32.
- 25. Amanda Young, p. 75; Monchaux, pp. 209, 211, 219.
- 26. Monchaux, pp. 209, 211.
- 27. The number of layers is disputed. Most sources from the era say twenty-one, so this is the figure I have stuck to here. Amanda Young, however, who wrote a book on the topic for the Smithsonian Air and Space Museum, says the Omega contained twenty-six layers.
- 28. Today, the suits are beginning to degrade and decay, as the chemicals within the layers react with one another. A campaign on Kickstarter has even been launched to revamp the very suit Armstrong wore on mankind's first voyage to the moon. Arena.
- 29. DeGroot, p. 149.
- 30. "What Is a Spacesuit"; Allan Needell, in Amanda Young, p. 9.
- 31. Case and Shepherd, p. 33.
- 32. Collins, pp. 127, 100, 192.
- 33. Ibid., pp. 115-16; Case and Shepherd, p. 16.
- 34. DeGroot, p. 209; Amanda Young, p. 75.
- 35. Aldrin and McConnell, pp. 122-3; Heppenheimer, p. 218; Monchaux, p. 111.
- 36. Walta Schirra, in Glenn et al., pp. 47-8.
- 37. Heppenheimer, p. 222; Kluger; Monchaux, p. 104.
- 38. A.R. Slonim, Effects of Minimal Personal Hygiene and Related Procedures during Prolongued Confinement (Wright-Patterson Air Force Base, Ohio: Aerospace Medical Research Laboratories, October 1966), p. 4.
- 39. Ibid., pp. 6, 10; Borman, Lovell, and NASA, pp. 156-8; "Astronauts' Dirty Laundry."
- 40. NASA, Apollo 16, pp. 372, 435.
- 41. Hadfield, quoted in Roach, p. 46.
- 42. PBS; quoted in Nelson, p. 55.
- 43. Musk, "I Am Elon Musk"; Musk, "Instagram Post"; Brinson.
- 44. Monchaux, pp. 263, 95.
- 45. Grush; Mark Harris; Ross et al., pp. 1-11; Dieter.
- 46. Dieter; Newman; Mark Harris; Feinberg; Masse.
- 47. Howell; Burgess, pp. 209, 220-4.

12. Harder, Better, Faster, Stronger

1. "Swimming World Records in Rome."

- Ibid.; Crouse, "Biedermann Stuns Phelps"; Burn-Murdoch; "Swimming World Records in Rome."
- 3. Quoted in Brennan; Crouse.
- 4. Wilson

5. "Space Age Swimsuit Reduces Drag." Although you might not instantly be able to place it, polyurethane is a very common kind of plastic invented in 1937 and is used in all kinds of familiar products: your kitchen sponge is most likely made of polyurethane, as are spandex or elastane fabrics.

313

- 6. Milorad Cavic of Serbia, who came second, was also wearing an LZR Racer.
- 7. Slater.
- 8. Crouse, "Scrutiny of Suit Rises"; Wilson; Adlington.
- 9. Slater.
- 10. Knitted fabrics—made up of a series of tiny loops—naturally contain a good deal of mechanical stretch, as each of the loops acts like elastic. Woven fabrics, by contrast, lock out at a certain point and won't stretch farther, allowing swimwear designers to create a stiffer surface to help keep the swimmer's body from jouncing around too much. Christopher Clarey, "Vantage Point: New Body Suit Is Swimming Revolution," New York Times, 18 March 2000, section Sports https://www.nytimes.com/2000/03/18/sports/vantage-point-new-body-suit-is-swimming-revolution.html>[accessed 16 December 2017]; Santry.
- 11. Dickerman; Furniss.
- 12. Beisel, quoted in Associated Press, "Is Rio the End of High-Tech Swimsuits?"; Santry; Adlington. A similar opinion was also expressed by Stu Isaac, another former employee at Speedo. Isaac.
- 13. Isaac.
- 14. Quoted in Goldblatt, p. 9.
- 15. Kyle, pp. 82-3; Christesen.
- 16. Oil was rubbed into the skin before and after exercise. Gymnasiums would buy relatively low-grade oil in forty-gallon amphorae, which would then be poured into bronze vats with matching ladles. By some estimates, each man would use around a third of a pint daily. Perrottet, p. 26.
- 17. Ibid., pp. 6-7, 25; Xenophon quoted in Christesen, p. 201; 199-200, 202, 194
- 18. David C. Young, pp. 109-10; Kylo, pp. 82-3, Christesen, pp. 204, 207.
- 19 Theodore Andrea Couk, p. 70.
- 20. Kifner.
- 21. "From the 'lockbra' to Brandi Chastain"; Sandomir; Vecsey; "40 Years of Athletic Support."
- 22. Schofield; "Nike Launches Hijab for Female Muslim Athletes"; Izzidien.
- 23. Koppett.
- 24. Williams; Raszeja.
- 25. Lee, quoted in Camphell; Roberts; Reuell.
- 26. Koppett.
- 27. Noble, pp. 57, 58, 62, 64, 66, 68, 71; Stuart Miller.
- 28. Associated Press, "Roger Bannister's Sub Four-Minute Mile Running Shoes."
- 29. Litsky; "From the Lab to the Track."
- Woolf; "Nike Engineers Knit for Performance"; Howarth; "This Is Nike's First Flyknit Apparel Innovation"; Kipoche, quoted in Caesar.
- 31. Tabuchi; Heitner.
- 32. Heitner; Elizabeth Harris.
- 33. Adlington.
- 34. Wigmore; Tucker.
- 35. "The Mad Science behind Nike's NBA Uniforms"; Garcia; Rhodes.
- 36. As we have seen with sports bras, modesty itself is up for debate. FINA's updated regulations, which came into force in January 2010, stipulated that suits be made from textile fabrics, only extend from knee to navel for men and from shoulder to knee for women, and also specified that designs "shall not offend morality and good taste." Rogan, quoted in Crouse, "Biedermann Stuns Phelps;" Federation International de Natation.
- 37. Tillotson; "Why Do Swimmers Break More Records Than Runners?"
- 38. Ibid.
- 39. Isaac; Steyger.
- 40. Isaac.

13. The Golden Cape

- 1. Kennedy.
- 2. Author interview with Simon Peers, 8 November 2016.
- 3. Mandel
- 4. Hadley Legget.
- 5. Anderson, pp. 1, 3; Clarke; Wilder, Rypstra, and Elgar, p. 31.
- 6. "Golden Orb Weaving Spiders."
- 7. Vollrath quoted in Adams; Hayashi.
- 8. Vollrath and Selden, p. 820; Hayashi.
- 9. Randy Lewis.
- 10. Simon Peers told me that he used to ask people to close their eyes and tell him when they felt him lower a spider-silk tassel onto their outstretched hand. It was so light that they were rarely able to feel it right away.
- 11. Hambling.
- 12. William F. Leggett, p. 7.
- 13. Peers, Golden Spider Silk, p. 6; Werness, p. 285; Ackerman, pp. 3-4.
- 14. Gotthelf; Ledford; Wilder, Rypstra, and Elgar.
- 15. While the story's most famous teller is Ovid, it is believed the tale is far older: a representation of it was found on a small Corinthian jug that dates from around 600 BC.
- 16. In another version of the tale, Arachne tries to hang herself but Athena doesn't want her rival to get away so easily. Taking the inspiration from the dangling rope Arachne has used, the goddess transfigures the girl into a spider dangling from a thread, a warning to others minded to disrespect the gods.
- 17. Quoted in Peers, p. 37.
- 18. Ibid., p. 14.
- 19. Bon, pp. 9-11.
- 20. René-Antoine Ferchault de Récamier quoted in Peers, p. 19.
- 21. Simon Peers suggests in his book that these hangings might not even have been spider silk at all. Contemporary reports said that the hangings were made from around 100,000 m of 24-strand silk, the product of 25,000 spiders. From his work, this would have been impossible: 25,000 spiders could not have produced sufficient silk. Peers, pp. 17, 21, 36, 39.
- 22. Peers, phone interview with author.
- 23. No trace of spiders having been routinely captured and silked in the nineteenth century remained in the cultural memory of the island. Before Simon and Nicholas's projects began, spiders were only ever caught by Madagascan locals to be eaten. They are the principal ingredient in a local delicacy: the legs are removed, the body fried and served with a little rum.
- 24. Peers, p. 44; Hadley Leggett.
- 25. Mandel.
- 26. Why goats? The reason for the odd choice, according to Nexia, lay in the similarity between spider silk glands and the milk-producing ones of goats.
- Hirsch; Kenneth Chang, "Unraveling Silk's Secrets, One Spider Species at a Time," New York Times, 3 April 2001 http://www.nytimes.com/2001/04/03/science/unravelingsilk-s-secrets-one-spider-species-at-a-time.html [accessed 5 February 2017]; Rogers.
- 28. Even if someone could replicate a spider's spinnerets, it would still be insufficient: they produce silk too slowly for an exact mechanical copy to work commercially.
- 29. Dr. Randy Lewis, molecular biologist at the University of Utah.
- 30. Adams.
- Fritz Vollrath, zoology professor, University of Oxford, Skype interview with author, February 2017.
- 32. Vollrath, "The Complexity of Silk," p. 1151.

- 33. Fritz Vollrath, zoology professor, University of Oxford. Vollrath, "Follow-up Queries."
- 34. Ibid. Adams.
- 35. Jamie Bainbridge, VP of product development at Bolt Threads, told me proudly: "There are no spiders in our building."
- Widmaier, "Spider Silk: How We Cracked One of Nature's Toughest Puzzles"; Widmaier, phone call with author.
- 37. Bainbridge.
- 38. Widmaier, phone call with author.
- 39. Bainbridge.
- 40. Peers, phone interview with author.

Golden Threads: A Coda

- The statue of the Lady of Uruk, for example, was clothed in a garment spangled with golden stars and 688 other ornaments. Incredibly, a surviving Neo-Babylonian text records sixty-one golden stars from another divine piece of cloth being sent to a goldsmith for repair.
- 2. Bremmer; Colavito, pp. 187, 207.
- 3. Ruixin et al., p. 42.
- 4. Bayly, p. 62.
- 5. The following contemporary description of some of the members of Francis I's entourage will give some indication of the spectacle. "[O]ther captains, all in cloth of gold, with gold chains about their necks, and accompanied by the arohers with their hocquetons of gold-smiths' work, and horror barded with the same." Brewer; de Morga quoted in Brook, p. 205.

6. "Glass Dresses a 'Fad.' "

1. Eliot Stein; Paradiso.

Bibliography

Ackerman, Susan, "Asherah, the West Semitic Goddess of Spinning and Weaving?," Journal of Near Eastern Studies, 67 (2008), 1-30 https://doi.org/10.1086/586668

Adams, Tim, "Fritz Vollrath: 'Who Wouldn't Want to Work with Spiders?,'" the Observer, 12 January 2013, section Science https://www.theguardian.com/science/2013/jan/

12/fritz-vollrath spiders-tim-adams> [accessed 13 February 2017]

Adlington, Rebecca, interview with author, 2018

"Advertisement: Courtauld's Crape Is Waterproof," *Illustrated London News*, 20 November 1897, p. 737

"Advertisement: Dry Goods, Clothing, &c.," *Daily Morning News* (Savannah, Georgia), 21 September 1853, p. 1

"Advertisement for Augusta Clothing Store," Augusta Chronicle & Georgia Advertiser (Augusta), 26 November 1823, p. 1

Ainley, Janine, "Replica Clothes Pass Everest Test," BBC, 13 June 2006, section Science and Technology http://news.bbc.co.uk/1/hi/sci/tech/5076634.stm> [accessed 16 June 2017]

"A Lady of the Twelfth Dynasty: Suggested by the Exhibition of Egyptian Antiquities in the Metropolitan Museum of Art," the Lana Magualne, 3 (1912), 99-108

Albers, Anni, On Weaving (Princeton: Princeton University Press 1995)

Aldrin, Bunn, and McConnell, Malcolm, Men from Earth (London: Bantam, 1990)

Alexander, Caroline, "The Race to the South Pole," National Geographic, September 2011, 18-21

Ali Manik, Julfikar, and Yardley, Jim, "17 Davs in Darkness, a Cry of 'Dave Me,' and Joy," New York times, 11 May 2013, section Asia Pacific, p. A1

—, "Building Collapse in Bangladesh Kills Scores of Garment Workers," New York Times, 24 April 2013, section Asia Pacific, p. 1

Allon, Niv, "Re: I'm Searching for Senbtes, Can You Help?," 5 June 2017

Anderson, E. Suc, "Captive Breeding and Husbandry of the Golden Orb Weaver Nephila Inaurata Madagascariensis at Woodland Park Zoo," *Terrestrial Invertebrate Taxon* Advisory Group, 2014 http://www.titag.org/2014/2014papers/

GOLDENORBSUEANDERSEN.pdf> [accessed 3 January 2017]

An Individual's Guide to Climatic Injury (Ministry of Defence, 2016)

"A Norse-Viking Ship," the *Newcastle Weekly Courant* (Newcastle-upon-Tyne, 5 December 1891), section News

"Apollo 11—Mission Transcript," Spacelog https://ia800607.us.archive.org/28/items/NasaAudioHighlightReels/AS11_TEC.pdf> [accessed 7 December 2017]

Appleton Standen, Edith, "The Grandeur of Lace," the Metropolitan Museum of Art Bulletin, 16 (1958), 156-62 https://doi.org/10.2307/3257694

Arbiter, Petronius, *The Satyricon*, ed. by David Widger (Project Gutenberg, 2006) ">http://www.gutenberg.org/files/5225/5225-h/stm>">http://www.gutenberg.org/files/5225/5225-h/stm> [accessed 14 August 2017]

Arena, Jenny, "Reboot the Suit: Neil Armstrong's Spacesuit and Kickstarter," National Air and Space Museum, 2015 https://airandspace.si.edu/stories/editorial/armstrongspacesuit-and-kickstarter> [accessed 7 December 2017]

Arnold, Janet (ed.), Queen Elizabeth's Wardrobe Unlock'd: The Inventories of the Wardrobe of Robes Prepared in July 1600, Edited from Stowe MS 557 in the British Library, MS LR 2/121 in the Public Record Office, London, and MS v.6.72 in the Folger Shakespeare Library, Washington DC (London: W. S. Maney and Son, 1989) "Artificial Silk," *The Times*, 7 December 1925, p. 7

"Artificial Silk Manufacture," The Times, 12 September 1910, p. 8

Associated Press, "DuPont Releases Nylon," New York Times, 7 August 1941, section News, p. 6

--, "Is Rio the End of High-Tech Swimsuits?," *Chicago Tribune*, 5 August 2016 < http://www.chicagotribune.com/business/ct-olympics-swimsuits-20160805-story.html> [accessed 17 December 2017]

—, "Roger Bannister's Sub Four-Minute Mile Running Shoes Sell for £266,500," the Guardian, 11 September 2015, section UK news http://www.theguardian.com/ uk-news/2015/sep/11/roger-bannisters-sub-four-minute-mile-running-shoes-sell-for-266500> [accessed 6 January 2018]

"Astronauts' Dirty Laundry," NASA https://www.nasa.gov/vision/space/livinginspace/Astronaut_Laundry.html [accessed 12 December 2017]

- Bailey, Ronald, "The Other Side of Slavery: Black Labor, Cotton, and Textile Industrialization in Great Britain and the United States," *Agricultural History*, 68 (1994), 35–50
- Bainbridge, Jamie, VP of Product Development at Bolt Threads, Skype interview with author, October 2016
- Bajaj, Vikas, "Fatal Fire in Bangladesh Highlights the Dangers Facing Garment Workers," New York Times, 25 November 2012, section Asia Pacific, p. A4
- Balter, Michael, "Clothes Make the (Hu) Man," Science, 325 (2009), 1329
- "Bangladesh Factory Collapse Death Toll Tops 800," the *Guardian*, 8 May 2013, section World news http://www.theguardian.com/world/2013/may/08/bangladesh-factory-collapse-death-toll> [accessed 4 October 2017]

Bar-Yosef, Ofer, Belfer-Cohen, Anna, Mesheviliani, Tengiz, et al., "Dzudzuana: An Upper Palaeolithic Cave Site in the Caucasus Foothills (Georgia)," *Antiquity*, 85 (2011), 331–49

Bard, Kathryn A. (ed.), Encyclopedia of the Archaeology of Ancient Egypt (London: Routledge, 2005) https://archive.org/stream/EncyclopediaOfTheArchaeologyOf AncientEgypt/EncyclopediaOfTheArchaeologyOfAncientEgypt_djvu.txt

- Barras, Colin, "World's Oldest String Found at French Neanderthal Site," New Scientist, 16 November 2013 https://www.newscientist.com/article/ mg22029432-800-worlds-oldest-string-found-at-french-neanderthal-site/ [accessed 15 March 2018]
- Bayly, C. A., "The Origins of Swadeshi (Home Industry)," in *Material Culture: Critical Concepts in the Social Sciences* (London: Routledge, 2004), II, 56–88
- Beckert, Sven, "Empire of Cotton," *The Atlantic*, 12 December 2014 https://www.theat-lantic.com/business/archive/2014/12/empire-of-cotton/383660/

-, Empire of Cotton: A Global History (New York: Vintage Books, 2014)

- Bedat, Maxine, and Shank, Michael, "There Is a Major Climate Issue Hiding in Your Closet: Fast Fashion," *Fast Company*, 2016 https://www.fastcompany.com/3065532 /there-is-a-major-climate-issue-hiding-in-your-closet-fast-fashion> [accessed 5 October 2017]
- Bender Jørgensen, Lise, "The Introduction of Sails to Scandinavia: Raw Materials, Labour and Land," in N-TAG TEN: Proceedings of the 10th Nordic TAG Conference at Stiklestad, Norway, 2009 (Oxford: Archaeopress, 2012), pp. 173-81

Benns, Whitney, "American Slavery, Reinvented," *The Atlantic*, 21 September 2015 https://www.theatlantic.com/business/archive/2015/09/prison-labor-in-america/406177/

Berkin, Carol, Miller, Christopher, Cherny, Robert and Gormly, James, *Making America: A History of the United States*, 5th edn (Boston: Houghton Mifflin, 2008), I

- Bilefsky, Dan, "ISIS Destroys Part of Roman Theater in Palmyra, Syria," New York Times, 20 January 2017, section Middle East, p. 6
- Birkeboek Olesen, Bodil, "How Blue Jeans Went Green: The Materiality of an American Icon," in *Global Denim*, ed. by Daniel Miller and Sophie Woodward (Oxford: Berg, 2011), pp. 69–85
- Blanc, Paul David, Fake Silk: The Lethal History of Viscose Rayon (New Haven: Yale University Press, 2016)
- Blanchard, Lara C. W., "Huizong's New Clothes," Ars Orientalis, 36 (2009), 111-35
- Bleser, Carol (ed.), Secret and Sacred: The Diaries of James Henry Hammond, A Southern Slaveholder (New York: Oxford University Press, 1988)
- Bon, Monsieur, "A Discourse upon the Usefulness of the Silk of Spiders," *Philosophical Transactions*, 27 (1710), 2–16
- Booker, Richard, "Notices," Virginia Gazette (Virginia, 24 December 1772), p. 3
- Boopathi, N. Manikanda, Sathish, Selvam, Kavitha, Ponnaikoundar, et al., "Molecular Breeding for Genetic Improvement of Cotton (Gossypium Spp.)," in Advances in Plant Breeding Strategies: Breeding, Biotechnology and Molecular Tools (New York: Springer, 2016), pp. 613–45
- Borman, Frank, Lovell, James, and NASA, Gemini VII: Air-to-Ground, Ground-to-Air and On-Board Transcript, Vol. I (NASA, 1965) https://www.jsc.nasa.gov/history/ mission_trans/GT07_061.PDF>
- Brady, Tim (ed.), The American Aviation Experience: A History (Carbondale: Southern Illinois University Press, 2000)
- Branscomb, Mary, "Silver State Stampede Revived 15 Years Ago," Elko Daily Free Press (Elko, Nevada, 9 July 2002) http://elkodaily.com/silver-state-stampede-rovived years ago/article_ca661754-83ec-5751-93a0-ba285f4fe193.html> [accessed 3 April 2018]
- Bremmer, Jan, "The Myth of the Golden Fleece," Journal of Ancient Near Eastern Religions, 2007, 9–38
- Brennan, Christine, "Super Outfits Show Fairness Is Not Swimming's Strong Suit," USA Ioday, 29 July 2009, section Sports https://usatoday30.usatoday.com/sports/ columnist/brennan/2009-0/-29-swimming-suits N.htm> [accessed 4 January 2018]
- Brower, J.S. (ed.), Letters and Papers, Foreign and Domestic, Henry VIII (Her Majesty's Stationery Office, 1867), III http://www.british-history.ac.uk/letters-papers-hen8/vol3/pp299-319 [accessed 17 April 2018]
- Brindell Fradin, Dennis, Bound for the North Star: True Stories of Fugitive Slaves (New York: Clarion Books, 2000)
- Brinson, Ryan, "Jose Fernandez: The Man Sculpting and Shaping the Most Iconic Characters in Film," *Bleep Magasine*, 2016 [accessed 12 December 2017]
- Brook, Timothy, The Confusions of Pleasure: Commerce and Culture in Ming China (Berkeley: University of California, 1999)
- Brown Jones, Bonny, "How Much Cotton Does It Take to Make a Shirt?," *Livestrong*, 2017 https://www.livestrong.com/article/1006170-much-cotton-make-shirt/> [accessed 27 November 2017]
- Brown, Mark, "George Mallory and Everest: Did He Get to the Top? Film Revisits 1920s Climb," the *Guardian*, 27 August 2010, section World news https://www.theguardian.com/world/2010/aug/27/george-mallory-everest-new-film
- Brown, Rosellen, "Monster of All He Surveyed," New York Times, 29 January 1989, p. 22 Buckley, Chris, and Piao, Vanessa, "Rural Water, Not City Smog, May Be China's
- Pollution Nightmare," New York Times, 12 April 2016, section Asia Pacific, p. A4
- Burgess, Colin (ed.), Footprints in the Dust: The Epic Voyages of Apollo, 1969–1975 (Lincoln: University of Nebraska Press, 2010)

- Burn-Murdoch, John, "Rio Olympics 2016: Is Michael Phelps the Most Successful Olympian?," the *Financial Times*, 8 August 2016 https://www.ft.com/content/8ac4e7c2-5d7f-11e6-bb77-a121aa8abd95 [accessed 4 January 2018]
- Caesar, Ed, "Nike's Controversial New Shoes Made Me Run Faster," Wired, 2017 https://www.wired.com/2017/03/nikes-controversial-new-shoes-made-run-faster/ [accessed 10 January 2018]
- Campbell, Jule, "Light, Tight and Right for Racing," Sports Illustrated, 12 August 1974 http://www.si.com/vault/1974/08/12/616563/light-tight-and-right-for-racing [accessed 7 January 2018]
- Carey, Juliet, "A Radical New Look at the Greatest of Elizabethan Artists," Apollo, June 2017, pp. 29–30
- Carter, Robert A., "Boat Remains and Maritime Trade in the Persian Gulf During Sixth and Fifth Millennia BC," *Antiquity*, 80 (2006), 52–63
- Carter, Howard, and Mace, Arthur C., "Excavation Journals and Diaries" http://www.griffith.ox.ac.uk/discoveringTut/journals-and-diaries/season-4/journal.html [accessed 30 May 2017]
 - -----, The Tomb of Tut-Ankh-Amen: Discovered by the Late Earl of Carnarvon and Howard Carter, 3 vols (London: Cassell & Co., 1923), I
 - ------, The Tomb of Tut-Ankh-Amen: Discovered by the Late Earl of Carnarvon and Howard Carter, 3 vols (London: Cassell & Co., 1927), II
- Case, Mel, Senior Design Engineer ILC Industries, and Shepherd, Leonard, Vice President of Engineering, ILC Industries, NASA Oral History Project, 1972
- Chapman, Paul, "Brand Name That Took Hillary to the Top Goes Back in the Closet," the Daily Telegraph, 17 September 2003, section World News http://www.telegraph.co.uk/ news/worldnews/australiaandthepacific/newzealand/1441788/Brand-name-that-took-Hillary-to-the-top-goes-back-in-the-closet.html [accessed 11 June 2017]
 - —, "Who Really Was First to Climb Mount Everest?," the Daily Telegraph, 19 May 2010, section World News http://www.telegraph.co.uk/news/worldnews/australiaandthepacific/australia/7735660/Who-really-was-first-to-climb-Mount-Everest. html> [accessed 11 June 2017]
- Ch'ien, Ssu-Ma, *Records of the Grand Historian of China*, trans. by Burton Watson, 2nd edn (New York: Columbia University Press, 1962)
- Chamerovzow, L. A. (ed.), Slave Life in Georgia: A Narrative of the Life, Sufferings and Escape of John Brown, A Fugitive Slave, Now in England (London: The British and Foreign Anti-Slavery Society, 1855)
- Chang, Kenneth, "Unraveling Silk's Secrets, One Spider Species at a Time," New York Times, 3 April 2001 < http://www.nytimes.com/2001/04/03/science/unraveling-silks-secrets-one-spider-species-at-a-time.html> [accessed 5 February 2017]
- Changing Markets, Dirty Fashion: How Pollution in the Global Textiles Supply Chain Is Making Viscose Toxic (Changing Markets, June 2017)
- Cherry, John F., and Leppard, Thomas P., "Experimental Archaeology and the Earliest Seagoing: The Limitations of Inference," World Archaeology, 47 (2015), 740–55
- Cherry-Garrard, Apsley, *The Worst Journey in the World*, Vintage Classics, 4th edn (London: Vintage Books, 2010)
- Choi, Charles Q., "The Real Reason for Viking Raids: Shortage of Eligible Women?," Live Science, 2016 https://www.livescience.com/56786-vikings-raided-to-find-love. html>[accessed 18 October 2017]
- Christesen, P., "Athletics and Social Order in Sparta in the Classical Period," Classical Antiquity, 31 (2012), 193-255 https://doi.org/10.1525/ca.2012.31.2.193
- Christian, David, "Silk Roads or Steppe Roads? The Silk Roads in World History," Journal of World History, 11 (2000), 1-26
- Christian, Scott, "Fast Fashion Is Absolutely Destroying the Planet," Esquire, 14 November

2016 <http://www.esquire.com/style/news/a50655/fast-fashion-environment/> [accessed 5 October 2017]

- "Cistercians in the British Isles," *Catholic Encyclopedia* http://www.newadvent.org/cathen/16025b.htm> [accessed 19 May 2017]
- Clarey, Christopher, "Vantage Point: New Body Suit Is Swimming Revolution," New York Times, 18 March 2000, section Sports <https://www.nytimes.com/2000/03/18/sports /vantage-point-new-body-suit-is-swimming-revolution.html> [accessed 16 December 2017]
- Clark, Charlotte R., "Egyptian Weaving in 2000 BC," *The Metropolitan Museum of Art* Bulletin, 3 (1944), 24–9 https://doi.org/10.2307/3257238
- Clarke, Dave, interview at London Zoo, 2017
- "Climbing Mount Everest Is Work for Supermen," New York Times, 18 March 1923, p. 151
- "Clothing: Changing Styles and Methods," Freeze Frame: Historic Polar Images http://www.freezeframe.ac.uk/resources/elothing/10 [accessed 11 June 2017]
- "Clothing: What Happens When Clothing Fails," *Freeze Frame: Historic Polar Images* ">http://www.freezeframe.ac.uk/resources/clothing/3> [accessed 11 June 2017]

Cloud, N. B. (ed.), "A Memoir," The American Cotton Planter: A Monthly Journal Devoted to Improved Plantation Economy, Manufactures, and the Mechanic Arts, 1 (1853)

Colavito, Jason and the Argonauts through the Ages (Jefferson: McFarland & Co., 2014)

Collins, Michael, Carrying the Fire: An Astronaut's Journeys (London. W. H. Allen, 1975)

Cook, James, A Voyage towards the South Pole and Round the World (Project Gutenberg, 2005), i http://www.gutenberg.org/cache/epub/15777/pg15777-images.html [accessed 21 June 2017]

- Cook, Theodore Andrea, 1 he bourth Olympiad. Being the Official Report of the Olympic Games of 1908 Celebrated in London under the Patronago of His Moss Onuclous Mugesty Aing Edward VII and by the Sanction of the International Olympic Committee (London: The British Olympic Association, 1908)
- Cooke, Bill, Cluisdansen, Carol, and Hammarlund, Lena, "Viking Woollen Square-Saile and Pabric Gover Factor," *The International Journal of Nautical Archaeology*, 31 (2002), 202-10
- Correspondent, A., "Touring in Norway," *The Times* (London, 30 September 1882), section News, p. 4

Cotton and the Environment (Organic Trade Association, April 2017)

Crouse, Karen, "Biedermann Stuns Phelps amid Debate over Swimsuits," New York Times, 29 July 2009, p. B9

——, "Scrutiny of Suit Rises as World Records Fall," New York Times, 11 April 2008, section Sports, p. D2

- DeGroot, Gerard, Dark Side of the Moon: The Magnificent Madness of the American Lunar Quest (London: Jonathan Cape, 2007)
- DeLeon, Jian, "Levi's Vintage Clothing Brings Back the Original 'Canadian Tudo,' " GQ, 18 October 2013 < https://www.gq.com/story/levis-vintage-clothing-bingcrosby-denim-tuxedo> [accessed 3 April 2018]
- Devnath, Arun, and Srivastava, Mehul, "'Suddenly the Floor Wasn't There,' Factory Survivor Says," *Bloomberg.com*, 25 April 2013 https://www.bloomberg.com/news/articles/2013-04-25/-suddenly-the-floor-wasn-t-there-factory-survivor-says [accessed 4 October 2017]
- Dickerman, Sara, "Full Speedo Ahead," *Slate*, 6 August 2008 http://www.slate.com/articles/sports/fivering_circus/2008/08/full_speedo_ahead.html

Dieter, Bill, President, Terrazign Inc., Terrazign's Glenn Harness, 2017

Donkin, R. A., "Cistercian Sheep-Farming and Wool-Sales in the Thirteenth Century," The Agricultural History Review, 6 (1958), 2–8 Dougherty, Conor, "Google Wants to Turn Your Clothes into a Computer," New York Times, 1 June 2015, section Business, p. B4

- Douglas, Ed, "What Is the Real Cost of Climbing Everest?," *BBC Guides* ">http://www.bbc.co.uk/guides/z2phn39> [accessed 27 June 2017]
- Douglass, Frederick, Narrative of the Life of Frederick Douglass (Oxford: Oxford University Press, 1999)
- Downey, Lynn, A Short History of Denim (Levi Strauss & Co., 2014) http://www.levis-trauss.com/wp-content/uploads/2014/01/A-Short-History-of-Denim2.pdf>
- Duncan, John, "Notices," Southern Banner (Athens, Georgia, 7 August 1851), p. 3
- Dusenbury, Mary M. (ed.), Color in Ancient and Medieval East Asia (Yale: Spencer Museum of Art, 2015)
- Dwyer, Jim, "From Looms Came Computers, Which Led to Looms That Save Fashion Week," New York Times, 5 September 2014, p. A19
- Eamer, Claire, "No Wool, No Vikings," Hakai Magazine, 23 February 2016 < https://hakaimagazine.com/features/no-wool-no-vikings>
- "Earliest Silk, The," *New York Times*, 15 March 1983, section Science http://www.nytimes.com/1983/03/15/science/l-the-earliest-silk-032573.html [accessed 21 August 2017]
- Eaton-Krauss, Marianne, "Embalming Caches," The Journal of Egyptian Archaeology, 94 (2008), 288–93
- Editorial Board, "One Year after Rana Plaza," New York Times, 28 April 2014, section Opinion, p. 20
- Equiano, Olaudah, *The Interesting Narrative and Other Writings*, 2nd edn (London: Penguin Classics, 2003)
- Espen, Hal, "Levi's Blues," New York Times, 21 March 1999, section Magazine https://www.nytimes.com/1999/03/21/magazine/levi-s-blues.html> [accessed 29 March 2018]
- Estrin, James, "Rebuilding Lives after a Factory Collapse in Bangladesh," Lens Blog, New York Times, 2015 https://lens.blogs.nytimes.com/2015/04/23/rebuilding-lives-aftera-factory-collapse-in-bangladesh/ [accessed 22 September 2017]
- Farchy, Jack, and Meyer, Gregory, "Cotton Prices Surge to Record High amid Global Shortages," the *Financial Times*, 11 February 2011 https://www.ft.com/content/3d876e64-35c9-11e0-b67c-00144feabdc0 [accessed 27 November 2017]
- Federal Trade Commission, Four National Retailers Agree to Pay Penalties Totaling \$1.26 Million for Allegedly Falsely Labeling Textiles as Made of Bamboo, While They Actually Were Rayon, 3 January 2013 < https://www.ftc.gov/news-events/press-releases/2013/ 01/four-national-retailers-agree-pay-penalties-totaling-126-million> [accessed 19 September 2017]
- Federal Writers' Project of the Works Progress Administration for the State of North Carolina, ed., North Carolina Narratives, Slave Narratives: A Folk History of Slavery in the United States from Interviews with Former Slaves (Washington: Library of Congress, 1941), XI
- Federation International de Natation, *FINA Requirements for Swimwear Approval (FRSA)* (Federation International de Natation, 5 August 2016), p. 26
- Feinberg, David, "The Unlikely Pair of Brooklyn Designers Who Are Building a Better Space Suit—Motherboard," *Motherboard*, 2013 https://motherboard.vice.com/en_us/article/9aajyz/spaced-out-space-suit-makers-video [accessed 7 December 2017] Feltwell, John, *The Story of Silk* (Stroud: Alan Sutton, 1990)
- "40 Years of Athletic Support: Happy Anniversary to the Sports Bra," NPR (NPR, 2017) ">https://www.npr.org/sections/health-shots/2017/09/29/554476966/40-years-of-athletic-support-happy-anniversary-to-the-sports-bra>">https://www.npr.org/sections/health-shots/2017/09/29/554476966/40-years-of-athletic-support-happy-anniversary-to-the-sports-bra>">https://www.npr.org/sections/health-shots/2017/09/29/554476966/40-years-of-athletic-support-happy-anniversary-to-the-sports-bra>">https://www.npr.org/sections/health-shots/2017/09/29/554476966/40-years-of-athletic-support-happy-anniversary-to-the-sports-bra>">https://www.npr.org/sections/health-shots/2017/09/29/554476966/40-years-of-athletic-support-happy-anniversary-to-the-sports-bra>">https://www.npr.org/sections/health-shots/2017/09/29/554476966/40-years-of-athletic-support-happy-anniversary-to-the-sports-bra>">https://www.npr.org/sections/health-shots/2017/09/29/554476966/40-years-of-athletic-support-happy-anniversary-to-the-sports-bra>">https://www.npr.org/sections/health-shots/2017/09/29/554476966/40-years-of-athletic-support-happy-anniversary-to-the-sports-bra>">https://www.npr.org/sections/health-shots/2017/09/29/554476966/40-years-of-athletic-support-happy-anniversary-to-the-sports-bra>">https://www.npr.org/sections/health-shots/2017/09/29/55447696/40-years-of-athletic-support-happy-anniversary-to-the-sports-bra>">https://www.npr.org/sections/health-shots/2017/09/29/55447696/40-years-of-athletic-support-happy-anniversary-to-the-sports-bra>">https://www.npr.org/sections/health-shots/2017/09/29/55447696/40-years-of-athletic-support-happy-anniversary-to-the-sports-bra>">https://www.npr.org/sections/health-shots/2017/09/29/55447696/40-years-of-athletic-support-happy-athletic-support-happy-athletic-support-happy-athletic-support-happy-athletic-support-happy-athletic-support-happy-athletic-support-happy-athletic-support-happy-athl
- Fowler, Susanne, "Into the Stone Age with a Scalpel: A Dig With Clues on Early Urban Life," New York Times, 8 September 2011, section Europe https://www.nytimes.com

/2011/09/08/world/europe/08iht-M08C-TURKEY-DIG.html> [accessed 16 March 2018]

Franits, Wayne, Dutch Seventeenth-Century Genre Painting: Its Stylistic and Thematic Evolution (New Haven: Yale University Press, 2004)

Frankopan, Peter, The Silk Roads: A New History of the World (London: Bloomsbury, 2015)

Freud, Sigmund, New Introductory Lectures on Psychoanalysis (New York: W. W. Norton, 1965)

"From the 'Jockbra' to Brandi Chastain: The History of the Sports Bra" (WBUR, 2017) http://www.wbur.org/onlyagame/2017/02/24/sports-bra-lisa-lindahl [accessed 8 January 2018]

"From the Lab to the Track," *Forbes*, 13 May 2004 https://www.forbes.com/2004/05/13/cz_tk_runningslide.html

Fryde, E. B., Studies in Medieval Trade and Finance (London: Hambledon Press, 1983)

Furniss, Steve, Co-Founder and Executive Vice President of Tyr, interview with author, Boxing Day 2017

Garcia, Ahiza, "Fast Break: Nike's New NBA Jerseys Keep Ripping Apart," CNNMoncy, 2017 http://money.cun.com/2017/11/07/news/companies/nike-nba-jerseys-falling-apart/index.html [accessed 11 January 2018]

Gilligan, Ian, "The Prehistoric Development of Clothing: Archaeological Implications of a Thermal Model," Journal of Archaeological Method and Theory, 17 (2010), 15–80

Gillingham, John, Richard I (London: Yale University Press, 2002)

Gillman, Peter (ed.), Everest: Eighty Years of Triumph and Tragedy, 2nd edn (London: Little, Brown, 2001)

"Glass Dresses a 'Fad," New York Times, 29 July 1803, pootion News, p. 2

Glonn, John, Oarpenter, Scott, Shepard, Alan, et al, Into Orbit, by the Seven Astronauts of Project Maxim y (London: Cassell & Co., 1962)

Goldblatt, David, *The Games: A Global History of the Olympics* (London: Macmillan, 2016) "Golden Orb Weaving Spiders, Nephila Sp.," The Australian Museum, 2005 http://

australianmuscum.net.au/golden-orb-wcaving-spiders> [accessed 3 January 2017] Gong, Yuxan, Li, Li, Gong, Decar, et al., "Biomolecular Evidence of Silk from 8,500 Years Ago," PLOS ONE, 11 (2016), 1-9

Good, Irone, "On the Question of Silk in Pre-Han Eurosia," Antiquity, 69 (1995), 959–68 https://doi.org/10.1017/S0003598X00082491

Gotthelf, Jeremias, *The Black Spider*, trans. by S. Bernofsky (New York: New York Review Books, 2013)

Granville, A. B., "An Essay on Egyptian Mummies; With Observations on the Art of Embalming among the Ancient Egyptians," *Philosophical Transactions of the Royal* Society of London, 115 (1825), 269-316

Grush, Loren, "These Next-Generation Space Suits Could Allow Astronauts to Explore Mars," *The Verge*, 2017 https://www.theverge.com/2017/8/15/16145260/nasa-spacesuit-design-mars-moon-astronaut-space-craft

Halime, Farah, "Revolution Brings Hard Times for Egypt's Treasures," New York Times, 31 October 2012, section Middle East https://www.nytimes.com/2012/11/01/world/middleeast/revolution-brings-hard-times-for-egypts-treasures.html [accessed 7 June 2017]

Hamblin, James, "The Buried Story of Male Hysteria," *The Atlantic*, 29 December 2016 https://www.theatlantic.com/health/archive/2016/12/testicular-hysteria/511793/

Hambling, David, "Consult Your Webmaster," the Guardian, 30 November 2000, section Science ">https://www.theguardian.com/science/2000/nov/30/technology">https://www.theguardian.com/science/2000/nov/30/technology

Hamilton, Alice, "Healthy, Wealthy—if Wise—Industry," The American Scholar, 7 (1938), 12–23

323

, "Industrial Accidents and Hygiene," Monthly Labor Review, 9 (1919), 170-86

, Industrial Poisons in the United States, (New York: The Macmillan Company, 1929)

ment/cotton-is-king/> [accessed 25 November 2017]

Handley, Susannah, "The Globalization of Fabric," New York Times, 29 February 2008, section Fashion and Style

Hansen, James R., First Man: The Life of Neil A. Armstrong (New York: Simon & Schuster, 2012)

Hansen, Valerie, The Silk Road: A New History (Oxford: Oxford University Press, 2012) , "The Tribute Trade with Khotan in Light of Materials Found at the Dunhuang Library Cave," Bulletin of the Asia Institute, 19 (2005), 37–46

Harris, Elizabeth, "Tech Meets Textiles," New York Times, 29 July 2014, section Business, p. B1

Harris, Mark, "In Pursuit of the Perfect Spacesuit," Air & Space, September 2017 < https:// www.airspacemag.com/space/space-wear-180964337/>

Harris, Richard, "These Vintage Threads Are 30,000 Years Old," NPR.org http://www.npr.org/templates/story/story.php?storyId=112726804> [accessed 17 March 2017]

- Harrison, R. G., and Abdalla, A. B., "The Remains of Tutankhamun," Antiquity, 46 (1972), 8-14
- Hastie, Paul, "Silk Road Secrets: The Buddhist Art of the Magao Caves," BBC, 23 October 2013, section Arts and Culture http://www.bbc.co.uk/arts/0/24624407 [accessed 4 August 2017]
- Havenith, George, "Benchmarking Functionality of Historical Cold Weather Clothing: Robert F. Scott, Roald Amundsen, George Mallory," *Journal of Fiber Bioengineering* and Informatics, 3 (2010), 121–29

Hayashi, Cheryl, The Magnificence of Spider Silk, Ted Talk, 2010 https://www.ted.com/talks/cheryl_hayashi_the_magnificence_of_spider_silk [accessed 6 December 2016]

Hegarty, Stephanie, "How Jeans Conquered the World," BBC News, 28 February 2012, section Magazine http://www.bbc.co.uk/news/magazine-17101768 [accessed 23 March 2018]

Heitner, Darren, "Sports Industry to Reach \$73.5 Billion by 2019," Forbes, 19 October 2015 https://www.forbes.com/sites/darrenheitner/2015/10/19/sports-industry-toreach-73-5-billion-by-2019/ [accessed 13 January 2018]

Helbaek, Hans, "Textiles from Catal Huyuk," Archaeology, 16 (1963), 39-46

Herodotus, The History of Herodotus, trans. by G. C. Macaulay, 4 vols (Project Gutenberg, 2006), II https://www.gutenberg.org/files/2131/2131-h/2131-h.htm [accessed 4 June 2017]

—, The History of Herodotus, trans. by G. C. Macaulay, 4 vols (Project Gutenberg, 2008), 1 https://www.gutenberg.org/files/2707/2707-h/2707-h. htm#link22H 4_0001> [accessed 25 May 2017]

Heyerdahl, Thor, Kon-Tiki: Across the Pacific by Raft, trans. by F. H. Lyon, 2nd edn (New York: Pocket Books, 1984)

Hillary, Edmund, The View from the Summit, 2nd edn (London: Corgi Books, 2000)

Hinton, David (ed.), Classical Chinese Poetry: An Anthology (New York: Farrar, Straus and Giroux, 2008)

—, "Su Hui's Star Gauge," Ocean of Poetry, 2012 < http://poetrychina.net/wp/wellingmagazine/suhui> [accessed 18 August 2017]

Hirsch, Jesse, "The Silky, Milky, Totally Strange Saga of the Spider Goat," Modern Farmer, 2013 http://modernfarmer.com/2013/09/saga-spidergoat/>

Heppenheimer, T. A., Countdown: A History of Space Flight (New York: John Wiley & Sons, 1997)

- Hirst, K. Kris, "A Glimpse of Upper Paleolithic Life in the Republic of Georgia," *ThoughtCo* https://www.thoughtco.com/dzudzuana-cave-early-upper-paleolithic-cave-170735 [accessed 16 March 2017]
- Hobsbawm, Eric, Industry and Empire: From 1750 to the Present Day (New York: The New Press, 1999)
- Hogan, Lauren, "The Gokstad Ship," National Maritime Museum Cornwall, 2016 https://nmmc.co.uk/object/boats/the-gokstad-ship/ [accessed 27 October 2017]

- Homer, The Odyssey, trans. by Martin Hammond (London: Bloomsbury, 2000)
- Hope Franklin, John, and Schweninger, Loren, Runaway Slaves: Rebels on the Plantation (Oxford: Oxford University Press, 1999)
- Howarth, Dan, "Nike Launches Lightweight Flyknit Sports Bra," Deseen, 2017 <a href="https://www.dezeen.com/2017/07/12/nike-fenom-flyknit-lightweight-sports-bra-design/spor
- Howell, Elizabeth, "Spacesuit Undergoes Zero-G Testing Above Canada to Prepare for Commercial Flights," Space.com, 2017 https://www.space.com/38832-spacesuit-zero-g-testing-canadian-flight.html> [accessed 7 December 2017]
- Hoyland, Graham, "Testing Mallory's Clothes on Everest," The Alpine Journal, 2007, 243–6
- Humbert, Agnès, Résistance: Memoirs of Occupied France, trans, by Barbara Mellor, 3rd edn (London: Bloomsbury, 2004)
- Hunt-Hurst, Patricia, "'Round Homespun Coat & Pantaloons of the Same": Slave Clothing as Reflected in Fugitive Slave Advertisements in Antebellum Georgia," The Georgia Historical Quarterly, 83 (1999), 727–10
- Hurst, Derek, Sheep in the Cotswolds: The Medieval Wool Trade (Strond. Tompus, 2005)
- Hussiin, Thailk, "wny Did Vikings Have 'Allah' on Clothes?," BBC News, 12 October 2017, section Europe http://www.bbc.co.uk/news/world-europe-41567391 [accessed 29 October 2017]
- Imray, Chris, and Oakley, Howard, "Cold Still Kills: Cold-Related Illnesses in Military Practice Freezing and Non-Freezing Cold Injury," JR Army Med Corps, 152 (2006), 218–22
- Isaac, Stu, Founder of The Isaac Sports Group, Former Speedo Employee, telephone interviews with author, Midwinter's Eve 2016, 2017
- Izzidien, Ruqaya, "The Nike Pro Hijab: A Tried and Tested Review," The New Arab https://www.alaraby.co.uk/english/blog/2018/1/5/the-nike-pro-hijab-a-tried-and-tested-review [accessed 14 April 2018]
- Jesch, Judith, Ships and Men in the Late Viking Age: The Vocabulary of Runic Inscriptions and Skaldic Verse (Woodbridge; Boydell, 2001)

- Jones, Gabriel, "Notice," Virginia Gasette (Virginia, 30 June 1774), p. 3
- Jourdain, M., "Lace as Worn in England Until the Accession of James I," The Burlington Magazine, 10 (1906), 162-8
- "Journey to the South Pole," *Scott's Last Expedition* http://www.scottslastexpedition.org/expedition/journey%2Dto%2Dthe%2Dsouth%2Dpole/ [accessed 11 June 2017]
- Jowitt Whitwell, Robert, "English Monasteries and the Wool Trade in the 13th Century. I," Vierteljahrschrift Für Sosial- Und Wirtschaftsgeschichte, 2 (1904), 1-33
- K. S. C., "The Price the Sherpas Pay for Westerners to Climb Everest," *The Economist*, 2015 http://www.economist.com/blogs/prospero/2015/12/new-film-sherpas [accessed 27 June 2017]
- Kautilya, *The Arthashastra*, ed. by L. N. Rangarajan (New Delhi: Penguin, 1992) Keith, Kathryn, "Spindle Whorls, Gender, and Ethnicity at Late Chalcolithic Hacinebi

Holman, Helen, "Viking Woollen Sails," 2 November 2017

Johnstone, Paul, The Sea Craft of Pre-History (London: Routledge, 1980)

Tepe," Journal of Field Archaeology, 25 (1998), 497-515 https://doi.org/10.2307/530641

- Kelly, F. M., "Shakespearian Dress Notes II: Ruffs and Cuffs," *The Burlington Magazine*, 29 (1916), 245–50
- Kemp, Barry J., and Vogelsang-Eastwood, Gillian, The Ancient Textile Industry at Amarna (London: The Egypt Exploration Society, 2001)

Kennedy, Randy, "At the American Museum of Natural History, Gossamer Silk from Spiders," New York Times, 22 September 2009 http://www.nytimes.com/2009/09/ 23/arts/design/23spiders.html> [accessed 3 January 2017]

- Kessler, Mike, "Insane in the Membrane," *Outside Magasine*, April 2012 ">https://www.outsideonline.com/1898541/insane>
- Kifner, John, "Thump . . . Thump . . . Gasp . . . Sound of Joggers Increases in the Land," New York Times, 10 June 1975, p. 24
- Kittler, Ralf, Kayser, Manfred, and Stoneking, Mark, "Molecular Evolution of Pediculus Humanus and the Origin of Clothing," *Current Biology*, 13, 1414–17
 https://doi.org/ 10.1016/S0960-9822(03)00507-4>

Kluger, Jeffrey, A Spacewalk From Hell, Countdown http://time.com/4903929/count-down-podcast-gemini-9/> [accessed 12 December 2017]

Koppett, Leonard, "Can Technology Win the Game?," New York Times, 24 April 1978, section Sports, pp. C1, C10

- Kraatz, Anne, *Lace: History and Fashion*, trans. by Pat Earnshaw (London: Thames and Hudson, 1989)
- Krakauer, Jon, Into Thin Air: A Personal Account of the Everest Disaster, 2nd edn (London: Pan Books, 2011)
- Kuhn, Dieter and Feng, Zhao (eds), Chinese Silks: The Culture and Civilization of China (New Haven: Yale University Press, 2012)
- Kuzmin, Yaroslav V., Keally, Charles T., Jull, A.J. Timothy, et al., "The Earliest Surviving Textiles in East Asia from Chertovy Vorota Cave, Primorye Province, Russian Far East," Antiquity, 86 (2012), 325–37 https://doi.org/10.1017/S0003598X00062797

Kvavadze, Eliso, Bar-Yosef, Ofer, Belfer-Cohen, Anna, et al., "30,000-Year-Old Wild Flax Fibers," Science, 325 (2009), 1359

- Kyle, Donald G., Sport and Spectacle in the Ancient World, II (Chichester: Wiley Blackwell, 2015)
- Lacemaker, The, Louvre <http://www.louvre.fr/en/oeuvre-notices/lacemaker>
- Larsen, Paul, "Re: Clothes, Clothes, Clothes," 24 June 2017
- Laskow, Sarah, "How Gore-Tex Was Born," *The Atlantic*, 8 September 2014 https://www.theatlantic.com/technology/archive/2014/09/how-gore-tex-was-born/379731/
- Lavoie, Amy, "Oldest-Known Fibers to Be Used by Humans Discovered," Harvard Gazette, 2009 [accessed 16 February 2017]
- Lazurus, Sydney, "Viscose Suppliers to H&M and Zara Linked to Severe Health and Environmental Hazards," *Spend Matters*, 2017 < http://spendmatters.com/2017/06/ 22/viscose-suppliers-hm-zara-linked-severe-health-environmental-hazards/> [accessed 19 September 2017]
- Ledford, Adam, "Spiders in Japan: The Tiniest Kaiju," *Tofugu*, 2014 ">https://www.tofugu.com/japan/spiders-in-japan/> [accessed 11 January 2017]
- Lee Blaszczyk, Regina, "Styling Synthetics: DuPont's Marketing of Fabrics and Fashions in Postwar America," *The Business History Review*, 80, 485–528
- "Leeds Woollen Workers Petition," *Modern History Sourcebook* (Leeds, 1786) https://sourcebooks.fordham.edu/halsall/mod/1786machines.asp

Leggett, Hadley, "1 Million Spiders Make Golden Silk for Rare Cloth," Wired, 2009 Leggett, William F., The Story of Linen (New York: Chemical Publishing Company, 1945) Lenzing Group, The Global Fibre Market in 2016 (Lenzing Group, 2017) http://www.lenzing.com/en/investors/equity-story/global-fiber-market.html [accessed 19 September 2017]

Levey, Santina M., Lace: A History (London: W. S. Maney and Son, 1983)

Lewis, Cathleen, "What Does Alan Shepard's Mercury Suit Have to Do with Neil Armstrong's Apollo 11 Suit?," *National Air and Space Museum*, 2015 https://airand-space.si.edu/stories/editorial/what-does-alan-shepard%E2%80%99s-mercury-suit-have-do-neil-armstrong%E2%80%99s-apollo-11-suit [accessed 9 December 2017]

Lewis, David, The Voyaging Stars: Secrets of the Pacific Island Navigators (Sydney: Collins, 1978)

Lewis, Randy, Molecular Biologist at the University of Utah, interview with author, September 2016

- Lightfoot, Amy, "From Heather-Clad Hills to the Roof of a Medieval Church: The Story of a Woollen Sail," Norwegian Textile Letter, II (1996), 1–8
- Linden, Eugene, "The Vikings: A Memorable Visit to America," Smithsonian, December 2004 http://www.smithsonianmag.com/history/the-vikings-a-memorable-visit-to-america-98090935/ [accessed 18 October 2017]
- Litherland, Piers, "Re: Egyptian Linen," 12 June 2017
- Litsky, Frank, "El-Guerrouj Sets Record in Mile," New York Times, 8 July 1999, section Sports, pp. 56, 60
- Lu, Yongxiang (ed.), A History of Chinese Science and Technology, trans. by Chuijun Qian and Hui He (Shanghai: Springer, 2015), II
- Lucas, A., and Harris, J. R., Ancient Egyptian Materials and Industries, 4th edn (New York: Dover Publications, 1999)
- Ma, Ii-Ying, Ji, Jia-Jia Ding, Qing, et al., "The Effects of Carbon Disultide on Male Sexual Function and Semen Quality," *Toxicology and Industrial Health* 26 (2010), 375 92 https://doi.org/10.1177/0748233710369127>
- Mace, Arthur C., and Winlock, Herbert E., The Tomb of Senebtisi at Lisht (New York: Metropolitan Museum of Art, 1916) http://libmina.contentdm.oclc.org/cdm/ref/collection/p15324coll10/id/163988>

"The Mad Science Behind Nike's NBA Uniforms," Nike News, 2017 https://news.nike.com/news/how-nba-uniform is made> [accessed 17 December 2017]

Magnusson, Magnus, Vikings! (London: The Bodley Head, 1980)

- Mandel, Charles, "Cow Used in Man-Made Spider Web," Wired, 2002 <https://www.wired.com/2002/01/cow-used-in-man-made-spider-web/ [accessed 12 December 2016]
- Marshall, Megan, "The King's Bed," New York Times, 15 October 2006, section Sunday Book Review, p. 714

Maspero, Gaston, Les Momies Royales de Deir El-Bahari (Paris: E. Leroux, 1889) http://gallica.bnf.fr/ark:/12148/bpt6k511070x>

Masse, Bryson, "Here's What the Next Generation of Space Travellers Might Be Wearing," Motherboard, 2016 https://motherboard.vice.com/en_us/articlc/gv5kpj/project-possum-NRC-spacesuit-final-frontier-design

- "McKenzie's Unshrinkable Mittens," Scott Polar Research Institute News Blog, 2014 < http: //www.spri.cam.ac.uk/museum/news/conservation/2014/04/07/mckenziesunshrinkable-mittens/> [accessed 13 June 2017]
- McLaughlin, Raoul, Rome and the Distant East: Trade Routes to the Ancient Lands of Arabia, India and China (London: Continuum International, 2010)

Meyer, Carl, "Apparel Giant Joins Movement to Stop Fashion from Destroying Forests," National Observer, 28 February 2017, section News http://www.nationalobserver.com/2017/02/28/news/apparel-giant-joins-movement-stop-fashion-destroying-forests [accessed 19 September 2017]

Mikanowski, Jacob, "A Secret Library, Digitally Excavated," The New Yorker, 9 October

2013 <http://www.newyorker.com/tech/elements/a-secret-library-digitally-excavated> [accessed 4 August 2017]

- Miller, Daniel, and Woodward, Sophie, "Introduction," in Miller, Daniel, and Woodward, Sophie, *Global Denim* (Oxford: Berg, 2011), pp. 1–22
- Miller, Randall M., "The Fabric of Control: Slavery in Antebellum Southern Textile Mills," Business History Review, 55 (1981), 471–90
- Miller, Stuart, "Which Tennis Ball Is in Use? It Makes a Difference," New York Times, 4 September 2016, section Sport, p. 7
- Mirsky, Jeannette, Sir Aurel Stein: Archaeological Explorer (Chicago: University of Chicago Press, 1977)
- Molotsky, Irvin, "Early Version of 'Gatsby' Gets a Chance of Its Own," New York Times, 27 November 1999, section Books http://www.nytimes.com/1999/11/27/books/ early-version-of-gatsby-gets-a-chance-of-its-own.html> [accessed 14 August 2017]

Monchaux, Nicholas de, Spacesuit: Fashioning Apollo (Cambridge: MIT Press, 2011)

- Morris, Bernadine "Nylon Gets a New Role in Fashion," New York Times, 7 February 1964, p. 27
- Morrison, Jim, "Spanx on Steroids: How Speedo Created the New Record-Breaking Swimsuit," Smithsonian, 26 June 2012 ">http://www.smithsonianmag.com/sciencenature/spanx-on-steroids-how-speedo-created-the-new-record-breaking-swimsuit-9662/> [accessed 17 December 2017]
- Moryson, Fynes, An Itinerary (London: J. Beale, 1617), IV http://archive.org/details/fynesmorysons04moryuoft>
- Moshenska, Gabriel, "Unrolling Egyptian Mummies in Nineteenth-Century Britain," British Journals for the History of Science, 47 (2014), 451-77
- "Most Bangladeshi Garment Workers Are Women, but Their Union Leaders Weren't. Until Now," Public Radio International (PRI, 2015) https://www.pri.org/stories/2015-09-16/most-bangladeshi-garment-workers-are-women-their-union-leaders-werent-untilnow> [accessed 2 January 2018]
- Moulherat, Christophe, Tengberg, Margareta, Haquet, Jérôme-F, and Mille, Benoit, "First Evidence of Cotton at Neolithic Mehrgarh, Pakistan: Analysis of Mineralized Fibres from a Copper Bead," *Journal of Archaeological Science*, 29 (2002), 1393–1400
- Mulder, Stephennie, "Dear Entire World: #Viking 'Allah' Textile Actually Doesn't Have Allah on It. Vikings Had Rich Contacts w/Arab World. This Textile? No," @stephenniem, 2017 https://twitter.com/stephenniem/status/919897406031978496>
- Muldrew, Craig, "'Th'ancient Distaff' and 'Whirling Spindle': Measuring the Contribution of Spinning to Household Earnings and the National Economy in England, 1550–1770," *The Economic History Review*, 65 (2012), 498–526

Murray, Margaret Alice, The Tomb of Two Brothers (Manchester: Sherratt & Hughes, 1910)

Musk, Elon, "I Am Elon Musk, CEO/CTO of a Rocket Company, AMA!-R/IAMA," Reddit, 2015 https://www.reddit.com/r/IAmA/comments/2rgsan/i_am_elon_musk_ceocto_of_a_rocket_company_ama/> [accessed 12 December 2017]

- , "Instagram Post," Instagram, 2017 <https://www.instagram.com/p/BYIPmEFAIIn /> [accessed 12 December 2017]
- NASA, Apollo 16-Technical Air-to-Ground Voice Transcript, April 1972 https://www.jsc.nasa.gov/history/mission trans/AS16_TEC.PDF>
 - -, Lunar Module: Quick Reference Data
- Nelson, Craig, Rocket Men: The Epic Story of the First Men on the Moon (London: John Murray, 2009)

"New Fibres Spur Textile Selling," New York Times, 19 April 1964, section Finance, p. 14 Newman, Dava, "Building the Future Spacesuit," Ask Magasine, January 2012, 37–40 Nightingale, Pamela, "The Rise and Decline of Medieval York: A Reassessment," Past &

Present, 2010, 3-42

- "Nike Engineers Knit for Performance," Nike News, 2012 https://news.nike.com/news/nike-flyknit> [accessed 9 January 2018]
- "Nike Launches Hijab for Female Muslim Athletes," the Guardian, 8 March 2017, section Business http://www.theguardian.com/business/2017/mar/08/nike-launches-hijab-for-female-muslim-athletes [accessed 17 December 2017]

Niles' Weekly Register, 1827, xxxiii

Noble, Holcomb B., "Secret Weapon or Barn Door?," New York Times Magazine, 21 November 1976, pp. 57, 58, 62, 64, 66, 68, 71

- Noble Wilford, John, "US-Soviet Space Race: 'Hare and Tortoise,'" New York Times, 22 December 1983, p. 15
- Norton, E. F., "The Climb with Mr. Somervell to 28,000 Feet," The Geographical Journal, 64 (1924), 451-5 https://doi.org/10.2307/1781918
- "Notices," Southern Watchman (Athens, Georgia, 7 June 1855), p. 4
- Nuwer, Rachel, "Death in the Clouds: The Problem with Everest's 200+ Bodies," BBC, 2015 http://www.bbc.com/future/story/20151008-the-graveyard-in-the-clouds-everests-200-dead-bodies> [accessed 19 June 2017]
- Odell, N. E., "The Last Climb of Mallory and Irvine," The Geographical Journal, 64 (1924), 455–61 https://doi.org/10.2307/1781919>
- Ohlgren, Thomas H., Robin Hood: The Early Poems, 1465-1560. Texts, Contexts, and Ideology (Newark: University of Delaware Press, 2007)
- Owen, James, "South Pole Expeditions Then and Now: How Does Their Food and Gear Compare?," National Geographic, 26 October 2013 http://news.nationalgeographic.com/news/2013/10/131025-antarctica-south pole-scott-expedition-science-polar/> [news/2013/10/131025-antarctica-south pole-scott-expedition-science-polar/>
- Pagel, Mark, and Bodmer, Walter, "A Nalted Apc Would Have Fewer Parasiten," Proceedings of the Royal Society of London. Series B: Biological Sciences, 270 (2003), S117 https://doi.org/10.1098/rsbl.2003.0041>
- Pain, Stephanie, "What Killed Dr Granville's Mummy?," New Scientist, 17 December 2008 ">https://www.newscientist.com/article/mg20026877-000-what-killed-dr-granvillesmummy/> [accessed 9 June 2017]
- Pantolia, Maria C., "Spinning and Weaving: Ideas of Domestic Order in Homer," The American Journal of Philology, 114 (1993), 493–501 https://doi.org/10.2307/295422>
- Paradiso, Max, "Chiara Vigo: The Last Woman Who Makes Sea Silk," *BBC Magazine*, 2 September 2015 <www.bbc.co.uk/news/magazine-33691781>
- Parsons, Mike, and Rose, Mary B., Invisible on Everest: Innovation and the Gear Makers (Philadelphia: Northern Liberties, 2003)
- PBS. Women in Space: Peeing in Space https://www.pbs.org/vldeo/makers-women-who-make-america-makers-women-space-peeing-space/> [accessed 11 December 2017]
- Pccrs, Simon, creator of the spider-silk textiles and author, phone interview with author, November 2016
- Peers, Simon, Golden Spider Silk (London: V&A Publishing, 2012)
- Pepys, Samuel, The Diary of Samuel Pepys, 1664 < http://www.pepysdiary.com/diary/1664/ 08/12/> [accessed 17 July 2017]
- Perrottet, Tony, *The Naked Olympics: The True Story of the Ancient Games* (New York: Random House Trade Paperbacks, 2004)
- Petty, William, The Economic Writings of Sir William Petty, Together with the Observations upon the Bills of Mortality, ed. by Charles Hull (New York: Augustus M. Kelley, 1963), I
- Phillips Mackowski, Maura, Testing the Limits: Aviation Medicine and the Origins of Manned Space Flight (College Station: Texas A&M University Press, 2006)
- "Plans Discussed to Convert Silk," New York Times, 8 August 1941, section News, p. 6

Pliny the Elder, *The Natural History*, trans. by John Bostock (Perseus, 1999) http://www.perseus.tufts.edu/hopper/text?doc=Perseus%3atext%3a1999.02.0137

- Plutarch, Isis and Osiris (Part 1 of 5), 5 vols (Loeb Classical Library, 1936), i [accessed 25 May 2017]">http://penel-ope.uchicago.edu/Thayer/e/roman/texts/plutarch/moralia/isis_and_osiris*/a.html>[accessed 25 May 2017]
- Polo, Marco, The Travels of Marco Polo, ed. by Hugh Murray, 3rd edn (Edinburgh: Oliver & Boyd, 1845)
- Power, Eileen, *The Wool Trade in English Medieval History*, Third (London: Oxford University Press, 1941)
- "Prison Labour Is a Billion-Dollar Industry, with Uncertain Returns for Inmates," *The Economist*, 16 March 2017 https://www.economist.com/news/united-states/21718897-idaho-prisoners-roast-potatoes-kentucky-they-sell-cattle-prison-labour
- Prude, Jonathan, "To Look upon the 'Lower Sort': Runaway Ads and the Appearance of Unfree Laborers in America, 1750–1800," *The Journal of American History*, 78 (1991), 124–59 https://doi.org/10.2307/2078091
- "Public Sentiment," Southern Banner (Athens, Georgia, 24 August 1832), p. 1

"Rana Plaza Collapse: 38 Charged with Murder over Garment Factory Disaster," the Guardian, 18 July 2016, section World news http://www.theguardian.com/world/2016/jul/18/rana-plaza-collapse-murder-charges-garment-factory> [accessed 4 October 2017]

- Raszeja, V. M., "Dennis, Clara (Clare) (1916–1971)," Australian Dictionary of Biography http://adb.anu.edu.au/biography/dennis-clara-clare-9951
- Reeves, Nicholas, "The Burial of Nefertiti?," Amarna Royal Tombs Project, 1 (2015) <http://www.academia.edu/14406398/The_Burial_of_Nefertiti_2015_> [accessed 30 May 2017]
- Reuell, Peter, "A Swimsuit like Shark Skin? Not so Fast," *Harvard Gasette*, 2012 https://news.harvard.edu/gazette/story/2012/02/a-swimsuit-like-shark-skin-not-so-fast/ [accessed 7 January 2018]
- Rhodes, Margaret, "Every Olympian Is Kind of a Cyborg," WIRED, 15 August 2016 https://www.wired.com/2016/08/every-olympian-kind-cyborg/> [accessed 10 January 2018]
- Riello, Giorgio, and Parthasarathi, Prasannan (eds), The Spinning World: A Global History of Cotton Textiles, 1200–1850, 1st edn (New York: Oxford University Press)
- Riggs, Christina, "Beautiful Burials, Beautiful Skulls: The Aesthetics of the Egyptian Mummy," *The British Journal of Aesthetics*, 56 (2016), 247–63 https://doi.org/10.1093/aesthj/ayw045>
 - -, Unwrapping Ancient Egypt (London: Bloomsbury, 2014)

Roach, Mary, Packing for Mars: The Curious Science of Life in Space (Oxford: Oneworld, 2011)

- Roberts, Jacob, "Winning Skin," *Distillations*, Winter 2017 https://www.chemheritage.org/distillations/magazine/winning-skin [accessed 8 January 2018]
- Robson, David, "There Really Are 50 Eskimo Words for 'Snow,' "Washington Post, 14 January 2013, section Health & Science https://www.washingtonpost.com/national/health-science/there-really-are-50-eskimo-words-for-snow/2013/01/14/e0e3f4e0-59a0-11e2-beee-6e38f5215402_story.html [accessed 7 June 2017]
- Rodriguez McRobbie, Linda, "The Classy Rise of the Trench Coat," Smithsonian Magazine, 2015 http://www.smithsonianmag.com/history/trench-coat-made-its-mark-world-war-i-180955397/> [accessed 19 June 2017]
- Rogers, Kaleigh, "The Amazing Spider Silk: The Natural Fibre That Can Help Regenerate Bones," Motherboard https://motherboard.vice.com/en_us/article/

the-amazing-spider-silk-the-natural-fiber-that-can-help-regenerate-bones> [accessed 12 February 2017]

- Romey, Kristin, "The Super-Ancient Origins of You Blue Jeans," National Geographic News, 14 September 2016 https://news.nationalgeographic.com/2016/09/peruindigo-cotton-discovery-textiles-archaeology-jeans-huaca/ [accessed 23 November 2017]
- Ross, Amy, Rhodes, Richard, Graziosi, David, et al., "Z-2 Prototype Space Suit Development" (presented at the 44th International Conference on Environmental Systems, Tucson, Arizona, 2014), pp. 1–11 https://ntrs.nasa.gov/archive/nasa/casi. ntrs.nasa.gov/20140009911.pdf>
- Ruixin, Zhu, Bangwei, Zhang, Fusheng, Liu, et al, A Social History of Middle-Period China: The Song, Liao, Western Xia and Jin Dynasties, trans. by Bang Qian Zhu (Cambridge: Cambridge University Press, 1998)
- Ryder, M. L., "Medieval Sheep and Wool Types," *The Agricultural History Review*, 32 (1984), 14–28
 - —, "The Origin of Spinning," Textile History, 1 (1968), 73-82 <https://doi.org/ 10.1179/004049668793692746>
- Sample, Ian, "Fresh Autopsy of Egyptian Mummy Shows Cause of Death Was TB Not Cancer," the Guardian, 30 September 2009, section Science https://www.theguardian.com/science/2009/sep/30/autopsy-egyptian-mummy-tb-cancer>
- Sandomir, Richard, "Was Sports Bra Celebration Spontaneous?," New York Times, 18 July 1999, section Sports Business, p. 6
- Santry, Joe, Innovation Director at Lululemon. Former Head of Research at Speedo Aqualab, Speedo Aqualab and Lululemon, telephone interview 2017
- Sawer, Patrick, "The Secret Relationship between Climbing Legend George Mallory and a Young Toucher," the Daily Telegraph, 28 October 2015, section History http://www.telegraph.co.uk/history/11960859/The-secret-relationship-betweenclimbing-legend-George-Mallory-and-a-young-teacher.html [accessed 13 June 2017]
- Sawyor, P. II., Kings and Vikings: Scandinavia and Europe AD 700-110, 2nd edn (London: Routledge, 2003)
- Schlossberg, Tatiana, "Choosing Clothes to Be Kind to the Planet," New York Times, 1 June 2017, section Climate, p. D4
- Schofield, Brian, "Denise Johns: There Is More to Beach Volleyball Than Girls in Bikinis," *The Sunday Times*, 20 July 2008 ">https://www.thetimes.co.uk/article/denise-johns-there-is-more-to-beach-volleyball-than-girls-in-bikinis-wc3crndnmh8>">https://www.thetimes.co.uk/article/denise-johns-there-is-more-to-beach-volleyball-than-girls-in-bikinis-wc3crndnmh8>">https://www.thetimes.co.uk/article/denise-johns-there-is-more-to-beach-volleyball-than-girls-in-bikinis-wc3crndnmh8>">https://www.thetimes.co.uk/article/denise-johns-there-is-more-to-beach-volleyball-than-girls-in-bikinis-wc3crndnmh8>">https://www.thetimes.co.uk/article/denise-johns-there-is-more-to-beach-volleyball-than-girls-in-bikinis-wc3crndnmh8>">https://www.thetimes.co.uk/article/denise-johns-there-is-more-to-beach-volleyball-than-girls-in-bikinis-wc3crndnmh8>">https://www.thetimes.co.uk/article/denise-johns-there-is-more-to-beach-volleyball-than-girls-in-bikinis-wc3crndnmh8>">https://www.thetimes.co.uk/article/denise-johns-there-is-more-to-beach-volleyball-than-girls-in-bikinis-wc3crndnmh8>">https://www.thetimes.co.uk/article/denise-johns-there-is-more-to-beach-volleyball-than-girls-in-bikinis-wc3crndnmh8>">https://www.thetimes.co.uk/article/denise-johns-there-is-more-to-beach-volleyball-than-girls-in-bikinis-wc3crndnmh8>">https://www.thetimes.co.uk/article/denise-johns-there-is-more-to-beach-volleyball-than-girls-in-bikinis-wc3crndnmh8>">https://www.thetimes.co.uk/article/denise-johns-there-is-more-to-beach-volleyball-than-girls-in-bikinis-wc3crndnmh8>">https://www.thetimes.co.uk/article/denise-johns-there-is-wolleyball-than-girls-in-bikinis-wc3crndnmh8>">https://www.thetimes.co.uk/article/denise-johns-there-is-wolleyball-than-girls-in-bikinis-wc3crndnmh8>">https://www.thetimes.co.uk/article/denise-johns-there-is-wolleyball-than-girls-in-bikinis-wolleyball-than-girls-in-bikinis-wolleyball-than-girls-in-bikinis-wolleyball-t
- Schütz, Karl, Vermeer: The Complete Works (Cologne: Taschen, 2015)
- Schwartz, Jack, "Men's Clothing and the Negro," Phylon (1960-), 24 (1963), 224-31 https://doi.org/10.2307/273395
- Scott, Robert Falcon, Journals: Captain Scott's Last Expedition, ed. by Max Jones, Oxford World Classics, 2nd edn (Oxford: Oxford University Press, 2008)
- Shaer, Matthew, "The Controversial Afterlife of King Tut," Smithsonian Magazine, December 2014, pp. 30–9
- Siegle, Lucy, "The Eco Guide to Cleaner Cotton," the Guardian, 22 February 2016, section Environment http://www.theguardian.com/environment/2016/feb/22/ eco-guide-to-cleaner-cotton> [accessed 27 November 2017]
- Simonson, Eric, Hemmleb, Jochen, and Johnson, Larry, "Ghosts of Everest," Outside Magazine, 1 October 1999 https://www.outsideonline.com/1909046/ghosts-everest [accessed 19 June 2017]
- Sims-Williams, Nicholas (trans.), "Sogdian Ancient Letters" https://depts.washington.edu/silkroad/texts/sogdlet.html [accessed 10 August 2017]

- Slackman, Michael, "A Poet Whose Political Incorrectness Is a Crime," New York Times, 13 May 2006, section Africa https://www.nytimes.com/2006/05/13/world/africa/13negm.html [accessed 5 June 2017]
- Slater, Matt, "Goodhew Demands Hi-Tech Suit Ban," BBC, 20 January 2009, section Sport http://news.bbc.co.uk/sport1/hi/olympic_games/7900443.stm [accessed 5 January 2018]
- Slonim, A. R., Effects of Minimal Personal Hygiene and Related Procedures during Prolongued Confinement (Wright-Patterson Air Force Base, Ohio: Aerospace Medical Research Laboratories, October 1966)

Smith, John H., "Notice," Daily Constitutionalist, 9 March 1847, p. 3

Snow, Dan, "New Evidence of Viking Life in America?," BBC News, 1 April 2016, section Magazine http://www.bbc.co.uk/news/magazine-35935725> [accessed 18 October 2017]

"Soap-Tax, The," The Spectator, 27 April 1833, p. 14

Soffer, O., Adovasio, J. M., and Hyland, D. C., "The 'Venus' Figurines," Current Anthropology, 41 (2000), 511–37 https://doi.org/10.1086/317381

"Space Age Swimsuit Reduces Drag, Breaks Records," NASA Spinoff, 2008 https://spinoff.nasa.gov/Spinoff2008/ch_4.html [accessed 4 January 2018]

- Spivack, Emily, "Paint-on Hosiery during the War Years," Smithsonian, 10 September 2012 https://www.smithsonianmag.com/arts-culture/paint-on-hosiery-during-the-war-vears-29864389/> [accessed 8 April 2018]
 - —, "Wartime Rationing and Nylon Riots," *Smithsonian* ">https://www.smithsonian-mag.com/arts-culture/stocking-series-part-1-wartime-rationing-and-nylon-riots-25391066/> [accessed 8 April 2018]

St Clair, Kassia, The Secret Lives of Colour (London: John Murray, 2016)

Statutes of the Realm. Printed by Command of His Majesty King George the Third in Pursuance of an Address of The House of Commons of Great Britain, The (London: Dawsons of Pall Mall, 1963), I

Stein, Aurel, "Central-Asian Relics of China's Ancient Silk Trade," T'oung Pao, 20 (1920), 130–41

——, "Explorations in Central Asia, 1906–8," *The Geographical Journal*, 34 (1909), 241–64 https://doi.org/10.2307/1777141

Stein, Eliot, "Byssus, or Sea Silk, Is One of the Most Coveted Materials in the World," BBC Magazine, 6 September 2017 <www.bbc.com/travel/story/ 20170906-the-last-surviving-sea-silk-seamstress>

Steyger, Greg, Global Category Manager, Arena, telephone interview with author, 2018

Strauss, Mark, "Discovery Could Rewrite History of Vikings in New World," National Geographic News, 2016 http://news.nationalgeographic.com/2016/03/ 160331-viking-discovery-north-america-canada-archaeology/> [accessed 18 October

2017]

- Stubbes, Philip, Anatomy of Abuses in England in Shakespeare's Youth (London: New Shakespeare Society, 1879)
- Suetonius, The Lives of the Caesars, trans. by John Carew Rolfe, 2 vols (London: Loeb Classical Library, 1959)

"Sulphur and Heart Disease," The British Medical Journal, 4 (1968), 405-6

"Summary Abstracts of the Rewards Bestowed by the Society, From the Institution in 1754, to 1782, Inclusive, with Observations on the Effects of Those Rewards, Arranged under the Several Classes of Agriculture, Chemistry, Colonies & Trade, Manufactures, Mechanicks, Polite Arts, and Miscellaneous Articles," *Transactions of the Society, Instituted at London, for the Encouragement of Arts, Manufactures, and Commerce*, 1 (1783), 1–62

"Swimming World Records in Rome," BBC, 3 August 2009, section Sport < http://news.

bbc.co.uk/sport1/hi/other_sports/swimming/8176121.stm> [accessed 4 January 2018]

- Tabuchi, Hiroko, "How Far Can a Trend Stretch?," New York Times, 26 March 2016, section Business Day, p. B1
- Tacitus, "Germania," Medieval Sourcebooks https://sourcebooks.fordham.edu/source/tacitus1.html [accessed 31 October 2017]
- Taylor, Kate, "Stolen Egyptian Statue Is Found in Garbage," *New York Times*, 17 February 2011 http://www.nytimes.com/2011/02/17/arts/design/17arts-STOLENE-GYPTI_BRF.html [accessed 7 June 2017]
- Terrell, W. M., "Letter from Dr. Terrell," *Southern Watchman* (Athens, Georgia, 18 January 1855), p. 2
- Thatcher, Oliver J. (ed.), The Library of Original Sources (Milwaukee: University Research Extension Co., 1907), 1: The Ancient World http://sourcebooks.fordham.edu/ancient/hymn-nile.asp [accessed 5 June 2017]
- Thomas, Hugh, The Slave Trade: The History of the Atlantic Slave Trade 1440–1870 (London: Phoenix, 2006)
- Tillotson, Jason, "Eight Years Later, the Super Suit Era Still Plagues the Record Books," Swimming World, 2018 <https://www.swimmingworldmagazine.com/news/eightyears-later-the-super-suit-era-still-plagues-the-record-books/> [accessed 10 January 2018]
- Tocqueville, Alexis de, Alexis de Tocqueville on Democracy, Revolution, and Society, ed. by John Stone and Stephen Mennell (Chicago: The University of Chicago Press, 1960)
- "Tombs of Meketre and Wah, Thebes," The Metropolitan Museum of Art <http://www meunuseum.org/met-around-the-world/?page=10157> [accessed 5 June 2017]
- Toups, Melissa A., Kitchen, Andrew, Light, Jessica E., and Reed, David L., "Origin of Clothing Lice Indicates Early Clothing Use by Anatomically Modern Humans in Africa," *Molecular Biology and Evolution*, 20 (2011), 29-32 https://doi.org/10.1093/ molbev/msq234>
- Tucker, Ross, "It's Time to Ban Hi Tcch Shoes," *Times Live*, 2017 https://www.timeslive.co.za/sport/2017-11-27-its-time-to-ban-hi-tech-shoes/ [accessed 17 December 2017]
- Vainker, Shelagh, Chinese Silk: A Cultural History (London: The British Museum Press, 2004)
- van Gogh, Vincent, "649: Letter to Emile Bernard, Arles," 29 July 1888, Van Gogh Letters http://vangoghletters.org/vg/letters/let649/letter.html [accessed 13 July 2017]
- Vecsey, George, "U.S. Wins Final with Penalty Kicks," New York Times, 11 July 1999, section Sport, pp. 1, 6
- Vedeler, Marianne, Silk for the Vikings, Ancient Textiles Series, 15 (Oxford: Oxbow Books, 2014)
- Venable, Shannon L., Gold: A Cultural Encyclopedia (Santa Barbara: ABC-Clio, 2011)
- Vickery, Amanda, Behind Closed Doors: At Home in Georgian England (Yale: Yale University Press, 2009)
 - -----, "His and Hers: Gender Consumption and Household Accounting in Eighteenth-Century England," *Past & Present*, 1 (2006), 12–38
- Vigliani, Enrico C., "Carbon Disulphide Poisoning in Viscose Rayon Factories," British Journal of Industrial Medicine, 11 (1954), 235–44
- "Viking Ship Is Here, The," New York Times (New York, 14 June 1893), p. 1
- "Viking Ship Sails, The," New York Times, (New York, 2 May 1893), p. 11

Vogt, Yngve, "Norwegian Vikings Purchased Silk from Persia," *Apollon*, 2013 https://www.apollon.uio.no/english/vikings.html [accessed 31 July 2017]

Vollrath, Fritz, "Follow-up Queries," 14 February 2017

- ——, "The Complexity of Silk under the Spotlight of Synthetic Biology," Biochemical Society Transactions, 44 (2016), 1151–7 https://doi.org/10.1042/BST20160058>
- Vollrath, Fritz, and Selden, Paul, "The Role of Behavior in the Evolution of Spiders, Silks, and Webs," Annual Review of Ecology, Evolution, and Systematics, 38 (2007), 819–46
- Vollrath, Fritz, Zoology Professor, University of Oxford, Skype interview with author, February 2017
- Wade, Nicholas, "Why Humans and Their Fur Parted Ways," New York Times, 19 August 2003, section News, p. F1
- Walker, Annabel, Aurel Stein: Pioneer of the Silk Road (London: John Murray, 1995)
- Walmsley, Roy, World Prison Population List, Eleventh Edition (Institute for Criminal Policy Research, October 2015)
- Walton Rogers, Penelope, Textile Production at 16-22 Coppergate, The Archaeology of York: The Small Finds (York: Council for British Archaeology, 1997), xvii
- Wardle, Patricia, "Seventeenth-Century Black Silk Lace in the Rijksmuseum," Bulletin van Het Rijksmuseum, 33 (1985), 207–25
- Wayland Barber, Elizabeth, Prehistoric Textiles: The Development of Cloth in the Neolithic and Bronze Ages (Princeton: Princeton University Press, 1991)
 - ——, Women's Work: The First 20,000 Years. Women, Cloth, and Society in Early Times (New York: W. W. Norton, 1995)
- Weber, Caroline, "'Jeans: A Cultural History of an American Icon,' by James Sullivan," New York Times Book Review," New York Times, 20 August 2006, section Sunday Book Review, p. 77
- Werness, Hope B., The Continuum Encyclopedia of Native Art: Worldview, Symbolism & Culture in Africa, Oceania & Native North America (New York: Continuum International, 2000)
- "What Is a Spacesuit," NASA, 2014 <https://www.nasa.gov/audience/forstudents/5-8/ features/nasa-knows/what-is-a-spacesuit-58.html>
- "What Lies Beneath?," *The Economist*, 8 August 2015 <https://www.economist.com/news/ books-and-arts/21660503-tantalising-clue-location-long-sought-pharaonic-tombwhat-lies-beneath> [accessed 13 May 2018]
- What to Wear in Antarctica?, Scott Expedition <https://www.youtube.com/watch?v= KF2WXIS1WvA&index=5&list=PLUAuh5Ht8DS266bwmWJZ5isWPhSEbsP-U>
- Wheelock, Arthur K., Vermeer: The Complete Works (New York: Harry N. Abrams, 1997)
- "When the Gokstad Ship Was Found," UiO: Museum of Cultural History, 2016 http://www.khm.uio.no/english/visit-us/viking-ship-museum/exhibitions/gokstad/1-gokstadfound.html [accessed 27 October 2017]
- White, Shane, and White, Graham, "Slave Clothing and African-American Culture in the Eighteenth and Nineteenth Centuries," Past & Present, 1995, 149-86
- "Why Do Swimmers Break More Records Than Runners?," BBC News, 13 August 2016, section Magazine http://www.bbc.co.uk/news/magazine-37064144 [accessed 10 January 2018]
- Widmaier, Dan, "Spider Silk: How We Cracked One of Nature's Toughest Puzzles," Medium, 2015 https://medium.com/@dwidmaier/spider-silk-how-we-cracked-oneof-nature-s-toughest-puzzles-f54aded14db3 [accessed 6 December 2016]
- Widmaier, Dan, Co-Founder and CEO of Bolt Threads, phone call with author on 17 February 2017
- Wigmore, Tim, "Sport's Gender Pay Gap: Why Are Women Still Paid Less Than Men?," New Statesman, 5 August 2016 https://www.newstatesman.com/

politics/sport/2016/08/sport-s-gender-pay-gap-why-are-women-still-paid-lessmen> [accessed 11 January 2018]

- Wilder, Shawn M., Rypstra, Ann L., and Elgar, Mark A., "The Importance of Ecological and Phylogenetic Conditions for the Occurrence and Frequency of Sexual
- Cannibalism," Annual Review of Ecology, Evolution, and Systematics, 40 (2009), 21–39 William of Newburgh, History, v <https://sourcebooks.fordham.edu/basis/williamofnewburgh-five.asp> [accessed 19 May 2017]
- —, History, IV < http://sourcebooks.fordham.edu/halsall/basis/williamofnewburghfour.asp#7> [accessed 4 May 2017]
- William of St-Thierry, "A Description of Clairvaux, C. 1143" https://sourcebooks.ford-ham.edu/Halsall/source/1143clairvaux.asp [accessed 19 May 2017]
- Williams, Wythe, "Miss Norelius and Borg Sct World's Records in Winning Olympic Swimming Titles," New York Times, 7 August 1928, p. 15
- Williamson, George C., Lady Anne Clifford, Countess of Dorset, Pembroke & Montgomery 1590-1676. Her Life, Letters and Work (Kendal: Titus Wilson & Son, 1922)
- Wilson, Eric, "Swimsuit for the Olympics Is a New Skin for the Big Dip," New York Times, 13 February 2008, section Sports, p. D4
- Wolfe, Tom, "Funky Chic," Rolling Stone, 3 January 1974, pp. 37-9

Wood, Diana, Medieval Economic Thought (Cambridge: Cambridge University Press, 2002)

- Woolf, Jake, "The Original Nike Flyknit Is Back in Its Best Colorway," GQ, 2017 https://www.gq.com/story/nike-flyknit-trainer-white-rerelease-information [accessed 9 January 2018]
- "Woollen Sailcloth," Viking Ship Museum http://www.vikingeskibsmuseet.dk/cn/professions/boatyard/experimental-archaeological-research/maritime-crafts/maritime-tech-nology/woollen-sailcloth/ [accessed 12 October 2017]
- Xinru, Liu, "Gillo and Religions In Eurasta, C. A.B. 600–1200," Journal of World History, 6 (1995), 25–48
- Yin, Steph, "People Have Been Dyeing Fabric Indigo Blue for 6,000 Years," New York Times, 20 September 2016, section Science, p. D2
- Young, Amanda, Spacesuits: The Smithsonian National Air and Space Museum Collection (Brooklyn: Powerhouse, 2009)
- Young, David C., A Brief History of the Olympic Games (Malden: Blackwell, 2004)
- Yu, Ying-shih, Trade and Expansion in Han China: A Study in the Structure of Sino-Barbarian Economic Relations (Berkeley: University of California, 1967)

Zhang, Peter, and Jie, Chen, "Court Ladies Preparing Newly Woven Silk," 25 October 2015 http://www.shanghaidaily.com/sunday/now-and-then/Court-Ladies-Preparing-Newly-Woven-Silk/shdaily.shtml [accessed 4 August 2017]

Zinn, Howard, "The Real Christopher Columbus," Jacobin Magazine, 2014 http://jacobin-mag.com/2014/10/the-real-christopher-columbus/> [accessed 26 November 2017]

335

Index

acrvlic 208, 295 Adam and Eve 292 Addison, Joseph 161 Adidas 262 Adlington, Rebecca 253, 254, 264 advertising 175, 205, 209 aeronauts 229 Africa cotton 161-2, 169 spider silk 278 Akhenaten 45, 47 Al-Bekri 161-2 Alberti family of Florence 124 Alcuin of York 112-13 Aldrin, Buzz 225, 227-8 Alexander the Groat 87 alphie exploration 186-91, 197-5, 196-7, 198 alum 295 Amaterasu 12 America Civil War 175 cotton 165, 168, 171 5, 179-80 denim 176-9 prison workers 180 rodeos 175-6 slavery 159-60, 162-6, 168-9, 172, 173-5 synthetic textiles 206-7, 210 Vikings 101-2 American Viscose Company 206, 220 AMSilk 286 Amsterdam 154-5 Amundsen, Roald 185, 194, 199 Anatomic of Abuses, An (Stubbes) 142, 151 Andersen, Hans Christian 10 Andersen, Magnus 101 Anker, Conrad 196, 198 Antarctica 183-5, 192, 195-6 Apis Embalming Ritual 48, 52 Apollo space program 225-7, 232-4, 236, 238, 241 Apuleius 45 Arab Spring 45 Arachne 276-7

archaeology Coppergate, York 121-3 cotton 167-8 earliest fibers 21-4, 32, 33 experimental 111 The Library, Mogao Caves 79-80 looms 6, 11, 30-1 needles 31 perishable materials 6, 29 satellites 100-1, 102 silk 63-4 tomb textiles 32 see also Egypt, ancient Arena 251, 253, 266 Arkwright, Richard 170 Armenians 82 Armstrong, Neil 225, 227-8 Ambanham 13 11, 10, 01 Assyria 14-15 astronauts 225-9, 231-3, 237-9, 240-3, 245 Athena 12, 277 Atropos 1

B. F. Goodrich 229, 231, 233 back-strap loom 6, 66-7 Bainbridge, Jamie 284, 285-6 baize 162, 184, 295 bamboo 219-20 Bangladesh Rana Plaza disaster 217-18 textile industry 16-17 banking 8, 126-7 Bannister, Roger 261 Bar-Yosef, Ofer 24 Barber, Elizabeth 11 basket weave 43, 295 basketball 259 bast 23, 28, 295 batik 295 Bayeux Tapestry 15 beach volleyball 258-9 Beisel, Elizabeth 251 Bender Jørgensen, Lise 114 Benedict Biscop 84

Benetton 218-19 Benoit, Joan 258 Beowulf 106 Bible: clothing prohibitions 3 Biedermann, Paul 249-51, 254 bills of exchange 125 **BioSteel 281** BioSuit 243 Bitcoin 7 black lace 141-2 Black Spider, The (Gotthelf) 276 Blanc, Paul David 203, 213, 221 blanket 123 bleaching: linen 45 boats earliest 104 longships 97-100, 101, 105-6, 111, 114 bobbin lace 144 bobbins 143, 144, 295 boiled wool 295 Bolt Threads 284-6 bombazine 295 Bombyx mori 60-1, 86, 282 Bon, François-Xavier 278, 279 Book of Odes, The 13, 59 Book of Rites (attr. Confucius) 65 Borg, Arne 260 Borg, Bjorn 261 Borman, Frank 240 Bowers, Henry 195 Bowman, Bob 250-1 braid 140 bras 257-8 breathability 26, 198 bridges 44 Britain cotton 169-71, 172 Industrial Revolution 170-1 laws 118, 148 Peasants Revolt 118 rayon 206-7 textile specialisms today 8-9 see also England British East India Company 168 broadcloth 123, 126, 162, 295 brocade 64, 290, 291, 295 Bronze Age 31 Brown, John 174-5 Brun, Michael 129 Buddhism 65, 84-5, 87 buoyancy 253 Burberry 185, 189, 190, 192, 198

burel 123 burials China 63, 64 Egypt 37-9, 40, 42, 45, 46-8, 53-4 Mongolia 70 Neolithic period 32, 34, 167 Vikings 89, 97-9 women 13 buttons 31, 189, 195 Byzantines 83, 86 calico 8, 162, 295 Caligula 92 calligraphy 17 Camboué, Paul Jacob 277, 279 cambric 164, 295 camels 82 candles 51 canions 146, 153 canvas 195, 239, 295 carbon disulphide 205, 213-17, 220 carbon fiber 266 carding cotton 165, 168 definition 295 wool 122 Caribbean 172, 173 Carter, Howard 37, 38-9, 45, 52, 53-4 Case, Mel 231, 232, 238 Catal Hüyük, Turkey 33-4 Caton-Thompson, Gertrude 32 cellulose 205, 219 Cernan, Eugene 239-40 Chambre Syndicale de la Couture Parisienne 209 Chanel 9, 209 Chanel, Gabrielle "Coco" 9, 139 Charlemagne 124-5 Charles I 154 Charles II 147-8 Charles, Jacques 229 Charlotte's Web (White) 275, 276 Chastain, Brandi 258 Cherry-Garrard, Apsley 183, 192-3 Chertovy Vorota cave, Russia 31 children lacemaking 155 textile work 2, 13, 17 China cotton 180 economics 67-8 embroidery 72

Index

laws 65-6, 67, 87-8, 290 looms 66-7, 86, 88 mythology 12 proverbs 13, 62 religion 64-5, 84, 87 reversible poems 57-9 silk 8, 13, 59-60, 62-8, 69-72, 80 spiders 276 synthetic textiles 220 trade 66, 68, 69-72, 81, 86, 290 tributary system 69-71 women 58, 65, 72 chintz 295 Christianity 84 Cistercians 121, 128-30, 132-3 Clairvaux Abbey, France 128 Clark, David 230, 231, 243 cleanliness 45, 145, 240 Cleopatra 86 clergy 126 climbing see alpine exploration cloaks 124-5 clothing breathability 26, 198 China 66 eiviligations 391 3 cleanliness 145 display and status 2-3, 24-5 Egypt, ancient 43, 44-5 exploration 184-6, 189, 191, 192-5, 196, 197-9 Georgian England 145 golden 289-90 Louis XIV 146 Norwegian sailors 113 prehistory 24-7, 31 Robin Hood 117-18 Romans, ancient 92-3 slaves 159, 160-1, 162-6 smartwear 7 stockings 207-8 sumptuary laws 3, 65-6, 118, 143, 290 uniforms 2-3 warmth 25, 26-7 see also social status; spacesuits; sportswear; underwear Clotho 1 cobwebs 272, 273, 274, 278, 283 Colbert, Jean-Baptiste 146, 147-8, 156 cold 189, 190, 191-4 collars 146, 153

Collins, Michael 225-6, 227, 228-9, 236 - 8colonialism 171 colonization 103-4, 114 color see also dve cotton 162 silk 66 woolens 117-18, 120, 121-2, 126 Columbus, Christopher 172 combing 122-3, 168, 173, 296 computers Jacquard looms 7-8 trousers 7 Confucius 65 Constantinople 83 Cook, James, Captain 102-3, 104, 184 Cooper, Charlotte 257 cord 32-3, 140 Corfe Castle, Dorset 88 Cormos 84 Cotswolds 120 cotton Africa 161-2 American plantations 165, 168, 172-5 archaeology 167-8 cului 102 cultivation 166-8, 173, 174 denim 176-9, 180 Egypt 44 employment numbers 170, 172 environmental impact 180 gabardine 185, 189 hand-spinning 30 Industrial Revolution 2, 170-1 Mughal Empire 8 patterns 162, 168 popularity 161, 179 processing 168, 173 slavery 161, 169, 172, 173-5 speculation 179 synthetic textiles growth 210 count: definition 296 Court Ladies Preparing Newly Woven Silk (Huizong) 62-3, 72 Courtaulds 206, 207, 209, 215-16, 221 cowboys 177, 178 Granford (Gaskell) 146 creativity in prehistory 34 crime 82 Crompton, Samuel 170 Cromwell, Oliver 154 Crosby, Bing 176, 177

339

crusaders 88, 131 cuffs 146 cultural exchange 2, 8, 66, 71, 81, 84, 87, 88 currency, silk as 68 curses 93 cutwork 143-4 da Gama, Vasco 168 Daizong (Chinese emperor) 87 damask Chinese silk 87, 88 definition 296 grave inventories 64 workshops 67, 68 Dandan-Uiliq 78, 84, 93 darning 18, 47, 113, 165 David Clark Company 233, 234 Davis, Jacob 177 de la Pole family 125 de Morga, Antonio 290 Defoe, Daniel 168 deforestation 219 deities China 65 Egypt 40, 276 Greek 87, 88, 277 Mesopotamia 289 Norse 99 women 12-13 see also religion Delaunay, Sonia 15 Delft, Netherlands 137 Democritus 275 denim 7, 162, 176-9, 180, 296 Dennis, Clare 260 Dieter, Bill 243 Ding Pei 16, 72 Dio Cassius 91 Dior 209 distaffs 5, 13, 42, 131, 296 Domesday Book 119-20 Douglass, Frederick 162 down suits 195, 197 dragon robes 66 Drapers, Mercers and Merchant Taylors guild 126 drawn threadwork 144 Dravton, Michael 117 Duchenne de Boulogne, Guillaume 213 Duke, Charles 241 Dunhuang, China 78-80, 85

DuPont 205, 207-9, 210, 216, 235 Durham, Tempe Herndon 165 Dutch East India Company 141, 148 Duthie, J.F. 277 dye black lace 142 cotton 162, 165 earliest fibers 23 indigo 180 wool 122 dyneema 243 Dzudzuana cave, Georgia 21-4, 27 Eco, Umberto 180 economics cotton 179-80 lace 155-6 silk 67-8,90 Silk Roads 83 wool 126 Edward I 127 Edward III 133 Edward IV 125, 126 Egil's Saga 97 Egypt, ancient deities 12, 40, 276 flax cultivation 40-1, 43-4 glass fabric 291 linen clothing 43, 44-5 linen: religious significance 2, 39, 45-6, 47, 53 linen spinning and weaving 42-3 looms 6, 29-30, 43 mummification 2, 46-7, 48-53 sails 105 silk 86 textile archaeology 29-30, 32 Tutankhamun 37-40 eiderdown 195, 197 el-Guerrouj, Hicham 262 Elizabeth I 3, 142, 150-3 Elko, Nevada 175-6 **Emancipation Proclamation 175** embroidery China 72 cutwork 143-4 development of lace 140, 144 drawn threadwork 144 gold 289-90 reversible poems 57-9 Viking burials 89 women's work 141

Index

341

employment numbers cotton 170, 172 modern apparel industry 218, 220 spinning 2, 16 England Eighteenth-century shopping 15-16 Industrial Revolution 170-1 lace 148, 155 Luddites 9-10 Richard I ransom 131-2 silk 88-9 spinning employment 2, 16 sumptuary laws 3, 118, 143 trade 125-7 wool 119-24 environmental impact cotton 180 synthetic textiles 219-20 Equiano, Olaudah 162, 164 erotica 63 Everest 186-91, 193, 194-5, 196-7, 198 evolution 25-6, 274 executions 152 exploration alpine 186-91, 192-5, 196-7, 198 Inita: 183mn, 197, 193-4

factories 170, 171, 206-7, 210, 211-18, 220-1 Fair Isle sweaters 108 Faiyum, Egypt 32 fashions cotton 168 denim 178, 179 lace 144-5, 147-8, 149, 152-3 Paris 209 synthetic textiles 208-10, 219, 221, 286 fastness 296 Fastskin 260, 266-7 Fates, the 1, 10 felt 29, 82, 88, 261, 296 felting 29 fibers, earliest 8, 21-3, 32, 33 Field of Cloth of Gold 290 Fiennes, Ranulph 196 filet 140, 141 film 178 FINA 250, 251, 254-5, 266 Final Frontier Designs 243 Finch, George 195, 197 flammability 238, 243

Flanders lace 144, 147, 148, 150 wool 125, 127 flax bast 28 cultivation 27, 40-1, 43-4 definition 296 earliest fabrics 8, 32 Egypt, ancient 40-1, 43-4 language 18 Plutarch 39 prehistory 27, 28, 32 fleece 196 Flemish cloth 125, 127 Florentine cloth 125 flying shuttle 169-70 Flyknit Racer 262 football 258 Foraker, Eleanor 234 forced labor 175, 180, 204, 211-12 see also slavery France buttons in prehistory 31 denim 177 lace 16, 147-8, 149-50, 155 Lassauri saves dil d laws 16, 142 Resistance 203-4 Francis I 290 Freeman, Ted 225 Freud, Sigmund 14 Frey QQ Frigg 12 frostbite 194, 195, 230 Fuller, Thomas 145, 154 fulling 110, 123-4, 296 funghi 221 fur 25, 185-6, 199 Furniss, Steve 254 fustian 18, 296 fuzz 168

gabardine 185, 189 Gardner, Elinor 32 Gaskell, Elizabeth 146 Gemini space program 233, 239-40 genetic engineering 281-2 *Germania* (Tacitus) 105 Germany 207, 211-12 "Get-me-down" suits 230-1 Gheeraerts, Marcus, the Younger 151 Gilligan, Ian 24

ginning 168, 173 Givenchy, Hubert de 209 Glanzstoff 207, 211 glass fabric 291 goats 281-2 Gobi Desert 68, 78, 82 Godley, Nicholas 271, 272, 279 Gokstad ship 97-8, 101 gold cloth 289-90 golden fleece 289 Gore-Tex 197-8 Gossypium 166-7 Gotthelf, Jeremias 276 Gower, John 119 Granville, Augustus Bozzi 49, 50-1, 52, 53 Gray, Hawthorne 229 Greeks, ancient Arachne 276-7 childbirth 13 deities 12, 277 the Fates 1, 10 golden fleece 289 looms 6, 43 Midas 10-11 Olympic Games 255-7 prehistory 32 textile work 14 Grimm brothers 11, 14 gros point 147 ground looms 30, 42-3 GT Law & Son 261 guilds 124, 125-6, 133, 155 gun sights 278

haberdashers 149 Habit de Lingère (l'Armessin) 149 habits 128 hackling/heckling 27, 28, 41, 296 Hadfield, Chris 241 Håkon V 111 Hals, Frans 152-3 Hamilton, Alice 211, 214, 215 Hamilton Standard 233, 234 Hammond, James Henry 171-2 Han dynasty 69-72 Hargreaves, James 170 Hartley, Dorothy 27 hatchel 18 health of factory workers 211-17, 220-1 Hebrew Scriptures 84 heckling/hackling 27, 28, 41, 296 heddle loom 6

Helbaek, Hans 33-4 Helios 87, 88 hemp 28 Henry III 127 Henry III of France 142 Henry VI, Holy Roman Emperor 131 Henry VIII 290 Herculaneum 91 Herodotus 40, 44, 45, 48, 52, 166 Heyerdahl, Thor 103 Higden, Ranulf 132 hijab 259 Hillary, Edmund 193, 197, 198 Hilliard, Nicholas 151 Histories (Herodotus) 45 hobnail boots 187 Hobsbawm, Eric 2 Holda 12 holland 16, 296 Homer 11-12, 142, 291 homespun fabric 162 Horace 92 Horse, Goose and Sheep (Lydgate) 119 hosiery 207-8 hot-air ballooning 229 Hoyland, Graham 194, 198 Huaca Prieta, Peru 167 Huguenots 150 Huizong (Chinese emperor) 62-3, 72 Hull 121, 125 humans: lack of fur 25-6 Humbert, Agnès 203-5, 210, 211-12, 216 - 17hygiene 240 hypothermia 25, 190, 192 I. G. Farben 207, 211 Ibn Fadlan, Ahmad 99

Ibn Fadlan, Ahmad 99 Icebreaker 199 Icelandic sagas 99, 101 Incas 12, 172 India cotton 168, 170, 180 Mughal Empire 8 spinning 14, 16, 170 synthetic textiles 220 trade 81, 168 weaving 13-14 "*indigen 162*, 177, 180 Indonesia 219, 220 industrial espionage 147

Index

Industrial Revolution 2, 9-10 International Latex Company (ILC) 233-5, 236 Inuits 52, 185 Iona 113 Irvine, Andrew "Sandy" 187-8, 190 Isaac, Stu 267 Isis and Osiris (Plutarch) 39, 44 Italian banking 126-7 Italy lace 144, 150, 156 rayon 207, 211, 214-15 textile specialisms today 8 Jacquard, Joseph Marie 7-8 Jacquard loom 7-8, 296 Jaeger 185, 189 James I 88, 153 Jamestown, Virginia 89 Japan deities 12 jorōgumo 276 ravon 207 silk 208 textile specialisms 9 Jasan and the Argonauts 209 jean 163 jeans 163, 176-9, 180 jersey 209, 296 Icws: Silk Roads 84 Jiahu, Henan, China 63 jin fabrics 87 jockstraps 258 Johnson, Samuel 137 jorōgumo 276 **Julius Caesar** 91 **Justinian I 86** jute 28 Kay, John 169 Kevlar 263 King Cotton speech 171 Kingswood Abbey, Wiltshire 129 Kipchoge, Eliud 262-3 Knighton, Henry 118 knights 289 knitting, nålebinding 113

Knitting, naleoinaing 113 Kon-Tiki expedition 103 Koppett, Leonard 259, 261 Krakauer, Jon 193, 197 Kublai Kahn 88 Kvavadze, Eliso 21 lace definition 140 development of 140 fashions 144-5, 147-8, 149, 152-3 lawsuits 153-4 Louis XIV 146 metal 142-3, 151 patterns 140-1, 144 silk 141 social status 139, 143 threads 141 see also ruffs Lace Wars 147-8 Lacemaker, The (Vermeer) 137-9, 143, 144 lacemaking calligraphy 17 complexity 143 Flanders 144, 147, 148, 150 France 16, 147-8, 149-50, 155-6 Netherlands 137, 154-5 poverty 154-6 techniques 144 Venice 147, 148, 150 Lachesis 1 Langland, William 117 language boats 104 Egypt, ancient 52 Latin 91 ravon 205 words and phrases derived from textiles xi-xii, 1, 13, 17-18, 119 lanolin 109, 122, 185 l'Armessin, Nicolas de 149 Larsen, Paul 192, 197, 198 Lascaux caves, France 32-3 Laughing Cavalier, The (Hals) 152-3 laws Britain 118, 148 China 67, 87-8, 290 France 16, 142 lace 155-6 Netherlands 16 Romans, ancient 92 sails 111 see also sumptuary laws Lee, Bill 260 Lee, Stan 276 Leeds 9-10 Leggett, William F. 22 Leonov, Alexei 238-9

Leopold, Duke of Austria 131

343

Levi's 176, 177-9 Lewis, Randy 282 Lezak, Jason 252 lice 25, 39 Lincoln, Abraham 175 Lincoln Green 117-18 Lincolnshire 129 Lindisfarne 112-13 linen attributes 44 Egypt, ancient 2, 38-9, 40-1, 43, 44-8, 52-3 Georgian England 145 language xi, 18 see also lace linseeds 41 lint 168 Linton Tweeds 9 livery 126 loft 197 loincloths 256, 257 longships 97-100, 101, 105-6, 111, 114 looms archaeology 30 back-strap loom 6, 66-7 China 67-8, 86, 88 definition 5-6, 296 ground looms 30, 42-3 heddle loom 6 Industrial Revolution 9-10, 170 Jacquard 7-8, 296 treadle loom 123 two-beam loom 123 vertical looms 43 Vikings 110 warp-weighted 6, 31, 123 Loti, Pierre 50 Louis XIV 146-8, 153, 279 Loulan princess 80 Lovelace, Randy 229-30 Lovell, James 240 Love's Labour's Lost 17 Lucan 86 Luddites 10 Lululemon 263 lustring 296 Lycra 208, 267 Lydgate, John 119 LZR Racer 251-3

Mack, Chaney 162 MacRae, Alexander 259-60

Madagascar 271, 272, 279-80 madder 122 Magalotti, Lorenzo 155 make-up 208 Mallory, George 186, 187-9, 190-1, 192, 194, 199 maltote (evil toll) 127 Mama Ocllo 12 Manchester 170, 171 Manet, Edouard 161 Mansur 87 Mantero 8 Martial 91 Mary Queen of Scots 141, 152 Maspero, Gaston 52, 53 Master, James 156 McCartney, Stella 286 Meaux Abbey, Yorkshire 129, 130, 132 medical technology 284 Medici, Catherine de" 141 Medici family 8 Mehrgarh, Pakistan 167 Meketre tomb, Egypt 42 Mendeleev, Dmitri 206 mercers 296 Mercury space program 231-2, 239 merino wool 199 Mesopotamia 12, 105, 276, 289 Messikommer, Jakob 29 metal lace 142-3, 151 metaphors 18 see also language Midas 10-11 Midsummer Night's Dream, A 278 midrash 84 Miles, Richard 169 milk 281-2 Miller, Daniel 176-7 mills, cotton 170, 171 Ming dynasty 65, 67 Mirour de l'Omme (Gower) 119 modesty 257-8, 259 Mogao Caves, China 78-80, 85 Moiseev, Nik 244 molluscs 92, 291 monasteries 84, 112-13, 128-30, 133 Monchaux, Nicholas de 235 Mongolia 68-70, 88, 290 monks 84, 85, 86, 112, 121, 128 Montague, Alice 151-2 Montastruc, France 31 Montgolfier brothers 229 moon landings 225-6, 232

345

mordants 142, 296 morlings 122 Morvson, Fvnes 148-9 moths: archaeology 23 mountaineering 186-91, 192-5, 196-7, 198 mourning 209 Mughal Empire 8 mulberry 60, 61, 86, 88-9 mummification 2, 38-9, 46-7, 48-53 Musk, Elon 242-3 muslin 162, 296 mycelium funghi 221 mythology golden fleece 289 Norse 99 silk 59-60, 80, 89 spiders 275-7 Teflon 236 textile influence 10-13 nålebinding 113 nankeen 296 nap 124, 296 Nardi, Giovanni 50 MARA 227, 233 4, 236 6, 240, 252 natron 45 needle lace 144 needles: archaeology 31 needlework poor laws 154-5 women 138, 141, 155 Negm, Ahmed Fouad 42 Neith 12, 40, 276 Neolithic period cotton 167 earliest textiles 21-4, 31, 32-3 Egypt 47 silk 63-4 Nephila Madagascariensis 273, 279 Nero 90, 91 Netherlands lacemaking 137, 154-5 laws 16 Netscher, Caspar 138 Newman, Dava 243 Nexia Biotechnologies 281-2 Nicolas of Ludlow 125 Nike 259, 261-2 Nile river 41 Nîmes, France 177 nomads 68-9, 72

Normans 119–20 Norse mythology 1, 12, 99 Norton, Edward 189 Norway 97–8, 106–7, 108 nudity 255–7, 292 nursery rhymes 276 nylon 207–8, 209–10, 230, 231, 243, 266

Oates, Lawrence 195 occupational health 211-18, 220-1 Odell, Noel 187-8, 190, 191 Odyssoy (Homer) 11-12, 142, 291 Oedipus 10 Offa of Mercia 124-5 Oliver, Thomas 214 Olympia (Manet) 161 Olympic Games 249, 252, 253, 255-7, 258, 260, 266 oracle bones 64 Orban, David 7 Orlon 208 Oseberg ship 89 osnaburg 162, 163, 164, 297 Ovid xiii **Oxford Biomaterials 284** Oxford 3llk Group 283, 284

Pagano, Mathio 141 pageantry 126 Palmyra 83, 84 paper 17 parasites 25-6 Parcae 1 Parcak, Sarah 100, 102 Paris 209 parkas 185, 196 passementerie 140, 144, 155 patching 47, 165 patterns cotton 162, 168 lace 140-1, 144 silk 66, 87-8, 89 Peasants Revolt 118 Peers, Simon 271-2, 279-80, 286 Pegolotti, Francesco Balducci 128 pelts 26 Penelope (Odyssey) 11-12 Pepys, Samuel 142 Periplus Maris Erythraei 85 Persians 44, 86, 87 perspiration 192 Peru 167, 172

Peterson, Frederich 213 Petronius 90, 91 Pettigrew, Thomas 49, 50 Petty, William 9 Phelps, Michael 249-51, 252, 254-5 Philip III, Duke of Burgundy 289 Philostratus, Flavius 1 Phoenicians 44 Pi-an-fu, China 84 Piers Plowman (Langland) 117 pile 297 pilgrims 85, 87 pilots 229-31 Pinna Nobilis 291 pins 235 Pizarro, Francisco 172 plain weave 5, 43, 297 plains 162 plantations 165, 168 Plato 256 Plavtex 233-5 Pliny the Elder 91, 92, 93 plus fours 189 Plutarch 39, 44 ply definition 297 earliest fibers 23, 32 poems The Book of Odes 13, 59 reversible 57-9 on wool 119, 122 point de venise 147 points de France 147-8 polar exploration 183-6, 192, 195-6 pollution 220 Polo, Marco 80, 83-4 Poly-Olbion (Drayton) 117 Polychronicon (Higden) 133 polyester 208, 219, 297 Polynesia 103-4 polyurethane 250, 252, 253, 254, 265 - 6Pompeii 91 poor laws 154-5, 156 Portmohomac, Scotland 113 Post, Wiley 229 Postlethwayt, Malachi 169 potash 297 power: clothing as symbol 3 see also royalty; social status power loom 9, 170 Poyntz, Adrian 140

prehistory clothing 24-7, 31 textile production 2, 21-4, 31, 32, 33 priests 3,45 prison workers 204, 211-12 prisoners 180 Project Jacquard 7 prostitutes 92 proverbs and sayings 13, 62 punto in aria 144 Qin dynasty 67 Qing dynasty 66 ramie 8, 28 Ramses II 52, 53 Ramses III 47 Rana Plaza disaster 217-18 ransoms 131-2 rayon (viscose) 203, 204, 205-7, 211-12, 214-15, 216-17, 219-21, 297 Reael, Laurens 141 Reebok 263 religion China 64-5, 84, 87 Egypt, ancient 2, 39, 44-6, 53 Huguenots 149-50 Mesopotamia 289 Silk Roads 84, 87 see also deities Renoir, Auguste 137 retting 28, 41, 297 rewards: textiles as 65, 87 rib 297 Richard I 130-2, 133 Richard II 126 Richtofen, Ferdinand von 81 Rievaulx Abbey, Yorkshire 128 Ringgold, Faith 15 rippling 28, 296 Risala (Ibn Fadlan) 99 Roach, Mary 242 Roanoke River 220 Robert de Skyrena 130 Robin Hood 117-18, 130 rodeos 175-6 Rogan, Markus 265 Romans, ancient 1, 90-3 rooing 109 rove 297 roves 42 Royal Society 50, 51

347

rovalty guilds 126 lace 151, 153-4 rubber 212-13 ruffs 3, 143, 149, 151 running shoes 261-3, 265 Rus 83 russet 123 Russia 31-2 S-twist 5, 23, 42, 297 Sack: definition 120, 297 sailcloth 106-8, 109-11, 114 sails 98, 99, 100, 104-5, 106, 108, 113 Sais, Egypt 40-1 samite 89 samplers 17 sandstorms 82 Santry, Joseph 254 Sardinia 291 sarpler 297 sarsenet 297 Sasanid Empire 87 satellite archaeology 100-1, 102 satin 88, 297 Satyricon (Petronius) 90, 91 Scandinavia 89, 97-8 Schirra, Walter 231-2, 239 Scott, Robert Falcon 183, 184, 186, 194, 195-6, 199 scouring 297 scutching 28, 41, 297 sea silk 291 Second World War 203-4, 208, 211, 214-15, 216-17, 229-30 Seeger, Pete 289 Seneca 92, 272 sericin 61 sericulture 60-2, 63, 67, 80, 86 sewing: Egypt, ancient 44 Shackleton, Ernest 185, 186, 191, 192 Shakespeare, William 17, 278 Shang dynasty 64, 66 Shanteau, Eric 251

shearing 109, 297

monasteries 128-9

Vikings 108-9, 114

prehistory 28-9

Shepard, Alan 232

Britain medieval period 120, 121

shed 6, 297

sheep

Shepherd, Lenny 234, 236 shoelaces 6 shoes, running 261-3, 265 shopping: women's role 15-16 shrines 45-6, 78 shuttles 169-70, 297 Sigvatr the Skald 102 silk archaeology 63-4 artificial see rayon China 8, 59-60, 62-8, 69-72 color 66 as currency 68 England 88-9 Japan 208 lace 141 Latin 91 legends 59-60, 61, 80 patterns 66, 87-8, 89 Racerback swimsuit 259-60 reworking 86 Romans, ancient 90-3 samile 89 sea silk 291 social status 88, 90, 91, 100 see also sumptuary laws taxation 67 as wealth source 67 8 see also spider silk Silk Roads cities 83-4 cultural exchange 2 Gobi Desert 68 Mogao Caves, China 78-80 name 81 pilgrims 85, 87 Romans, ancient 90-1 routes 81-2 traveling conditions 82-3 silkworms America 89 compared to spiders 274, 279, 282 farming 13, 61-2, 86 lifecycle 60-1 Roman understanding of 91 smuggling 80, 86 silver cloth 290 Silver State Stampede rodeo 175-6 Skithblathnir 99 slavery 159-60, 162-6, 168-9, 172, 173 - 5sleeping bags 193

slub 297 Smith, Adam 9 smörring 110-11 smuggling, silkworms 80, 86 soap 145 Sobek 40 social status Africa 162 China 65-6, 290 Egypt, ancient 47 gold cloth 290 lace 139, 142, 143, 151 Robin Hood 117-18 silk 65-6, 88, 90, 91, 100 slaves 161, 162-4, 165 sumptuary laws 3, 65-6 Sogdians 82-3 Somervell, Howard 189 Song dynasty 66 Southern, Ted 244 space tourism 245 spacesuits 225-9, 231-8, 239-42, 243-4 Spain 290 spandex 208, 260 speculation 129-30, 133, 179 Speedo 251-3, 254, 260, 266-7 Spiber 286 Spider-Man 276 spider silk 271-2, 274-5, 277-86 spiders 272-4, 275, 276, 279, 283 spindle whorls 6, 30, 123, 297 spindles 5, 42, 297 spinning cotton 165, 168, 170 definition 297 deities 12 Egypt, ancient 42 employment numbers 2, 16 hand-spinning skill 30 Industrial Revolution 170 process 4-5 spider inspiration 275 superstitions 14 wool 109-10 spinning jenny 9, 170 spinsters 13, 16 sportswear 252, 253, 257-67 Ssu-ma Ch'ien 64-5 Standen, Edith Appleton 139 staples 122, 206, 297 Star Gauge (Su Hui) 57-9 statues 45-6, 65, 289

steam-powered-mule 170 Stein, Aurel 68, 77-8, 79-80, 82-3, 84, 85, 93 stockings 3, 207-8 storytelling 11, 18, 117-18 Strauss, Levi 7, 177 string 24, 33, 34 Stubbes, Philip 142, 151 Su Hui 57-9, 72 Suetonius 92 Sumerians 12 sumptuary laws 3, 65-6, 118, 143, 290 superheroes 276 superstitions 14 sweat 192, 198, 239-40, 257, 259 swimming 249-54, 257, 259-60, 265-7 Switzerland 32 synthetic textiles consumer demand 209-10, 219, 221 down 197 employment numbers 218, 220 environmental impact 219-20 fashions 209-10 fleece 196 Gore-Tex 197-8 health of factory workers 211-17, 220-1 Heattech 9 Lycra 208 nylon 207-8, 209-10, 230, 231 polyester 208, 219 rayon 203, 204, 205-7, 211-12, 214-15, 216-17, 219-21 spacesuits 235, 243, 244 spider silk 285-6 sportswear 252, 253, 261, 262, 263, 265 - 7T-1 suit 230 Ta-in-fu, China 84 tabby weave 5, 43 Tacitus 105 Tait/Tayet 12 Tang dynasty 66 taxation Richard I ransom 132-3 silk 67 soap 145 wool 127, 129 tea 59,61

teasels 124, 298

tennis 261

Teichman, Eric 77

Teflon 197, 235-6, 252

Index

349

tenterhooks 18, 124 Terra Nova expedition 183, 184-6 Terrazign 244 Thomas of Merton 132 Thucydides 256 Tocqueville, Alexis de 170 tombs China 63, 64 Egypt 37-9, 40, 42, 45, 46-8, 53-4 Mongolia 70 Neolithic period 32 Tomkins, Thomas 151 Torres, Dara 253 Touchett, Samuel 170 tow 18, 162, 298 tow-headed 18 trade America 173 China 66, 68, 69-72, 81, 86, 290 cotton 169, 171, 173, 179 cultural exchange 2.8 Egypt, ancient 44 England 125-7, 129-30 gold cloth 200 India 81, 168 sea routes 168 slavery 169 Vikings 83, 100 see also Silk Roads trainers 261-3. 265 treadle looms 123 Treatise on Embroidery (Ding Pei) 72 tributary system 69-71 Trondenes, Norway 106-8 Trousers: computers 7 Troy 31 Tucker, Ross 264, 265 tulle 298 Turkey 33-4 Turner, Jeffrey 281 Tutankhamun 37-9, 40, 45-6, 47, 48, 52, 53-4 tweed 9 twill 5, 110, 162, 298 twine 298 two-beam looms 123 Tvr 254 Under Armour 263 underwear anti-odour 263

bras 258

spacesuits 240, 241-2 uniforms 2-3 Unialo 9 urine 241-2 Uttu 276 Valkyries 12 van der Voort, Cornelis 141 Van Dyck, Anthony 153 van Gogh, Vincent 138 Vedic mantras 21 Velásquez, Diego 152 velvet 290, 298 Venice: lace 143, 147, 148, 150 Vermeer, Johannes 137-9, 143, 144 vertical looms 43 Victoria's Secret 243 Vigliani, Enrico 214-15 Vigo, Chiara 291 Vikings America 101-2 hurials 89 longships 97-100, 101, 105-6, 111, 114 raids 112-13 sailcloth 109-11 sheep 108-9, 114 trade 83, 100 Villiani 125 virtue 138, 145 viscose see rayon Vollrath, Fritz 283, 284

exploration 198-9

W. L. Gore 197-8 walnut 162 Wang Bo 77 Wang Mang (Chinese emperor) 68 Wang Yuanlu 78-9, 85 warp 5, 30, 109, 298 warp-weighted looms 6, 31, 123 Washington, George 171 water frame 9, 170 water pollution 220 water resistance, wool 109 Wayland Barber, Elizabeth 24 wealth cotton 170 lace 139, 142, 143, 145 silk 67-8, 90, 92

vulcanization 212-13

Vykukal, Hubert 243

wealth (continued) Silk Roads 83 wool 125-6, 133 Weathers, Beck 195 weaving Arachne myths 276-7 China 65, 67 cotton 168 definition 298 deities 12 earliest fibers 24, 34 Egypt, ancient 42-3 flying shuttle 169-70 folk songs 4 guilds 124 India 12-13 Industrial Revolution 170 process 5 spider inspiration 275 spider silk 280 wool 110, 123 webs 272, 273, 274, 278, 283 weft 5, 30, 110, 298 weld 122 Wenzong (Chinese emperor) 87-8 White, E. B. 275 White, Ed 239 whiteness 45 Whitney, Eli 173 whorls 123, 298 Widmaier, Dan 285, 286 Wilde, Oscar 255 Wilfork, Vince 259 William of Newburgh 132, 133 William of St-Thierry 128 Wilson, Edward 186, 193 Wilson, Eric 251 Wilton, Kate 263 Winric of Treves 122 woad 122 Wolfe, Tom 179 Wolsey 185 women burials 13 China 58, 65, 72 clothing 180 needlework 138, 141, 155 role models 12 Romans, ancient 92 shopping 15-16 spider women 276 sportswear 257-9

textile work 2, 12, 13, 14-15, 16-17, 168 wool attributes 107, 109 Egypt, ancient 44 felting 29 lanolin 109, 122 measurements 120 merino 199 prehistory 28-9, 34 processing 109, 122-3 quality 109, 120, 121, 122 sailcloth 106-8, 109-11, 114 speculation 129-30, 133 spinning 109-10 taxation 127, 129 tennis balls 261 weaving 110, 123 yak 199 woolens Britain medieval period 118, 119-24, 125 - 33Britain today 8-9 cloth grades 123, 162 color 117-18, 121-2, 126 Flemish cloth 125, 127 Florentine cloth 125 fulling 110, 123-4 guilds 125-6 Norwegian sailor's clothing 113 polar exploration 185, 193 social status 117-18 see also sumptuary laws swimsuits 259-60 see also broadcloth Woolsack 133 worsted 15, 298 wound dressings 278, 284 Wright Lab 230-1 Wu (Chinese emperor) 70, 81 Wu Zetian (Chinese empress) 67 Wyatt, Thomas 152 xanthate 205

Xenophon 256 Xerxes 44 Xia dynasty 65 Xiling 59–60, 61, 65 Xiongnu 68–72 Xuanzang 85, 87

yak wool 199

351

yarn definition 298 earliest fibers 23 Yeager, Chuck 230 York 120-3, 126 York Weavers guild 124 Yorkshire 120-1 Yü (Chinese emperor) 64-5 Yuan dynasty 88

Z-twist 5, 298 Zeus 255, 289 Zhangzong (Chinese emperor) 66, 290 Zhou dynasty 66, 67, 68 Zoom Vaporfly 262

Kassia St. Clair is a design and culture writer and author. Her first book, *The Secret Lives of Color*, was a Radio 4 Book of the Week. She lives in London.